JESSIE WILLCOX SMITH
A Bibliography

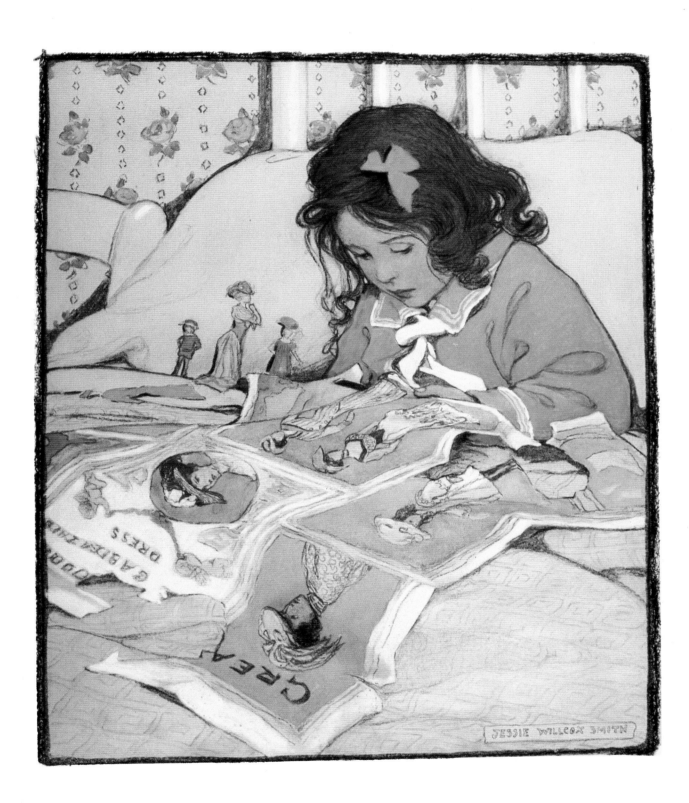

JESSIE WILLCOX SMITH
A Bibliography

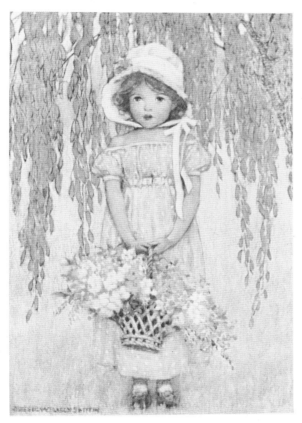

Edward D. Nudelman

Pelican Publishing Company

GRETNA 1989

Library of Congress Cataloging-in-Publication Data

Nudelman, Edward D.
 Jessie Willcox Smith: a bibliography.

 Bibliography: p.
 Includes index.
 1.Smith, Jessie Willcox, 1863-1935—Bibliography.
2. Illustration of books—19th century—United States—
Bibliography. 3. Illustration of books—20th century—
United States—Bibliography. I. Title.
Z8820.83.N8 1989 016.7416′092′4 87-31576
[NC975.5.S64] N8
ISBN 0-88289-696-2
ISBN 0-88289-697-0 (special deluxe ed.)

The dustjacket, frontispiece, and slipcase
illustration is reproduced from the original
painting, which was loaned by an anonymous
collector. In its published form, in **THE
BEDTIME BOOK**, the illustration's colora-
tion was altered. This is the first appearance of
the illustration as it was painted by Jessie Willcox
Smith.

The title-page illustration is from **A LITTLE
CHILD'S BOOK OF STORIES**, facing
page 71.

Book design: Bill McBride

Published by Pelican Publishing Company, Inc.
1101 Monroe Street, Gretna, Louisiana 70053

Printed in Hong Kong

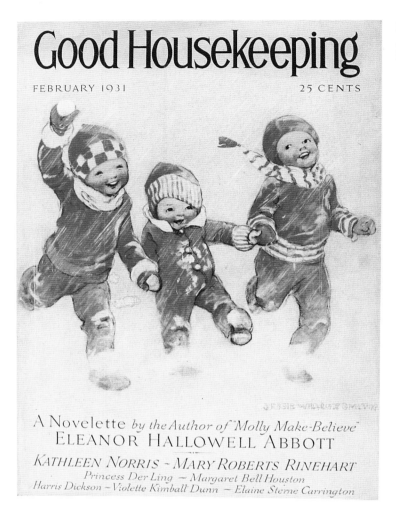

For Susan, my wife;
Aaron, my son; and
Katie and Sarah, my two daughters.

Acknowledgments

An undertaking of this size and scope could not have even begun without the generous help of so many people. I would like to thank my wife, **Susan**, for her love, support and forbearance; and also for showing me the first book illustrated by Jessie Willcox Smith I ever saw, a remnant from her childhood. I would also like to thank two collectors who have given me unreserved access to their personal collections: **Elizabeth A. Clifton**, Seattle, and **Horace Brown**, Las Vegas. The following have very cheerfully provided for me valuable bibliographic information, for which I am most grateful: **Helen Younger** (Aleph-Bet Books), **Selma Peterson, Jo Ann Reisler, Ruth DeBoer, Richard Devictor, Terry Booth, Mrs. David Comstock, Dr. Jacob Foster, Cathe Hart, Sharon A. Packard, Michael Warner, Lee Walp, Esther Watkins, Mrs. Stephen Potter, Malcolm M. Ferguson, Vera Colman** and **Barbara Stone**. A special thanks to all those who dutifully answered my letters asking for information on Jessie Willcox Smith. Among the over sixty institutional libraries, dozens of private galleries and art museums, and a few relentless Smith admirers, the following have been most helpful: **Ann Barton Brown**, Brandywine River Museum: **Jonathan Dodd**, Dodd, Mead and Company; **Kenneth W. Lang**, Doubleday and Co; Rare Book Department, Library of Congress; Rare Book Department, The British Museum; **Pierre M. Purves, Mr. C. Douglas Buck, Jr; Mrs. Edward H. Doolin, Mrs.** and **Lawrence M. C. Smith**. So many of the staff of the following institutions offered their valuable time and assistance, for which I thank them heartily: The Pennsylvania Academy of the Fine Arts, The Delaware Art Museum, The Chicago Art Institute, and the Bryn Mawr College Archives Department. A final thanks to **Mrs. William S. Crowder** and the late **Miss Edith Emerson** for giving generously of their time in granting interviews and showing me examples of Smith's art and personal life. Special thanks to **Ras and Reah Jennings** for the kind lending of items from their collection, and to **Tom Holt** for expert photography.

A3. Evangeline, *facing p. 98*

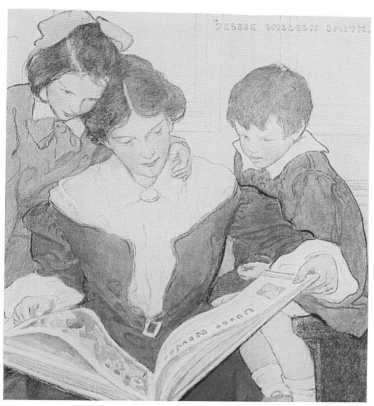

A41. When Christmas Comes Around, *facing p. 10*

Table of Contents

Acknowledgments . 6
Bibliographic Method 8
Introduction . 9
Sources . 22
American Editions of Books 23
English Editions of Books 119
Illustrations in Periodicals 143
Calendars . 155
Posters . 163
Advertisements . 165
Prints . 169
Miscellaneous . 171
Index of First Appearances of Illustrations . . 175
Index of Book Titles 183
Index of Book Authors 184

Bibliographic Method.

Title: A "quasi-facsimile" transcription of the title-page is given with a slash, / , designating a new line. In most cases, any illustrations or decorations that are not a part of the wording of the title-page are not included in the transcription, but appear in the Description Entry.

Pagination and Collation: Each book (and also some calendars in the form of bound sheets) has been carefully described with an attempt to preserve the designated pagination used in the work. As is everywhere evident publishers differ considerably in their assignments of page numbers. It is not uncommon, especially in the pages preceding the text, for page numbers to appear and disappear, and not always totally inclusive for all the pages present. Our method is to represent each page of the book, starting with the half-title and going all the way through the book to the last page with printing, by either an Arabic or a Roman numeral. If the page is not numbered in the work, then the designation will be in [brackets]. Roman numerals always precede the text, Arabic numbers may appear anywhere in the work. Pages in the form of either front or rear blanks are not ordinarily designated except when they distinguish a point of issue. In the majority of cases, plates which are inserted are not paginated and the illustrations are designated as: *Facing page x*. Thus, the frontispiece insertions are not identified in the pagination, but are indicated in the collation.

Example: LITTLE WOMEN

Pagination: viii, [2], 617, [1] p. means there are ten pages prior to the text, the last two of which are not numbered, followed by 617 pages of text, followed by one unnumbered page. Note that any or all of the seven pages preceding, viii, may be unnumbered, and the full identification of these pages is given in the collation which follows the pagination.

Size of Book: Given in centimeters, with the height (from bottom of cover to top of cover) given first, followed by the width (from spine to outer edge of cover). Note: since the spine of many books is rounded, the measurement for the width of the book is taken from an imaginary plane at the outer edge of the spine.

Size of Leaf: Given in centimeters, with the height given first, followed by the width.

Collation: Corresponds to pagination scheme. Copyright data not given in facsimile, but relevant dates and attributions are presented along with notations on copyright page which may attribute a priority to an issue.

Description: Description of how the book is bound (i.e. cloth or paper covered boards, etc.), color, texture, etc. is given followed by a "quasi-facsimile" transcription of the cover and spine lettering and decoration. Endpapers are described as well as cover jackets when issued.

Paper: The two types of paper appearing in this bibliography are wove and laid, with most books issued on wove paper. Laid paper means paper watermarked with close, fine parallel lines. Coated wove paper with glossy sheen is distinguished from plain wove paper, and the relative thickness of the paper is given qualitatively.

Illustrations: Each illustration by Jessie Willcox Smith is listed even if not credited in a list of illustrations. If no title or caption appears in the book, we have given the illustration an appropriate title in brackets.

Issue Points: Determination of points and priority of issue is based upon examination of multiple copies of each work with the following criteria in mind: owner's dated inscription, publisher's designations as listed in trade journals (*Book Buyer*, *Publisher's Weekly*, etc.), advertisements on wrappers (i.e. dates of publication of books advertised), price of book as listed on wrapper or box (versus price listed in Copyright Registry), entries in Union catalogue, British Museum, etc., and qualitative assessments based upon the usual printing habits of the respective publishers. We have also solicited and received data from over two hundred United States libraries who own books illustrated by Jessie Willcox Smith, including the Library of Congress and the British Museum in London. The author's own complete collection served as a valuable resource as did generous loans from many private collectors.

Publication Notes: Date of appearance in *Publisher's Weekly* is given, along with the page where entry may be found. The Copyright Registration date (first entry) and the date of Receipt (second entry) by the Library of Congress are given. Also, the holder of the copyright is given if available.

Price at Issuance: As recorded in the *Copyright Registration Record*, *Publisher's Weekly*, or *Book Buyer*.

Note on Illustrations: Cross-referencing of illustrations in the work with other appearances of the illustrations either in prior or subsequent issues of books, magazines, calendars, posters, etc.

Introduction

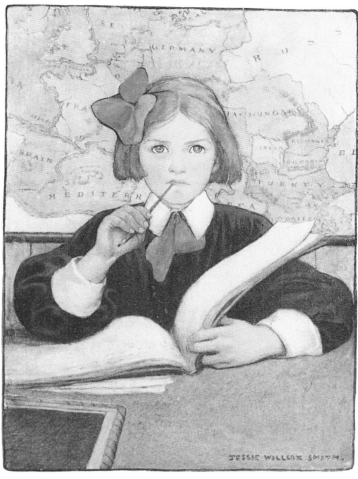

A29. The Seven Ages of Childhood, *facing p. 34*

GOOD HOUSEKEEPING

MARCH, 1919 25 CENTS

Good Housekeeping

SEPTEMBER,
1927 25 CENTS

Beginning "SILVER SLIPPERS"
TEMPLE BAILEY'S
New Novel

GOOD HOUSEKEEPING

OCTOBER, 1921 25 CENTS

"His Soul Goes Marching On" *by Mary R. S. Andrews*
A Love Story of Hawaii *by Fanny Heaslip Lea*

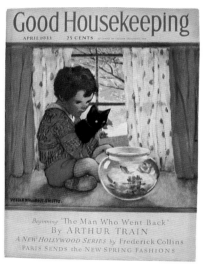

Good Housekeeping

APRIL 1931 25 CENTS

Beginning "The Man Who Went Back"
BY **ARTHUR TRAIN**
A *NEW HOLLYWOOD SERIES by Frederick Collins*
PARIS SENDS the NEW SPRING FASHIONS

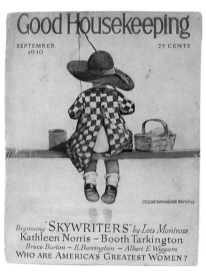

Good Housekeeping

SEPTEMBER
1930 25 CENTS

Beginning "SKYWRITERS" *by Lois Montross*
Kathleen Norris ~ Booth Tarkington
Bruce Barton ~ E. Barrington ~ Albert E. Wiggam
WHO ARE AMERICA'S GREATEST WOMEN?

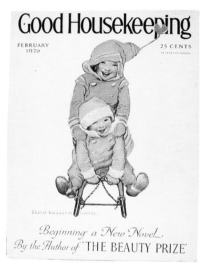

Good Housekeeping

FEBRUARY
1926 25 CENTS

Beginning a New Novel
By the Author of "THE BEAUTY PRIZE"

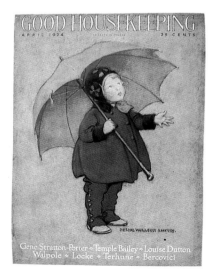

GOOD HOUSEKEEPING

APRIL 1924 25 CENTS

Gene Stratton-Porter ~ Temple Bailey ~ Louise Dutton
Walpole ~ Locke ~ Terhune ~ Bercovici

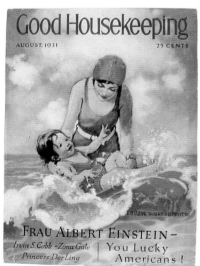

Good Housekeeping

AUGUST, 1931 25 CENTS

FRAU ALBERT EINSTEIN –
Irvin S. Cobb ~ Zona Gale | **You Lucky**
Princess DerLing | **Americans!**

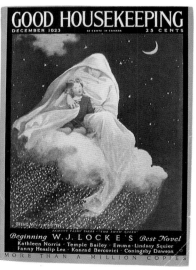

GOOD HOUSEKEEPING

DECEMBER 1923 25 CENTS

Beginning **W. J. LOCKE'S** *Best Novel*
Kathleen Norris ~ Temple Bailey ~ Emma ~ Lindsay Squier
Fanny Heaslip Lea ~ Konrad Bercovici ~ Coningsby Dawson
MORE THAN A MILLION COPIES

A3. Evangeline, facing p. 60

A14. Baby's Red Letter Days, page 9

In nearly forty productive years as an artist, Jessie Willcox Smith established herself as America's greatest and most prolific female illustrator. In her professional career from 1888 to 1932, Smith illustrated over sixty different books, adorned the pages of literally hundreds of magazines, created magnificent posters, prints, calendars, postcards and even pictorial handkerchiefs. Near the end of her career Jessie Willcox Smith became an accomplished, well-known portrait artist.

Drawing on the influences of a fertile art community in Philadelphia at the turn of the century, Smith refined and mastered the art of decorative illustration. At this time, illustration in America was experiencing a renewed prosperity and popularity brought about by a combination of several factors. The revival of book design in England, as well as numerous technological advances in color printing, made the profession of book illustration more feasible for young aspiring artists. By 1880, enrollment in American art schools had seen an unprecedented increase, largely due to the influx of women into the field. In Philadelphia, the Philadelphia Academy of Fine Arts, the Drexel Institute of Arts, and the Philadelphia School of Design led the way for women in illustration. With graduates such as Thomas Eakins, Cecilia Beaux, and Mary Cassatt, the Philadelphia Academy of Fine Arts was universally recognized as one of the finest schools for developing superior technical skills in art. It was here that Jessie Willcox Smith enrolled in 1885 and for three years was under the tutelage of Thomas Eakins, the great and irascible American painter.

Jessie Willcox Smith had never intended to become an artist. Her childhood years were spent in preoccupations quite removed from the realms of artistic inclinations. In her own words: "The margins of my schoolbooks were perfectly clean and unsullied with any virgin attempt at drawing." She was born September 6, 1863, the youngest daughter of Charles Harry Smith and Katherine DeWitt (Willcox) Smith. Her early years were spent in the quiet environment of middle-class upbringing. In 1879, at the age of sixteen, Smith was sent by her parents to Cincinnati to finish her education and study for a career as a kindergarten teacher. She had always felt a closeness and sensitivity to younger children. "I had always loved children, and since I was obliged to earn my own living, decided to be a kindergarten teacher. The friend with

whom I lived while I was studying was an artist and had consented to give some lessons to a young chap who was anxious to learn to draw. I went along as a chaperon My friend looked around the room in which the lessons were about to begin. "What do you want to draw? she asked the boy, 'Here's a student lamp. Try that. Why don't you sketch it, too, Jessie, just for fun?' The boy grasped his crayon hard, screwed up his face and began laboriously to copy the lamp; I took a pencil, made a few swift lines and then went on with the book that I had brought to read. When my friend saw the sketch she exclaimed, 'Why, Jessie, you can draw—that's good! How do you do it?' She took the sketch to her mother who was an illustrator of some note and on the strength of that sketch of a student lamp I was actually persuaded to cut short my kindergarten course and study art." Her early experiments were as a sculptor and, in the few figures which remain, one can see the hidden perspective and sensitivity which was to later characterize her art. But this phase was short-lived: "My career as sculptor, however, was brief, for my clay had bubbles in it and would burst when it was being fired. 'Heavens,' I decided, 'being a sculptor is too expensive. I'll be a painter!' " In an effort to pursue her new-found interest in painting, Smith enrolled in the School of Design for Women in Philadelphia in 1884. It soon became apparent to Smith, however, that it was no place to realize her potential as an artist. The School of Design was intended as a finishing school for ladies, with strong emphasis in the more traditional crafts of embroidery, weaving, etc. After less than a year's study at the School of Design, in 1885, Smith decided to drop her studies and enroll in the Pennsylvania Academy of Fine Arts. This was unquestionably the turning point in her artistic career and the real beginning of her formal artistic education. It was here that Smith studied with the famous Thomas Eakins and the much admired Thomas Anschutz. Eakins was a highly sophisticated, well-trained artist who scrupulously taught the fundamentals of art. It has been said that Eakins possessed the greatest pictorial intelligence of all his contemporaries in the field of American painting. He taught the most rigorous and scientific class on anatomic structure and function ever offered at the Academy, even bringing in cadavers for examination and investigation. It was no secret, however, that Smith and Eakins did not get along well. The volatile mentor was often

demonstrative and theatrical. According to one critic "only the most tenacious student could subject herself to the rigorous demands of Eakins's teaching, which made no allowance for the frailties of women." Despite this, Smith was to learn invaluable skills under Eakins's guidance, including the fundamentals of photography. These she would use and benefit from throughout her career, especially in her later years of portrait painting. Smith's first published illustration was made during her final year at the Academy. The drawing, entitled *"Three Little Maidens All in a Row,"* appeared in the May, 1888 issue of *St. Nicholas Magazine*, and later in Ida Waugh's famous book, **Ideal Heads**, (1890), on a preliminary page. Reminiscent of Kate Greenaway's gentle line, the drawing is well executed and full of sentiment.

After graduating from the Academy in June 1888, Smith began to search for work as an illustrator. Her first assignment was for a notions firm called Dreka in Philadelphia. "The first work I sold was some place cards. They had been ordered by someone who was having a performance of 'The Mikado'. I can remember distinctly painting the little Japanese figures on them." Anxious to find a more secure prominent position in the art community, Smith applied for work with *The Ladies' Home Journal* in Philadelphia. She was accepted into the advertising department and soon became an active contributor. At the outset in 1889, her assignments were limited to supportive work for some of the more established artists. These jobs ranged from finishing rough sketches to drawing borders and designs as head- or tail-pieces. Soon, however, her skill as an accomplished and knowledgeable artist was fully appreciated and the demand for her work by various national advertisers increased proportionally.

In 1892, Smith's first book illustrations appeared in an obscure book of poems by Mary Wiley Staver entitled **New and True**. The drawings by Smith were technically a bit crude and without animation. However, the mere fact that the relatively young artist could contribute such a large number of illustrations to a book brought out by a major publisher (Lee and Shepard), represented a quantum leap in Smith's career.

In 1893, Smith was very active in the advertising department of *The Ladies' Home Journal* and her illustrations appeared in

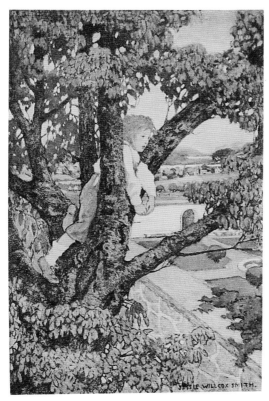

A22. A Child's Garden of Verses, *facing p. 10*

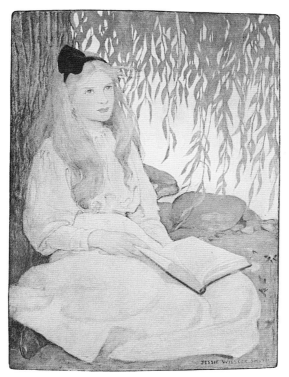

A29. The Seven Ages of Childhood, *facing p. 46*

advertisements for such varied products as gloves, root beer, stoves, and facial soap. Smith, though grateful for the monetary security which this arrangement afforded, was nevertheless anxious to broaden her experience in the art world. Pictorial illustration in the major periodicals of the day had seen a striking increase in both the frequency of illustrated stories and in the number of new artists on the scene. Smith knew her work was of the quality to merit publication in this medium.

In 1894, Smith set her mind to the eventual goal of becoming a general illustrator, and to gain additional experience she enrolled in the Drexel Institute of Arts in Philadelphia where she would remain for the next three years. In the same year, Howard Pyle, who was to be a major influence on Smith, joined the staff at Drexel Institute. Pyle had wanted to teach at the Academy of Fine Arts, but was rejected; Drexel, however, welcomed him happily. Here he began a course in the elements of practical illustration and composition with thirty-nine young, eager students. Jessie Willcox Smith, and later, Elizabeth Shippen Green and Violet Oakley, soon became the prominent and preeminent female pupils in the class.

Pyle's influence as both a teacher and a model cannot be overemphasized. Smith, in comparing her work at *The Ladies' Home Journal* to this class stated, "When, however, I came under guidance of Howard Pyle, I began to think of illustration in a light different from that of a pot boiler." Pyle, dubbed "the dean of American illustration," was a magnetic and inspiring teacher with great presence, an artist who led by example as well as by principle. Among Pyle's male disciples were N. C. Wyeth, Maxfield Parrish, Frank Schoonover and Stanley Arthurs. Possessed of unusual drive and determination, Pyle commanded attention and respect. His method of teaching was refreshing and vitalizing, bringing the student out of the classroom to the open outdoors. Here he felt the student could more naturally observe and depict the qualities of objects. Pyle's students worked continually, painting both at daybreak and at midnight, under the natural light of the moon. Perhaps Pyle's greatest contribution to Smith during this period was a love and appreciation for color. He felt that painting more suitably captured the dramatic moment than drawing, and that drawing was prerequisite to illustrative reality: "Its [painting's] color and fluidity capture 'real things', real surroundings,

real backgrounds. A tone for a background will not do." Apart from all this, Pyle also offered his students a forum for presenting their art. More than most teachers of the period, Pyle had a keen sense for the commercial feasibility of illustration, and he was always the supreme advocate for his pupils. In 1897, Pyle arranged with Houghton, Mifflin and Company to publish an edition of Longfellow's **Evangeline** containing chromolithograph illustrations by Jessie Willcox Smith and Violet Oakley. The book, with a preface by Pyle introducing his two students, was issued in both green and red gilt-stamped cloth, and contained five color plates by each artist, as well as head- and tail-pieces for chapter headings. As would be the case with many of Smith's future books, this book was also issued in England, with the same sheets and plates but with a cancel title page bearing the publishers Gay and Bird. The bold chromolithography in **Evangeline**, though failing somewhat in a technical sense, nevertheless offered the public for the first time a colorful representation of the ability of these two rising artists. Smith's style in these drawings was almost indistinguishable from that of Oakley's and the two styles reflected strongly the influence of Howard Pyle's tutelage.

The Head of a Hundred, by the popular Maud Wilder Goodwin, was issued in 1897 by Little, Brown and Co. and contained two black-and-white illustrations by Smith. These, along with the six illustrations for **The Young Puritans in Captivity** (1899, Little Brown and Co.), dealt with subject matter that was to Smith most unattractive: "One time I, fortunately or unfortunately, got the illustrating of an Indian book. I hated to do Indians and I struggled and plodded through the task and was delighted at last to complete the commission and dispatch it to the publisher. You imagine my surprise when, a few days later, the same publishers sent me another Indian story to illustrate. I received it with none too good grace, but in those days I was not declining any work, and I appreciated that my future hinged on how I fulfilled my early commissions. So, unpleasant though I found the work, I took infinite pains to make it both attractive and accurate in detail. When the third Indian story came in quick succession, I said to myself, 'This must cease.' And so, I wrote to the publisher that I did not know much about Indians and that if they had just an every-day book about children, I thought I could do it

better. I was immediately rewarded with one of Louisa M. Alcott's stories, and a letter saying they were glad to know I did other things as they had supposed Indians were my specialty."

Before this edition of Alcott's renowned **An Old Fashioned Girl** was to appear in 1902, Smith would illustrate four separate stories, contribute single illustrations to two Hawthorne classics, and produce a baby book with dozens of tinted illustrations. This was a busy time for the artist, taking on a good deal of work, while at the same time establishing close ties with Elizabeth Shippen Green and Violet Oakley. Moreover, her commissions for illustrations in periodicals had been steadily increasing. During this period of only two years, Smith also published illustrations in *St. Nicholas, Harper's Weekly, Harper's Bazaar,* and *Scribner's Magazine*, produced two calendars for Bryn Mawr College as well as numerous illustrations for the Procter and Gamble Company for advertisements for Ivory Soap. In 1901, Smith won first prize in that company's picture competition for her drawing, *"Child Washing"*. The books illustrated by Smith during this time helped establish her name at last in the realm of publishers. However, all of the illustrations in this period were in black and white, and those such as appeared in the *"Brenda Books"* by Helen Leah Reed were unassuming and not comparable to her later work. In 1900, she illustrated a curious book entitled **Reminiscences of the Old Chest of Drawers** by Sarah Cauffman Sill. The slender book was very nicely produced by J. B. Lippincott and contained six full-page, black-and-white plates as well as line drawings by Smith. These illustrations are unique and not representative of her usual style. Executed in charcoal and watercolor, the drawings vary from pictures of a chest of drawers to sketches of a church and a house. In 1902, A. C. McClurg issued a story for young readers by Mary Imlay Taylor entitled **Little Mistress Goodhope**. Smith's illustrations for this work include a color frontispiece and a headpieces throughout in tint. It is a nicely balanced work and it contains the first major color illustration used in the text (excluding the chromolithograph plates in **Evangeline** and minor color portrait in the 1900 reissue of **The Head of a Hundred**).

Though experiencing much commercial success, it was clear to Smith that for her to develop as a major illustrator, she would have to

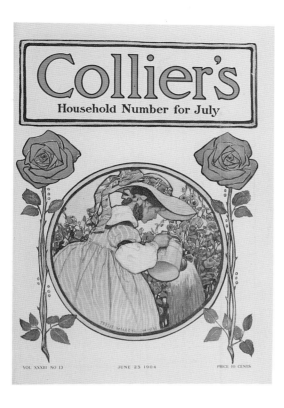

A53. At the Back of the North Wind, *facing p. 140*

publish in color. The development of color in her art was influenced not only by Pyle's teaching, but also by her relationship with her close friends Violet Oakley and Elizabeth Shippen Green. In 1897, Smith rented a studio in Philadelphia with Oakley and Green, cementing friendships begun earlier in Pyle's initial class. During the next few years these three would rise to prominence in illustration in Philadelphia. Each artist, though closely allied by common origins and influences, nevertheless was an individual person with differing goals and aspirations. Green would inevitably concentrate on magazine and book illustration, but her output would be minimized by her eventual decision to marry and settle into domestic lifestyle. Oakley, less interested in illustration, and influenced by a continuing affiliation with the Christian Scientist church, was to become an accomplished and celebrated muralist. But at this early stage in the three artists' careers, kindred instincts and talents drew them together both in their personal relationships and their artistic styles. In the early development of their use of color, Green and Smith were more closely related. In fact, the two artists teamed on two different projects which were destined to bring them much acclaim and advancement in their respective careers. These were the Bryn Mawr Calendars in 1901 and 1902, and the publication of **The Book of the Child**, by the much admired Mabel Humphrey. The calendars, entirely designed and illustrated by the two artists, were commissioned by the college's Students Association. The general graphic layout of the calendars together with the decorative illustrations by Smith and Green in tinted colors, marked the initial appearance of the style which would later characterize much of Smith's art. However, it was more the publication of **The Book of the Child**, and later in the same year the publication of a calendar with the book's illustrations, that marked the first major economic success for either artist. The enormous lapbook, measuring 38x35 cm, was issued by Frederick A. Stokes, a publisher that had already begun producing books illustrated by the renowned Mabel Humphrey. **The Book of the Child** was unique and, in many ways, an extraordinary production. The entire text is hand lettered, with each capital a bold letter, and the chapter headings are all printed in bright orange. Smith contributed four illustrations, including the

15

cover illustration; Green added four more. The production costs for a book of this size and weight, with seven full-page color plates on coated paper, pictorial covers in color and even a printed dust wrapper, were enormous. Considering this, it is interesting that the book was bound with four heavy-duty staples and the signatures glued to a cloth spine. Because of this binding technique and the immensity of the book, very few copies remain. The drawings by Smith in this work are strikingly bold and colorful with large flat masses of color.

Both Smith's and Elizabeth Shippen Green's art in **The Book of the Child** reflect a number of influences including Japanese prints and the aquatints of Mary Cassatt. Smith was also a great admirer of the popular French illustrator Boutet deMonvel, who painted with a peculiar static quality. This aspect is readily visible in these drawings, where oftentimes the subject appears to be frozen in space, creating a visually pleasing effect. The illustrations are warm and inviting, full of the decorative element which would fill her canvases throughout the remainder of her professional career.

Also issued in 1903 was Betty Sage's enchanting **Rhymes of Real Children**, a children's lapbook in the truest sense of the word. This was the first of Smith's books to be published by Duffield and Company of New York. The large, flat format was perfectly suited for the illustrations of Smith, and served as a prototype for the many future Duffield productions (including two more illustrated by Smith: **The Bed-Time Book** in 1907 and **When Christmas Comes Around** in 1915). The illustrations in **Rhymes of Real Children**, painted in water-color over charcoal, are among her most decorative and are full of sensitivity and warmth. The frontispiece, entitled *"Mother"* shows the back of a mother hugging her daughter, with more than half of the picture taken up by a huge patterned armchair. This theme would recur throughout Smith's art, that of the interaction and feeling between a mother and her child, and would come to be one of Smith's most memorable images.

In 1904, Smith teamed up with the famous Frances Hodgson Burnett in a handsome production of **In the Closed Room,** published by McClure, Phillips and Co. The book was issued in bright green cloth with bold gilt-stamped decorations on the front cover, on the decorated endpapers and throughout the text

and was issued in a decorated dust wrapper. Smith contributed eight illustrations for the text, using pastel colors and different framing techniques. The work was reissued in the same year by Grosset & Dunlap, but with only four illustrations. About the same time Smith began work on these illustrations, she received a very important letter from the prestigious firm of Charles Scribner's Sons in New York. The well-known publishing company had seen brilliant success with their *Scribner's Illustrated Classics,* a series established by Joseph H. Chapin, art editor at Scribner's. It was Chapin's idea to showcase America's greatest illustrators by setting them to illustrate some of the most popular juvenile fiction. The first title in this series, **Poems of Childhood**, by Eugene Field, was issued in 1904 and contained brilliant illustrations by Maxfield Parrish. It was thus quite a compliment, if not an endorsement, for Smith to receive this commission. In a letter to Smith dated December 23, 1903, Chapin writes concerning the proposed contract: "It is understood that you are to illustrate (in colors) **The Child's Garden of Verses** for the lump sum of $3600, we to own the originals and have exclusive publication rights. It is further understood that there are to be:

12 Full pages at $200	$2400
1 Cover design	75
1 Lining design	75
1 Title page .	50
100 Small drawings	1000

(Or whatever number is necessary to distribute properly throughout the book - when final dummy is arrived at it will probably be found that some of the drawings can be very slight.) We will appreciate it greatly if you will make an early selection of the twelve (12) full-page subjects in order that *Collier's Weekly* may nominate from this list of twelve, the six (6) which they will reproduce. The six drawings which they will publish will, of course, have to be done first as we must begin to deliver these drawings to them for reproduction as early as October and November, 1904." This cooperative arrangement with a different periodical was somewhat unusual, as Scribner's could have also published these in their own journal. They must have felt that the larger format available in *Collier's* would more ably showcase the illustrations.

In 1904, Smith moved into a new home in

Chestnut Hill with Oakley, Green and Henrietta Cozens, a gardener and close friend. The abode was called Cogslea, the first four letters standing for the first letter of each of the women's names. **A Child's Garden of Verses** was issued by Scribner's shortly after this move. A facsimile edition also appeared in England simultaneously, with the cancel title page bearing Longmans Green and Co. Among the illustrations for this work, *"The Land of Counterpane",* stands out as a compositional masterpiece. Smith uses foreshortened perspective to give the impression of a faraway city, all within the confines of the bedsheets. In these illustrations, the strong double contours of **The Book of the Child** are present, but are less distinct, and space is treated more naturally. More realistic color is also evident and there is greater attention to detail. Both the public and Scribner's were well pleased with the work. In a letter from Art Editor Joseph Chapin to Jessie Willcox Smith, this was expressed: I have used up all the adjectives that I believe in using, (there are certain ones which are ruled out) so I will simply say that the last two drawings which reached me today are delightful examples of the sort of thing of which you are master." A critic further echoed these sentiments: "Miss Smith has created for us more of a type of childhood. There is no mistaking a drawing or painting by this artist: that charm in children that appeals to all pervades her work, and although it is essentially illustrative in its rendering, a high order of craftsmanship is displayed"

Only one book appeared in 1906 with illustrations by Smith, a tiny volume by John Luther Long entitled **Billy-Boy**. The black-and-white illustrations are clever, but quite unassuming. On the other hand, there are some remarkably original and creative illustrations to be found in the *Collier's Weekly*. After seeing one of the covers from *Collier's Weekly*, the renowned author Bliss Carman wrote Smith: "I am sure you must be oversupplied with letters of admiration, and any words of mine would be superfluous. This is merely an exuberant note to vent my own delight"

The Bed-Time Book was published in 1907 and **Dream Blocks** in 1908, both issued by Duffield and Company with full-page color illustrations. These were also issued shortly thereafter by Chatto and Windus in London. Both works depict Smith's use of the decorative element in her illustration. Large, flat masses of

color and dark contours typify these illustrations, with a poster-like quality to the composition. **Dream Blocks** contained fifteen color plates, color cover insert and a pictorial dustwrapper. This was the largest number of color illustrations ever to appear in any of Smith's books. Due to the large number of inserted plates, printed on thick, glossy paper, the book is often found lacking one or more illustrations and is very scarcely found in fine condition.

In 1909, Moffat and Yard issued **The Seven Ages of Childhood**, a remarkably balanced and attractive work, with poems by the ever-popular Carolyn Wells. By now, Smith was established as a major illustrator to the point where she participated in the planning and the preparatory process of an idea. This was the case with the production of **The Seven Ages of Childhood**. It was Smith's hope to procure the talents of Edward S. Martin, who had written an exceptionally popular book entitled **The Luxury of Children**, illustrated by Sarah Stillwell, and published by Harper's in 1904. But he declined, and Moffat urged Smith to try and persuade him to reconsider. Smith, however, wrote the publishers saying that this would not at all be appropriate. Moffat then wrote Smith: "We appreciate that there must be indeed many children's books with which you have no patience, and your advice and idea will be very valuable indeed from a business point of view as well as from the point of view of personal taste" In another letter to Smith, the editors elaborate on availability of an author. "Miss Wells is apt to be the higher priced of the two and it may be that we would not get her without a royalty because some of her books are such capital sellers. She would bring a very distinct public with her — a good deal more of a public, I can assure you, than Helen Hay Whitney." Smith was able to interpret Wells's simple verse with remarkable sensitivity and perception. One of the more universal of all her paintings is the one with the poem, *The Sixth Shifts to lean and slender maidenhood. With thoughtful eyes and quite mien."* It captures a young lady resting at the base of a willow tree, with book in hand, her gaze up from the book and into a realm we are not privileged to enter.

During this period Smith was working harder than ever, with contributions weekly to such noted periodicals as *Collier's, Ladies' Home Journal, Scribner's,* and *Women's Home Companion.* She was also quite active in her advertising illustration, though she favored this medium least of all. Her drawings for Kodak, Ivory Soap, and Cream of Wheat were by now ubiquitous. The Cream of Wheat company sent Smith a most congratulatory letter after receiving her rough sketch for their advertisement. "We have had this idea in for several years and have had sketches from same made by many different artists, none of which, however, have seemed to catch the idea as you have in the present sketch."

In 1910 Smith produced for Duffield and Company a volume of illustrated verse entitled **A Child's Book of Old Verses**. The work represents Smith's first book of her own selected poems, and the illustrations and line drawing are very well suited for the text. For the frontispiece illustration, Smith won the coveted Beck Prize given by the Philadelphia Water Color Club in 1911. The illustration, entitled *A Child's Grace,* shows two young children, hands folded and at the table, with a loaf of bread in front of them. The first child's eyes are closed, but the second child's are open and staring at the bread.

In 1911, Smith illustrated three very successful books, all by different publishers: **The Five Senses, A Child's Book of Stories,** and **The Now-A-Days Fairy Book.** All three contained full-page color illustrations and all but **The Five Senses** were also issued in England. **The Now-A-Days Fairy Book** was a large, heavy book with tipped-in color plates mounted onto stock plates. These were the first of Smith's illustrations to appear in this manner. Though impressive, the production was not comparable to many of the limited, signed editions of Smith's English colleagues, and the color reproduction was not the highest quality. This was in contrast to the crystal clear reproduction of her ten, full-page color illustrations for **Dickens's Children,** published by Scribner's in 1912, and also issued simultaneously by Chatto and Windus in England. Printed on glossy card paper, the book was well-conceived and produced. The illustrations for this book were later added to a text by Samuel McChord Crothers in the 1925 production of **The Children of Dickens,** issued again by Scribner's. In this edition printed on cheaper paper, the plates do not show the same clarity and brilliance as the original 1912 issue.

Another work issued in 1912 was Clement Clarke Moore's **Twas the Night Before Christmas**. The oblong book, with bright red pictorial covers, was illustrated by Smith with twelve full-page color pictures, vignettes, and line drawings. It was published by Houghton Mifflin, and originally issued in a pictorial dustwrapper. The illustrations are quite different from the style that Smith had shown in previous books, and the wispy, near-caricature figures are not found in any later illustrations.

With the marriage of Elizabeth Shippen Green in 1911, the cohesive group of artists was broken tangibly, though not in spirit, as the three remained close friends throughout their lives. The separation did, however, mark a new era for Smith. With Green gone and Oakley spending much time out of the studio working on her murals, Smith felt the need to become more independent. In 1914 she moved to a new house and studio near Cogslea with her brother, an aunt, and her friend Henrietta Cozens. She named this estate Cogshill, and she resided here until her death. In the same year, Dodd, Mead and Company published the famous **Jessie Willcox Smith Mother Goose**, an immense book with twelve color and five black-and-white illustrations, and line drawings throughout. The oblong quarto, with plates on glossy, coated paper, was an instant success and brought Smith much fame. The book was originally issued in a pictorial box with a price of $2.50; the following year the price was changed to $5.00. The illustrations had appeared earlier in *Good Housekeeping Magazine* in consecutive issues from December 1912 to April 1914. However, these appeared in black and white, and were nothing compared to their combined presence in the book. One reason for the widespread popularity of these illustrations was Smith's portrayal of the nursery rhymes in a realistic, easily identifiable style. With the dark-lined borders almost entirely absent, and more subtle, muted coloring, Smith breathed life and vitality into these pictures. The shift of style toward realism is noteworthy and typical of the versatility of the artist. Unlike many of the English illustrators of her time, Smith was never locked into any one style, but adapted and evolved her style throughout her career.

In 1915 Smith's illustrations appeared in four books. **A Child's Stamp Book of Old Verses** was a unique book, reproducing the illustrations from **A Child's Book of Old Verses** in miniature stamps which came in an envelope inside the front of the book. A book by little-known Priscilla Underwood, entitled **When Christmas Comes Around**, was published by Duffield in 1915, and simultaneously in London by Chatto and Windus. The large, flat book had six full-page color illustrations by Smith. Though decorative and colorful, these illustrations appear rather hastily contrived and are not her best work. **The Everyday Fairy Book**, issued by Dodd, Mead and Co. in 1915 and reprinted several times in England, contained seven color plates, but was printed on cheaper wove paper, and the reproduction of the original *Collier's* illustrations were of poor quality. The other book published in 1915 was a superb production of Alcott's **Little Women**, published by Little, Brown and Company. Unlike the cheaper production of Alcott's **An Old-Fashioned Girl** (1902), this edition contained eight full-page color plates, a color insert on the cover and all edges gilt. These illustrations rank among the finest ever made for this story, and the book was very well received.

During the next four years, from 1916 to 1920, Smith was to develop an expertise in illustrating fairy tales as well as to nurture her continuing interest in portrait painting. The latter was evidenced in the many familiar figures of children and mothers seen on the covers of the *Good Housekeeping Magazine*. A Smith color illustration appeared on each and every cover of *Good Housekeeping* from December 1917 through April 1933. There was no issue in January 1920 due to a strike. Smith added one additional illustration in May of 1934, for a total of 184 illustrations. This ranks as one of the longest single runs of published covers in the history of pictorial illustration. In conjunction with the appearance of these covers, The Cosmopolitan Print Department, a division of *Good Housekeeping Magazine*, issued an extensive series of color prints, reproducing nearly every cover during this period.

During the four year period of 1916-1920, there appeared over ten books with illustrations by Smith, and all of them dealt with fantasy of fairy tale themes. The greatest of these were **The Water Babies, The Way to Wonderland, At the Back of North Wind,** and **The Princess and the Goblin**. The latter two were classics by the universally admired George MacDonald. These works, published in 1919

and 1920 respectively, were issued by David McKay of Philadelphia, a publisher who had a reputation for books of quality and beauty. David McKay issued both of these in several different cloth states and the color reproduction of Smith's paintings is among the finest in all her books. Printed by the Beck Engraving Company, these illustrations, reproduced on coated, glossy paper, were in vivid and varied colors. Smith's art in these books is again decorative in style with an added ethereal quality. The subject matter made it necessary for Smith to blend colors and shapes as she never had done before. Unlike the hard line of Edmund Dulac or Arthur Rackham, Smith's fantasy world still belied a close relation to natural objects and shapes. Nowhere is this more evident than in the pictorial endpapers of **The Princess and the Goblin.** Here we see a legion of goblins marching in a line through a forest, all in the most natural of poses, carrying picks and lanterns on their backs.

In 1917, Dodd, Mead and Company continued their tradition of publishing Smith's illustrations with the production of a fantasy story by Mary Stewart entitled **The Way to Wonderland.** The book contained six, full-page color plates by Smith as well as a cover insert and pictorial endpapers. It was later issued in 1920 by Hodder and Stoughton in London with a lavish gilt pictorial cover. But Smith's greatest work of this period, and considered by many to be her greatest group of illustrations, was Kingsley's **Water Babies.** Issued in 1916 by Dodd, Mead, and Co., and reprinted many times in England in various formats, this work was the culmination of Smith's imaginative style and technical ability. The paintings were all executed on canvas using mixed media. The overlays of water color and oil over charcoal reveal a careful and methodical approach. The illustrations represent a return to decorative style with broad, flat patterning of shapes and colors. The publishers spared no expense in the production of this work. The original edition, issued in full-color pictorial box, was a heavy quarto with illustrations printed on glossy paper. Line drawings in green fill up the text as well as the endpapers. Smith considered these paintings to be here best work and bequeathed the entire set of twelve original oils to the Library of Congress. This is the only known group of paintings for any single book illustrated by Smith which has remained

together as a group. The illustrations as compositions are very innovative and imaginative. One illustration shows a group of large fish approaching the tiny figure of a child hiding behind underwater foliage and gives both the feeling of either a friendly meeting or a foreboding adventure. The many illustrations involving underwater scenes would prove a challenge to any artist, but Smith executed them remarkably. It was said by one critic that Smith's paintings for **The Water Babies** rank among the finest ever rendered for this classic.

In 1922, **Heidi,** the famous story by Johanna Spyri was issued by David McKay. It contained ten full-page color plates, a color pictorial wrapper, a color insert on the cover, pictorial endpapers, and colored lined drawings. This was again a fine production, typical of David McKay's work. The book represents the last major children's story in which Smith specifically designed illustrations. Fourteen separate books followed until Smith's death in 1935, but all of these were either composites of illustrations previously published as *Good Housekeeping* covers, or they represented relatively minor contributions of only a few illustrations. This was not to minimize in any way her later work. In fact many of these books remain among the more popular and collected of all her work. A special group of these might be termed, "The Child's Book of . . ." Series. These were all published by Duffield, beginning with **A Child's Book of Modern Stories** (1920) and ending with **A Child's Book of Country Stories** (1925). In between, there were two additional titles: **A Little Child's Book of Stories** (1922) and **A Very Little Child's Book of Stories** (1923). All of these books had similar designs, with a color pictorial insert on the cover and various color plates. The basic quality of the production was average, but the overall effect was very endearing, and the books were very heartily bought and read with pleasure. In all, there were a total of thirty-one illustrations in these four books taken from covers of *Good Housekeeping Magazine.* These four works, together with **A Child's Book of Old Verses,** were reissued by The Dial Press in 1935 with color pictorial wrappers and boxes. Smith also illustrated a book for the Cosmopolitan Book Corporation in 1923 with illustrations taken from *Good Housekeeping* covers. The book, entitled **The Boys and Girls of Bookland,** was issued in a pictorial wrapper,

and although the quality of the paper for the text was average, the eleven full-page color plates were quite vivid and bright. The large quarto was later reissued by David McKay in a production inferior to those of his earlier publications.

Near the end of Smith's career, with the available time and energy for illustration declining, quite a few books appeared with only a frontispiece or a dustwrapper designed by Smith. This was the case with Annie W. Franchot's, **Bobs, King of the Fortunate Isle,** in 1928, where Smith contributed the frontispiece and the dustwrapper illustration. Smith had earlier done the same for this author's work, **Bugs and Wings and Other Things,** in 1918. Similarly, **The Lullaby Book** (1921) and **Rhymes and Reminiscences** (1929), had frontispiece illustrations by Smith.

Smith also contributed a few illustrations for various private publications. In 1924, Emily Eldredge Saville issued her story, **Memories and a Garden,** with a color frontispiece and wrapper design by Smith. **A Child's Prayer,** printed by David McKay, but privately produced for Cora Cassard Toogood in 1925, appeared with a full-color illustration on the cover by Smith, as well as numerous line drawings for the text printed in blue. The book was originally issued in cloth with a color pictorial wrapper. Another private production, by Kathryn Jarboe Bull entitled **Little Paul's Christ Child,** was published in 1929 and contained two black-and-white illustrations from *Harper's Weekly,* 1902. Smith's last illustration was for a cookbook for children entitled **Kitchen Fun,** published in 1932. This illustration first appeared as a cover of *Good Housekeeping* in 1931.

Smith's attention to portrait work became more pronounced about 1925, but she remained active in book and magazine illustration right up to her death in 1935. "I shall never do portrait work to the exclusion of everything else," she related, but it was true that even as a young artist Smith's ambition was to do portrait painting. "My work began as the result of using a neighbor's child to pose for an illustration. The picture proved so true to life that the parents wanted the original painting because of its portrait value. This incident has since been repeated several times, and so I kill two birds with one stone, the little model's family having the original and the public having

its print either as a book illustration or as a cover design for *Good Housekeeping Magazine"* Smith never lacked for money in her lifetime, an attribute of her career not shared by many of her professional peers. Termed "The Mint" by her friends, Smith was nonetheless very generous and selfless, giving a good deal of her earnings to the support of her invalid sister and her sister's children. She was also involved with various philanthropic interests. Her posters for the Welfare Federation attest to her genuine concern for the needy. The riveting pictorial messages are captioned with such epithets as *"Suppose Nobody Cared"* or merely the haunting word, *"Give."*

Upon the death of Jessie Willcox Smith in 1935 there followed a wave of commemoration and admiration, both in the art community and the general public as well. Never had an American female illustrator been so admired and recognized in her own lifetime. In 1936, the Pennsylvania Academy of Fine Arts held a Memorial Exhibition which contained 191 original paintings for magazines, and posters, as well as many portraits.

In the Philadelphia *Evening Public Ledger,* the article announcing her death and remembering her as an artist, bears the headline: "Death Takes Away Her Brush," a fitting eulogy, as it is sure that no other obstacle would ever have caused her to stop painting. Her energy and initiative was truly remarkable, but this was overshadowed by her keen sensitivity and awareness, not only for the composition of a painting, but also for the world around her. A tribute, offered by her close friend Edith Emerson, captures well the inspiration and personality of Jessie Willcox Smith, an artist whose painting was her life:

"Nothing morbid or bitter ever came from her brush. This is not because the difficulties of life left her untouched. She had more than her full share, but when they came she met and conquered them. She demanded nothing for herself but obeyed the simple injunction on the poster she designed for the Welfare Federation — GIVE. She helped those in need, the aged, the helpless, the unfortunate. She gave honest and constructive advice to students who came for criticisms. She rejoiced in the success of others and was modest about her own. Tall, handsome and straightforward, she carried herself well, with no trace of self-assertion. She always spoke directly and to the point. She lived quietly, and loved natural unaffected things and people. Altogether hers was a brave and generous mind, comprehending life with a large simplicity, free from all the pettiness, and unfailingly kind".

E. D. N., 1988

Sources

Articles

Armstrong, Regina. "Representative American Women Illustrators: The Decorative Workers." "The Critic" 36 (June, 1900). Interesting and early overview of the artist. Contains sketch of Smith drawn by Violet Oakley.

Bright, Norma. "Art in Illustration." Book News (July, 1905): 848-855. Two black-and-white reproductions by Smith, biographical sketch.

Earle, Mary Tracy. "The Red Rose." The Lamp, Vol. XXVI, No 4. New York: Charles Scribner's Sons, May, 1903. Interesting early background material on Smith. Many photographs of the Red Rose Inn.

Likos, Patt. "Ladies of the Red Rose." The Feminist Art Journal. (Fall, 1976): 11-15, 43.

Morris, Harris. "Jessie Willcox Smith." The Book Buyer 24 (April, 1902): 201-205. Four black-and-white reproductions, photograph of Smith. Excellent early survey of her art career.

"Mother-Love in Jessie Willcox Smith's Art." Current Literature 60 (1908): 638.

Nudelman, Edward D. "The Art of Jessie Willcox Smith." Northwest Book Arts, Vol. II, No. 2 (December 1981 / January 1982). Photographs of covers and illustrations, bibliographical and biographic information.

Smith, Jessie Willcox. "Jessie Willcox Smith." Good Housekeeping 60 (1917): 24.

Books

Freeman, Ruth S. Jessie Willcox Smith: Children's Great Illustrator. Watkins Glen: Century House, Inc. Rather crudely produced booklet with xeroxed reproductions. Contains some bibliographic information.

Huber, Christine Jones. The Pennsylvania Academy and Its Women. Philadelphia: Pennsylvania Academy of Fine Arts, 1973. p. 39.

Mahoney, Bertha and Whitney. Contemporary Illustrators of Children's Books. Boston: Women's Educational and Industrial Union, 1930. pp. 68-69. Brief biographical sketch.

Mitchell, Gene. The Subject was Children. New York: E. P. Dutton, 1979. Brief biographical sketch. Many color reproductions.

Schnessel, S. Michael. Jessie Willcox Smith. New York: Thomas Y. Crowell, 1977. Definitive biography of Smith's career with excellent detail and accuracy. Rather weak bibliographically.

Stryker, Catherine Connell. The Studios at Cogslea. Wilmington: The Delaware Art Museum, 1976. Contains excellent biographical and bibliographical material. Black-and-white reproductions of her work and studio.

Reference Books

Benezit. Dictionnaire Vol. 7. p. 813. Biographical Sketches of American Artists. p.293.

Clement. "Women in the Fine Arts." pp. 319-329.

Philadelphia: Three Centuries of American Art. Philadelphia: The Philadelphia Museum of Art, April 11-October 10, 1976. pp. 304-306. Contains biographical as well as bibliographical information.

Other Sources

The personal letters of Jessie Willcox Smith. Archives Department, The Pennsylvania Academy of the Fine Arts.

Interviews with Edith Emerson, close friend of Jessie Willcox Smith.

Interviews with Mrs. William S. (Lewis) Crowder, Jessie Willcox Smith's private nurse.

Exhibitions

Note: Numbers refer to exhibition lot or catalog number.

Art Institute of Chicago

April 23-June 7, 1903: 285; August: 286; December: 287-290. Illustrations.
April 28-June 5, 1904: 357-359. Method of Charles Stuart York (illustrations); 360. Girl's Head.
May 11-June 13, 1909: 288. Summer's Passing.
May 10-June 8, 1910: 257. Frills; 258. The Prayer; 259. The Seven Ages of Childhood "The Scholar"; 260. The Seven Ages of Childhood "The Infant".
May 7-June 5, 1912: 240. Design for June cover; 241. Madonna; 242. Fairy Pool; 243. Sweet and Low.
May 11-June 7, 1916: 264. Jack and Jill; 265. Rose Red and Snow White.
May 15-May 21, 1922: The Second International Water Color Exhibition: Addenda. 373. Cover Design for January.

Philadelphia Art Alliance

December 4-28, 1924: Portraits, Drawings and Illustrations of Jessie Willcox Smith. Nos. 49, 54.

The Pennsylvania Academy of Fine Arts

1917: The Fifteenth Annual Watercolor Exhibition. Nos. 605, 606.
March 14-April 12, 1936. Memorial Exhibition of the Work of Jessie Willcox Smith. 191 paintings. Catalogue issued by the Academy includes An Appreciation by Edith Emerson and photograph of Smith in her studio painting a portrait. Each painting itemized lists title and person lending it.

Delaware Art Museum

September 14-October 15, 1972: The Golden Age of American Illustration 1880-1914. Three oil paintings from THE WATER BABIES, "And Tom sat upon the buoy long days"; "Oh, don't hurt me!"; and "He felt how comfortable it was to have nothing on but himself". Illustrated catalogue with one reproduction by Smith and a brief background sketch of her life and work.

Brandywine River Museum

September 6-November 23, 1975: Women Artists in the Howard Pyle Tradition. 15 paintings by Smith, brief biographical sketch. And Tom sat on the buoy long days (THE WATER BABIES); Come play with me (IN THE CLOSED ROOM); Future Aviator (Good Housekeeping); The Garden Wall (Scribner's, December 1903); Goldilocks (A CHILD'S BOOK OF STORIES, 1911); He felt how comfortable it was to have nothing on but himself (THE WATER BABIES); Portrait of Eleanor Houston, 1912; Madonna and Child (Good Housekeeping, December 1924); Mother and Child, ca. 1908; Mrs. Doasyouwouldbedoneby (THE WATER BABIES); Peter, Peter, Pumpkin Eater (MOTHER GOOSE); Portrait of Pierre Marot, 1912; Tom reached and clawed down the hole after him (THE WATER BABIES).
Each entry with description and lender given.

Brandywine River Museum

September 11-November 21, 1976. 114. Come Play With Me. (IN THE CLOSED ROOM). Lender and description given. Catalogue issued with reproduction of this painting, brief biographical sketch.

Copley Gallery

March 17, 1913. 27 paintings by Jessie Willcox Smith (documented in a letter of receipt from Bayley to Smith).

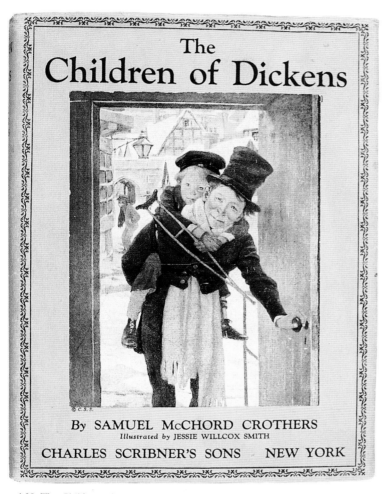

A65. The Children of Dickens, *cover jacket, first issue*

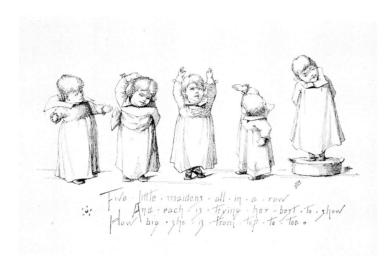

Page 3

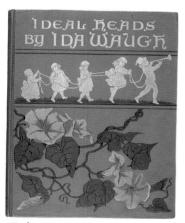

Book cover

A1. IDEAL HEADS
Waugh, Ida.
Philadelphia, 1890.
Sunshine Publishing Company.

Title: IDEAL HEADS / By / Ida Waugh / (drawing in black and white) / twenty Lithoed Water-Color Engravings / with / Illustrations on Wood by Eminent Artists / Philadelphia / Sunshine Publishing Company / 1890.

Size of Book: 35.5 x 28 cm.

Size of Leaf: 34.5 x 27 cm.

Pagination: [92]

Collation: Half-title (IDEAL HEADS BY IDA WAUGH) [1]; drawing [2]; drawing (Five little maidens all in a row) by Jessie Willcox Smith in black and white [3]; verse [4]; title [5]; copyright with drawing (London, Paris, New York, Sunshine Publishing Company) [6]; drawing [7]; drawing [8]; list of Engravings in Colors [9]; [10]; text [11]-[91].

Description: Issued in full cloth (light brown) with pictorial cover of petunias in green and blue, and gold stamped illustration of five children marching in line. Stamped in gold IDEAL HEADS by Ida Waugh. Spine stamped in gold lengthwise: IDEAL HEADS BY IDA WAUGH. Endpapers decorated with green floral design.

Paper: Printed on thick coated paper with color plates lithographed on thick, textured paper. All edges gilt.

Illustrations: One black-and-white illustration by Jessie Willcox Smith, 20 full-page color illustrations (portraits of children) by Ida Waugh, 21 full-page black-and-white illustrations and many marginal line drawings by various artists.

Page {3} [Five maidens all in a row:] By Jessie Willcox Smith.

Note: Illustration first appeared in *St. Nicholas Magazine* May, 1888.

A2. NEW AND TRUE
Staver, Mary Wiley.
Boston, 1892.
Lee and Shepard Publishers.

Title: NEW AND TRUE / Rhymes and Rhythms / And Histories Droll / For Boys and Girls / From Pole to Pole / by / Mary Wiley Staver / "and childhood had its litanies / In every age and clime" / —Whittier / Boston / Lee and Shepard Publishers / 1892.

Size of Book: 25.7 x 19.8 cm.

Size of Leaf: 24.9 x 19 cm.

Pagination: [11], 12-14, [15-16], 136 pp.

Collation: [1] half-title; frontispiece facing title page; (black-and-white illustration); title [3]; copyright (1891, Mary Wiley Staver) imprint (Press of Rockwell and Churchill, Boston) (Engravings by John Andrew and Son, Boston) [4]; dedication [5]; verse (Rhymes and rhythms) [7]; Illustrated by [five artists] [9]; list of poems [11]-14, New and True [15]; text, 17-136.

Description: Issued in full cloth (olive green or red) with pictorial cover stamped in gold and black. Front cover: NEW / AND / TRUE (gold) / by / Mary Wiley Staver / Rhymes and Rhythms / and Histories Droll / For Boys and Girls / From Pole to Pole / (drawing) / "Eighty Degrees in the Shade above all the Rhyming Juveniles / For Several Seasons" Robert J. Burdette. Spine stamped in gold and black: NEW / AND / TRUE / by / Mary / Wiley / Staver (black) / (publisher's colophon) (gold). Endpapers with floral pattern in brown.

Paper: Wove.

Illustrations: Full-page black-and-white frontispiece, three full-page, black-and-white illustrations, eleven half-page illustrations by Smith, numerous illustrations by other artists.

Full-Page Plates:

Frontispiece	We Took A Walk.
Page 27	The Bell.
Page 57	Little Jack Hale.
Page 65	The Hard Lesson.

Half-Page Illustrations:

Page 32	What Do You Think?
Page 42	Ah-Goo.
Page 47	Little Mabel.
Page 88	The Moon.
Page 94	Frisky & Flossy.
Page 106	Winkie Wee.
Page 107	And Waking Up the Sleepy Ones.
Page 117	Pray, what's in your basket?
Page 118	The Holiday.
Page 123	Bye-Lo-Land.
Page 136	Riding on a rail-car.

Issue Points: Issued in olive green or red cloth with no priority known.

Note on Illustrations: First and only appearance of these illustrations.

Frontispiece

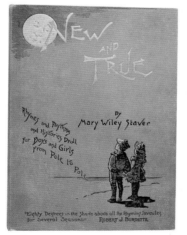

Book cover

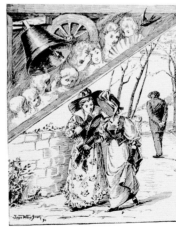

Page 27

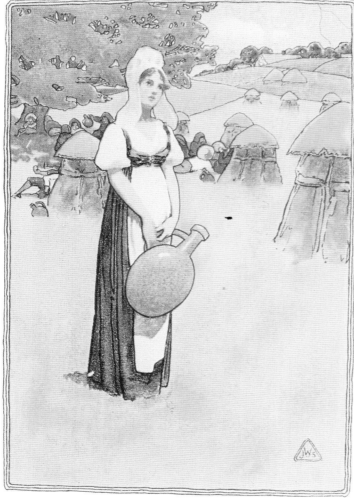

Frontispiece

Cover jacket, Binding B

Book cover, Binding A

A3. EVANGELINE

Longfellow, Henry Wadsworth.
Boston, 1897.
Houghton, Mifflin & Co.

Title: EVANGELINE (red) / A TALE OF ACADIE / by / Henry Wadsworth Longfellow / with illustrations by / Violet Oakley / And / Jessie Willcox Smith / (publisher's colophon) / Boston and New York / Houghton, Mifflin and Company / The Riverside Press, Cambridge / MDCCCXCVII (red).

Size of Book: 22.5 x 15.8 cm.

Size of Leaf: 22 x 15 cm.

Pagination: xv, [5], 143, [1] p.

Collation: Half-title [i]; frontispiece in color facing title with captioned tissue guard and tissue laid in; title (rubricated) [iii]; copyright (1897, Houghton, Mifflin and Company) (All rights reserved) [iv]; introduction [v]-xi; note on the illustrations [xiii]-xv; list of illustrations [2]; divisional title [4]; text, [3]-143; imprint (The Riverside Press, Cambridge Massachusetts, U.S.A.) Electrotyped and Printed by H.O. Houghton and Co.) [1].

Description: Binding A; Issued in full-cloth (light green) with gilt-stamped designs on front and back covers and spine. Front cover stamped in gold: EVANGELINE. Spine stamped in gold: EVANGELINE / Longfellow / Illustrated / Houghton / Mifflin & Co.

Paper: Coated wove. Endpapers plain laid paper. Top edges gilt.

Illustrations: Ten full-page chromolithograph plates, five by Smith, five by Oakley all with captioned tissue guards. Twelve head pieces in orange, six by Smith, six by Oakley. Twelve chapter initials in orange and black (unsigned).

Frontispiece	Fair in sooth was the maiden (page 11). By Jessie Willcox Smith.
Facing p. 10	Reverend walked among them. By Violet Oakley.
Facing p. 38	Whispered together, beholding the moon rise. By Violet Oakley.
Facing p. 50	"What madness has seized you?" By Violet Oakley.
Facing p. 60	Speaking words of endearment, where words of comfort availeth not. By Jessie Willcox Smith.
Facing p. 76	Her endless search and endeavor. By Jessie Willcox Smith.
Facing p. 88	Water-lilies in myriads rocked on the slight undulations. By Violet Oakley.
Facing p. 98	A blast, that resounded . . . through the still damp air of the evening. By Jessie Willcox Smith.
Facing p. 120	Breathed like the evening wind, and whispered love to the maiden. By Violet Oakley.
Facing p. 140	All was ended now, the hope, and the fear, and the sorrow. By Jessie Willcox Smith.

Issue Points: Binding A (green cloth) is first issue, predating "Holiday Edition" (Binding B in red cloth). The "Holiday Edition" was issued in two states: State B.1 with gold patterned endpapers, and State B.2 with plain endpapers and printed cover jacket.

Cover Jacket Description: Beige coated paper printed in black front cover: EVANGELINE / Illustrated / Holiday / Edition. Spine printed in black: EVANGELINE / Illustrated / Longfellow / Houghton / Mifflin & Co.

Cover Jacket Dimensions: 22.5 x 49 cm.

There is a cheap 1916 reissue by Houghton Mifflin which reproduces three of Smith's illustrations.

Publication Notes: First issue (Binding A) listed in *Book Buyer,* October 1897. Second issue (Binding B) listed in *Book Buyer.* December 1897. *Publisher's Weekly,* Dec. 4, 1897, "New Holiday Edition" (Binding B).

Price at Issuance: First issue (Binding A), $2.00. Second issue (Binding B), $2.50.
Note on Illustrations: First and only appearance of these illustrations.

A4. THE HEAD OF A HUNDRED
Goodwin, Maud Wilder.
Boston, 1897.
Little, Brown and Co.

Title: THE HEAD OF A / HUNDRED (red) / Being / An Account of Certain / Passages in the Life of / Humphrey Huntoon Esq. / Sometime an Officer / in the Colony of / Virginia / Edited By / Maud Wilder Goodwin / Author of "the / Colonial Cavalier." / Boston / Little, Brown & Co. (red) / 1897.
Size of Book: 17.7 x 12 cm.
Size of Leaf: 17 x 11.2 cm.
Pagination: [ii], [8], 225, [1] p.
Collation: Half-title [i]; frontispiece (black-and-white plate) facing title with captioned (in red) tissue guard and tissue laid in; title (bordered by line drawings) [1]; copyright (1895, Little, Brown and Company) imprint (University Press: John Wilson and Son, Cambridge, U.S.A.) [2];dedication [3]; table of contents [5]; list of illustrations [7]; text 9-225; publisher's colophon [1].
Description: Issued in full cloth (green) with elaborate gilt-stamped designs on front cover stamped in gold: ROMANCES / OF / COLONIAL VIRGINIA / THE HEAD / OF A / HUNDRED / MAUD / WILDER / GOODWIN. Spine stamped in gold: THE / HEAD / OF A / HUNDRED / (rule) / GOODWIN / LITTLE / BROWN / & CO.
Paper: Laid paper with plain laid endpapers. Top edges gilt, other edges untrimmed.
Illustrations: Two full-page, black-and-white illustrations by Jessie Wilcox Smith. One full-page black-and-white illustration by each of the following: Sophie B. Steel, Charlotte Harding, and Winfield S. Lukens. Decorative title-page by K. Pyle; three decorative headings by Clyde O. DeLand. Each plate with captioned tissue guard and tissue insert.

Frontispiece.	"I beheld, twirling his mustachios, the figure of a gallant." By Sophie B. Steel.
Facing p. 68	"She bent her head and I stood over her." By Jessie Willcox Smith.
Facing p. 97	"Kneeling beside him I laid my hand on his head." By Charlotte Harding.
Facing p. 142	"His balance being weak, he fell to the ground." By Winfield S. Lukens.
Facing p. 205	"With a shriek they turned and fled as from a pestilence." By Jessie Wilcox Smith.

Issue Points: First issued in 1895 without illustrations. First illustrated edition by Smith in 1897. Also, sold together with WHITE APRONS by same author in box, in 1897. Later re-issued in 1899 in beige cloth with same format as 1897 but bearing 1899 on title-page. Another illustrated edition was issued in 1900 with additional color frontispiece by Smith. The 1900 edition appears in unique format. (See A6).
Publication Notes: Listed in *Publisher's Weekly.* "New Illustrated Holiday Edition," Nov. 13, 1897.
Price at Issuance: $1.50 sold separately; $3.00 in box with WHITE APRONS.
Notes on Illustrations: First appearance of these illustrations. All illustrations appear in 1900 edition.

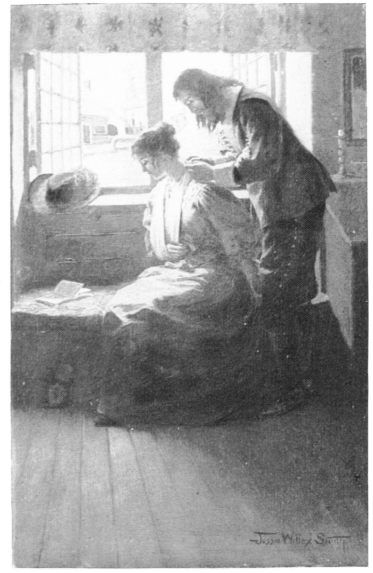

Facing p. 68

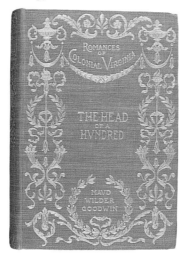

Book cover, first issue

(below) 1899 edition, book cover

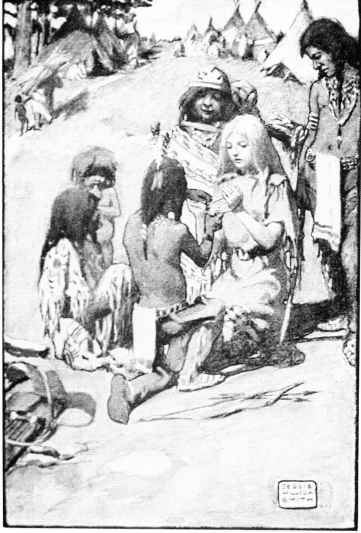

Frontispiece

Book cover

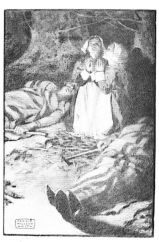

Facing p. 43

A5. *THE YOUNG PURITANS IN CAPTIVITY*
Smith, Mary P. Wells.
Boston, 1899.
Little, Brown and Company.

Title: Young Puritans Series / (long rule) / THE / YOUNG PURITANS / IN / CAPTIVITY / By / Mary P. Wells Smith, / Author of "The Young Puritans of Old Hadley;" "The Young Puritans / in King Philip's War," "The Jolly Good Times Series," etc. / Illustrated by Jessie Willcox Smith / Boston: / Little, Brown and Company / 1899.

Size of Book: 18.8 x 13.2 cm.

Size of Leaf: 18.3 x 12.4 cm.

Pagination: ix, [5], 323, [5] pp.

Collation: Half-title [i]; frontispiece (black-and-white plate) facing title with tissue guard; title [iii]; copyright (1899, Little, Brown, and Company) (All rights reserved)imprint (University Press: John Wilson and Son, Cambridge, U.S.A.) [iv]; dedication [v]; preface [vii]-ix; contents [2]; illustrations [4]; text 1-323; publishers prospectus [2]-[5].

Description: Issued in full cloth (gray) with pictorial cover in black and white. Front cover printed in red: THE YOUNG PURITANS / IN CAPTIVITY / By Mary P. Wells Smith. Spine with picture of young girl printed in black and white and red. Spine stamped in gold: THE / YOUNG / PURITANS / IN / CAPTIVITY / (picture of a girl) / By / Mary P. Wells / Smith / Little, Brown / and Company. Endpapers printed with green floral pattern.

Paper: Wove.

Illustrations: Six full-page, black-and-white illustrations by Smith. No captions, only frontispiece with tissue guard.

Frontispiece	"I have taught him to play Cat's-cradle with a bit of string."
Facing p. 43	The girls knelt on the branches with clasped hands.
Facing p. 78	"We must run away."
Facing p. 158	Running the gauntlet.
Facing p. 213	"He's a papist priest," thought John.
Facing p. 302	"Howl away, my painted beauties."

Issue Points: Also issued in brown floral endpapers with different design. No known priority. Also issued with THE YOUNG PURITANS OF OLD HADLEY and THE YOUNG PURITANS IN KING PHILIP'S WAR in a box, $3.75. Later re-issued in 1907 with booklist on verso of half-title, plain endpapers, and 1907 on title-page.

Publication Notes: Listed in *Book Buyer,* Sept. 1899.

Price at Issuance: $1.25.

Note on Illustrations: First and only appearance of these illustrations.

A6. *THE HEAD OF A HUNDRED*
Goodwin, Maud Wilder.
Boston, 1900.
Little, Brown and Co.

Title: THE HEAD OF A HUNDRED / IN / THE COLONY OF
VIRGINIA / 1622 / by / Maud Wilder Goodwin / Author of
"White Aprons,""The Colonial Cavalier," / "Flint," etc. /
Illustrated / (ornament-heart) / Boston / Little, Brown and
Company / 1900.

Size of Book: 20.1 x 13.8 cm.

Size of Leaf: 19.5 x 13 cm.

Pagination: [10], 221, [3] pp.

Collation: Half-title [1]; frontispiece (color plate facing title
with tissue guard; title [3]; copyright (1895, 1900, Little,
Brown and Company) (All rights reserved) imprint
(University Press, John Wilson and Son, Cambridge,
U.S.A.) [4]; dedication [5]; contents [7]; illustrations [9];
text 1-221; publisher's prospectus [2]-[3].

Description: Issued in full red cloth with gilt-stamped
portrait medallion on front cover, gilt-stamped lettering
front cover and spine. Front cover: THE HEAD OF A
HUNDRED / IN THE COLONY OF VIRGINIA 1622 / (portrait) /
BY MAUD WILDER GOODWIN / AUTHOR OF "WHITE
APRONS." Spine: THE / HEAD / OF A / HUNDRED / MAUD /
WILDER / GOODWIN / LITTLE, BROWN / AND COMPANY.

Paper: Wove.

Illustrations: One color, two black-and-white illustrations
by Smith. One black-and-white illustration by each of the
following: Sophie B. Steel, Charlotte Harding, and Winfield
S. Lukens. Frontispiece with tissue guard, others without.

Frontispiece	Betty Romney in color by Jessie Willcox Smith.
Page 22	"I beheld, twirling his mustachios, the figure of a gallant." By Sophie B. Steel.
Page 60	"She bent her head and I stood over her." By Jessie Willcox Smith.
Page 89	"Kneeling beside him, I laid my hand on his head." By Charlotte Harding.
Page 137	"His balance being weak, he fell to the ground." By Winfield S. Lukens.
Page 201	"With a shriek they turned and fled as from a pestilence." By Jessie Willcox Smith.

Publication Notes: Listed in *Publisher's Weekly,* Oct. 20,
1900.

Price at Issuance: $1.50.

Note on Illustrations: Except for frontispiece, all
illustrations first appeared in the 1897 edition.

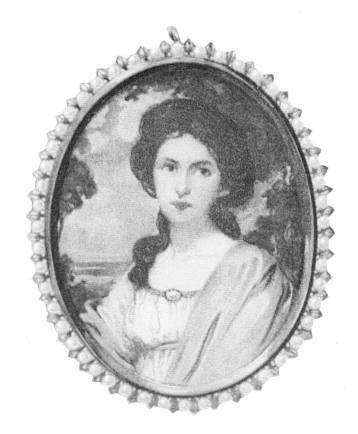

Frontispiece

Book cover

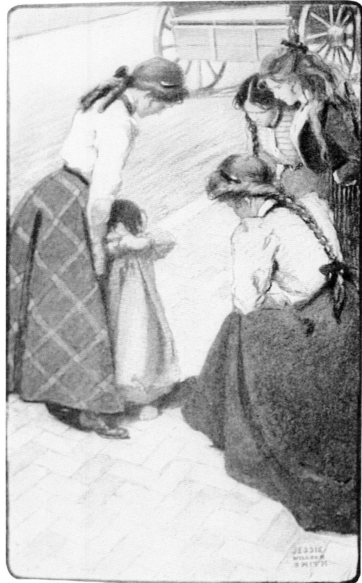

Frontispiece

A7. *BRENDA, HER SCHOOL AND HER CLUB*
Reed, Helen Leah.
Boston, 1900.
Little, Brown and Co.

Title: BRENDA, / HER SCHOOL AND HER CLUB / by / Helen Leah Reed / Author of "Miss Theodora," Etc. / Illustrated by Jessie Willcox Smith / Boston / Little, Brown and Company / 1900.

Size of Book: 19.8 x 14.5 cm.

Size of Leaf: 19.2 x 13.7 cm.

Pagination: vii, [3], 328, [4] pp.

Collation: Half-title [i]; frontispiece (black-and-white plate) with tissue guard [iv]; title [v]; copyright (1900, Little, Brown and Company) (All rights reserved) [vi]; contents vii; illustrations [2]; text 1-328; publisher's colophon [1]; publisher's prospectus [3]-[4].

Description: Issued in full green cloth with pictorial cover stamped in beige, black and blue. Gilt-stamped lettering front cover and spine. Front cover stamped in gold: BRENDA / HER SCHOOL / AND HER / CLUB / BY / HELEN / LEAH / REED. Spine stamped in gold: BRENDA / HER SCHOOL / AND / HER CLUB / (ornament-flower) BY / HELEN / LEAH / REED / LITTLE, BROWN / AND COMPANY.

Paper: Wove.

Illustrations: Five full-page black-and-white illustrations by Smith. Frontispiece with tissue guard, others without.

Frontispiece	"The child himself surrounded by a group of curious girls, clung to Nora's hand".
Page 42	"Oh, I'll tell you what, girls,—let us work for Manuel!"
Page 135	"She was able to rush on and pick them up as they were dashed against a lamp-post".
Page 192	"Now as Julia sat there drinking tea from the quaintest of old-fashioned china cups".
Page 316	"Why, Brenda Barlow, why are you lying in this downcast position?"

Publication Notes: Listed in *Publisher's Weekly,* Oct. 27, 1900.

Price at Issuance: $1.50.

Note on Illustrations: First and only appearance of these illustrations.

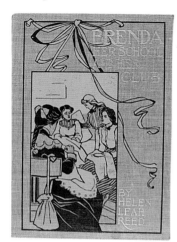

Book cover

Page 135

A8. REMINISCENCES OF THE OLD CHEST OF DRAWERS
Sill, Sarah Cauffman.
Philadelphia, 1900.
J. B. Lippincott Company.

Title: REMINISCENCES OF THE / OLD CHEST OF DRAWERS / by / Sarah Cauffman Sill / Illustrated by / Jessie Willcox Smith / (square vignette) / Philadelphia / Printed by J.B. Lippincott Company / 1900.
Size of Book: 20.6 x 18 cm.
Size of Leaf: 20.4 x 17.8 cm.
Pagination: [40] pp.
Collation: Half-title (REMINISCENCES OF THE / OLD CHEST OF DRAWERS) (in bordered design) [1]; frontispiece (black-and-white photograph) [4]; title [5]; dedication [7]; text [11]-[40].
Description: Issued in full tan cloth with design and gilt ruled border front cover stamped in gold: REMINISCENCES OF THE / OLD CHEST OF DRAWERS.
Paper: Coated wove. All edges gilt.
Illustrations: Six full-page black-and-white plates as well as line drawings by Smith throughout.

Page 10	"Where nothing was seen but the Quaker gown."
Page 12	[Oh, how I enjoyed a dull, rainy day.*]
Page 22	[So into dear Susan's charge I was given.*]
Page 24	[And my dear mistress, now Mistress D—.*]
Page 32	[Then the third generation, one by one.*]
Page 38	[And now I am in the country once more.*]

* - Uncaptioned illustrations. Titles taken from text facing illustrations.
Note on Illustrations: First and only appearance of these illustrations

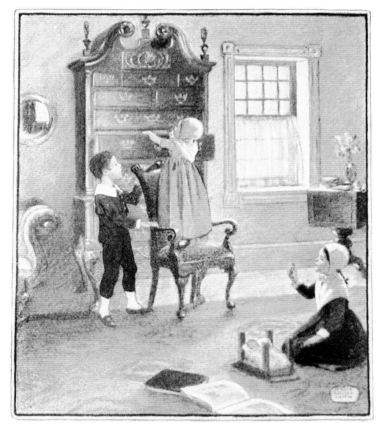

Page 12

Book cover

Page 10

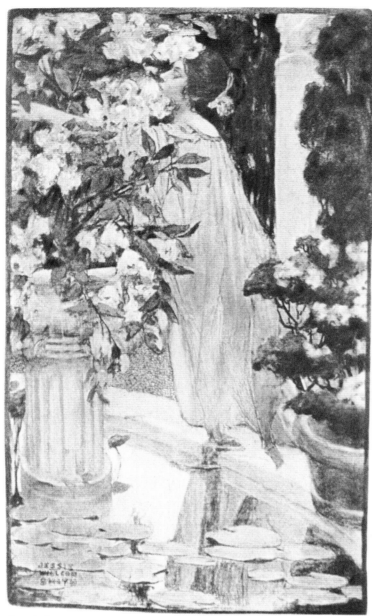

Frontispiece

A9. MOSSES FROM AN OLD MANSE
(Autographed Edition)
Hawthorne, Nathaniel.
Boston and New York, 1900.
Houghton, Mifflin and Company.

Title: MOSSES FROM AN OLD / MANSE (red) / By / Nathaniel Hawthorne / In Two Volumes / Volume 1 / (publisher's colophon) (red) / Boston and New York / Houghton, Mifflin and Company / The Riverside Press, Cambridge (red) / MDCCCC.

Size of Book: 22.7 x 15.5 cm.

Size of Leaf: 22 x 15 cm.

Pagination: [2], xxvi, 345, [1] p.

Collation: Half-title THE COMPLETE WRITINGS OF / NATHANIEL HAWTHORNE / (ornament-red) / Autograph Edition / Etc. [1]; Limitation page [i]; frontispiece in black and white by Jessie Willcox Smith and signed in pencil by Smith at base of illustration (with captioned tissue guard facing plate); illustrated half-title; title (rubricated) [iii]; copyright (1900, Houghton, Mifflin & Co.) (All Rights Reserved) [iv]; table of contents [v]; list of illustrations [vii]; introductory note, ix-xxii; bibliographical note, xxiii-xxvi; text, 1-345; imprint (The Riverside Press, Electrotyped and printed by H.O. Houghton and Company, Cambridge, Mass., U.S.A.) [1].

Description: Issued in three-quarter crushed morocco (light blue with tan spine), marbled paper covered boards with gilt ruled borders, raised bands on spine and gilt tooling and lettering on spine. Spine stamped in gold: Nathaniel Hawthorne / (rule) / 4 / MOSSES FROM AN OLD / MANSE / 1 / Autographed Edition. With elaborate gilt tooled designs. Endpapers marbled in light blue-gray, yellow, and maroon swirling pattern.

Paper: Printed on laid paper. Top edges gilt, others uncut.

Illustrations: Seven full-page, black-and-white illustrations (with captioned tissue guards) by various artists.
Frontispiece by Jessie Willcox Smith and signed by her at base of illustration.

Frontispiece	"Give me thy breath, my sister". By Jessie Willcox Smith.
Engraved title	The Old Manse (half-title). By Frank B. Masters.
Facing p. 70	"Carefully now, Aminadab". By Eliot Keen.
Facing p. 120	"Bring forth the converts!" By W.B. Brown, Jr.
Facing p. 202	The ruddy gleam of blazing wood. By Helen Kibbey.
Facing p. 228	With a lamp also in his hand. By Bertha Rockwell.
Facing p. 342	The sordid patchwork of his real composition. By Frank B. Masters.

Issue Points: Issued in 22 volumes, limited to 500 numbered and signed sets, each with frontispiece signed by a different artist in pencil at the base of the illustration. Illustrators include: Elenore Plaisted Abbot, Stanley M. Arthurs, Mary Ayer, Anna Whelan Betts, Ethyl Franklin Betts, W. B. Brown, Jr., C. S. Chapman, A. H. Clark, Genevieve C. Cowles, Bertha C. Day, W. H. Everett, Harry Fenn, Edmund Garrett, Jules Guerin, Child Hassam, A. I. Keller, Helen Kebbey, F. B. Masters, Emlem M. Connell, Frank T. Merrill, Eric Pape, E. C. Peixotto, Howard Pyle, Bertha Rockwell, Frank E. Schoonover, E. Boyd Smith , Jessie Willcox Smith, Alice Barber Stephens, Sarah S. Stillwell, Ross Turner, F. C. Yohn. Included are many photographs by Clifton Johnson. Also issued with additional frontispiece in each volume, hand-colored.

Publication Notes: Listed in *Publisher's Weekly,* Mar. 9, 1901, "Autographed Edition", 22 Volumes, levant. Also buckram edition, same date.
Price at Issuance: Levant $9.00 per volume; buckram $5.00 per volume.
Note on Illustrations: First and only appearance of these illustrations.

A10. TALES AND SKETCHES
(Autographed Edition)
Hawthorne, Nathaniel.
Boston and New York, 1900.
Houghton, Mifflin & Company.

Title: TALES AND SKETCHES (red) / By / Nathaniel Hawthorne / (publisher's colophon) (red) / Boston and New York / Houghton, Mifflin and Company / The Riverside Press (red) / MDCCCC.
Size of Book: 22.7 x 15.5 cm.
Size of Leaf: 22 x 15 cm.
Pagination: [2], xii, 358, [2] pp.
Collation: Half-title (THE COMPLETE WRITINGS OF / NATHANIEL HAWTHORNE / (ornament-red) / Autographed Edition / Etc.) [1]; limitation page [i]; frontispiece in black and white (with captioned tissue guard facing plate); illustrated half-title; title (rubricated) [iii]; copyright (1876, James R. Osgood and Co.) (1883, 1900, Houghton, Mifflin & Co.) (All Rights Reserved) [iv]; table of contents [v]; list of illustrations [vii]; introductory note, ix-xxii; bibliographical note, xxiii-xxvi; text, 1-358; (imprint) (The Riverside Press, Electrotyped and Printed by H. O. Houghton and Company, Cambridge, Mass, U. S. A.) [2].
Description: As MOSSES FROM AN OLD MANSE (Autographed Edition). Spine stamped in gold: NATHANIEL / HAWTHORNE / (rule) / 16 / TALES AND / SKETCHES / Autographed Edition. With elaborate gilt tooled designs.
Paper: Printed on laid paper. Top edges gilt, others uncut.
Illustrations: Six full-page black-and-white illustrations (with captioned tissue guards) by various artists. One black-and-white illustration by Smith.

Frontispiece	"Let us begone from this place". By F. C. Yohn.
Half-title	"He sits his horse most gallantly". By F. C. Yohn.
Facing p. 220	"How hard this elderly lady works!" By L. Lander Phelps.
Facing p. 240	The spectre of Walter Brome. By C. S. Chapman.
Facing p. 294	The children . . . ran to me. By Jessie Willcox Smith.
Facing p. 352	"Attention to the roll call!" By C. S. Chapman.

Issue Points: See MOSSES FROM AN OLD MANSE (Autographed Edition).
Publication Notes: See MOSSES FROM AN OLD MANSE (Autographed Edition).

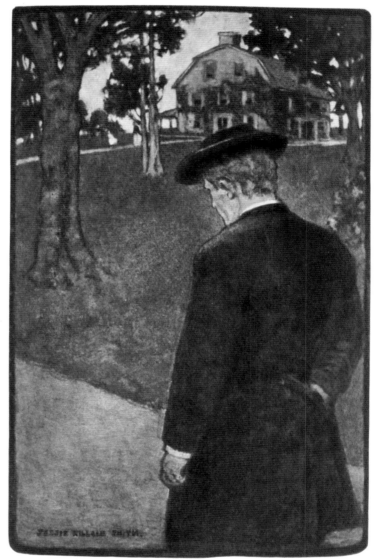

Facing p. 294

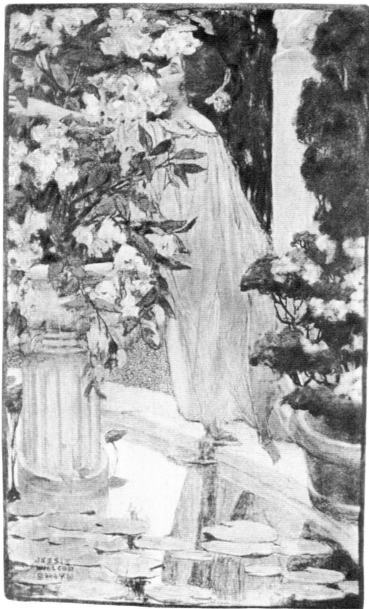

Frontispiece

A11. MOSSES FROM AN OLD MANSE
Hawthorne, Nathaniel.
Boston and New York, 1900.
Houghton, Mifflin & Company.

Title: MOSSES FROM AN OLD / MANSE / by / Nathaniel Hawthorne / in two volumes / Volume 1 / (publisher's colophon) / Boston and New York / Houghton, Mifflin and Company / The Riverside Press, Cambridge.

Size of Book: 19.6 x 13 cm.

Size of Leaf: 19.1 x 12.7 cm.

Pagination: xxvi, 345, [1] p.

Collation: Half-title (Old Manse Edition) [i]; frontispiece (black-and-white plate) with captioned tissue guard, facing title insert; title insert (black-and-white illustration); title [iii]; copyright (1900, Houghton, Mifflin & Co.) (All Rights Reserved) [iv]; table of contents [v]; list of illustrations [vii]; introductory note ix-xxii; bibliographical note xxiii-xxvi; text 1-345; imprint (The Riverside Press, Electrotyped and printed by H.O. Houghton & Co., Cambridge, Mass., U.S.A.) [1].

Description: Issued in full cloth (red) with spine stamped in gold: (double rule) / HAWTHORNE'S / WORKS / IV / MOSSES FROM / AN OLD MANSE / I / Houghton, Mifflin & Co. Two volumes.

Paper: Wove. Top edges gilt.

Illustrations: Seven black-and-white illustrations by various artists. One black-and-white illustration by Jessie Willcox Smith.

Frontispiece "Give me thy breath, my sister".

Issue Points: Issued as part of a set of 22 volumes in 1900. Re-issued 1903 and various years following. Also, issued in limited edition with signed frontispiece illustrations by various artists in 1900. (See A9 and A10).

A12. TALES AND SKETCHES
Hawthorne, Nathaniel.
Boston and New York, 1900.
Houghton, Mifflin & Company.

Title: TALES AND SKETCHES / by / Nathaniel Hawthorne / (publisher's colophon) / Boston and New York / Houghton, Mifflin and Company / The Riverside Press, Cambridge.
Size of Book: 19.6 x 13 cm.
Size of Leaf: 19.1 x 12.7 cm.
Pagination: xii, 323, [1] p.
Collation: Half-title (Old Manse Edition) [i]; frontispiece (black-and-white plate) facing title insert with captioned tissue guard; title insert (black-and-white illustration); title [iii]; copyright (1876, James R. Osgood & Co.) (1883 and 1900, Houghton, Mifflin & Co.) (All Rights Reserved) [iv]; table of contents [v]; list of illustrations [vii]; introductory ix-xii; text 1-323; imprint (The Riverside Press, Electrotyped and Printed by H. O. Houghton and Co., Cambridge. Mass., U. S. A.) [1].
Description: Same as A11.
Paper: Same as A11.
Illustrations: Six full-page black-and-white illustrations. One full page by Jessie Willcox Smith.
Facing p. 294 The Children . . . Ran to Meet Me.

Facing p. 294

36

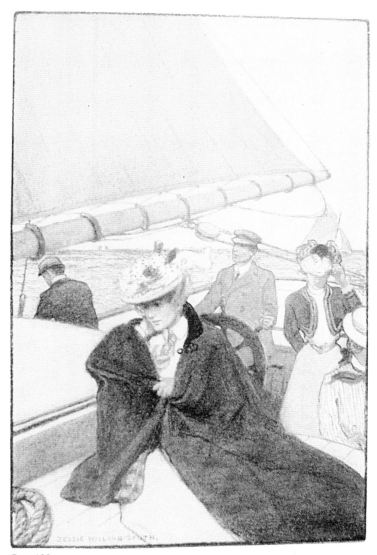

Page 120

A13. BRENDA'S SUMMER AT ROCKLEY
Reed, Helen Leah.
Boston, 1901.
Little, Brown and Company.

Title: BRENDA'S SUMMER AT / ROCKLEY / A Story for Girls / by Helen Leah Reed / Author of "Brenda, Her School and Her Club" / "Miss Theodora", Etc. / Illustrated by Jessie Willcox Smith / Boston / Little, Brown, and Company / 1901.

Size of Book: 19.8 x 14 cm.

Size of Leaf: 19.1 x 13.7 cm.

Pagination: vi, [2], 376. [4] p.

Collation: Half-title [i]; frontispiece (black-and-white plate)with tissue guard facing title; title [iii]; copyright (1901, Little, Brown and Company) (All Rights Reserved) (October, 1901), (imprint) (University Press, John Wilson and Son, Cambridge, U. S. A.) [iv]; contents [v]-vi; illustrations [1]; text 1-376; publisher's colophon [1]; publisher's advertisements [3]-[4].

Description: Issued in full blue cloth. Pictorial decorated cover with illustration of young lady at beach stamped in white, black, and gray. Front cover and spine with gilt-stamped lettering. Front cover: BRENDA'S / SUMMER AT / ROCKLEY / BY HELEN LEAH REED. Spine: BRENDA'S / SUMMER / AT / ROCKLEY / (ornament-flower) / BY / HELEN / LEAH / REED / LITTLE,BROWN / AND COMPANY.

Paper: Wove.

Illustrations: Five full-page black-and-white illustrations by Smith.

Frontispiece	But in spite of herself she listened.
Facing p. 120	There was a dreamy look in Amy's eyes.
Facing p. 225	Using her oar as a lever, she tried to push off.
Facing p. 305	They felt a little perturbed as they stood in the small vestibule of the chapel.
Facing p. 355	Lifted in his arms, and walked with great strides across the beach.

Issue Points: Later issues with respective change of date on title-page. Pictorial cover jacket found in a 1904 edition.

Publication Notes: Listed in *Publisher's Weekly,* Oct. 26, 1901.

Price at Issuance: $1.20.

Note on Illustrations: First and only appearance of these illustrations.

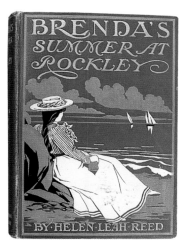

Book cover

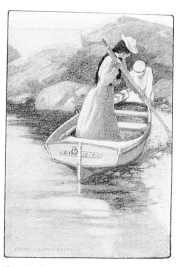

Page 225

A14. BABY'S RED LETTER DAYS
Smith, Jessie Willcox.
Syracuse, 1901.
Just's Food Company.

Title: BABY'S / RED LETTER / DAYS / (drawing) / Illustrated / by / Jessie / Willcox / Smith / (drawing) / Published / by / Just's Food Co. / Syracuse, N. Y.

Size of Book: 19.3 x 15.6 cm.

Size of Leaf: 19 x 15.3 cm.

Pagination: [24] pp.

Collation: Title (orange bordered design) [1]; copyright (1901, Just's Food Company, Syracuse, N. Y.) [2]; dedication [3]; text [5]-[24]; imprint (Bartlett & Company, The Orr Press, New York) [24].

Description: Full card wrappers (beige) with illustration on front cover embossed: BABY'S / RED / LETTER / DAYS. Issued with glassine dust-wrapper, silk ties at spine. Front and back free fly illustrated in orange. Originally issued with Just's Food Company advertisement, *"The Food That Feeds"* (30.0 x 19.0 cm). Also laid in "OTHER FOLKS' BABIES" record book (18.5 x 14.7 cm). Inside rear cover printed in orange are directions for obtaining more copies of book (rectangular box 1½" x ⅝").

Paper: Coated wove.

Illustrations: Five full-page tints, ten one-half page tinted illustrations, six full-page illustrated borders and designs, copyright vignettes (frame), and illustrated title-page.

Full page illustrations:

Page 4	Baby is Born.
Page 9	Baby's First Outing.
Page 13	Christmas Has Come.
Page 17	First Step.
Page 21	The First Prayer.

Issue Points: Originally sent to doctors for presentation to patients and was accompanied by an explanatory letter from the publishers. Original copies may be found in Just's Food Company mailing envelopes with red string tie. Reissued in 1906 with covers colored in light orange, blue, and yellow. Copyright states 1906, all else identical to 1901 issue.

Note on Illustrations: First and only appearance of these illustrations.

Book cover

Title page

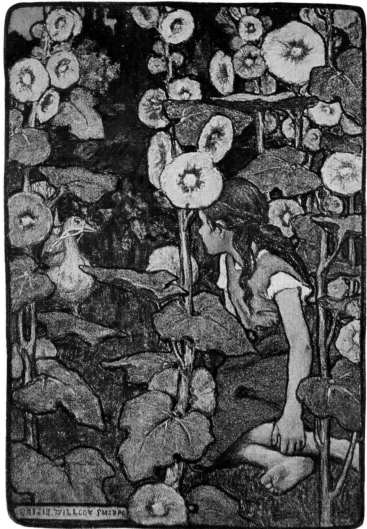

Frontispiece

Book cover

A15. *LITTLE MISTRESS GOODHOPE*
Taylor, Mary Imlay.
Chicago, 1902.
A. C. McClurg.

Title: LITTLE MISTRESS / GOODHOPE (red) / and Other Fairy Tales / By Mary Imlay Taylor / With Frontispiece in Color and Illustrations / in the Text by Jessie Willcox Smith / "Wee folk, good folk, / Trooping all together; / Green jacket, red cap, / And gray cock's feather". / Chicago. A.C. McClurg (red) / and Company (red) MDCCCCII.

Size of Book: 19.2 x 14.3 cm.

Size of Leaf: 18.7 x 13.8 cm.

Pagination: [12], 186, [2] pp.

Collation: Half-title [1]; frontispiece in color with caption [4]; title (rubricated) [5]; copyright (1902, A. C. McClurg) (Published September 27, 1902) [6]; dedication [7]; contents [9]; divisional title [11]; text 13-186; imprint (The University Press, John Wilson and Son [inc.], Cambridge, U. S. A.) [1].

Description: Issued in full blue buckram with pictorial insert front cover of dog and peacock (9.0 x 4.0 cm). Front cover and spine stamped in gold. Front cover: (insert) / LITTLE MISTRESS GOODHOPE / AND OTHER FAIRY TALES. Spine: LITTLE / MISTRESS / GOODHOPE / by / Mary Imlay / Taylor / (goose) / A. C. / McClurg / & Co.

Paper: Wove. All edges stained blue.

Illustrations: Frontispiece in color, seven head-pieces in tints, seven chapter initials and one vignette at end.

Frontispiece	"On the goose's back sat a tiny figure."
Page 13	[Little Mistress Goodhope]
Page 43	[Rob, The Peddler's Boy]
Page 71	[The Abbot's Trout]
Page 97	[The Madness of the Abbot of Buckfast]
Page 125	[Tommy the Bad]
Page 145	[Good Greeneye and Her Ass]
Page 181	[Little Eleanor and Little Pepper] (reproduced on cover insert).

Issue Points: First issue with cover insert of dog and peacock, and all edges stained blue. Variant first issue with cover insert of goose. Second issue in dark green cloth (not buckram) without cover insert, spine without gold-stamped picture of goose, and all edges unstained.

Publication Notes: Listed in *Publisher's Weekly,* Oct. 11, 1902.

Price at Issuance: $1.50.

Note on Illustrations: First and only appearance of these illustrations.

A16. AN OLD-FASHIONED GIRL
Alcott, Louisa May.
Boston, 1902.
Little, Brown and Company.

Title: AN OLD-FASHIONED GIRL / By / Louisa M. Alcott / Author of "Little Women," "Little Men," "Eight Cousins," / "Aunt Jo's Scrap-Bag," etc. / Illustrated by / Jessie Willcox Smith / (vignette) / Boston / Little, Brown and Company / 1902.

Size of Book: 20.2 x 14 cm.

Size of Leaf: 19.4 x 13.4 cm.

Pagination: vi, [4], 371, [7] pp.

Collation: Half-title [i]; frontispiece (black-and-white plate) with tissue guard facing title; title (with drawing) [iii]; copyright (1870, Louisa M. Alcott) (1897, 1898, John S. P. Alcott) (1902, Little, Brown and Company), imprint (University Press, John Wilson and Son, Cambridge, U. S. A.) [iv]; preface [v]-vi; contents [1]; list of illustrations [3]; text 1-371; publisher's prospectus [2]-[7].

Description: Full green cloth with pictorial cover stamped in green, beige, and maroon. Front cover stamped in gold: AN / OLD-FASHIONED / GIRL / (oval gilt-rule) / Louisa M. Alcott. Spine stamped in gold: AN OLD / FASHIONED / GIRL / (vignette) / LOUISA M. / ALCOTT (with bordered design) / LITTLE, BROWN / & COMPANY.

Paper: Wove. Top edges gilt.

Illustrations: Twelve full-page black-and-white illustrations by Smith, vignette on title-page by Smith.

Frontispiece	Polly.
Title	Polly and Tom.
Facing p. 18	"Why must you be so fine to go to school?" asked Polly.
Facing p. 41	So Polly tucked herself up in front.
Facing p. 76	He surveyed himself with satisfaction.
Facing p. 109	"I choose this," said Polly, holding up a long white kid glove.
Facing p. 150	"You should have seen my triumphal entry into the city, sitting among my goods and chattels."
Facing p. 178	Pushing open the door, she went quietly into the dimly lighted room.
Facing p. 219	For a moment her hands wandered over the keys.
Facing p. 260	"Now then fall to, ladies, and help yourselves."
Facing p. 293	"Oh, Tom, what is it?" cried Polly, hurrying to him.
Facing p. 340	They both sat quiet for a minute.
Facing p. 363	"Polly, I want to tell you something!"

Issue Points: Reprinted in same format nearly every year through 1918 with respective change of date on title-page. Issued by P. F. Collier and Son with color frontispiece by another artist in 1920.

Publication Notes: Listed in *Publisher's Weekly*. Nov. 22, 1902.

Price at Issuance: $2.00.

Note on Illustrations: First and only appearance of these illustrations.

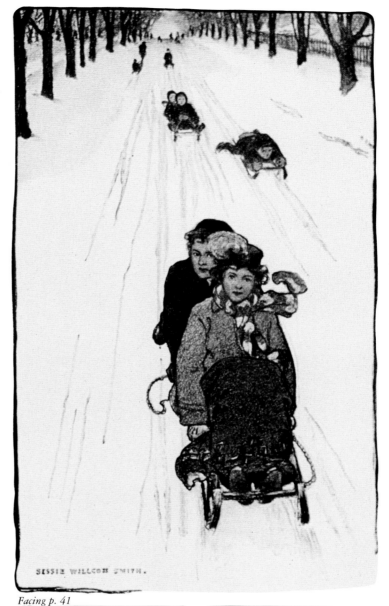

Facing p. 41

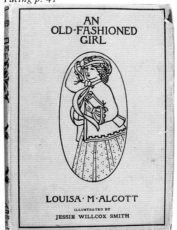

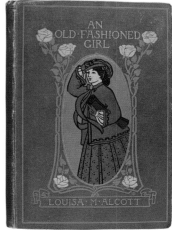

Cover jacket found on later edition *Book cover*

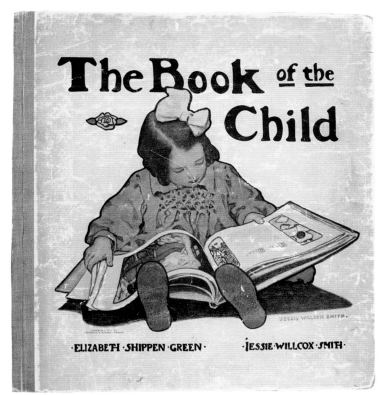

Book cover

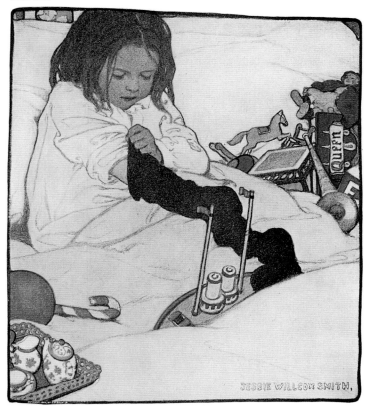

Page 53

A17. *THE BOOK OF THE CHILD*

Humphrey, Mabel.
New York, 1903.
Frederick A. Stokes.

Title: (orange rule) / THE BOOK OF / THE CHILD / (orange rule) / With Facsimiles of / Drawings in Colour by / Jessie Willcox Smith and / Elizabeth Shippen Green / and with Stories and verses / Written for the Pictures / by Mabel Humphrey / New York / Frederick A. Stokes Company / Publishers / (orange rule) / Copyright, 1903, by Frederick A. Stokes Company, Copyright, 1902, by C. W. / Beck, Jr. Published in October, 1903.

Size of Book: 38.3 x 35.4 cm.

Size of Leaf: 37.5 x 35.1 cm.

Pagination: [60] pp.

Collation: Half-title (printed in orange) [1]; frontispiece in color [4]; title and copyright (printed in orange and black) (1903, Frederick A. Stokes Company) (1902, C.W. Beck, Jr.) (published in October, 1903:) [5]; text [7]-[59].

Description: Issued in quarter cloth (gray-green), color pictorial paper-covered boards front and back cover. Printed in black on cover: THE BOOK OF THE / CHILD / Copyright, 1903, by / Frederick A. Stokes Company (small letters) / Elizabeth Shippen Green, Jessie Willcox Smith. Issued in color pictorial cover jacket. Orange and blue lettering in hand-printed style throughout.

Cover Jacket Description: Printed on brown paper in orange and black on front cover: (orange rule) THE BOOK OF / THE (orange "T") CHILD (orange "C") / (orange rule) / With Facsimiles of / Drawings in Colour by / Jessie Willcox Smith and (orange) / Elizabeth Shippen Green (orange) / And with Stories and Verses / Written for the Pictures / by Mabel Humphrey (orange) / New York / Frederick A. Stokes Company / Publishers / (orange rule) / Copyright, 1903, By Frederick A. Stokes Company Published in October, 1903.

Cover Jacket Dimensions: 38.3 x 80 cm.

Paper: Thick coated wove.

Illustrations: Seven full-page color plates, three by Jessie Willcox Smith, four by Elizabeth Shippen Green. Six headpiece drawings in orange and black by Smith, six by Green. Cover pictorial covers in color by Smith.

Frontispiece	Playing Chess. By Elizabeth Shippen Green.
Page 13	Warming Feet. By Jessie Willcox Smith.
Page 21	Playing Parcheesi. By Elizabeth Shippen Green.
Page 29	Mushrooms. By Elizabeth Shippen Green.
Page 37	On the Hammock. By Jessie Willcox Smith.
Page 45	Apples. By Elizabeth Shippen Green.
Page 53	Toys. By Jessie Willcox Smith.

Issue Points: First and only edition; no distinguishing points.

Publication Notes: Listed in *Publisher's Weekly,* Nov. 21, 1903.

Price at Issuance: $2.00.

Note on Illustrations: These illustrations also reproduced in a large calendar for 1903, entitled "The Child"; and as a portfolio of prints in 1903.

A18. RHYMES OF REAL CHILDREN
Sage, Betty.
New York, 1903.
Fox, Duffield and Company.

Title: RHYMES OF / REAL CHILDREN (orange) / by / Betty Sage / With Pictures by / Jessie Willcox Smith / (publisher's device) / New York: Fox, Duffield / and Company, MCMIII.

Size of Book: 29.7 x 27.5 cm.

Size of Leaf: 29 x 27.5 cm.

Pagination: 32 pp.

Collation: Half-title [1]; frontispiece in color facing title-page; title (rubricated with decorative border in orange and black) [3]; copyright (1903, Fox, Duffield and Company) (Published October, 1903) (Printed in the United States of America) (Engravings by the Beck Engraving Company), imprint (Press of S. H. Burbank & Company, Philadelphia) [4]; dedication (with tinted illustration) [5]; contents [6]; text 7-32.

Description: Issued in color pictorial paper-covered boards, quarter tan cloth. Front and back cover identical with illustration of three children on bench. Printed in black: RHYMES / OF / REAL CHILDREN / By Betty Sage / (illustration) / copyright 1903, by Fox, Duffield & Co. (in small letters) / Pictures by Jessie Willcox Smith / Fox, Duffield & Co., New York.

Paper: Coated wove.

Illustrations: Six full-page color plates, vignette on dedication page, line drawings in orange and black as borders throughout. Color pictorial illustrated covers.

Frontispiece Mother.
Facing p. 8 When Daddy Was a Little Boy.
Facing p. 12 Natural History.
Facing p. 16 The New Baby.
Facing p. 20 Miss Mariar.
Facing p. 24 Kittens.

Issue Points: Later printings with respective changes in Roman numerals on title-page. Issued by David Nutt, London in 1905 with Nutt cancel title and copyright page.

Publication Notes: Listed in *Publisher's Weekly,* Dec. 5, 1903.

Price at Issuance: $1.50.

Note on Illustrations: First and only book appearance of these illustrations. Illustrations reproduced in 1903, by Duffield, in the form of pictorial handkerchiefs.

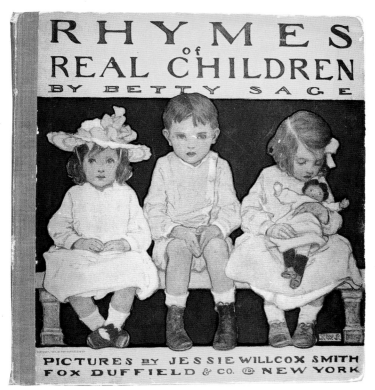

Book cover

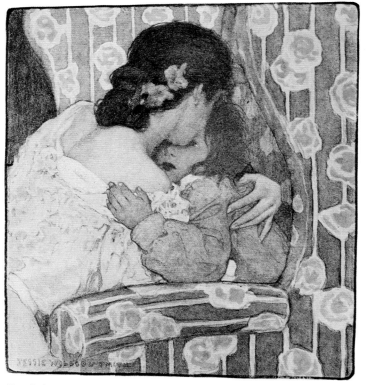

Frontispiece

Frontispiece

A19. *TRUTH DEXTER*
McCall, Sidney.
Boston, 1903.
Little, Brown and Co.

Title: TRUTH DEXTER / By / Sidney McCall / Boston / Little, Brown and Company / 1903.
Size of Book: 19 x 13 cm.
Size of Leaf: 18.3 x 12.2 cm.
Pagination: viii, 375, [5] pp.
Collation: Half-title [i]; frontispiece (black-and-white plate by Smith) facing title; title [iii]; copyright (1901, Little, Brown and Company) [iv]; foreword [v]; contents [vii]-viii; text [1]-375; publisher's prospectus [2]-[5].
Description: Issued in full cloth (light blue). Front cover stamped in black: TRUTH DEXTER / (design) / Sidney / McCall. Spine stamped in black: TRUTH / DEXTER / by / Sidney / McCall / (design) / Little, Brown / and Company.
Paper: Wove.
Illustrations: One black-and-white illustration by Jessie Willcox Smith.
Frontispiece [Drawing of young woman]
Issue Points: First published in 1901 without Smith illustration. 1903 edition is first appearance of Smith drawing. Reissued in 1906 in same format bearing 1906 on title-page.
Note on Illustration: First and only appearance of this illustration.

Book cover

A20. IN THE CLOSED ROOM
Burnett, Frances Hodgson.
New York, 1904.
McClure, Phillips & Co.

Title: (Green ornament) / IN / THE CLOSED / ROOM / by / Frances Hodgson Burnett / Author of Little Lord Fauntleroy / and THE LITTLE PRINCESS / (green ornament) / Illustrations by / Jessie Willcox Smith / New York / McClure, Phillips & Co. / MCMIV / (green ornament).

Size of Book: 21.6 x 14.7 cm.

Size of Leaf: 20.8 x 14.5 cm.

Pagination: [2], iv, 129, [1] p.

Collation: Half-title [1]; frontispiece in color with tissue guard, facing title; title [i]; copyright (1904, McClure, Phillips & Co.) (Published, October, 1904) (copyright 1904 by S. S. McClure Co.) [ii]; list of illustrations iii; divisional title [1]; text 3-129, [1] p.

Description: Issued in full cloth (green) with gold stamped decorations on front cover. Cover design by William Jordan, also reproduced on cover jacket. Front cover stamped in gold: IN THE / CLOSED / ROOM / By / Frances / Hodgson / Burnett. Spine stamped in gold: IN THE / CLOSED / ROOM / By / Frances / Hodgson / Burnett / McClure / Phillips / & Co. Decorated endpapers and decorations and borders throughout in green.

Cover Jacket Description: Beige coated paper printed in green with identical markings as gold stamped design and lettering on book with the addition of: "Pictures in color / by / Jessie Willcox Smith" appearing at the bottom of the front cover.

Cover Jacket Dimensions: 21.6 x 42 cm.

Paper: Thick wove. Top edges gilt, others untrimmed.

Illustrations: Eight full-page color illustrations by Smith, each with a caption.

Frontispiece	The playing today was even a lovelier, happier thing than it had ever been before.
Facing p. 14	She often sat curving her small long fingers backward.
Facing p. 28	They gazed as if they had known each other for ages of years.
Facing p. 34	"Come and play with me".
Facing p. 62	She must go and stand at the door and press her cheek against the wood and wait—and listen.
Facing p. 68	She began to mount the stairs which led to the upper floors.
Facing p. 74	The ledge of the window was so low that a mere step took her outside.
Facing p. 100	"I'm going to play with the little girl, mother . . . you don't mind, do you?"

Issue Points: Subsequently issued by Grosset & Dunlap with only four color illustrations and different cover design. Issued simultaneously in England by Hodder and Stoughton.

Publication Notes: Listed in *Publisher's Weekly*, Oct. 15, 1904.

Price at Issuance: $1.50.

Note on Illustrations: All illustrations first appeared in *McClure's Magazine* in consecutive issues, August and September 1904.

THE LEDGE OF THE WINDOW WAS SO LOW THAT A MERE STEP TOOK HER OUTSIDE

Facing p. 74

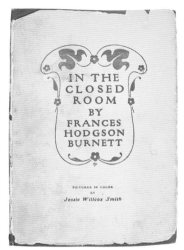

Cover jacket

Book cover

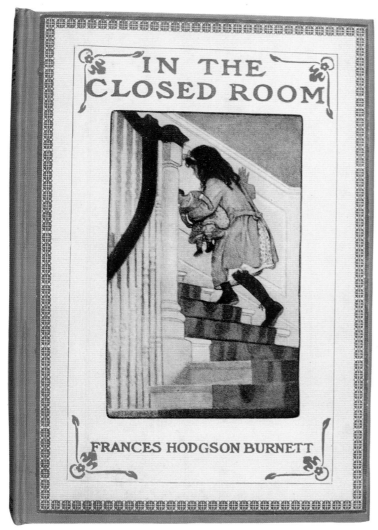

Book cover

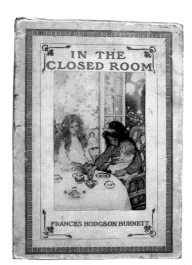

Box lid

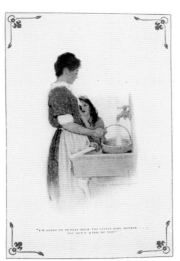

Facing p. 100

A21. IN THE CLOSED ROOM
Burnett, Frances Hodgson.
New York, 1904.
Grosset & Dunlap.

Title: IN / THE CLOSED / ROOM / by / Frances Hodgson Burnett / Author of Little Lord Fauntleroy / and The Little Princess / (device) / Illustrations by / Jessie Willcox Smith / New York / Grosset & Dunlap / Publishers.
Size of Book: 21.5 x 14.5 cm.
Size of Leaf: 20.9 x 14.4 cm.
Pagination: [2], [iv], 129, [1] p.
Collation: Half-title [1]; frontispiece in color facing title; title [i]; copyright (1904, McClure, Phillips & Co.) (Published, October, 1904) (second impression) (1904, S.S. McClure Co.) [ii]; list of illustrations; iii; divisional title [1]; text 3-129, [1] p.
Description: Issued in full cloth (light blue) with full-size color inlay front cover. Cover printed in gold: IN THE / CLOSED ROOM / Frances Hodgson Burnett. Spine printed in blue: IN THE / CLOSED / ROOM / by / Frances / Hodgson / Burnett / Grosset / & Dunlap. Decorated endpapers and decorations and borders throughout in blue. Issued in color pictorial box and glassine wrapper.
Box Description: Cover of box with color illustration of two girls at tea (identical to frontispiece in McClure edition - A20.). Lettering and decorations on box cover identical to that of book. Title and author appear in box on bottom side panel of box.
Size of Box: 22.5 x 15.5 x 2.5 cm.
Paper: Thick wove.
Illustrations: Four full-page color plates by Smith, color inlay on cover.

Cover Inlay	She began to mount the stairs which led to the upper floors.
Frontispiece	They gazed as if they had known each other for ages of years.
Facing p. 14	She often sat curving her small long fingers backward.
Facing p. 62	She must go and stand at the door and press her cheek against the wood and wait—and listen.
Facing p. 100	"I'm going to play with the little girl, mother . . . you don't mind, do you?"

Issue Points: Second impression and only re-issue (other than English edition). Differs from McClure edition (A20) as follows: a) Only four plates and cover inlay, b) endpapers and decorations printed in blue, c) top edges not gilt, d) spine not stamped in gold, e) no tissue guard to frontispiece, and f) no imprint at end.

A22. A CHILD'S GARDEN OF VERSES
Stevenson, Robert Louis.
New York, 1905.
Charles Scribner's Sons.

Title: (color illustration) A CHILD'S GARDEN OF VERSES / Robert Louis Stevenson / With Illustrations by / Jessie Willcox Smith / Charles Scribner's Sons / New York — MCMV.

Size of Book: 24.3 x 18.4 cm.

Size of Leaf: 23.8 x 17.7 cm.

Pagination: xii, 124, [2] p.

Collation: Half-title (A CHILD'S GARDEN / OF VERSES) [i]; illustrated title in color [iii]; copyright (1905, Charles Scribner's Sons) [iv]; dedication - verse v-vi; contents vii-ix; illustrations xi-xii; divisional title [1]; text 3-124, [1] p.

Description: Issued in full cloth (black) with color pictorial insert front cover. Printed in black on front cover: A CHILD'S GARDEN OF VERSES / Robert Louis Stevenson / With Illustrations By / Jessie Willcox Smith. Spine stamped in gold: A / CHILD'S / GARDEN / OF / VERSES / (ornament - flower) / Robert / Louis / Stevenson / Illustrated / by / Jessie / Willcox / Smith / Scribners. Endpapers illustrated by Smith in two colors.

Paper: Wove. Top edges gilt, other edges untrimmed.

Illustrations: Twelve full-page color plates with captioned tissue guards, black-and-white line drawings throughout. Front cover insert and title illustrations in color by Smith.

Facing p. 4	Bed in Summer.
Facing p. 10	Foreign Lands.
Facing p. 20	The Land of Counterpane.
Facing p. 24	My Shadow.
Facing p. 42	Foreign Children.
Facing p. 52	Looking-glass River.
Facing p. 60	The Hayloft.
Facing p. 64	Northwest Passage.
Facing p. 78	Picture-books in Winter.
Facing p. 88	The Little Land.
Facing p. 98	The Flowers.
Facing p. 116	To Auntie.

Issue Points: The earliest issue is distinguished from all later issues by having all of the following points: a) MCMV appears on the title-page; b) Scribner's colophon absent from copyright page; c) impression for cover insert measures 21.8 cm. (later issue nearly 1 cm. longer); d) printing on copyright page, (Charles Scribner's Sons), measures 3.1 cm. wide (later issue is 2.6 cm. wide); e) cover insert with heavy gilt in sky; and f) *Scribner's* on spine at very bottom, lower than in later issues. Later printings with respective changes on title-page. Issued in England by Longmans, Green and Co. in 1905 with Longmans cancel title-page.

Publication Notes: Listed in *Publisher's Weekly,* Oct. 28, 1905.

Price at Issuance: $2.50.

Note on Illustrations: Two illustrations appeared before issuance and four appeared subsequently in *Collier's Magazine:*

Facing p. 4	Bed in Summer. Dec. 22, 1906 (frontispiece).
Facing p. 20	The Land of Counterpane. July 28, 1906 (frontispiece).
Facing p. 42	Foreign Children. April 15, 1905 (p. 15).
Facing p. 60	Hayloft. Sept. 16, 1905 (cover).
Facing p. 64	Northwest Passage. Nov. 25, 1905 (cover).
Facing p. 78	Picture-books in Winter. Dec. 23, 1905 (cover).

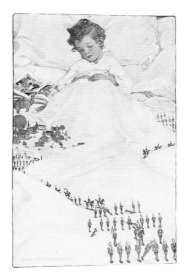

Book cover

Title page

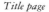

Facing p. 20

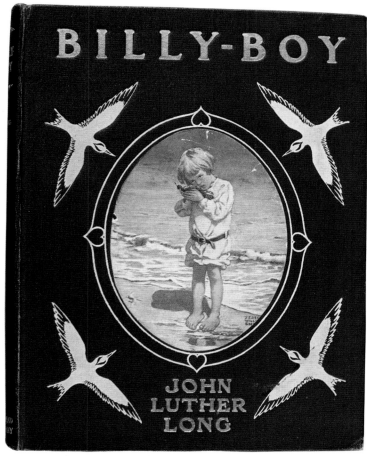

Book cover

Page 27 *Page 49*

A23. *BILLY-BOY*
Long, John Luther.
New York, 1906.
Dodd, Mead & Company.

Title: (drawing - boat) / BILLY-BOY / A Study in
Responsibilities / by John Luther Long / Author of "Madame
Butterfly", / "The Darling of the Gods", etc. / (rule) / With
illustrations by / Jessie Willcox Smith and / Decorations by
Robert McQuinn / (drawing - bird) / New York / Dodd,
Mead & Company / 1906 / (double rule).
Size of Book: 19.2 x 15.3 cm.
Size of Leaf: 19 x 14.7 cm.
Pagination: [10], 74 pp.
Collation: Half-title [1]; frontispiece in color, facing title;
title [3]; copyright (1905, P. F. Collier & Son) (1906, John
Luther Long) (Published September, 1906) [4]; dedication
[5]; acknowledgments [6]; contents [7]; illustrations [9];
text 1-74.
Description: Issued in full cloth (blue) with color insert
(oval) front cover. Cover with four birds and oval ruled
borders stamped in white. Cover stamped in gold: BILLY-
BOY / John / Luther / Long. Spine stamped in gold: (white
bird) / BILLY- / BOY / (white bird) / Long / Dodd, Mead / &
Company. Blue illustrated endpapers by Robert McQuinn.
Cover Jacket Description: Issued in printed glassine cover
jacket with blue double ruled border on front cover. Printed
in blue on cover: BILLY-BOY / A Study in Responsibilities /
by / John Luther Long / Author of / "Madame Butterfly" /
"The Darling of the Gods," etc. / (ornament) / (two
paragraphs 14 lines - describing book and its appeal).
Cover Jacket Dimensions: 19.3 x 36 cm.
Paper: Wove. Top edges gilt, others untrimmed.
Illustrations: Cover insert in color, color frontispiece and
three black-and-white full-page illustrations all by Smith.
Line drawings in blue throughout by Robert McQuinn.

Cover insert	Billy-Boy.
Frontispiece	Billy-Boy.
Page 17	I found that Billy had put a chair under the lock.
Page 27	He put it into my hand . . . so tenderly that for the first time I began, perhaps, to understand.
Page 49	It was "arms all 'round".

Issue Points: First issue with top edges gilt and pictorial
endpapers. Second issue does not have these features and is
about 2 mm thinner from cover to cover.
Publication Notes: Copyright registered July 19, 1906,
John Luther Long. Copies received Sep. 26, 1906. Listed in
Publisher's Weekly, Oct. 20, 1906 (p. 1089).
Price at Issuance: $1.25.
Note on Illustrations: All illustrations first appeared in
Collier's Magazine, Dec. 30, 1905. The Frontispiece (same as
cover insert) appeared with the text.

A24. THE BED-TIME BOOK
Whitney, Helen Hay.
New York, 1907.
Duffield and Company.

Title: THE BED-TIME BOOK (orange) / By / Helen Hay Whitney / Author of "The Punch and Judy Book," / "Verses for Jock and Joan," etc. / Pictures by / Jessie Willcox Smith / (publisher's device) / New York: Duffield / and Company: MCMVII.

Size of Book: 31.3 x 27.6 cm.

Size of Leaf: 30.7 x 27 cm.

Pagination: 31, [1] p.

Collation: Half-title (with drawing) [1]; two drawings [2]; frontispiece in color facing title; title (with drawings) [3]; copyright (1907, Duffield and Company) (Published, August 1907) (Engravings by The Beck Engraving Company), imprint (Press of S. H. Burbank & Company, Philadelphia) [4]; text 5-31, [1] p.

Description: Issued in quarter red-brown cloth, color pictorial paper covered boards; front and back covers with illustration of child in bed reading THE BED-TIME BOOK. Front cover and back: THE / BED-TIME BOOK / By Helen Hay Whitney / Pictures by Jessie Willcox Smith / Duffield & Co., New York. Yellow endpapers with drawings of children holding candles set off in white.

Paper: Coated wove.

Illustrations: Six full-page color plates, orange-and-black drawings throughout.

Frontispiece	Picture Papers.
Facing p. 6	Auntie.
Facing p. 12	Scales.
Facing p. 18	Noah's Ark.
Facing p. 24	At Gran'papa's.
Facing p. 30	Hats.

Issue Points: Simultaneously published in England by Chatto and Windus.

Publication Notes: Copyright registered, Aug. 1, 1907, Duffield and Co. Copies received, Aug. 1, 1907. Listed in *Publisher's Weekly,* Nov. 9, 1907 (p. 1385).

Price at Issuance: $1.50.

Note on Illustrations: First and only appearance of these illustrations. "Scales" later reproduced in A CHILD'S BOOK OF OLD VERSES, 1915, as "Cradle Hymn".

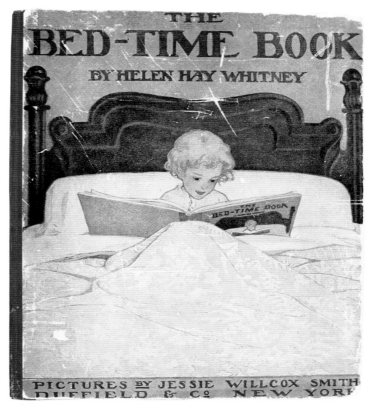

Book cover

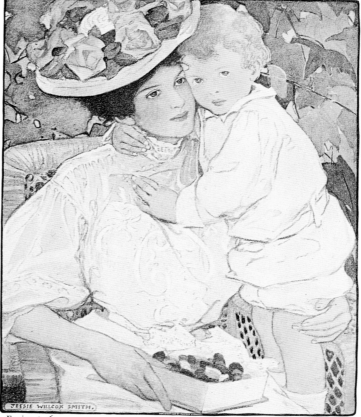

Facing p. 6

Facing p. 14

Facing p. 30

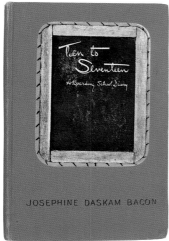

Book cover

A25. *TEN TO SEVENTEEN*

Bacon, Josephine Daskam.
New York and London, 1908.
Harper & Brothers Publishers.

Title: TEN TO SEVENTEEN (red) / A Boarding-School Diary (red) / By / Josephine Daskam Bacon / Author of / "The Memoirs of a Baby" / Illustrated / (device) / New York and London / Harper & Brothers Publishers (red) / 1908.

Size of Book: 19.3 x 13.0 cm.

Size of Leaf: 18.8 x 12.7 cm.

Pagination: [x], 261, [1] p.

Collation: Frontispiece in tint facing title with tissue guard; title (rubricated) [i]; copyright (1906, 1908, Harper and Brothers) (1903, 1904, 1905, Charles Scribner's Sons) (1907, Phillips Publishing Company and D. Appleton & Co.) (All rights reserved) (Published, January, 1908) [ii]; dedication [iii]; contents [v]; illustrations [vii]; divisional title [ix]; text 1-261.

Description: Issued in full fine rib cloth (green) with pictorial insert in tint on cover. Offset in white on insert: TEN TO / SEVENTEEN / A BOARDING SCHOOL DIARY. Stamped in gold on cover: Josephine Daskam Bacon. Spine stamped in gold: TEN / TO / SEVENTEEN / (rule) / Josephine / Daskam / Bacon / Harpers.

Paper: Wove.

Illustrations: Fourteen full-page tinted illustrations, four by Florence Scovel Shinn, three by Jessie Willcox Smith, three by Elizabeth Shippen Green, two by Sarah Stilwell, and two by Dere Meaux.

Frontispiece	"The little girl sat down near her and watched her." By Elizabeth Shippen Green.
Facing p. 10	"All the girls saw it." By Jessie Willcox Smith.
Facing p. 14	"All of a sudden Ben pinched me." By Jessie Willcox Smith.
Facing p. 30	"A Man in dirty overalls." By Jessie Willcox Smith.
Facing p. 38	"Ben wrote the letter." By Sarah Stilwell.
Facing p. 58	"He kept asking her what would be the prettiest thing to draw." By Sarah Stilwell.
Facing p. 90	"She scolded them and called them names." By Florence Scovel Shinn.
Facing p. 114	"He was eighteen and very funny, we thought." By Florence Scovel Shinn.
Facing p. 138	"Weeksy is no great wonder, but she is kind-hearted." By Florence Scovel Shinn.
Facing p. 144	"She was so light there was nothing to her." By Florence Scovel Shinn.
Facing p. 186	"Do you mean that your Aunt's Aunt isn't an angel?" By Dere Meaux.
Facing p. 206	"This is the hand of Cleopatra and Sarah Bernhardt." By Dere Meaux.
Facing p. 236	"A lock of black curly hair tied with blue ribbon." By Elizabeth Shippen Green.
Facing p. 254	"A blue ribbon with a silver heart strung on it." By Elizabeth Shippen Green.

Publication Notes: Listed in *Publisher's Weekly*, Feb. 1, 1908 (p. 736).

Price at Issuance: $1.50.

Note on Illustrations: All three illustrations by Smith first appeared in *Scribner's*, April 1903, in a story entitled, "The Blue Dress," by Josephine Daskam. One of the illustrations was reproduced in *Scribner's*, Jan. 1937.

A26. *DREAM BLOCKS*
Higgins, Aileen C.
New York, 1908.
Duffield & Company.

Title: (Color illustration with boy looking out window)
DREAM BLOCKS / By / Aileen Cleveland Higgins / Copyright,
1908, By Duffield & Co. (printed in small letters at base of
illustrations) / (publisher's colophon in red) / Pictures by
Jessie Willcox Smith / Duffield & Company / New York.
Size of Book: 25.7 x 18.7 cm.
Size of Leaf: 25.1 x 18.5 cm.
Pagination: [x], 47, [1] p.
Collation: Half-title [i]; color illustrated title [iii]; contents
[v]-[vi]; illustrations [vii]; copyright with drawing (1908,
Duffield & Company) (Engravings by The Beck Engraving
Company), (imprint) (Presswork by S. H. Burbank and Co.,
Philadelphia) [viii]; divisional title [ix]; drawing [x]; text 1-
47; drawing [1].
Description: Issued in full cloth (beige) with color pictorial
insert (full size) front cover. Front cover printed in black:
DREAM BLOCKS / Aileen Cleveland Higgins / With
illustrations / by Jessie Willcox Smith / Duffield & Co., New
York / (printed in white in small letters: Copyright 1908 by
Duffield and Co.). Spine stamped in gold: DREAM BLOCKS
(lengthwise). Endpapers illustrated with children reading
and holding book in blue, yellow, and brown. Issued in color
pictorial cover jacket with same illustration as cover insert.
Paper: Thick wove. Plates printed on thick coated paper.
Illustrations: Fifteen full-page color plates, color insert
front cover and cover jacket, and red-and-black line
drawings throughout. Color illustration on title-page and
pictorial endpapers in color by Smith.

Cover insert	[Mother kissing child's hand on cement bench]
Title-page	Boy at Window.
Facing p. 1	Dream Blocks.
Facing p. 2	Stupid You.
Facing p. 4	Doorsteps.
Facing p. 6	The Big Clock.
Facing p. 10	A Quandary.
Facing p. 14	A Rainy Day.
Facing p. 18	The Runaway.
Facing p. 22	The Sick Rose.
Facing p. 26	Frills.
Facing p. 30	Home.
Facing p. 34	A Prayer.
Facing p. 38	Summer's Passing.
Facing p. 40	Punishment.
Facing p. 44	Treasure Craft.

Issue Points: Issued in England in 1911 by Chatto and
Windus.
Publication Notes: Copyright registered, Oct. 22, 1908,
Duffield and Co. Copies received, Oct. 23, 1908. Listed in
Publisher's Weekly, Oct. 17, 1908 (p. 1051).
Price at Issuance: $1.50.
Note on Illustrations: First and only appearance of these
illustrations.

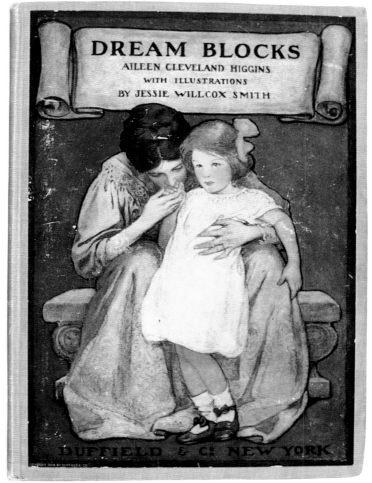

Book cover

Title page *Facing p. 26*

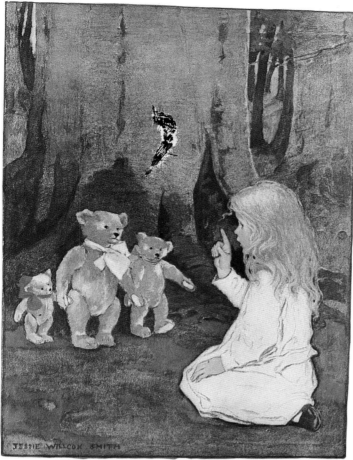

Page 11

A27. THIRTY FAVORITE PAINTINGS
New York, 1909.
P. F. Collier & Son.

Title: THIRTY / FAVORITE PAINTINGS (orange) / By Leading American Artists (within banner) / (with first letter of last names in orange). Maxfield Parrish Howard Chandler Christy / Frederic Remington Sarah S. Stillwell / Henry Hutt A. B. Frost Louis Loeb / Harrison Fisher W. J. Aylward Henry Reuterdahl / Jessie Willcox Smith George Wright W. T. Smedley / A. B. Wenzell Charles Dana Gibson E. W. Kemble / Albert Sterner J. C. Leyendecker A. I. Keller / Edward Penfield.
Size of Book: 28.3 x 41.5 cm.
Size of Leaf: 27.4 x 41.1 cm.
Pagination: [62] pp.
Collation: Frontispiece facing title; Title (rubricated) [1]; copyright (1908, P. F. Collier & Son) [2]; Table of Contents [3]; text [4]-[62].
Description: Issued in quarter cloth (black) with red paper-covered boards. Paper label on cover with gold border and 20 illustrators printed in red.
Paper: Thick coated wove.
Illustrations: 30 full-page illustrations, 8 in full color, 8 in tint, and 14 in black and white. Each with a caption and design facing page. One full-page color plate, one in tint, by Jessie Willcox Smith.

| Page 11 | Goldilocks and the Three Bears (in full color). |
| Page 53 | A Friendly Game (in tint). |

Publication Notes: Not entered in Copyright Office. Listed in *Publisher's Weekly,* June 5, 1909 (p. 1861).
Price at Issuance: $1.50.
Note on Illustrations: *Goldilocks* first appeared in *Collier's Magazine,* Sep. 28, 1907, as a frontispiece in full color. *A Friendly Game* first appeared in *Collier's Magazine,* Jan. 27, 1906 as a tinted illustration. *Goldilocks* later appeared in 1911 in THE NOW-A-DAYS FAIRY BOOK (Duffield) entitled *The Three Bears* in full color.

Book cover

A28. *THE CHRONICLES OF RHODA*
Cox, Florence Tinsley.
Boston, (1909).
Small, Maynard & Company.

Title: THE CHRONICLES OF / RHODA / by / Florence Tinsley Cox / Illustrated by / Jessie Willcox Smith / "O the radiant light that girdled / Field and forest, land and sea, / When we were all very young together, / And the world was new to me." (publisher's device) / Boston / Small, Maynard & Company / Publishers.

Size of Book: 19.4 x 13 cm.

Size of Leaf: 18.8 x 12.6 cm.

Pagination: [viii], 287, [1] p.

Collation: Half-title [i]; frontispiece in color, with tissue guard, facing title; title (enclosed in ornamental box) [iii]; copyright (1909, Small, Maynard & Company) (incorporated) (Entered in Stationer's Hall), imprint (The University Press, Cambridge, U. S. A.) [iv]; dedication [v]; contents [vii]; divisional title [1]; text 3-287.

Description: Issued in full cloth (red) with bold rectangular gold-stamped box front cover leaving letters offset in red: THE CHRONICLES / OF RHODA / Florence Tinsley Cox. Spine stamped in gold: THE / CHRONICLES / OF / RHODA / (rule) / Cox / Small / Maynard / & Company. Gold rule at top and bottom of spine.

Paper: Wove.

Illustrations: Color frontispiece with tissue guard, and one color plate by Smith, both uncaptioned.

Frontispiece: [We were both silent].

Facing p. 78 [An hour has slipped by, but still the major did not come].

Publication Notes: Copyright registered, Oct. 23, 1909, Small, Maynard and Company. Copies received, Oct. 28, 1909. Listed in *Publisher's Weekly,* Oct. 2, 1909 (p. 946).

Price at Issuance: $1.25.

Note on Illustrations: The frontispiece [Two children at the front door] first appeared in color in *McClure's Magazine,* April 1905, with caption, "We were both silent. There did not seem to be anything more to talk about." Illustration facing p. 78 [Young girls on gate post with flowers] first appeared in *McClure's Magazine,* February 1905, as color frontispiece with caption, "An hour has slipped by, but still the major did not come." Both of these illustrations appear in LITTLE FOLKS ILLUSTRATED ANNUAL (1918).

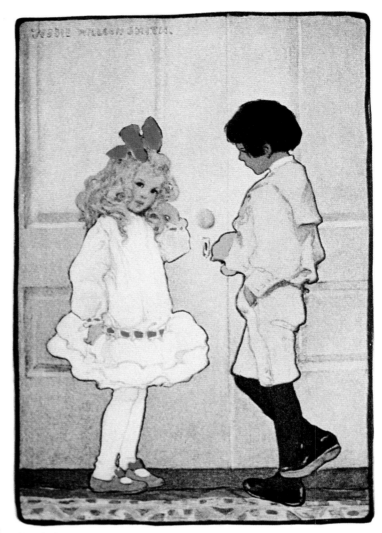

Frontispiece

Book cover

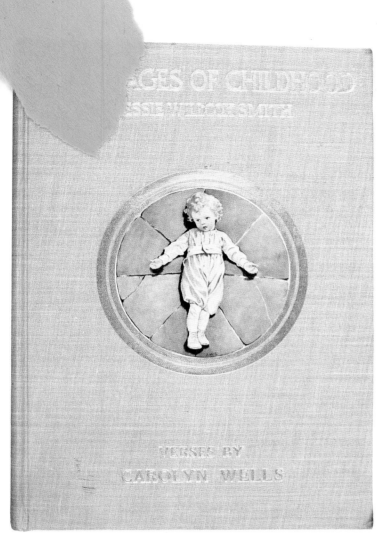

Book cover

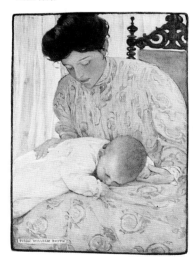

Frontispiece

Facing p. 26

A29. *THE SEVEN AGES OF CHILDHOOD*
Wells, Carolyn.
New York, 1909.
Moffat, Yard and Company.

Title: THE SEVEN AGES / OF / CHILDHOOD (black) / Pictures by / Jessie Willcox Smith / Verses by / Carolyn Wells (brown) / (drawing in black of child) / New York (black) / Moffat, Yard and Company (brown) / 1909 (black).
Size of Book: 26 x 18.7 cm.
Size of Leaf: 25.4 x 18 cm.
Pagination: [viii], 56 pp.
Collation: Half-title with drawings (THE SEVEN AGES / OF / CHILDHOOD) [i]; frontispiece in color, with tissue guard, facing title; title with drawings (rubricated in brown) [iii]; copyright (1908, 1909, The Curtis Publishing Company) (1909, Moffat, Yard and Company, New York) (All rights reserved), imprint (The Plimpton Press, Norwood, Mass., U. S. A.) [iv]; dedication [v]; drawing [vi]; illustrations [vii]; drawing [viii]; divisional title [1]; drawing [2]; text 3-56.
Description: Issued in full linen cloth (light brown) with circular color insert on cover. Front cover stamped in gold: SEVEN AGES OF CHILDHOOD / Jessie Willcox Smith / (color insert with double-ruled gilt borders) / Verses by / Carolyn Wells. Spine stamped in gold lengthwise: SEVEN AGES OF CHILDHOOD. Illustrated endpapers with repeating design of child and potted flower in brown.
Cover Jacket Description: Issued in color pictorial cover wrapper printed on thick glossy white paper protected by glassine wrapper. Cover of wrapper with lettering and circular ruling around illustration in gold identical to book. Spine printed lengthwise in gold: SEVEN AGES OF CHILDHOOD / Verses by Carolyn Wells / Illustrations by Jessie Willcox Smith. No printing on flaps. Circular color illustration identical to that of the book.
Cover Jacket Dimensions: 26 x 42 cm.
Paper: Thick wove.
Illustrations: Seven full-page color plates, color insert on cover, brown line drawings throughout, pictorial endpapers, all by Smith.

Cover insert	[Child with hands outstretched].
Frontispiece	First the Infant in its Mother's arms.
Facing p. 10	Then the Toddling Baby Boy.
Facing p. 18	Then the Epicure.
Facing p. 26	Then the Lover sighing like a furnace.
Facing p. 34	Then the Scholar.
Facing p. 46	The Sixth Age Shifts to lean and slender maidenhood
Facing p. 54	Last Scene of all that ends this strange and eventful history

Issue Points: Reissued by Donohue and Company, Chicago, several years later. Donohue reprint issued in full cloth (red) with "Then the Epicure" plate appearing as cover insert and lettering printed in black. This edition, with the Donohue cancel title-page, has no date on title-page.
Publication Notes: Copyright Registered, Oct. 30, 1909, Moffat, Yard and Company. Copies received, Oct. 29, 1909. Listed in *Publisher's Weekly*, Nov. 6, 1909 (p. 1237).
Price at Issuance: $2.00.
Note on Illustrations: These illustrations first appeared as a series of black-and-white drawings for *The Ladies' Home Journal* as follows:
"First the Infant" November 1908
"The Toddling Boy" December 1908
"Then the Epicure" January 1909
"Then the Lover" March 1909
"Then the Scholar" April 1909
"Then the Lean" August 1909
"Last Scene of All" September 1909
These illustrations were initially copyrighted by the Curtis Publishing Company and were reproduced by them for postcards and prints.

A30. A CHILD'S BOOK OF OLD VERSES
Smith, Jessie Willcox.
New York, 1910.
Duffield & Company.

Title: A CHILD'S BOOK OF / OLD VERSES / Selected and
Illustrated / by / Jessie Willcox Smith / (publisher's device) /
New York / Duffield & Company / 1910.
Size of Book: 24.1 x 18.3 cm.
Size of Leaf: 23.3 x 17.8 cm.
Pagination: ix, [3], 124 pp.
Collation: Half-title (A CHILD'S BOOK OF / OLD VERSES) [i];
frontispiece in color facing title with captioned tissue-guard;
title [iii]; copyright (1910, Duffield & Company), imprint
(The Trow Press, New York) [iv]; contents v-viii; list of
illustrations ix; divisional title [2]; verse - Robert Louis
Stevenson [3]; text 1-124.
Description: Issued in full fine rib cloth (blue). Front cover
with pictorial insert in color. Cover stamped in gold: A
CHILD'S BOOK / OF OLD VERSES / (insert) / With Pictures by /
Jessie Willcox Smith. Spine stamped in gold: A / CHILD'S /
BOOK / OF OLD / VERSES / JESSIE / WILLCOX / SMITH /
Duffield. Pictorial printed endpapers with little girl rolling a
hoop (repeated design) in blue.
Paper: Thick wove. Top edges gilt, others untrimmed.
Illustrations: Ten full-page color illustrations, each with
captioned tissue guards. Color pictorial insert front cover.
Black-and-white drawing of girl reading books as head-piece
repeated throughout by Smith.

Cover Insert	[Girl with book, gold background]
Frontispiece	A Child's Grace.
Facing p. 14	A Child's Question.
Facing p. 24	How Doth the Busy Bee.
Facing p. 34	I Love Little Pussy.
Facing p. 44	Going into Breeches.
Facing p. 58	Little Drops of Water.
Facing p. 70	Let Dogs Delight.
Facing p. 84	Sweet and Low.
Facing p. 104	Seven Times One.
Facing p. 116	Twinkle, Twinkle Little Star.

Issue Points: First issue with pictorial endpapers and top
edges gilt, the second issue without both features.
Publication Notes: Copyright Registered, Oct. 15, 1910
Duffield and Company. Copies received, Oct. 18, 1910.
Listed in *Publisher's Weekly*, Nov. 5, 1910 (p. 1728)
Price at Issuance: $2.50.
Note on Illustrations: First and only appearance of the
following: A Child's Question, I Love Little Pussy, Going
Into Breeches, Sweet and Low, and Seven Times One. The
following first appeared in *Woman's Home Companion:* How
Doth the Busy Little Bee, March 1910; Little Drops of
Water, September 1910; and Twinkle, Twinkle Little Star,
December 1909. A Child's Grace appeared subsequently in
The Ladies' Home Journal, November 1912. All of these
illustrations, plus an additional one, appeared in A CHILD'S
STAMP BOOK OF OLD VERSES (1915).

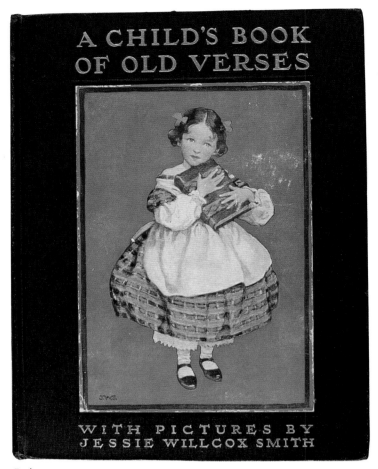

Book cover

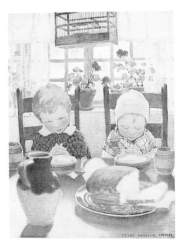

Frontispiece

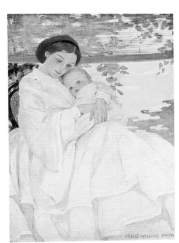

Facing p. 84

That's the way all the orphans'll be took
care of when — when the millennium
comes, ez you say.

Facing p. 44

Book cover

A31. SONNY'S FATHER
Stuart, Ruth McEnery.
New York, 1910.
The Century Co.

Title: SONNY'S FATHER / In which the father, now become / grandfather, a kindly observer of / life and a genial philosopher, in his / desultory talks with the family doc- / tor carries along the story of Sonny. / By / Ruth McEnery Stuart / Author of "Sonny, a Christmas Guest," "Napoleon Jackson, the / Gentleman of the Plush Rocker," "Aunt Amity's / Silver Wedding," etc. / Illustrated / (drawing of boy in tree) / New York / The Century Co. / 1910.

Size of Book: 18 x 12 cm.

Size of Leaf: 17.5 x 11.5 cm.

Pagination: [viii], 240 pp.

Collation: Half-title [i]; frontispiece (black-and-white plate) facing title, with tissue laid in; title [iii]; copyright (1910, The Century Co.) (Published, October, 1910), imprint (Electrotyped and printed by C. H. Simonds & Co., Boston) [iv]; contents [v]; list of illustrations [vii]; divisional title [1]; text 3-240.

Description: Issued in full cloth (light green) with oval cover design of acorns stamped in olive green and black. Black ruled borders. Cover stamped in gold: SONNY'S FATHER / Ruth / McEnery / Stuart. Spine stamped in gold: (black rule) SONNY'S / FATHER / (black bird) / Ruth / McEnery / Stuart / (acorns) / The / Century / Co. / (black rule).

Paper: Wove. Top edges gilt, other edges untrimmed.

Illustrations: Eleven full-page, black-and-white illustrations, two by Jessie Willcox Smith. All illustrations with captions.

Frontispiece	"I'll tell you, Doc, it's a great and awful thing to be inherited." (with tissue insert).
Facing p. 44	"That's the way all the orphans'll be took care of when—when the millennium comes." By Jessie Willcox Smith.
Facing p. 62	"The Chief-o-rater."
Facing p. 68	The Mother's Meeting.
Facing p.76	"Her bicycle was the first ever rid down the Simkinsville Road."
Facing p. 106	"Located so that you might be lookin' right at it an' not see it."
Facing p. 138	"Every little orphan asylum child is in a sense of waitin' outside our gates."
Facing p. 156	"How can any institutional child have a fair chance o' bein' fully human?" By Jessie Willcox Smith.
Facing p. 184	"When the heathen Chinee come th'ough."
Facing p. 196	"An' so we set it out. An' now I'm glad we did."
Facing p. 220	"Do you ricollec' how I turned my dumb face to you in wonderment?"

Publication Notes: Copyright registered, Oct. 22, 1910, Century and Co. Copies received, Oct. 27, 1910. Listed in *Publisher's Weekly,* Oct. 29, 1910 (p. 1674).

Price at Issuance: $1.00.

Note on Illustrations: Both illustrations by Smith first appeared in *Century Magazine,* Dec. 1902, "While the Mother Works."

A32. THE FIVE SENSES
Keyes, Angela M.
New York, 1911.
Moffat, Yard and Company.

Title: THE FIVE SENSES / By / Angela M. Keyes (red) / Illustrated / By / Jessie Willcox Smith / New York / Moffat, Yard and Company / 1911 (entire title enclosed in double red-ruled box).

Size of Book: 21.3 x 14.6 cm.

Size of Leaf: 20.5 x 14.3 cm.

Pagination: ix, [5], 252 pp.

Collation: Half-title (enclosed in double-ruled box) [i]; frontispiece in color facing title with tissue guard; title (rubricated) [iii]; copyright (1910, Moffat, Yard and Company, New York) (All rights reserved) (Published, September, 1911) [iv]; foreword [v]; acknowledgments [vi]; contents vii-ix; list of illustrations [2]; divisional title [4]; verse [5]; text 3-252.

Description: Issued in full cloth (beige) with pictorial cover printed in cream, blue and dark green (signed AB). Front cover printed in green: THE FIVE / SENSES / (picture of kids playing) / Angela M. Keyes / Illustrated by / Jessie Willcox Smith. Spine printed in green: THE / FIVE / SENSES / (ornament) / Angela / M. / Keyes / Moffat Yard / & Company.

Paper: Laid paper. Endpapers plain wove.

Illustrations: Five full-page color illustrations with captions by Smith, only the frontispiece with tissue guard.

Frontispiece Tasting.
Facing p. 36 Smelling.
Facing p. 72 Touching.
Facing p. 142 Hearing.
Facing p. 184 Seeing.

Publication Notes: Copyright registered, Aug. 26, 1911, Moffat, Yard and Company. Copies received, Sep. 1, 1911. Not listed in *Publisher's Weekly.*

Price at Issuance: $1.00.

Note on Illustrations: The illustrations first appeared in *McClure's Magazine,* October 1907, in a series of color plates. They were also issued as a set of matted prints in 1907 by Charles Beck Engraving Company.

Book cover

Facing p. 36

Frontispiece

Book cover

A33. *A CHILD'S BOOK OF STORIES*
Coussens, Penrhyn W.
New York, 1911.
Duffield & Company.

Title: A CHILD'S BOOK OF / STORIES / Selected and Arranged by / Penrhyn W. Coussens / Editor of "Poems Children Love" / With Pictures by / Jessie Willcox Smith / (publisher's device) / New York / Duffield & Company / 1911.

Size of Book: 24.7 x 18.8 cm.

Size of Leaf: 24 x 18.5 cm.

Pagination: xi, [3], 463, [1] p.

Collation: Half-title [i]; frontispiece in color facing title with captioned tissue guard; title [iii]; copyright (1911, Duffield & Company), imprint (The University Press, Cambridge, U. S. A.) [iv]; dedication [v]; preface vii-viii; contents ix-xi; illustrations [2]; text 1-463.

Description: Issued in full fine rib cloth (blue) with color pictorial insert front cover. Front cover stamped in gold: A CHILD'S BOOK / OF STORIES / (color insert with 0.3 cm. solid ruled border stamped in gold) / With Pictures By / Jessie Willcox Smith. Spine stamped in gold: (rule) / A CHILD'S BOOK / OF STORIES / Coussens / (rule) / Pictures by / Jessie Willcox Smith / Duffield / (rule). Pictorial endpapers with blue drawing of fairy and child, not by Smith.

Paper: Wove. Top edges plain, side edges untrimmed.

Illustrations: Ten full-page color plates with captioned tissue guards, color pictorial insert front cover.

Cover insert	[Girl with Fairy]
Frontispiece	Babes in the Wood.
Facing p. 4	Hansel and Gretel.
Facing p. 42	The Goose Girl.
Facing p. 70	Jack and the Bean-Stalk.
Facing p. 108	Goldilocks; or The Three Bears.
Facing p. 150	Snow-White and Rose-Red.
Facing p. 200	Cinderella.
Facing p. 250	Red Riding-Hood.
Facing p. 300	The Sleeping Beauty.
Facing p. 380	Snow-Drop and the Seven Little Dwarfs.

Issue Points: First issue with 1911 on copyright page and with pictorial endpapers. Later issues with corresponding change of date on title-page, and with plain endpapers.

Publication Notes: Copyright registered, Sep. 30, 1911, Duffield and Company. Copies received, Oct. 4, 1911. Listed in *Publisher's Weekly,* Nov. 18, 1911 (p. 2003).

Price at Issuance: $2.25.

Note on Illustrations: First appearance of these illustrations. Six of the illustrations later appeared as color plates in *Woman's Home Companion* as follows: Snow White and Rose Red, Mar. 1913; Babes in the Woods, Apr. 1913; Cinderella, Sep. 1913; Goldilocks, Oct. 1913; Jack and the Bean-Stalk, Apr. 1914; Snow Drop and The Seven Little Dwarfs, Nov. 1915.

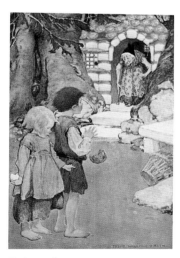

Facing p. 4

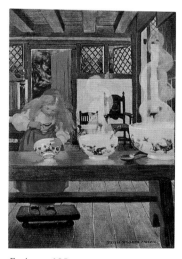

Facing p. 108

A34. THE NOW-A-DAYS FAIRY BOOK
Deluxe Tipped-in Edition
Chapin, Anna Alice.
New York, 1911.
Dodd, Mead and Company.

Title: THE NOW-A-DAYS / FAIRY BOOK / By / Anna Alice
Chapin / "There are just as many Fairies now-a-days" . . . /
What Grandmother always said / With Illustrations in Color
/ By Jessie Willcox Smith / (drawing of fairy sitting on
mushroom) / New York / Dodd, Mead and Company /
1911.

Size of Book: 32.0 x 24 cm.

Size of Leaf: 31.5 x 23.3 cm.

Pagination: [iv], 159, [1] p.

Collation: Half-title [i]; frontispiece (tipped-in color plate
with captioned tissue guard) facing title; title (with drawing)
[iii]; copyright (1911, Dodd, Mead & Co.) (P. F. Collier,
1907, 1908, 1909, 1910) (Published, October, 1911) [iv];
contents [1]; illustrations [3]; verse [5]; text 7-159; verse
[1].

Description: Issued in full cloth (red-brown) with full-size
color pictorial insert front cover. Printed in white on insert:
THE / NOW-A-DAYS / FAIRY / BOOK / by / Anna / Alice /
Chapin / Pictured by / Jessie Willcox Smith. Spine stamped
in white: THE / NOW-A / DAYS / FAIRY / BOOK / by / Anna /
Alice / Chapin / Dodd, Mead / & Company. Issued in
glassine cover jacket.

Glassine Cover Jacket Description: Glassine jacket with:
Price $2.00 Net, printed in black at bottom middle, front
cover.

Cover Jacket Dimensions: 32 x 63 cm.

Paper: Thick wove. Plates mounted onto thick yellow-
orange stock.

Illustrations: Six full-page color plates mounted onto thick
yellow-orange stock. Each plate with captioned tissue guard
facing illustration. Cover insert by Smith.

Cover insert	[Two children at base of fountain]
Frontispiece	Robin Put His Head Down on His Arm, and Shut His Eyes. Size of plate: 29.3 x 21 cm.
Facing p. 16	She Lufs Me—She Lufs Me Not. Size of Plate: 26 x 21 cm.
Facing p. 38	The Three Bears. Size of plate: 29.3 x 21 cm.
Facing p. 68	Beauty and the Beast. Size of plate: 29.3 x 21 cm.
Facing p. 122	Little Red Riding Hood. Size of plate: 29.3 x 21 cm.
Facing p. 158	A Modern Cinderella. Size of plate: 29.3 x 21 cm.

Issue Points: First issue with tipped-in plates. Also issued in
ordinary edition without mounted plates. Ordinary edition
does not have date on title-page and lacks captioned tissue
guards (except for plain tissue over frontispiece). Plates full
size in ordinary edition with anomalous plate facing p. 16
(She Lufs Me—She Lufs Me Not) having white margins on
top and bottom to account for reduction in size. The work
was also issued in 1913 by the Prospect Press, New York.
The Prospect edition is slightly smaller in size, with Prospect
cancel title-page, otherwise identical to ordinary edition.

Publication Notes: Copyright registered, Nov. 15, 1911,
Dodd, Mead and Company. Copies received, Nov. 16,
1911. Listed in *Publisher's Weekly,* Dec. 2, 1911 (p. 2304).

Price at Issuance: Tipped-in Edition: $2.00.

Note on Illustrations: All of the illustrations, except the
frontispiece, first appeared in the following issues of *Collier's
Magazine:* Cover insert [Two children at base of fountain],
Jun. 11, 1910; She Lufs Me—She Lufs Me Not, Jun. 29,
1907; The Three Bears, Sep. 28, 1907; Beauty and the

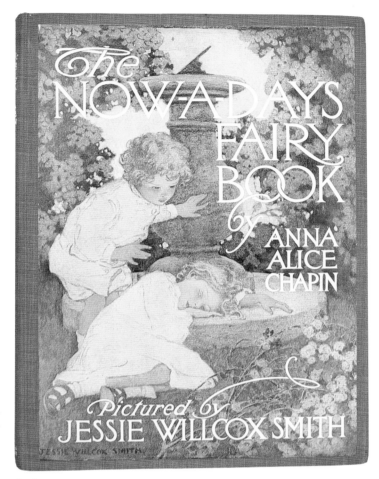

Book cover

Book cover with tissue jacket

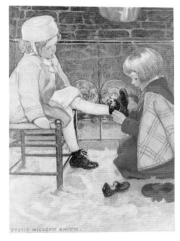

Facing p. 158

Book cover, Binding A

Binding B

Page 45

Beast, May 30, 1908; Little Red Riding Hood, Nov. 20, 1909; A Modern Cinderella, Dec. 12, 1908. The Three Bears also appeared in THIRTY FAVORITE PAINTINGS (1908).

A35. *DICKENS'S CHILDREN*
(Binding State A)
Dickens, Charles.
New York, 1912.
Charles Scribner's Sons.

Title: DICKENS'S / CHILDREN / Ten Drawings / By / Jessie / Willcox / Smith / New York / Charles Scribners Sons / MCMXII.
Size of Book: 24.4 x 17.4 cm.
Size of Leaf: 23.8 x 16.8 cm.
Pagination: [48] pp.
Collation: Half-title DICKENS'S / CHILDREN [1]; title (with orange decorative border) [3]; copyright (1912, Charles Scribner's Sons) [4]; list of subjects [5]; divisional title [7]; text [8]-[46]; publisher's colophon [47].
Description: Issued in fine rib cloth (green) with circular color insert front cover surrounded by gilt-stamped design.
Paper: Thick coated wove. Endpapers plain wove. Top edges gilt.
Illustrations: Ten full-page color illustrations, color insert front cover.

Page 9	Tiny Tim and Bob Cratchit on Christmas Day.
Page 13	David Copperfield and Peggotty by the Parlour Fire.
Page 17	Paul Dombey and Florence on the Beach at Brighton.
Page 21	Little Nell and Her Grandfather at Mrs. Jarley's.
Page 25	Pip and Joe Gargery.
Page 29	Jenny Wren, the Little Dolls' Dressmaker.
Page 33	Oliver's First Meeting with the Artful Dodger.
Page 37	Mrs. Kenwigs and the Four Little Kenwigses.
Page 41	The Runaway Couple.
Page 45	Little Em'ly.

Binding State B: Tan linen cloth with green border surrounding cover insert and green lettering identical to State A (described above). Top edges plain.
Issue Points: Issued in two binding states with Binding A first issue. Simultaneously issued in England by Chatto & Windus in Binding State A, and re-issued by Chatto in 1913.
Publication Notes: Copyright registered, Sep. 21, 1912, Charles Scribner's Sons. Copies received, Sep. 24, 1912. Listed in *Publisher's Weekly*, Oct. 5, 1912 (p. 1162).
Price at Issuance: $1.00.
Note on Illustrations: Six of the illustrations first appeared in *Scribner's Magazine* in color. The following four appeared in December 1911: Little Nell and Her Grandmother; Pip and Joe Gargery; Jenny Wren; Oliver's First Meeting. The following two appeared in August 1912: The Runaway Couple and Little Em'ly. All of the illustrations were reproduced in THE CHILDREN OF DICKENS (1925).

A36. TWAS THE NIGHT BEFORE CHRISTMAS
Moore, Clement C.
Boston and New York, 1912.
Houghton Mifflin Company.

Title: TWAS THE NIGHT BEFORE CHRISTMAS / A Visit from St. Nicholas / By Clement C. Moore / (illustration of two children playing with toys, in red and black) / With Pictures by Jessie Willcox Smith / Houghton Mifflin Company / Boston and New York.

Size of Book: (oblong) 17.0 x 24.2 cm.

Size of Leaf: 16.5 x 24 cm.

Pagination: [32] pp.

Collation: Title (with red and black drawing) [1]; copyright (1912, Houghton Mifflin Company) (All rights reserved) (Published October 1912), imprint (The Riverside Press, Cambridge, Mass., U. S. A.) [2]; introduction [3]-[4]; divisional title [5]; text [6]-[31]; drawing [32].

Description: Issued in paper covered boards (red) with green or red cloth spine. Circular illustration on cover in color of St. Nicholas with two children and small circular vignette in color on rear cover. Cover printed in gold: TWAS THE NIGHT BEFORE CHRISTMAS / (circular illustration) / Pictures by Jessie Willcox Smith. Color pictorial endpapers with illustration of children walking in line with socks. Issued in color pictorial cover jacket.

Cover Jacket Description: Printed on cream coated paper with circular hole on cover revealing illustration on cover of book. Front cover printed in red: TWAS THE NIGHT BEFORE CHRISTMAS / (two Christmas trees on each side of center hole) / Pictures by Jessie Willcox Smith. Back cover printed in black "Best Books for Little Children" 16 titles. Flaps blank.

Cover Jacket Dimensions: 17.5 x 73 cm.

Paper: Thick coated wove.

Illustrations: Twelve full-page color illustrations, red and black line drawings, vignettes and initials throughout. Cover illustrations, jacket and endpapers all by Smith.

(Titles taken from first line of text facing illustrations.)

Page 7	Twas the Night Before Christmas.
Page 9	The Children were nestled all snug in their beds.
Page 11	When out on the lawn there arose such a clatter.
Page 13	The moon on the breast of the new fallen snow.
Page 16	With a little old driver, so lively and quick.
Page 17	Now, Dasher! Now, Dancer! Now, Prancer and Vixen!
Page 21	He was dressed all in fur, from his head to his foot.
Page 23	His eyes—how they twinkled! His dimples how merry!
Page 25	The stump of a pipe he held tight in his teeth.
Page 27	He was chubby and plump, a right jolly old elf.
Page 29	He spoke not a word, but went straight to his work.
Page 31	He sprang to his sleigh, to his team gave a whistle.

Issue Points: First issue has all the following points: a) green or red cloth spine; b) "Published October 1912" on copyright page; and c) dustjacket containing window and trees on cover. A later printing, (A36.1), was issued in paper covered boards extending around spine. This edition *without* "Published October 1912" on copyright page, and with the addition of "Including the right to reproduce this book or parts thereof in any form" and "Printed in the U. S. A." on copyright page. The paper edition is slightly smaller,

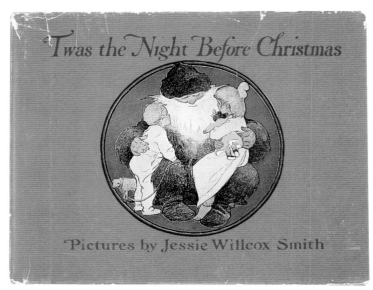

Cover jacket, second issue (A36.1)

Book cover, first issue

Page 9

RAWING by JESSIE WILLCOX SMITH. Rittenhouse Square was named in honor of David Rittenhouse, the eminent astronomer, mathematician and physicist. It is one of the group of four open squares marking the points of the city that were set forth in the original plan for the city of Philadelphia, and has an area of six and two-thirds acres. It has long been a popular rendezvous for the children of the fashionable district.

PHILADELPHIA
BY
PHILADELPHIA ARTISTS

PUBLISHED
BY THE
PHILADELPHIA
ART ALLIANCE

Cover Page

measuring 17.3 x 21.8 cm. and was issued in red color pictorial cover jacket reproducing exactly front and back covers. Front flap with Lucy Fitch Perkins Twin Series advertisement, back flap with Alphabet of Birds advertisement.

Publication Notes: Copyright registered, Oct. 5, 1912, Houghton Mifflin and Company. Copies received, Oct. 12, 1912. Listed in *Publisher's Weekly,* Oct. 12, 1912 (p. 1269).

Price at Issuance: $1.00.

Note on Illustrations: Cover and endpaper illustrations first appeared in *Collier's Magazine* December 21 and December 14, 1907, respectively.

A37. A PEREGRINATION OF PHILADELPHIA
Newton, A. Edward.
Philadelphia, n.d. (c. 1913).
Philadelphia Art Alliance.

Title: (drawing-Alladin's lamp) / A PEREGRINATION / OF PHILADELPHIA / A. Edward Newton / Illustrated by Views of the City / from sketches by / distinguished artists / Published by / the Philadelphia Art Alliance.

Size of Leaf: 22.2 x 15.9 cm.

Pagination: [4], [16] single sheets.

Collation: Title [1]; text [2]-[4]; illustrations [1]-[16] single sheets.

Description: Issued in paper folder with orange drawings front and back. Front cover of folder printed in black: PHILADELPHIA / By / PHILADELPHIA ARTISTS / (orange drawing - portrait) / Published / by the / Philadelphia / Art Alliance. Back cover with orange drawing of Alladin's lamp (Philadelphia Art Alliance seal) in orange followed by description of drawing printed in black. Issued with four page text by Newton and 16 single sheets, each with paragraph of explanation of illustration.

Dimensions of Folder: 39 x 23.5 cm.

Paper: Printed on laid paper. Folder stiff coated wove.

Illustrations: 16 black drawings on yellow ground measuring 14 x 8.5 cm. by various artists. One drawing by Jessie Willcox Smith: RITTENHOUSE SQUARE.

Issue Points: Also issued as a set of postcards.

Note on Illustrations: First publication of this illustration.

A38. AMERICAN ART BY AMERICAN ARTISTS—1914

NOTE: Book not available for photography

Title: (Title surrounded by 27 photographs of the artists represented in the book with a brief biographical sketch below each photo). AMERICAN ART BY AMERICAN ARTISTS / Representing the / best work in pen-and-ink and in color of / Twenty-seven Celebrated American Artists / (designs-two flowers) / P. F. Collier & Son / Publishers New York / Copyright by P. F. Collier & Son, 1898, 1899, 1901, 1902, 1903, 1904, 1905, 1906, 1907, 1908, 1909, 1910, 1911, 1912, 1913, 1914.

Size of Book: 29.5 x 42 cm.

Size of Leaf: 29 x 41.5 cm.

Pagination: [100] pp.

Collation: Title [1]; copyright (P. F. Collier, 1914) [1]; text [2]-[100].

Description: Bound in gray cloth with title stamped in gold on cover.

Paper: Printed on coated wove paper.

Illustrations: 100 illustrations in color and black and white by the following artists: Louis Loeb, Wm. Thomas Smedley, Howard Chandler Christy, Howard Pyle, Frederic Remington, Jessie Willcox Smith, Charles Dana Gibson, Maxfield Parrish, Albert E. Sterner, Arthur I. Keller, Orson Lowell, F. X. Leyendecker, Arthur B. Frost, Henry Reuterdahl, Harrison Fisher, W. J. Aylward, Willard Ortlip, Edward Penfield, Philip R. Goodwin, Thornton Oakley, Penrhyn Stanlaws, Charles A. MacLellan, Henry Hutt, Edward W. Kemble, J. Knowles Hare, Jr., Walter Appleton Clark, Nicholas P. Zarokilli. Five full-page color illustrations by Jessie Willcox Smith:
"The Helper."
"A Tempered Wind."
"Billy-Boy."
"Goldilocks."
"Beauty and the Beast."

Publication Notes: Copyright not entered. Listed in *Publisher's Weekly,* May 9, 1914 (p. 1552).

Price at Issuance: $1.00.

Note on Illustrations: The illustrations originally appeared in *Collier's Magazine* as follows: The Helper, Oct. 5, 1907; A Tempered Wind, May 26, 1906; Billy-Boy, Dec. 30, 1905; Goldilocks, Sep. 28, 1907; Beauty and the Beast, May 30, 1908.

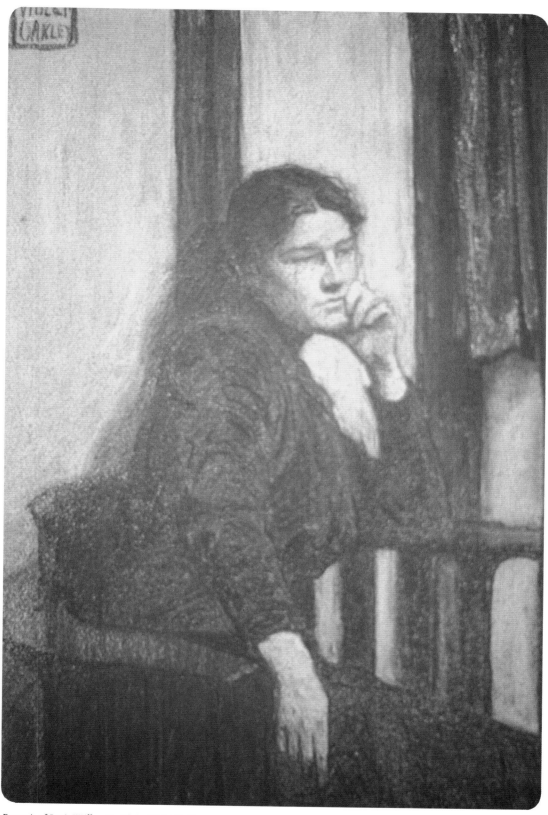

Portrait of Jessie Willcox Smith by Violet Oakley.

A39. *THE JESSIE WILLCOX SMITH MOTHER GOOSE*

Smith, Jessie Willcox (compiler).
New York, 1914.
Dodd, Mead and Company.

Title: THE JESSIE WILLCOX SMITH / MOTHER GOOSE / A
Careful and Full Selection of the Rhymes / With Numerous
Illustrations / In full color and black and white / By / Jessie
Willcox Smith / New York / Dodd, Mead & Company /
Publishers.
Size of Book: 22.4 x 30.7 cm.
Size of Leaf: 21.5 x 30 cm.
Pagination: 173, [1] p.

Collation: Half-title with drawing (THE JESSIE WILLCOX
SMITH / MOTHER GOOSE) [1]; verse with drawing [2];
frontispiece in color facing title; title with decorative
borders in blue and black [3]; copyright with drawing (1912,
1913, 1914, *Good Housekeeping Magazine*) (1914, Dodd,
Mead & Company) [4]; An Historical Note [5]-6; A List of
Rhymes [7]-14; A List of the Pictures [15]; verse [16];
explanation [17]; text 19-173.

Description: Issued in full cloth (black) with full size
pictorial insert on front cover. Printed in black: THE JESSIE
WILLCOX SMITH / MOTHER GOOSE. Spine stamped in
white: THE / JESSIE / WILLCOX / SMITH / MOTHER / GOOSE /
Dodd, Mead / & Company. Light orange endpapers with
contrasting dark orange and white pictorial illustration of
Mother Goose and goslings. Issued in pictorial box.
Paper: Thick wove.
Illustrations: Twelve full-page color and five black-and-
white plates, color pictorial insert on front cover. Illustrated
title-page, black-and-white drawings throughout, pictorial
endpapers all by Smith.

Cover insert	[Two children huddled beneath Mother Goose's wings]. Background is heavily gilt.
Frontispiece	Hush-a-by baby, on the treetop. In color.
Facing p. 20	One foot up, the other foot down. In color.
Facing p. 24	Little Jack Horner sat in a corner. In black and white.
Facing p. 30	Jack fell down and broke his crown. In color.
Facing p. 50	There was an old woman who lived in a shoe. In color.
Facing p. 60	Polly, put the kettle on, Polly, put the kettle on. In black and white.
Facing p. 70	Little Miss Muffet sat on a tuffet. In color.
Facing p. 80	Peter, Peter, pumpkin-eater. In color.
Facing p. 88	Hot cross buns, hot cross buns. In black and white.
Facing p. 98	Rain, rain, go away. In color.
Facing p. 110	Little Bo-Peep has lost her sheep. In color.
Facing p. 118	Pease porridge hot, pease porridge cold. In black and white.
Facing p. 130	Mary, Mary, quite contrary. In color.
Facing p. 138	See-saw, Margery Daw. In color.
Facing p. 150	A dillar, a dollar, a ten o'clock scholar. In black and white.
Facing p. 166	Curly locks! curly locks! wilt thou be mine. In color.
Facing p. 170	Ring-a-round a rosie. In color.

Note on Illustrations: Illustrations first appeared in a series
of black-and-white drawings for *Good Housekeeping
Magazine* as follows:
Pease-Porridge Hot: December 1912.
Little Miss Muffett: January 1913.
See-saw, Margery Daw: February 1913.
One Foot Up The Other Down; entitled "The Way to
London": March 1913.
Rain, Rain, Go Away: April 1913.

Box lid

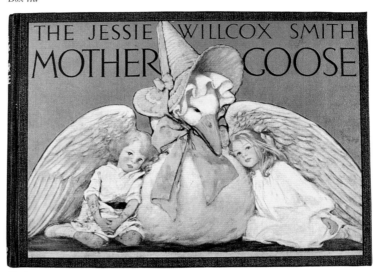

Book cover

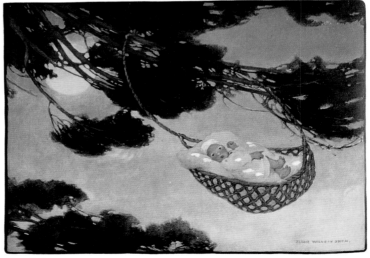

Frontispiece

There Was an Old Woman: May 1913.
Mary, Mary Quite Contrary: June 1913.
Little Bo-Peep: July 1913.
Jack and Jill:August 1913.
Rock-A-Bye Baby (Hush-a-by, baby): September 1913.
A Diller, A Dollar: October 1913.
Peter, Peter, Pumpkin Eater: November 1913.
Little Jack Horner: December 1913.
Curly Locks: January 1914.
Polly, Put the Kettle On February 1914.
Ring A-Round a Rosie: March 1914.
Hot Cross Buns: April 1914.

Issue Points: Reissued by Dodd, Mead and Company in 1916 with many subtle changes. A full listing of points distinguishing the two issues follows:

First Issue

Size of Book: 22.4 x 30.5 x 3.5 cm (across top)
Pictorial Box: Net $2.50 printed below *By Jessie Willcox Smith.*
Endpapers: Pictorial orange and white, printed on thick wove as text.
Blank Page: Before half-title.

Textual Points:

Page 9:	*Is John within?* with no asterisk.
Page 11:	a) *Old Mother Goose, etc.* with 32-33.
	b) **Pat-A-Cake, etc . . .* 31 appears at bottom of first column.
	c) **Pease-Porridge hot, etc . . .* 22 & 118 appears at top of second column.
	d) *Ride a cock-horse to Shrewsbury Cross* appears at top of third column.
	e) *See-Saw, Margery Daw, Jennie shall have a new master . . .* 25-138 appears bottom part of third column.
Page 13:	a) Third column does not have *What is the rhyme for porringer . . .* 79.
	b) *When I was taken from the fair body, etc . . .* 170 follows *When I was a little girl, etc.*
	c) *Whoever saw a rabbit* is last entry, last column.
Page 14:	a) *Who killed Cock Robin?* is first entry, first column.
	b) *Games and Riddles,* in first column, is 0.7 cm from previous line.
	c) *Purple, yellow, red and green, etc . . .* 57 is only entry for "P".
	d) *We are three brethren, etc . . .* with 22 & 159.
Page [15]:	Headpiece to *A List of Pictures* is the same as appears on p. 19.
Page 19:	The Jessie Willcox Smith Mother Goose, page number and crosswise rule appear above headpiece drawing.
Page 134:	[turnstile] with lower case "t".

Bracketed Word(s) Appear at TOP of Stanza: p. 63 *{The man had one eye, etc.};* p. 87 *{A Star};* p. 88 *{A Cherry};* p. 92 *{A bed};* p. 102 *{Coals};* p. 110 *{Imitate a Pigeon};* p. 112 *{Sunshine};* p. 148 *{A Well};* p. 151 *{A Horseshoer}.*

Third Issue

Size of Book: 22.3 x 29.8 x 3.0 cm (i.e., considerably thinner).
Pictorial Box: Not issued in box.
Endpapers: Plain.
Blank page: At end of book following last page of text, instead of before half-title.
Weight of Book: Considerably lighter than first and second issues.
Textual Points: Contains all changes as second issue.

Box and Glassine Jacket Decsription: Issued in ribbed glassine cover jacket. Box made of paper covered cardboard with cover printed in blue consisting of border illustration and titling. The border illustration is that of the title-page. Cover title and wording: THE JESSIE WILLCOX SMITH / MOTHER GOOSE / over 300 more rhymes than in any Edition / published / with numerous illustrations / In full color and black and white / By Jessie Willcox Smith / Net $2.50 / New York / Dodd, Mead / and Company.
Box Dimensions: 23.3 x 32.0 x 3.3 cm.
Publication Notes: Copyright registered, Nov. 18, 1914, Dodd, Mead and Company. Copies received Nov. 20, 1914. Listed in *Publisher's Weekly,* Jan. 16, 1915 (p. 145).
Price at Issuance: $2.50.

Second Issue

Size of Book: Same.
Pictorial Box: Net $5.00 stamp over $2.50 stamp.

Endpapers: Same.

Textual Points:

Page 9:	**Is John within?* (i.e. with asterisk).
Page 11:	a) *Old Mother Goose, etc.* with only 32.
	b) **Pat-A-Cake, etc . . .* 31 is deleted.
	c) **Pease-Porridge hot . . .* 22-118 appears at bottom of second column.
	d) *Ride a cock-horse to Shrewsbury Cross* appears at bottom of second column.
	e) **See-Saw, Margery Daw, Jennie, etc.* is split up into two entries: *Jack shall have, etc.* p. 25 and *Jennie shall have, etc.* p. 138.
Page 13:	a) *What is the rhyme for porringer . . .* 78 appears in third column.
	b) *When I was taken from the fair body . . .* 170 is deleted.
	c) *Who killed Cock Robin?* is last entry third column.
Page 14:	a) *Why is pussy in bed, pray? . . .* 130 is first entry first column.
	b) *Games and Riddles,* first column, is 1.1 cm from bottom of previous line.
	c) *"Pat-A-Cake, etc . . .* 31 is inserted above. *Purple, yellow, red, etc . . .* 57 in third column.
	d) *We are three brethren, etc.* in third column with only 159.
Page [15]:	Headpiece to *A List of Pictures* is same as appears on p. 39.
Page [19]:	Entire heading, page number and rule above headpiece are deleted (above headpiece).
Page 134:	*{Turnstile}* with upper case "T".

Same bracketed word(s) appear in second issue, but they are placed at BOTTOM of stanza.

A40. MOTHER GOOSE MELODIES TOYBOOKS

Smith, Jessie Willcox (compiler).
New York, 1914.
Dodd, Mead and Company.

Title: (front cover) HUSH-A-BYE-BABY / ON THE TREE TOP / and other / Mother Goose / Melodies / *Good Housekeeping Magazine* (small letters).

Size of Book and Leaf: 9 x 13.2 cm.

Pagination: 8 pp.

Collation: Half-title (printed at top) 1; copyright (1914, Dodd, Mead & Company) 2; text 1-8.

Description: Issued as a set of twelve card wrapper toybooks, each with color pictorial cover reproducing one of twelve color plates from THE JESSIE WILLCOX SMITH MOTHER GOOSE (Dodd, Mead & Co., 1914). Front cover with lettering and border in gilt. Rear cover with advertisement for Colgate's Cashmere Bouquet (1913, Colgate Co.), gilt border.

Paper: Wove.

Illustrations: Each toybook with color pictorial illustration front cover and black-and-white line drawings every other page.

Hush-a-bye, Baby on the Tree Top.
One Foot Up the Other Foot Down.
Jack and Jill Went Up the Hill.
There was an Old Woman Who Lived in a Shoe.
Little Miss Muffet Sat on a Tuffet.
Peter Peter Pumpkin Eater.
Rain, Rain Go Away.
Little Bo-Peep.
Mary, Mary Quite Contrary.
See Saw, Margery Daw.
Curly Locks! Curly Locks! Wilt Thou Be Mine?
Ring A-round a Rosie.

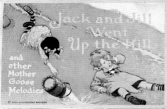

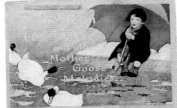
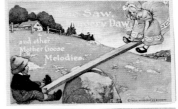

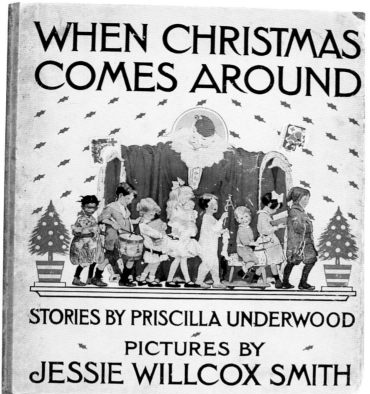

Book cover

Facing p. 24

A41. WHEN CHRISTMAS COMES AROUND
Underwood, Priscilla.
New York, 1915.
Duffield & Company.

Title: WHEN CHRISTMAS / COMES AROUND (orange) / Sketches of Children / by / Priscilla Underwood / Pictures in Color By Jessie Willcox Smith / (publisher's device) / New York / Duffield & Company (orange) / 1915.

Size of Book: 29.3 x 26.2 cm.

Size of Leaf: 28.8 x 26 cm.

Pagination: [vi], 26 pp.

Collation: Half-title [i]; verse [ii]; frontispiece in color facing title; title (rubricated) [iii]; copyright (1915, Duffield & Company) [iv]; contents [v]; illustrations [vi]; divisional title [1]; verse (by William Canton) [2]; text 3-26.

Description: Issued in quarter light brown cloth, color pictorial paper covered boards front and back cover. Front cover printed in black: WHEN CHRISTMAS / COMES AROUND / (color illustration of Santa and children) / Stories by Priscilla Underwood / Pictures By / Jessie Willcox Smith. Back cover same as front. Endpapers with orange drawings of children, instruments, toys, etc.

Paper: Thick coated wove, endpapers lighter bond.

Illustrations: Six full-page color plates, color pictorial covers, endpapers, orange drawings as borders throughout, all by Smith.

Frontispiece "Marie Louise stepped proudly across the pavement."

Facing p. 10 "John would perch on the arm of the chair and Mary would press her face close to her mother's head."

Facing p. 12 "On Easter morning, dressed in a fresh white suit, he came to claim his flower."

Facing p. 18 "Frederick squatted on the ground like a little Indian, heaping up the apples that Caroline shook down."

Facing p. 20 "Elizabeth sat on a little wicker footstool at her feet."

Facing p. 24 "They had made up their minds that they just would keep awake till Santa Claus came down that chimney."

Issue Points: Issued by Chatto and Windus, London, in 1915, with same format.

Publication Notes: Copyright registered, Aug. 14, 1915, Duffield and Company. Copies received Aug. 21, 1915. Listed in *Publisher's Weekly,* Oct. 9, 1915 (p. 1153).

Price at Issuance: $1.35.

Note on Illustrations: First appearance of these illustrations.

A42. A CHILD'S STAMP BOOK OF OLD VERSES

Smith, Jessie Willcox.
New York, 1915.
Duffield & Company.

Title: A CHILD'S STAMP BOOK / OF OLD VERSES / Picture Stamps / By / Jessie Willcox Smith / New York / Duffield & Company / 1915.

Size of Book: 18.2 x 14.4 cm.

Size of Leaf: 17.9 x 14 cm.

Pagination: 30, [2] pp.

Collation: Half-title (A CHILD'S / STAMP BOOK / OF OLD VERSES) (black-and-white drawing) [1]; (publisher's device) [2]; title [3]; copyright (1910, 1915, Duffield & Company) [4]; directions [5]; text 6-30, [1]; publisher's colophon (enlarged) [2].

Description: Issued in one-quarter cloth (beige) with color pictorial paper covered boards and color insert (stamp) front cover. Picture of two children with candles in red and black on front cover; printed in black: A CHILD'S STAMP BOOK / OF OLD VERSES / (stamp) / Pictures by / Jessie Willcox Smith. Leaflet of 12 color stamps pasted inside front cover.

Paper: Thick coated wove.

Illustrations: Twelve color stamps measuring 5.8 x 4.3 cm with perforated edges, by Smith, and repeating head piece each page of girl reading books. Color insert on cover (same as p. 17).

Cover insert	Little things. Page numbers indicate where stamps are to be pasted.
Page 7	How doth the little busy bee.
Page 9	Answer to a child's question. (A child's question).
Page 11	I like little Pussy. (I love little Pussy).
Page 13	A child's grace.
Page 15	Going into breeches.
Page 17	Little things. (Little drops of water).
Page 19	Let dogs delight to bark and bite. (Let dogs delight).
Page 21	Sweet and low.
Page 23	Seven times one.
Page 25	A thought. (Girl holding book*).
Page 27	The Star. (Twinkle, twinkle, little star).
Page 29	Cradle Hymn. (Girl playing piano).

* Same as cover insert, 1910 Duffield edition.

Titles of illustrations as they appear in A CHILD'S BOOK OF OLD VERSES, 1910, are shown in parentheses.

Publication Notes: Copyright registered, Sep. 16, 1915, Duffield and Company. Copies received, Sep. 22, 1915. Listed in *Publisher's Weekly,* Oct. 9, 1915 (p. 1152).

Price at Issuance: $0.50.

Note on Illustrations: Eleven of the twelve illustrations originally appeared in A CHILD'S BOOK OF OLD VERSES (1910). Cradle Hymn (p. 29) was added for this work (young girl playing piano) and first appeared in THE BED-TIME BOOK, 1907, as "Scales."

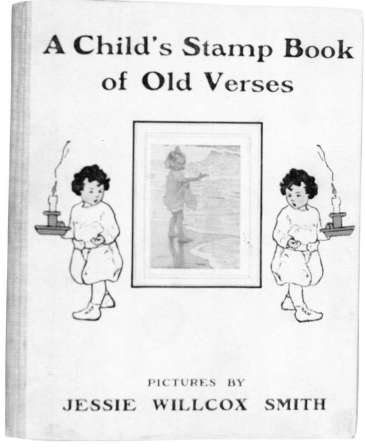

Book cover

Page 25 *Page 15*

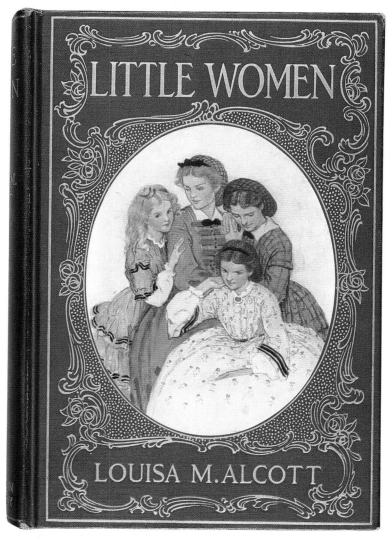

Book cover

Frontispiece

Facing p. 232

A43. *LITTLE WOMEN*
Alcott, Louisa May.
Boston, 1915.
Little, Brown and Company.

Title: LITTLE WOMEN / or / Meg, Jo, Beth and Amy / by / Louisa M. Alcott / With Illustrations in Color by / Jessie Willcox Smith / (publisher's device) / Boston / Little, Brown and Company / 1915.

Size of Book: 20.8 x 14.3 cm.

Size of Leaf: 20.2 x 13.6 cm.

Pagination: [x], 617, [1] p.

Collation: Half-title [i]; frontispiece in color facing title with tissue guard; title [iii]; copyright (1868, 1869, Louisa M. Alcott) (1896, 1910, John S. P. Alcott) (1915, Little, Brown and Company) (All rights reserved) imprint (S. J. Parkhill & Company, Boston, U. S. A.) [iv]; preface [v]; contents [vii]-viii; list of illustrations [ix]; text 1-617.

Description: Issued in full cloth (green) with color pictorial (oval) insert front cover. Front cover with elaborate gold stamped design and single ruled border. Cover stamped in gold: LITTLE WOMEN / (color insert) / Louisa M. Alcott. Spine stamped in gold: LITTLE / WOMEN / (ornament - flowers) / Louisa M. / Alcott / Little, Brown / and Company. Endpapers illustrated with repeating green silhouette design by TBH (Theodore B. Hapgood). Issued in color pictorial box with cover insert same as that of cover of book.

Paper: Wove. All edges gilt.

Illustrations: Eight full-page color plates, color insert front cover.

Cover insert	Meg, Jo, Beth and Amy (also facing p. 124).
Frontispiece	They all drew to the fire.
Facing p. 76	The great drawing-room was haunted by a tuneful spirit that came and went unseen.
Facing p. 124	Meg, Jo, Beth and Amy.
Facing p. 232	Holding onto the banisters, she put him gently away.
Facing p. 404	Jo and Beth.
Facing p. 465	He put his arms around her, as she stood on the step above him.
Facing p. 514	In a minute a hand came down over the page, so that she could not draw.
Facing p. 597	Passers-by probably thought them a pair of lunatics.

Issue Points: Reissued in 1917 in same format and with 1917 on title-page. Reissued by Little, Brown and Company in 1922 in black cloth and in larger format. Beacon Hill Bookshelf edition issued by Little, Brown and Company in 1930, and in Orchard House edition in 1945.

Publication Notes: Copyright registered, Sep. 30, 1915, Little, Brown and Company. Copies received, Sep. 18, 1915. Listed in *Publisher's Weekly*, Sep. 25, 1915 (p. 923).

Price at Issuance: $2.50.

Note on Illustrations: First appearance of these illustrations. The frontispiece appeared in *Delineator*, June 1915, and the cover insert in *The Independent*, Dec. 6, 1915, and *Good Housekeeping*, February 1923.

A44. *THE EVERYDAY FAIRY BOOK*

Chapin, Anna Alice.
New York, 1915.
Dodd, Mead and Company.

Title: THE EVERYDAY / FAIRY BOOK / By / Anna Alice Chapin / Author of "Humpty Dumpty," "The Now-a-Days Fairy Book," etc. / With illustrations in Color / By Jessie Willcox Smith / (black-and-white drawing of three children) / New York / Dodd, Mead & Company / 1915.

Size of Book: 29.7 x 22.5 cm.
Size of Leaf: 29 x 21.5 cm.
Pagination: [xii], 159, [1] p.
Collation: Half-title [i]; frontispiece in color with caption facing title; title with drawings [iii]; copyright (1915, Dodd, Mead and Company) (P. F. Collier & Son, 1905, 1906, 1909) (Dodd, Mead and Company, 1915) [iv]; contents [v]; illustrations [vii]; verse [ix]; divisional title [xi]; verse - Pretending [xii]; text 1-159, [1] p.
Description: Issued in full cloth (green) with color pictorial insert (full size) front cover. Printed in white: THE / EVERYDAY / FAIRY BOOK / by / Anna Alice Chapin / Pictured by / Jessie Willcox Smith. Spine stamped in beige: THE / EVERYDAY / FAIRY BOOK / by / Anna / Alice / Chapin / Dodd, Mead / & Company.
Paper: Wove.
Illustrations: Seven full-page color plates, color insert front cover, black-and-white vignette on title page.

Cover insert	[She knew she could eat one whenever she wanted to, so she was in no hurry.]
Frontispiece	Ever since he had been a little, little boy, he had thought what fun it would be if Jack should pop up and cry: "Hello, Frank!"
Facing p. 42	She came down from the platform, still bravely choking back her tears.
Facing p. 56	She knew she could eat one whenever she wanted to, so she was in no hurry.
Facing p.68	She was sitting in a hammock, trying to amuse herself with an old Atlas and not succeeding at all well.
Facing p. 92	Billy-Boy's discovery was a sea-gull, with an injured wing.
Facing p. 124	A Broken Head—and Heart.
Facing p. 144	He had crept downstairs to take a peep into the parlour.

Issue Points: Never reissued by Dodd, Mead & Co. Published by Harrap & Co., London, in 1917 and J. Coker, London, in 1935.
Publication Notes: Copyright registered, Oct. 2, 1915, Dodd, Mead and Company. Copies received, Oct. 6, 1915. Listed in *Publisher's Weekly*, Oct. 30, 1915 (p. 1371).
Price at Issuance: $2.00.
Note on Illustrations: The following illustrations first appeared in *Collier's Weekly*: "Ever since he had been a little, little boy, etc." (frontispiece), Nov. 24, 1906; "She was sitting in a hammock, etc." (facing p. 68), Jun. 24, 1905; "Billy-Boy's discovery, etc." (facing p. 124), Mar. 31, 1906 "He had crept downstairs, etc." (facing p. 144), Dec. 11, 1909.

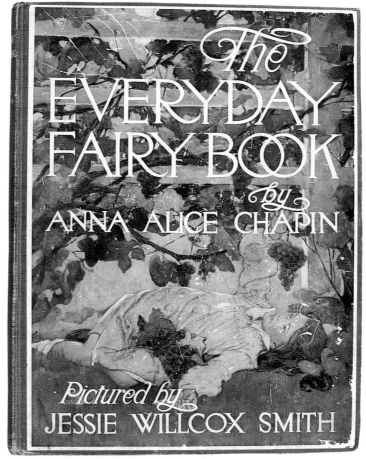

Book cover

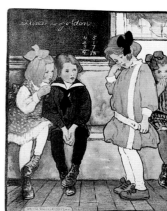

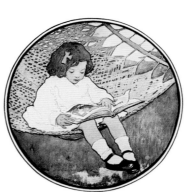

Facing p. 68 *Facing p. 42*

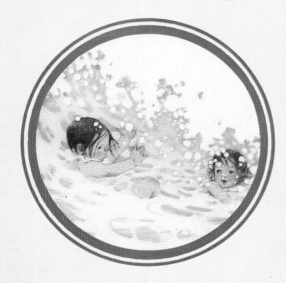

Box lid

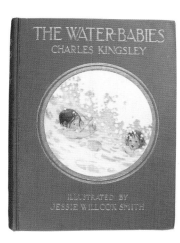

Book cover

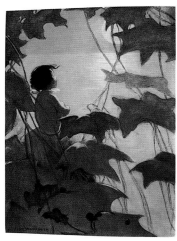

Frontispiece

A45. THE WATER-BABIES

Boxed Edition

Kingsley, Charles.
New York, 1916.
Dodd, Mead and Company.

Title: THE / WATER-BABIES / by / Charles Kingsley / (drawing) / Illustrated by / Jessie Willcox Smith / New York / Dodd, Mead & Company / Publishers.

Size of Book: 26 x 19.8 cm.

Size of Leaf: 25.4 x 19.1 cm.

Pagination: 362 pp.

Collation: Half-title (with drawing and decorative border in green) [1]; frontispiece in color facing title with caption; title (with drawings and decorative border in green) [3]; copyright (1916, Dodd, Mead & Company), imprint (Printed and bound by J. J. Little & Ives Co., New York) [4]; dedication (with drawing) [5]; introduction 7-9; illustrations [11]; chapter 1 (with drawing and decorative border in green) [13]; text 15-362.

Description: Issued in full linen cloth (green) with circular color insert surrounded by two solid gold stamped circular borders. Front cover stamped in gold: THE WATER-BABIES / Charles Kingsley / (color insert) / Illustrated by / Jessie Willcox Smith. Spine stamped in gold: THE / WATER- / BABIES / Charles / Kingsley / Dodd, Mead / & Company. Light green endpapers with illustrations in green, white, and black by Smith. Issued in box with same pictorial color insert as cover of book.

Box Description: Box pale yellow with printing on cover in green: THE WATER-BABIES / Charles Kingsley / (insert with double solid green circular borders) / Illustrated by / Jessie Willcox Smith / $3.00 Net / Publishers Dodd, Mead & Company New York.

Box Dimensions: 27 x 21 x 4.3 cm.

Paper: Thick coated wove.

Illustrations: Twelve full-page color plates with captions at bottom, circular color insert front cover and cover of box. Green and black line drawings by Smith throughout. Endpapers illustrated by Smith.

Cover insert	[Two children playing in surf]
Frontispiece	He looked up at the broad yellow moon . . . and thought that she looked at him (page 148).
Facing p. 36	"No. She cannot be dirty. She never could have been dirty."
Facing p. 86	He felt how comfortable it was to have nothing on him but himself.
Facing p. 140	"Oh, don't hurt me!" cried Tom. "I only want to look at you; you are so handsome."
Facing p. 158	And Tom sat upon the buoy long days.
Facing p. 174	He felt the net very heavy; and lifted it out quickly, with Tom all entangled in the meshes.
Facing p. 186	Tom reached and clawed down the hole after him.
Facing p. 194	They hugged and kissed each other for ever so long, they did not know why.
Facing p. 236	Mrs. Bedonebyasyoudid.
Facing p. 272	And there he saw the last of the Gairfowl standing up on the Allalonestone, all alone.
Facing p. 290	It took the form of the grandest old lady he had ever seen.
Facing p. 344	Mrs. Doasyouwouldbedoneby.

Issue Points: First issue with J. J. Little and Ives imprint on copyright page and with illustrated endpapers. Also issued with mounted color plates (Tipped-in Edition) in 1916. Tipped-in Edition was also issued in box. Eight of these illustrations appear in Smaller Edition (1916).

Publication Notes: Copyright registered, Oct. 28, 1916, Dodd, Mead and Company (boxed). Copies received, Oct.

31, 1916. Listed in *Publisher's Weekly*, Oct. 28, 1916 (boxed) (p. 1459).

Price at Issuance: $3.00 in box.

Note on Illustrations: First and only appearance of these illustrations.

A45.1 THE WATER-BABIES
Tipped-in Edition
Kingsley, Charles.
New York, 1916.
Dodd, Mead and Company.

Title: Identical to *A45*, but drawings colored in light grey, rather than green.

Size of Book: 26 x 19.5 cm.

Size of Leaf: 25.8 x 19 cm.

Description: Issued in full fine rib cloth (light green) with circular color insert on cover either "They hugged and kissed, etc.," (facing p. 194), or "It took the form of, etc.," (facing p. 290). Gold stamped lettering on cover and spine same as *A45*. Endpapers plain. Issued in color pictorial box.

Paper: Thick coated wove.

Illustrations: Twelve full-page color plates mounted onto thick gray stock paper. Captions printed on stock. Plates measure 19.3 x 14.3 cm. Line drawings throughout colored gray-green.

Issue Points: This issue slightly smaller than *A45*, without J. J. Little and Ives imprint and with fine rib cloth as opposed to linen cloth for *A45*. Line drawings in this issue are colored gray-green. A later Tipped-in edition was issued with the following changes: a) Only 11 mounted plates, with "He looked up at the broad yellow moon, etc." deleted; b) "They hugged and kissed each other, etc." appearing as the frontispiece; c) size of book and leaf slightly smaller than *A45.1;* and d) list of illustrations without line drawing at top, but with repeating floral line design at top. This edition of 11 color plates issued subsequently to *A45* and *A45.1*.

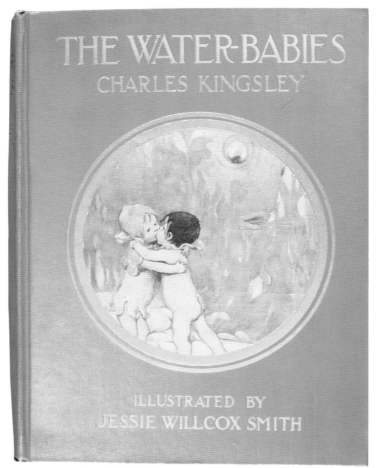

Book cover

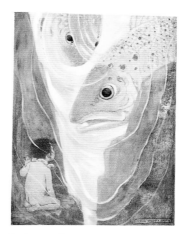

Facing p. 140

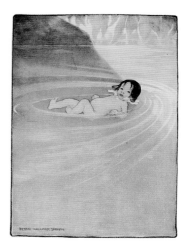

Facing p. 86

Jessie Willcox Smith, c. 1915. photographed by Haeseler. *Reproduced with permission of the Archives of American Art, Smithsonian Institution.*

A46. THE WATER-BABIES
Smaller Edition
Kingsley, Charles.
New York, 1916.
Dodd, Mead and Company.

Title: THE / WATER-BABIES / by / Charles Kingsley / (drawing) / Illustrated by / Jessie Willcox Smith / New York / Dodd, Mead & Company / Publishers.

Size of Book: 19.2 x 13 cm.

Size of Leaf: 18.6 x 12.6 cm.

Pagination: [xvi], 270 pp.

Collation: Half-title (with drawing) [i]; frontispiece in color with caption facing title; title with drawing and decorative border [iii]; copyright (1916, Dodd, Mead and Company, Inc.) [iv]; dedication with drawing [v]; introduction vii-ix; contents [xi]; illustrations [xiii]; divisional title with drawing [xv]; text 1-270.

Description: Issued in full cloth (olive green) with color pictorial insert on front cover. Front cover stamped in gold: THE WATER-BABIES / Charles Kingsley / (insert) / Illustrated by / Jessie Willcox Smith. Spine stamped in gold: THE / WATER- / BABIES / Charles / Kingsley / Dodd, Mead / & Company. Illustrated endpapers with child riding on top of fish in green repeated four times.

Paper: Wove.

Illustrations: Eight full-page color plates, color insert front cover. Black-and-white line drawings throughout, green illustrated endpapers, all by Smith.

Cover insert	And Tom sat upon the buoy long days.
Frontispiece	He looked at the broad yellow moon . . . and thought that she looked at him.
Facing p. 68	He felt how comfortable it was to have nothing on but himself.
Facing p. 98	"Oh, don't hurt me!" cried Tom. "I only want to look at you; you are so handsome."
Facing p. 110	And Tom sat upon the buoy long days.
Facing p. 124	He felt the net very heavy; and lifted it out quickly, with Tom all entangled in the meshes.
Facing p. 132	Tom reached and clawed down the hole after him.
Facing p. 172	Mrs. Bedonebyasyoudid.
Facing p. 258	Mrs. Doasyouwouldbedoneby.

Issue Points: First issue with green illustrated endpapers, second issue plain endpapers. First issue thicker, measuring 40 mm. across from cover to cover; later issues only 33 mm. across top. Later issues with "Printed in U. S. A." at bottom of copyright page. Also, first issue with Jessie Willcox Smith on front cover 0.8 cm. from bottom; later issues 1.6 cm. from bottom.

Publication Notes: This issue not entered in copyright office or cited in *Publisher's Weekly*.

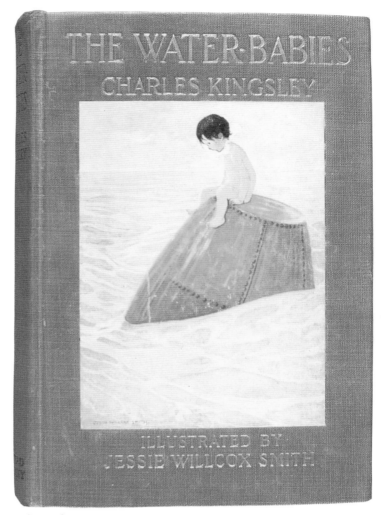

Book cover, later issue

Facing p. 132

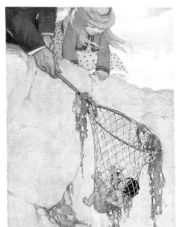

Facing p. 124

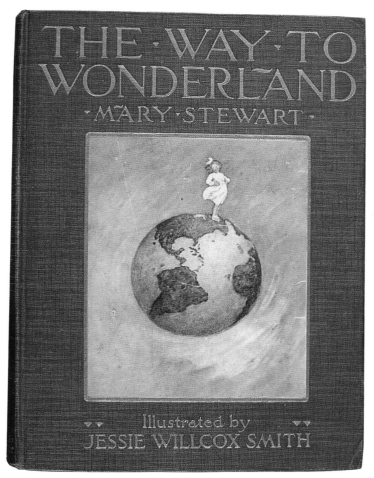

Book cover

Facing p. 62

Facing p. 190

A47. *THE WAY TO WONDERLAND*
Stewart, Mary.
New York, 1917.
Dodd, Mead and Company.

Title: THE WAY TO / WONDERLAND / Mary Stewart / Author of / Tell Me a True Story, etc; / With Illustrations by / Jessie Willcox Smith / Decorations by / Helen M. Barton / Dodd, Mead & Company / New York.

Size of Book: 23.6 x 17.5 cm.

Size of Leaf: 23 x 17 cm.

Pagination: [xii], 194 pp.

Collation: Half-title (with drawing by Barton) [i]; frontispiece in color with caption facing title; title with drawing and decorations by Barton [iii]; copyright (1917, Dodd, Mead and Company, Inc.) [iv]; dedication (with drawing by Barton) [v]; To Wonderland (decorative border and drawing by Barton) [vii]; contents [ix]; illustrations [xi]; divisional title (with drawing by Barton) [1]; text 3-194.

Description: Issued in full cloth (brown) with color pictorial insert on front cover. Front cover stamped in gold: THE WAY TO / WONDERLAND / Mary Stewart / (color insert with gold border) / Illustrated by / Jessie Willcox Smith. Spine stamped in gold: THE / WAY TO / WONDER- / LAND / Stewart / Dodd, Mead / & Company. Light blue endpapers with illustration of fairies in blue, yellow, and white by Barton.

Paper: Wove.

Illustrations: Six full-page color plates by Smith. Black-and-white drawings throughout by Barton. Endpapers illustrated by Barton. Cover insert by Smith.

Cover insert	Among the Stars.
Frontispiece	The Fairies' Picnic.
Facing p. 30	The Wind's Song.
Facing p. 62	The Door to Wonderland.
Facing p. 130	Moonlight in the Garret.
Facing p. 158	Among the Stars.
Facing p. 190	Merry Christmas.

Issue Points: First issue with brown cloth and color pictorial endpapers. The second issue is bound in light blue cloth, has plain endpapers and "Printed in the U. S. A." on copyright page. Issued at same time by Hodder & Stoughton in England.

Publication Notes: Copyright registered, Nov. 10, 1917, Dodd, Mead and Company. Copies received, Nov. 15, 1917. Listed in *Publisher's Weekly,* Nov. 10, 1917 (p. 1589).

Price at Issuance: $2.00.

Note on Illustrations: All illustrations first appeared in color in *McClure's Magazine,* Dec. 1909, pp.177-182, entitled, "A Child's World."

A48. THE LITTLE MOTHER GOOSE
Smith, Jessie Willcox.
New York, 1918.
Dodd, Mead and Company.

Title: THE / LITTLE MOTHER GOOSE / With numerous illustrations in full / color and black and white / By / Jessie Willcox Smith / (rule) / New York / Dodd, Mead & Company.

Size of Book: 15.1 x 20.2 cm. (oblong)

Size of Leaf: 14.5 x 20 cm.

Pagination: xv, [1], 176 pp.

Collation: Half-title with drawing [i]; captioned frontispiece in color facing title; title with illustrated border [iii]; copyright (1912, 1913, 1914, *The Good Housekeeping Magazine*) (1914, Dodd, Mead & Company, Inc.) (1918, Dodd, Mead & Company) [iv]; A List of Rhymes, v-xiv; A List of the Pictures, xv; text 1-176.

Description: Issued in full cloth (black) with color pictorial insert front cover of two children and goose. Heavy gilt on cover insert; printed in black: THE LITTLE MOTHER / GOOSE / Jessie Willcox Smith. Spine stamped in gold: THE / LITTLE / MOTHER / GOOSE / (ornament - five squares) / Jessie / Willcox / Smith / Dodd / Mead / & / Company.

Paper: Wove.

Illustrations: Twelve full-page color plates, black-and-white drawings throughout by Smith. Color pictorial insert on front cover.

Frontispiece	Hush-a-by baby, on the tree top.
Facing p. 10	See saw, Margery Daw.
Facing p. 20	Little Bo-Peep has lost her sheep.
Facing p. 38	One foot up, the other down.
Facing p. 58	Little Miss Muffet sat on a tuffet.
Facing p. 74	Ring-a-round a rosie.
Facing p. 88	Curly locks! curly locks! wilt thou be mine?
Facing p. 100	Peter, Peter pumpkin eater.
Facing p. 120	Rain, rain, go away.
Facing p. 136	Mary, Mary, quite contrary.
Facing p. 150	Jack fell down and broke his crown.
Facing p. 162	There was an old woman who lived in a shoe.

Issue Points: THE LITTLE MOTHER GOOSE was issued in many different bindings in various sizes. The first issue is distinguished from later issues by containing all of the following features: a) black cloth with cover insert of two children and goose, with heavy gilt background; b) size of book (15.1 x 20.2 x 3.3 cm. across top); and c) lacking "Printed in U. S. A." on copyright page. Also issued in brown cloth with red calf spine. This edition is slightly smaller (13.5 x 17.5 cm.) and has gold and green floral patterned endpapers. Later issued by The Musson Book Co., Toronto, 1921, in black cloth, and with cover insert background stark white and only 2 cm. across top of covers.

Publication Notes: Copyright registered, Sep. 28, 1918, Dodd, Mead and Company. Copies received, Oct. 1, 1918. Listed in *Publisher's Weekly,* Sep. 28, 1918 (p. 990).

Price at Issuance: $1.00.

Note on Illustrations: All illustrations appeared in THE JESSIE WILLCOX SMITH MOTHER GOOSE (1914).

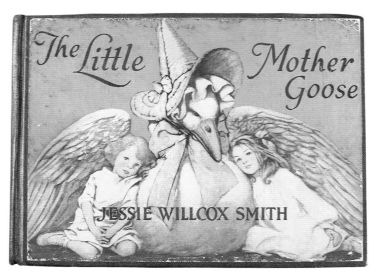

Book cover

Facing p. 162

Facing p. 120

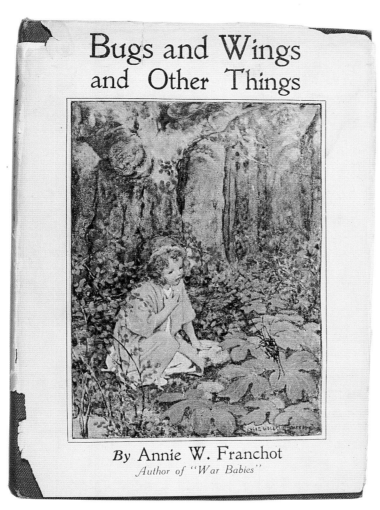

By Annie W. Franchot
Author of "War Babies"

Cover jacket

Book cover

A49. *BUGS AND WINGS AND OTHER THINGS*
Franchot, Annie W.
New York (1918).
E. P. Dutton & Company.

Title: BUGS AND WINGS / AND OTHER THINGS / By / Annie W. Franchot / Illustrated By / Jessie Willcox Smith / and / Harrison Cady / (drawing of frog) / New York / E. P. Dutton & Company / 681 Fifth Avenue.

Size of Book: 21.6 x 15.5 cm.

Size of Leaf: 21 x 15 cm.

Pagination: ix, [1], 99, [1] p.

Collation: Half-title (BUGS AND WINGS / AND OTHER THINGS) (drawing) [i]; frontispiece in color facing title with tissue guard; title (with drawing) [iii]; copyright (enclosed in box) with drawing (1918, E. P. Dutton) [iv]; dedication [v]; contents with drawing, vii; list of color plates (drawing) ix; divisional title, 1; text, 3-99.

Description: Issued in full linen cloth (green). Front cover stamped in gold: BUGS AND WINGS / AND OTHER THINGS / (rule) / Annie W. Franchot (between ornaments). Spine stamped in gold: BUGS / AND / WINGS / AND / OTHER / THINGS / (rule) / Franchot / E. P. Dutton / & Co. Endpapers illustrated in black and white by Harrison Cady. Issued in color pictorial cover jacket.

Cover Jacket Description: Jacket printed on white coated paper with color illustration on cover same as frontispiece. Front cover printed in black: BUGS AND WINGS / AND OTHER THINGS / (color illustration in black ruled box) / By Annie W. Franchot / Author of "War Babies". Spine printed in black: BUGS / AND / WINGS / AND OTHER / THINGS / (rule) / Annie W. / Franchot / Illustrated by / Jessie Wilcox (sic) / Smith / and / Harrison Cady / E. P. Dutton / & Co. Rear cover with 7 titles. Front flap with advertisement for "Bugs and Wings." Rear flap with advertisement for "Fairy Tales of Weir."

Cover Jacket Dimensions: 21.4 x 56 cm.

Paper: Wove.

Illustrations: Color frontispiece, "Myee in the Wood," reproduced on cover jacket, by Jessie Willcox Smith. Six full-page color plates by Harrison Cady, black-and-white drawings throughout by Cady.

Publication Notes: Copyright registered, Nov. 30, 1918, E. P. Dutton. Copies received. Dec. 14, 1918. Listed in *Publisher's Weekly,* Dec. 12, 1918 (p. 1940).

Price at Issuance: $1.50.

Note on Illustrations: First and only appearance of this illustration.

A50. *LITTLE FOLKS ILLUSTRATED ANNUAL*

Pratt, Charles Stuart and Pratt, Ella Farman (edited by).
Boston, 1918.
Small, Maynard and Company.

Title: LITTLE FOLKS / ANNUAL / For the Youngest Readers, Little Listeners and / Lookers at Pictures / Edited by Charles Stuart Pratt and Ella Farman Pratt / (publisher's device) / Boston / Small, Maynard & Company / Publishers.
Size of Book: 23.3 x 16.8 cm.
Size of Leaf: 22.7 x 16.4 cm.
Pagination: [555] pp.
Collation: Frontispiece in color facing title; title [1]; copyright (1918, S. E. Cassine Co., Salem, Mass.) [5]; text [5]-[555].
Description: Issued in beige paper covered boards with color pictorial insert on cover. Front cover with brown border and illustration. Offset from brown background (in beige): LITTLE FOLKS / ILLUSTRATED / ANNUAL / (in brown) Small, Maynard / and Company. Spine printed in brown: LITTLE / FOLKS / ILLUSTRATED / ANNUAL / Small (ornament) / Maynard / & Company.
Cover Jacket Description: Front cover identical to cover of book, but printed in blue. Same pictorial color insert. Spine same but with $1.25 in middle of two rules and without ornament at bottom. Front flap with advertisement for LITTLE FOLKS ANNUAL, rear flap with advertisement for FOUR PLAYS FOR CHILDREN. Back cover "Best Books for Young People" with nine titles.
Cover Jacket Dimensions: 23.3 x 62 cm.
Paper: Printed on pulp; frontispiece and title on coated wove. Endpapers coated wove.
Illustrations: Full-page color frontispiece, color insert on book, same color insert on cover jacket, all by Smith. Black-and-white illustrations throughout by various artists (none by Smith).
Cover insert &
Wrapper insert [Boy and girl at front door]
Frontispiece [Girl sitting on fence post]
Issue Points: Never reissued.
Publication Notes: Not entered in copyright office or listed in *Publisher's Weekly.*
Price at Issuance: $1.25.
Note on Illustrations: Cover and wrapper illustration first appeared in color in *McClure's Magazine,* April 1905. Frontispiece first appeared in *McClure's Magazine,* February 1905. Also appeared in THE CHRONICLES OF RHODA published by Small, Maynard and Co., 1909. Frontispiece appeared on p. 78, and the cover and wrapper insert appeared as frontispiece in THE CHRONICLES OF RHODA.

Book cover

Frontispiece

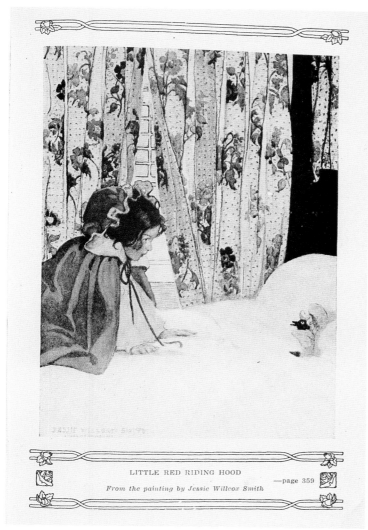

LITTLE RED RIDING HOOD —page 359
From the painting by Jessie Willcox Smith

Facing p. 354

Book cover

A51. FAIRY AND WONDER TALES
Patten, William (selected and arranged by).
New York (1918).
P. F. Collier & Son.

Title: THE / JUNIOR CLASSICS / Selected and Arranged by / William Patten / (eight lines) / Volume One / (in red) FAIRY AND WONDER / TALES / (ornament) / P. F. Collier & Son Corporation / New York.

Size of Book: 20 x 13 cm.

Size of Leaf: 19.4 x 12.5 cm.

Pagination: [ii], 514 pp.

Collation: Half-title (with publisher) [i]; frontispiece in color with tissue guard facing title; title (rubricated) [1]; copyright (1912, P. F. Collier & Son) (1918, P. F. Collier & Son) [2]; introduction, 3-7; note [8]; contents 9-12; illustrations 13-14; preface 15-18; text 19-514.

Description: Issued in full cloth (red) with blind-stamped designs on cover. Spine with black background and gold stamped: JUNIOR / CLASSICS / The / Youngfolks / Shelf / Of Books / FAIRY / AND / WONDER / TALES / 1 / Collier. Pictorial endpapers, green.

Paper: Wove.

Illustrations: Color frontispiece and seven black-and-white plates by various artists. One black-and-white illustration by Smith.

Facing p. 354 Little Red Riding Hood.

Note on Illustration: See NOW-A-DAYS FAIRY BOOK, A34.

A52. POEMS OLD AND NEW
Patten, William (selected and arranged by).
New York (1918).
P. F. Collier & Son.

Title: THE / JUNIOR CLASSICS / Selected and Arranged by / William Patten / (eight lines) / Volume Ten / (in red) POEMS OLD AND NEW / (ornament) / P. F. Collier & Son Corporation / New York.

Size of Book: 20 x 13 cm.

Size of Leaf: 19.4 x 12.5 cm.

Pagination: [ii], 529, [1] p.

Collation: Half-title (with publisher) [i]; frontispiece in color with tissue guard facing title; title (rubricated) [1]; copyright (1912, 1918, P. F. Collier & Son) (36 lines of credits) [2]; acknowledgments, 3-6; contents 7-17; illustrations 19-20; text 21-529.

Description: Issued in full cloth (red) with blind-stamped designs on cover. Spine with black background and gold stamped: JUNIOR / CLASSICS / The / Youngfolks / Shelf / Of Books / POEMS / OLD / AND / NEW / 10 / Collier. Pictorial endpapers, green.

Paper: Wove.

Illustrations: Color frontispiece and seven black-and-white plates by various artists. One black-and-white plate by Smith.

Facing p. 114 The Night Before Christmas.

Note on Illustration: See NOW-A-DAYS FAIRY BOOK, *A34.*

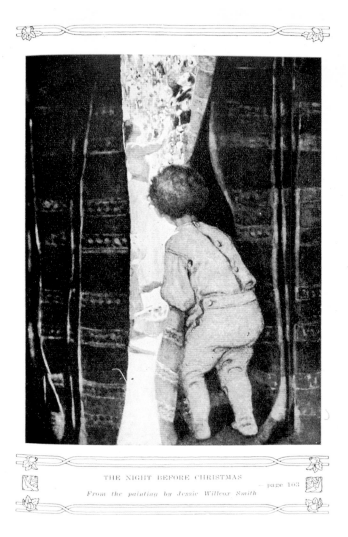

THE NIGHT BEFORE CHRISTMAS
From the painting by Jessie Willcox Smith
— page 103

Facing p. 114

Book cover

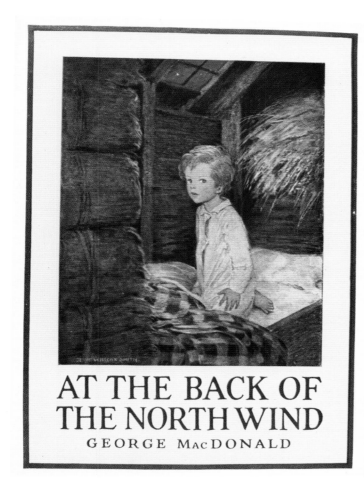

Cover jacket

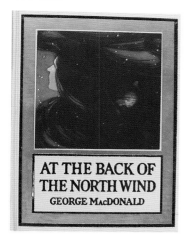

Book cover

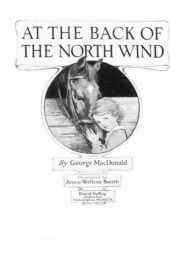

Title page

A53. *AT THE BACK OF THE NORTH WIND*
MacDonald, George.
Philadelphia, 1919.
David McKay Company.

Title: (Color illustration of boy with horse) AT THE BACK OF / THE NORTH WIND / By George MacDonald / Illustrated by / Jessie Willcox Smith / David McKay / Publisher / Philadelphia, MCMXIX / Copyright, 1919, by David McKay (printed in small letters).

Size of Book: 24.5 x 18.3 cm.

Size of Leaf: 23.5 x 17.7 cm.

Pagination: [ii], 342 pp.

Collation: Half-title (AT THE BACK OF THE / NORTH WIND) [i]; imprint (engraved and printed by The Beck Engraving Company, Philadelphia) [ii]; color illustrated title and copyright (1919, David McKay) [1]; illustrations [3]; contents [5]-[7]; text 9-342.

Description: Issued in full cloth (beige) with pictorial insert front cover. Front cover with 1.3 cm. gilt blocked border surrounded by blue ruled border. Printed in blue: AT THE BACK OF / THE NORTH WIND / George MacDonald. Spine stamped in gold: AT THE / BACK / OF THE / NORTH / WIND / (circular design) / George / MacDonald / Illustrated by / Jessie / Willcox / Smith / David McKay. Blue pictorial endpapers of North Wind and boat. Issued in color pictorial cover jacket.

Cover Jacket Description: Printed on white glossy paper. Cover with color illustration of Diamond in bed (p.14). Cover printing same as book cover, with printing in black, and light brown in place of gilt. Spine identical to that of book, printed in black. Rear cover and flaps blank.

Cover Jacket Dimensions: 24.5 x 57 cm.

Paper: Thick wove. Top edges gilt.

Illustrations: Eight full-page color plates, color illustration on title-page, color insert on book cover, color cover jacket, blue pictorial endpapers, all by Smith.

Cover insert	[North Wind and Diamond]
Facing p. 14	Against this he laid his ear, and then he heard the voice quite distinctly.
Facing p. 46	"Now you lead me," he said, taking her hand, "and I'll take care of you."
Facing p. 72	She took his hand and giving him the broad part of the spiral stair to walk on, led him down a good way.
Facing p. 100	"Are you ill, dear North Wind?"
Facing p. 120	"Dear Boy!" said his mother, "your father's the best man in the world."
Facing p. 140	So Diamond sat down again and took the baby in his lap.
Facing p. 198	The collar was almost the worst part of the business.
Facing p. 324	On the top of the great beech-tree.

Issue Points: First issue is distinguished from the second issue by having all the following features: a) beige cloth with gilt blocked border on cover; b) gilt lettering on cover and spine; c) pictorial endpapers; d) top edges gilt; e) without *"Printed in the United States of America"* on copyright page; and f) size of book (24.5 x 18.3 cm). The cover jacket appears in two states: background within black ruled border on cover either beige or brown, with no known priority.

Publication Notes: Copyright registered, Oct. 23, 1919, David McKay Company. Copies received, Oct. 15, 1919. Listed in *Publisher's Weekly,* Dec. 20, 1919 (p. 1624).

Price at Issuance: $2.50.

Note on Illustrations: Two of the illustrations appeared in *The Woman's Home Companion:* "Dear boy, etc.", September 1920; and "The collar, etc.", October 1920.

A53.1 AT THE BACK OF THE NORTH WIND
Plain Cloth Edition
Title: Identical to A53.
Size of Book: 24 x 18.3 cm.
Size of Leaf: 23.3 x 17.5 cm.

Pagination and Collation: Identical to A53 except for *"Printed in the United States of America"* on copyright page.
Description: Issued in full textured cloth (light brown) with cover insert same as A53. Ruled border, lettering and design on spine same as A53, but stamped in black. Endpapers plain.
Illustrations: Same as A53.
Issue Points: This edition issued subsequent to A53. See A53 for list of distinguishing points.

A54. A CHILD'S BOOK OF MODERN STORIES
Skinner, Ada M. & Eleanor L.
New York, 1920.
Duffield and Company.

Title: A CHILD'S BOOK OF / MODERN STORIES / Compiled by / Ada M. Skinner / and / Eleanor L. Skinner / Compilers of The Garnet, Emerald, Topaz, Pearl, / and Turquoise Story Books / With Pictures by / Jessie Willcox Smith / (publisher's device) / New York / Duffield and Company / 1920.
Size of Book: 24 x 18.3 cm.
Size of Leaf: 23.5 x 17.8 cm.
Pagination: [xii], 341, [1] p.
Collation: Half-title [i]; frontispiece in color facing title; title [iii]; copyright (1920, Duffield and Company) (Printed in the United States of America) [iv]; contents [v]-[vi]; illustrations [vii]; introduction [ix]-[xi]; divisional title [1]; text 3-341.
Description: Issued in full cloth (blue) with color pictorial insert on front cover. Front cover stamped in gold: A CHILD'S BOOK / OF MODERN STORIES / (color insert) / with pictures by / Jessie Willcox Smith. Spine stamped in gold: A CHILD'S BOOK / OF / MODERN STORIES / Skinner / (rule) / Duffield.
Paper: Wove.
Illustrations: Eight full-page color plates, color insert on cover.

Cover insert	[Two children on hammock reading book]
Frontispiece	The Knitters.
Facing p. 50	The Little Boy Who Forgot to Wash His Hands.
Facing p. 68	Charlotte and the Little Helper.
Facing p. 94	Betty's Posy Shop.
Facing p. 110	The Fairy Gardens.
Facing p. 150	The Fable of the Wish.
Facing p. 164	The Sea Blossom.
Facing p. 234	The Goldfish.

Issue Points: Reprinted by Dial Press, New York, in 1935.
Publication Notes: Copyright registered, Sep. 1, 1920, Duffield and Company. Copies received, Sep. 10, 1920. Listed in *Publisher's Weekly*, Oct. 9, 1920 (p. 1095).
Price at Issuance: $3.50.
Note on Illustrations: All of the illustrations first appeared as covers for *Good Housekeeping Magazine*, 1918-1919.

Cover insert	[Two children on hammock reading book] July 1918.
Frontispiece	[The Knitters] February 1918.
Facing p. 50	[The Little Boy Who Forgot to Wash His Hands] July 1919.
Facing p. 68	[Charlotte and the Little Helper] May 1919.

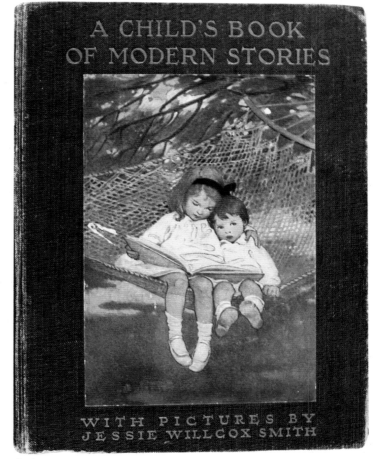

Book cover

Frontispiece *Facing p. 234*

Facing p. 94	[Betty's Posy Shop] June 1918.
Facing p. 110	[The Fairy Gardens] June 1919.
Facing p. 150	[The Fable of the Wish] February 1919.
Facing p. 164	[The Sea Blossom] August 1918.
Facing p. 234	[The Goldfish] April 1918.

Jessie Willcox Smith, ca. 1910

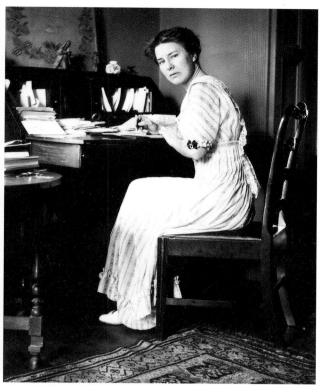

Jessie Willcox Smith, ca. 1900

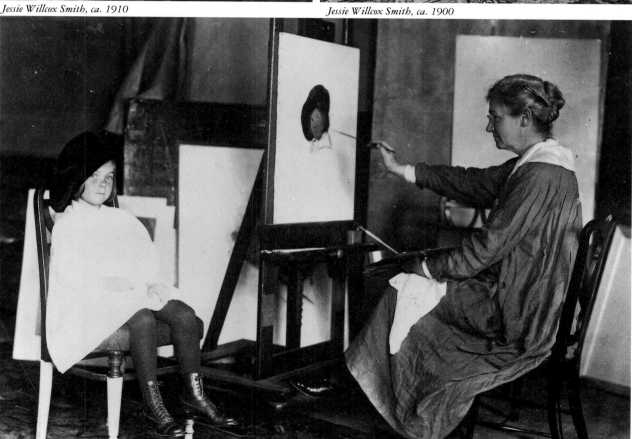

Jessie Willcox Smith, ca. 1925

Reproduced with permission of the Delaware Art Museum Archives.

A55. *THE PRINCESS AND THE GOBLIN* (Binding A)

MacDonald, George.
Philadelphia, 1920.
David McKay Company.

Title: THE PRINCESS / AND THE GOBLIN / By George MacDonald / Illustrated by / Jessie Willcox Smith / David McKay Company Publishers / Philadelphia, MCMXX / Copyright, 1920, by David McKay Company (in small letters).

Size of Book: 24.4 x 18.2 cm.

Size of Leaf: 23.3 x 17.2 cm.

Pagination: 203, [1] p.

Collation: Half-title (THE PRINCESS AND / THE GOBLIN) [1]; imprint (Engraved and Printed by The Beck Engraving Company, Philadelphia) [2]; color illustrated title and copyright (1920, David McKay Company) [3]; illustrations [5]; contents [7]; text 9-203.

Description: Issued in full cloth (beige) with color pictorial insert on front cover and 1.2 cm gilt borders. Front cover stamped in blue: THE PRINCESS / AND THE GOBLIN / By George MacDonald. Blue ruled borders. Spine stamped in gold: THE / PRINCESS / AND THE / GOBLIN / (circular design - flower) / George / MacDonald / Illustrated by / Jessie / Willcox / Smith / David McKay. Pictorial tinted endpapers by Smith. Issued in color pictorial cover jacket.

Cover Jacket Description: Color illustration front cover same as that of book (same dimensions). All printing on wrapper identical to that of book, printed in black. Flaps and back cover blank.

Cover Jacket Dimensions: 24.4 x 56 cm.

Paper: Thick wove. Top edges gilt.

Illustrations: Eight full-page color plates, color pictorial insert on cover, color title, color pictorial wrapper, tinted endpapers, all by Smith.

Cover insert	[Princess with Cape]
Facing p. 14	She ran for some distance, turned several times, and then began to be afraid.
Facing p. 22	She clapped her hands with delight, and up rose such a flapping of wings.
Facing p. 42	"Never mind, Princess Irene," he said, "You mustn't kiss me tonight. But you sha'n't break your word. I will come another time."
Facing p. 68	In an instant she was on the saddle, and clasped in his great strong arms.
Facing p. 96	"Come," and she still held out her arms.
Facing p. 118	The goblins fell back a little when he began, and made horrible grimaces all through the rhyme.
Facing p. 138	Curdie went on after her, flashing his torch about.
Facing p. 184	There sat his mother by the fire, and in her arms lay the princess fast asleep.

Issue Points: Issued in three different binding states. The first binding (A) is distinguished from the second state (B) and the third state (C) by having all of the following features: a) beige cloth with 1.2 cm gilt border surrounding cover insert and cover lettering; b) spine stamped in gold; c) *without* "Printed in the United States of America" on verso of half-title; d) size of leaf appreciably smaller (23.3 x 17.2 cm), e) 4 cm across top between front and back covers. (State C is 3.6 cm). The first state binding is also distinguished form the third state (C) by having top edges gilt. All three states appear with identical pictorial cover jacket.

Publication Notes: Copyright registered, Nov. 15, 1920, David McKay Company. Copies received, Nov. 22, 1920. Listed in *Publisher's Weekly*, Dec. 11, 1920 (p. 1809).

Price at Issuance: $3.50.

Note on Illustrations: First and only appearance of these illustrations.

84

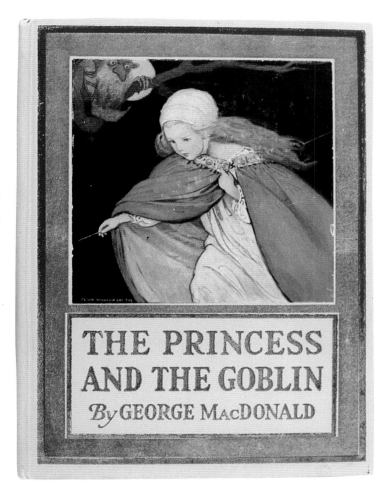

Cover, first issue binding (A)

Title page

Facing p. 14

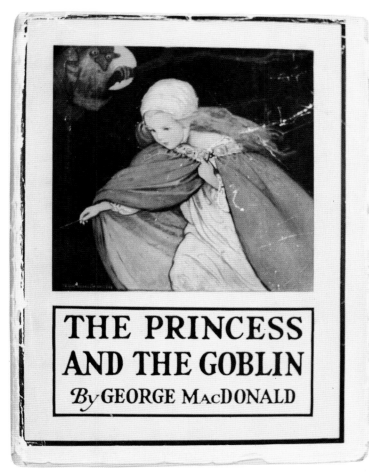

A55, cover jacket

A55.1 THE PRINCESS AND THE GOBLIN *{Binding B}*

Title: Identical to (A).
Size of Book: Identical to (A).
Size of Leaf: 23.6 x 17.5 cm.
Pagination and Collation: Identical to (A), except with "Printed in the United States of America" appearing on verso of half-title [2].
Description: Issued in full linen cloth (beige) with color pictorial insert as (A) but not impressed into cloth. Light blue ruling and lettering on cover and spine as (A). Endpapers and cover jacket same as (A).
Paper: Thick wove. Top edges gilt.
Illustrations: Identical to (A).
Issue Points: This edition postdates (A). See (A) for complete points distinguishing this issue from others.

A55.2 THE PRINCESS AND THE GOBLIN *{Binding C}*

Title: Identical to (A).
Size of Book: Identical to (A).
Size of Leaf: Identical to (A).
Pagination and Collation: Identical to (A), except with "Printed in the United States of America" on verso of half-title [2].
Description: Issued in full textured (cross-hatched) cloth (light green) with color insert same as (A). Cover and spine stamped in dark blue same as (A). Endpapers and pictorial cover jacket same as (A).
Paper: Thick wove. Top edges stained orange.
Illustrations: Identical to (A).
Issue Points: This edition postdates both (A) and (B). See (A) for complete listing of points distinguishing this issue from others.
Note: This title was reissued by David McKay several years later as a part of the Newberry Classics Series. This issue, much smaller in size, contains only four color illustrations by Smith.

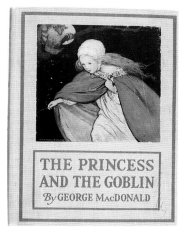

A55.1, book cover

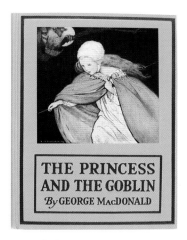

A55.2, book cover

A56. *THE LULLABY BOOK*
Shelby, Annie Blanche.
New York, 1921.
Duffield and Company.

Title: THE / LULLABY BOOK / or / Mothers' Love Songs / Compiled and arranged by / Annie Blanche Shelby / Frontispiece by Jessie Willcox Smith / (Publisher's colophon) / New York / Duffield and Company / 1921.

Size of Book: 21.3 x 14.3 cm.

Size of Leaf: 20.8 x 14.1 cm.

Pagination: xv, [3], 183, [1] p.

Collation: Half-title [i]; frontispiece in color facing title; title [iii]; copyright (1921, Duffield and Company) (Printed in U. S. A.) [iv]; dedication, v; contents vii-x; preface, xi-xii; acknowledgments, xiii-xv; divisional title [2]; text 1-183.

Description: Issued in full cloth (light blue). Front cover stamped in gold: THE LULLABY BOOK / (rule) / Annie Blanche Shelby. Spine stamped in gold: THE / LULLABY / BOOK / (rule) / Shelby / Duffield. Issued in color pictorial cover jacket.

Cover Jacket Description: Printed on glossy white paper with color illustration same as frontispiece. Printed in black: THE LULLABY BOOK / (color illustration) / Compiled by / Annie Blanche Shelby / (rule) / Duffield & Company. Spine printed in black: THE / LULLABY / BOOK / (rule) / Shelby / Duffield. Rear cover with eight titles in "The Jewel Series." Front flap with advertisement for "The Sapphire Story Book". Rear flap with advertisement for "The Emerald Story Book".

Cover Jacket Dimensions: 21.3 x 48 cm.

Paper: Wove.

Illustrations: Color frontispiece, of mother with child (Sweet and Low), also reproduced on Cover Jacket.

Publication Notes: Copyright registered, Dec. 12, 1921, Duffield and Company. Copies received, Dec. 19, 1921. Listed in *Publisher's Weekly,* Feb. 11, 1922 (p. 400).

Price at Issuance: $1.75.

Note on Illustration: This illustration first appeared in A CHILD'S BOOK OF VERSES (1910) facing p. 84.

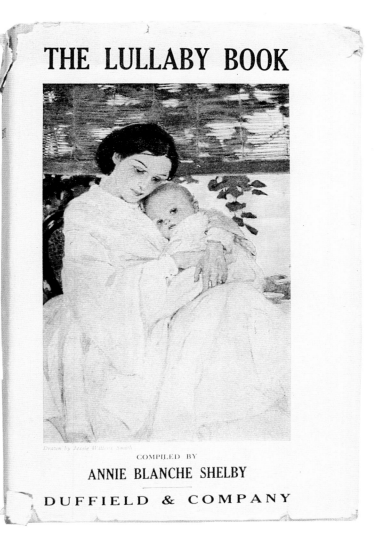

Cover jacket

Book cover

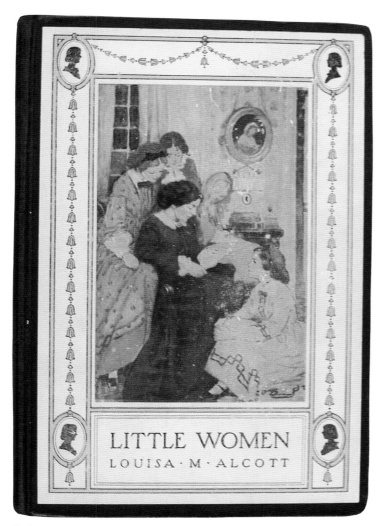

Book cover

A57. *LITTLE WOMEN*
Alcott, Louisa May.
Boston, 1922.
Little, Brown and Company.

Title: LITTLE WOMEN / or / Meg, Jo, Beth and Amy / By / Louisa M. Alcott / With Illustrations in Color by / Jessie Willcox Smith / (publisher's device) / Boston / Little, Brown and Company / 1922.
Size of Book: 23.3 x 16 cm.
Size of Leaf: 22.7 x 15.3 cm.
Pagination: [x], 397, [1] p.
Collation: Half-title [i]; By Louisa M. Alcott (8 titles) [ii]; frontispiece in color with caption facing title; title with decorative border [iii]; copyright (1869, Louisa M. Alcott) (1896, 1910, 1911, J. S. P. Alcott) (1915, Little, Brown and Company) (All rights reserved) (Printed in the United States of America) [iv]; preface [v]; contents [vii]-viii; illustrations [ix]; text [1]-397.
Description: Issued in full cloth (black) with full-size color pictorial insert front cover. Cover illustration "They all drew to the fire" (facing p.6). Front cover printed in black on insert: LITTLE WOMEN / Louisa M. Alcott. Spine stamped in white: LITTLE / WOMEN / (design) / Louisa / M. / Alcott / Little, Brown / and Company.
Paper: Wove.
Illustrations: Eight full-page color plates, color insert on front cover.

Cover insert	They all drew to the fire.
Frontispiece	Meg, Jo, Beth and Amy.
Facing p. 7	* (sic) They all drew to the fire.
Facing p. 48	The great drawing-room was haunted by the tuneful spirit that came and went unseen.
Facing p. 150	Holding onto the banisters, she put him gently away.
Facing p. 260	Jo and Beth.
Facing p. 299	He put his arm around her, as she stood on the step above him.
Facing p. 330	In a minute a hand came down over the page, so that she could not draw.
Facing p. 384	Passers-by probably thought them a pair of harmless lunatics.

*Some copies inspected had this plate facing p. 6.
Publication Notes: Copyright not registered in Copyright Office. Listed in *Publisher's Weekly*, Aug. 26, 1922 (p. 647).
Price at Issuance: $1.50.
Note on Illustrations: All of these illustrations originally appeared in the 1915 edition of LITTLE WOMEN.

Frontispiece

Facing p. 48

A58. HEIDI
Spyri, Johanna
Philadelphia, 1922.
David McKay Company.

Title: HEIDI / by Johanna Spyri / (color illustration) / Illustrated by / Jessie Willcox Smith / David McKay Company / Philadelphia / 1922 / D. Mc.K. (small letters).
Size of Book: 24.2 x 18.3 cm.
Size of Leaf: 23.6 x 18 cm.
Pagination: 380 pp.
Collation: Half-title [1]; imprint (Engraved and Printed by The Beck Engraving Company) [2]; color illustrated title and copyright (David McKay Company, Philadelphia, 1922) [3]; illustrations [5]; contents [7]; introduction, 9-10; (drawing colored in red) [11]; text 13-380.
Description: Issued in full linen cloth (light blue) with full-size pictorial insert on cover. Front cover insert with half-inch gilt on borders and one inch on top. Cover printed in black: HEIDI (with two goat silhouettes on each side). Spine stamped in gold: HEIDI / (circular drawing of goats) / Johanna / Spyri / Illustrated by / Jessie / Willcox / Smith / David McKay. Endpapers in blue-green tint by Smith. Issued in color pictorial cover jacket.
Cover Jacket Description: Printed on white glossy paper. Cover with same color illustration reproduced on cover insert of book. Spine identical to that of book, printed in black.
Cover Jacket Dimensions: 24.5 x 54 cm.
Paper: Thick wove. Top edges gilt.
Illustrations: Ten full-page color plates, color title-page, line drawings throughout colored in yellow, red, and blue; cover pictorial insert in color (reproduced on cover jacket); tinted endpapers, all by Smith.

Cover insert	[Heidi with Goat]
Title-page	[Heidi with Mother]
Facing p. 34	"I want to see what you have inside the house," said Heidi.
Facing p. 52	"You can have that, I have plenty."
Facing p. 70	"Are you the child that lives up with Alm-Uncle, are you Heidi?"
Facing p. 104	"I am never called anything but Heidi."
Facing p. 138	So Heidi had plenty of time from day to day to sit and picture how everything at home was now turning green, and how the yellow flowers were shining in the sun.
Facing p. 190	The moonlight was shining in through the open door and fell on a white figure standing motionless in the doorway.
Facing p. 228	The bells were ringing in every direction now, sounding louder and fuller as they neared the valley.
Facing p. 284	Down the mountain they shot like two birds darting through the air.
Facing p. 318	Heidi introduced each in turn by its name to her friend Clara.
Facing p. 344	"Put your foot down firmly once," suggested Heidi.

Issue Points: First issue has top edges gilt, colored line drawings throughout in red, green, and yellow, and without "Printed in the United States of America" on verso of half-title. The second issue, with top edges plain, uncolored line drawings, and with "Printed in the United States of America" on verso of half-title, is otherwise identical. Reprinted by Dial Press in 1935.
Publication Notes: Not entered in Copyright Registry. Listed in *Publisher's Weekly*, Oct. 7, 1922 (p. 1311).
Price at Issuance: $3.50.
Note on Illustrations: First and only appearance of these illustrations.

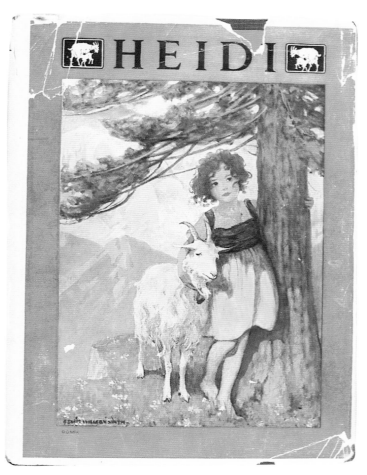

Cover jacket

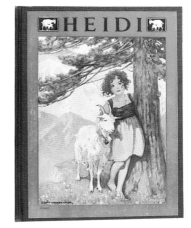

Book cover

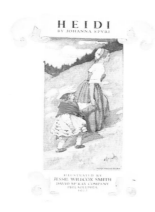

Title page

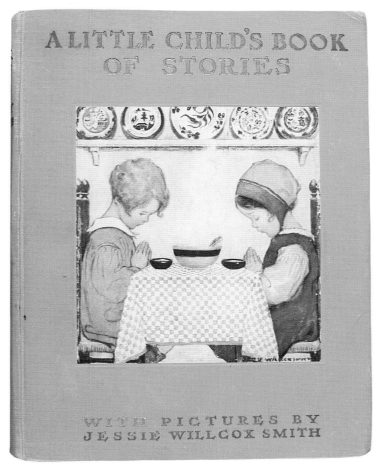

Book cover

A59. A LITTLE CHILD'S BOOK OF STORIES
Skinner, Ada M. and Eleanor L. (compilers).
New York, 1922.
Duffield and Company.

Title: A LITTLE CHILD'S / BOOK OF STORIES / Compiled by / Ada M. Skinner / and / Eleanor L. Skinner / With Pictures by / Jessie Willcox Smith / (publisher's device) / New York / Duffield and Company / 1922.
Size of Book: 24 x 18.5 cm.
Size of Leaf: 23.4 x 17.8 cm.
Pagination: [xii], 258 pp.
Collation: Half title (A LITTLE CHILD'S / BOOK OF STORIES) [i]; frontispiece in color facing title page; title [iii]; copyright (1922, Duffield and Company) (Printed in the U. S. A.) [iv]; contents [v]-[vii]; illustrations [ix]; acknowledgments [xi]-[xii]; divisional title [1]; text 3-258.
Description: Issued in full fine rib cloth (orange) with color pictorial insert on front cover. Front cover stamped in gold: A LITTLE CHILD'S BOOK / OF STORIES / (color insert) / With Pictures by / Jessie Willcox Smith. Spine stamped in gold: A LITTLE / CHILD'S BOOK / OF STORIES / Skinner / (rule) / Pictures by / Jessie Willcox Smith / Duffield.
Paper: Wove.
Illustrations: Eight full-page color plates, color insert on front cover.

Cover insert	We Give Thee Thanks.
Frontispiece	Moonbeams.
Facing p. 3	"Pals".
Facing p. 18	Blossoms.
Facing p. 49	Helping Hands.
Facing p. 71	A Posy.
Facing p. 109	The Butterflies.
Facing p. 181	The Coasters.
Facing p. 222	The Reading Hour.

Issue Points: Reprinted by the Dial Press in 1935.
Publication Notes: Copyright registered, Oct. 27, 1922, Duffield and Company. Copies received, Nov. 4, 1922. Listed in *Publisher's Weekly,* Nov. 18, 1922 (p. 1885).
Price at Issuance: $3.50.
Note on Illustrations: All of the illustrations first appeared in *Good Housekeeping Magazine,* 1919-1921.

Cover insert	[We Give You Thanks] November 1920.
Frontispiece	[Moonbeams] August 1921.
Facing p. 3	["Pals"] March 1920.
Facing p. 18	[Blossoms] May 1920.
Facing p. 49	[Helping Hands] October 1920.
Facing p. 71	[A Posy] May 1921.
Facing p. 109	[The Butterflies] September 1921.
Facing p. 181	[The Coasters] March 1919.
Facing p. 222	[The Reading Hour] November 1921.

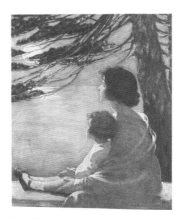

Frontispiece

Facing p. 109

A60. *A VERY LITTLE CHILD'S BOOK OF STORIES*
Skinner, Ada M. and Skinner, Eleanor L.
New York, 1923.
Duffield and Company.

Title: A VERY LITTLE CHILD'S / BOOK OF STORIES / Written and Compiled by / Ada M. Skinner / and / Eleanor L. Skinner / With Pictures by / Jessie Willcox Smith / (Publisher's device) / New York / Duffield and Company / 1923.

Size of Book: 24.1 x 18.7 cm.
Size of Leaf: 23.2 x 18 cm.
Pagination: xiv, 232 pp.
Collation: Half-title (A VERY LITTLE CHILD'S / BOOK OF STORIES) [i]; Other Books in the Series (4 titles) [ii]; frontispiece in color facing title; title [iii]; copyright (1923, Duffield and Company) (Printed in the U. S. A.) [iv]; contents, v-vii; illustrations [ix]; acknowledgments, xi; introduction xiii-xiv; text, 1-232.
Description: Issued in full fine rib cloth (blue) with color pictorial insert on front cover. Front cover stamped in gold: A VERY LITTLE CHILD'S / BOOK OF STORIES / (color insert) / Ada M. Skinner and / Eleanor L. Skinner / (rule) / With Pictures by / Jessie Willcox Smith. Spine Stamped in gold: A / VERY LITTLE / CHILD'S BOOK / OF STORIES / Skinner / Duffield.
Paper: Wove.
Illustrations: Eight full-page color plates, color insert on front cover.

Cover insert	The Runaway.
Frontispiece	Baby's Prayer.
Facing p. 24	Among Autumn Leaves.
Facing p 44	Don't Be Scared.
Facing p. 64	Tulip Time.
Facing p. 78	April Showers.
Facing p. 92	Playing Mother.
Facing p. 142	Clearing the Way.
Facing p. 208	A Game of Hearts.

Issue Points: Reprinted in 1935 by the Dial Press.
Publication Notes: Copyright Registered, Sep. 21, 1923, Duffield and Company. Copies Received, Oct. 19, 1923. Listed in *Publisher's Weekly*, Oct. 13, 1923 (p. 1300).
Price at Issuance: $3.50.
Note on Illustrations: All of these illustrations first appeared in the following issues of *Good Housekeeping Magazine:*

Cover insert	[The Runaway] July 1922
Frontispiece	[Baby's Prayer] October 1919
Facing p. 24	[(Among the Autumn Leaves] November 1918
Facing p. 44	[Don't Be Scared] August 1922
Facing p. 64	[Tulip Time] April 1919
Facing p. 78	[April Showers] April 1922
Facing p. 92	[Playing Mother] June 1922
Facing p. 142	[Clearing the Way] March 1921
Facing p. 208	[A Game of Hearts] February 1921

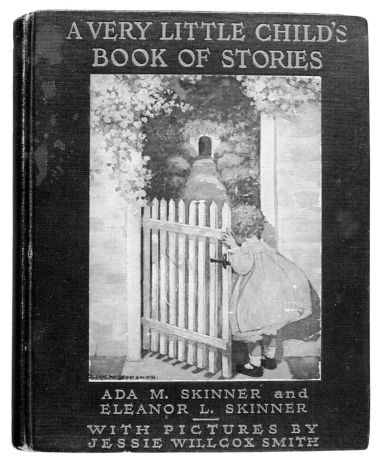

Book cover

Facing p. 24

Facing p. 142

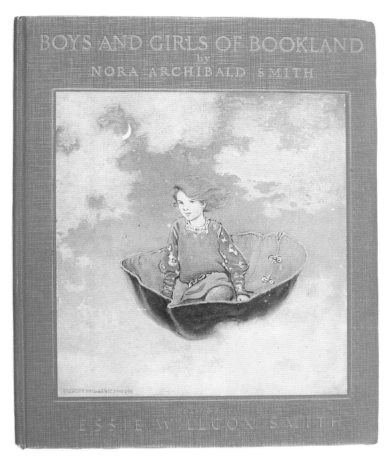

Book cover

Cover jacket

Facing p. 1

A61. BOYS AND GIRLS OF BOOKLAND
Smith, Nora Archibald.
New York, 1923.
Cosmopolitan Book Corporation.

Title: BOYS AND GIRLS / OF BOOKLAND (title in red) / By / Nora Archibald Smith / Pictures by / Jessie Willcox Smith / (publisher's device in red) / Cosmopolitan Book Corporation / New York MCMXXIII.
Size of Book: 31 x 25.2 cm.
Size of Leaf: 30.3 x 24.5 cm.
Pagination: [x], 100 pp.
Collation: Half-title [i]; title with decorative border (rubricated) [iii] copyright 1923, (Cosmopolitan Book Corporation) (All rights reserved) (1903, Kate Douglas Riggs plus 9 lines of type) (Printed in the United States of America) [iv]; acknowledgments [v]; illustrations [vii]; divisional title [ix]; text, 1-100.
Description: Issued in full cloth (grey-green) with color pictorial insert on front cover of "The Little Lame Prince". Front cover stamped in gold: BOYS AND GIRLS OF BOOKLAND / by / Nora Archibald Smith / (insert with gilt ruled border) / Pictures by / Jessie Willcox Smith. Spine stamped in gold lengthwise: BOYS AND GIRLS OF BOOKLAND. Endpapers tinted light green. Issued in color pictorial cover jacket.
Cover Jacket Description: Printed on white glossy paper. Front cover with color illustrations same as cover insert. Printing, identical to that of book, in black. Rear cover with three illustrations of Cosmopolitan Gift Editions, each pictured in color. Front flap with advertisement for BOYS AND GIRLS OF BOOKLAND. Rear flap with description of *"On Autumn Trails"*.
Paper: Wove.
Illustrations: Eleven full-page color plates. Color insert on front cover of book and cover jacket.

Cover Insert	The Little Lame Prince.
Facing p. 1	David Copperfield.
Facing p. 10	Little Women.
Facing p. 18	Jackanapes.
Facing p. 27	Tiny Tim.
Facing p. 36	Hans Brinker.
Facing p. 46	Alice in Wonderland.
Facing p. 56	The Little Lame Prince.
Facing p. 65	Heidi, The Alpine Rose.
Facing p. 74	Mowgli.
Facing p. 83	Little Nell.
Facing p. 92	Rebecca of Sunnybrook Farm.

Issue Points: The Cosmopolitan edition is the first issue and contains all of the following distinguishing points: a) full gray-green cloth with cover insert of "Little Lame Prince"; b) endpapers tinted light green; c) top edges untinted; d) title rubricated with Cosmopolitan imprint and MCMXXIII at bottom; e) "David Copperfield" facing page one; and f) with glossy white cover jacket. Also reissued by David McKay Company in cloth and paper covered boards. (See A61.1 and A61.2)
Publication Notes: Copyright Registered, Sep. 25, 1923, Cosmopolitan Book Corporation. Copies received, Sep. 26, 1923. Listed in *Publisher's Weekly*, Oct. 13, 1923 (p. 1300).
Price at Issuance: $2.50.
Note on Illustrations: All of the illustrations first appeared in *Good Housekeeping Magazine*, 1922-23 as follows:

Cover Insert,	
Cover Jacket, and	
Facing p.56	[Little Lame Prince] Apr., 1923.
Facing p. 1	[David Copperfield] November 1922.
Facing p. 10	[Little Women] February 1923.
Facing p. 18	[Jackanapes] June 1923.
Facing p. 27	[Tiny Tim] December 1922.
Facing p. 36	[Hans Brinker] January 1923.
Facing p. 46	[Alice in Wonderland] March 1923.

Facing p. 65 [Heidi] August 1923.
Facing p. 74 [Mowgli] October 1923.
Facing p. 83 [Little Nell] September 1923.
Facing p. 92 [Rebecca of Sunnybrook Farm] July 1923.

A61.1 BOYS AND GIRLS OF BOOKLAND
(Cloth Edition)
Smith, Nora Archibald.
Philadelphia, 1923.
David McKay Company.

Title: BOYS AND GIRLS / OF BOOKLAND / By / Nora
Archibald Smith / Pictures by Jessie Willcox Smith /
Philadelphia / David McKay Company / 604 South
Washington Square.
Size of Book: 31 x 24 cm.
Size of Leaf: 30 x 23.5 cm.
Pagination: [x], 100 pp.
Collation: Half-title [i]; frontispiece in color facing title;
title (with decorative border) [iii]; copyright (identical to
Cosmopolitan Edition) [iv]; acknowledgments [v];
illustrations [vii]; divisional title [ix]; text, 1-100.
Description: Issued in full cloth (dark green) with color
pictorial insert on front cover of "Alice and Wonderland."
Cover and spine stamped in gold as Cosmopolitan Edition.
Endpapers bright orange.
Paper: Wove. Top edges red.
Illustrations: Eleven full-page color plates, cover insert on
front cover. Plates in same position as Cosmopolitan
Edition, except David Copperfield appears as frontispiece,
rather than facing page one.
Issue Points: This issue can be distinguished from the
Cosmopolitan edition *(A61)* by containing all of the
following: cover insert with "Alice," endpapers bright
orange, title not rubricated, containing frontispiece "David
Copperfield", and with David McKay cancel title-page. Top
edges tinted red. Not entered in copyright office or cited in
Publisher's Weekly.

A61.2 BOYS AND GIRLS OF BOOKLAND
Smith, Nora Archibald.
Philadelphia, 1923
David McKay Company.

Title: Identical to McKay Cloth Edition.
Size of Book: 31 x 24 cm.
Size of Leaf: 30.5 x 23.5 cm.
Pagination: [viii], 100 pp.
Collation: Half-title [i]; acknowledgments [ii]; frontispiece
in color facing title; title with decorative border [iii];
copyright (identical to Cosmopolitan Edition) [iv];
illustrations [v]; divisional title [vii]; text, 1-100.
Description: Issued in brown paper covered boards
(imitation leather) with color pictorial insert on front cover
(Alice in Wonderland). Printing on cover and spine identical
to McKay Cloth Edition but stamped in black. Issued in
color pictorial cover jacket.
Cover Jacket Description: Front cover with color
illustration of Alice in Wonderland. Printed in black against
yellow background: BOYS AND GIRLS / OF BOOKLAND / By
Nora Archibald Smith / (color illustration) / Pictures by
Jessie Willcox Smith. Spine dark green with title printed
lengthwise in yellow. Rear cover with ten titles by Whitman
Publishing Company. Flaps blank.
Cover Jacket Dimensions: 31 x 73.5 cm.
Paper: Wove.
Illustrations: Identical to McKay Cloth Edition.
Issue Points: Same format as McKay Cloth Edition, with
different binding, top edges plain, and acknowledgments on
(ii).

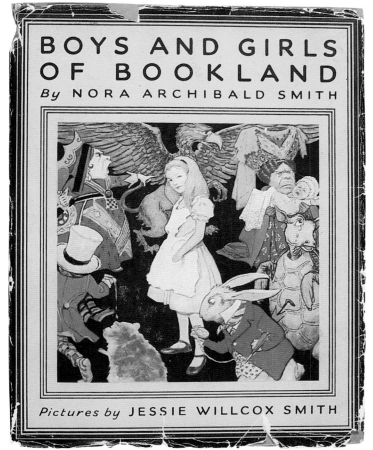

A61.2, cover jacket

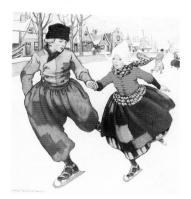

Facing p. 36

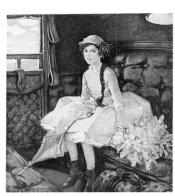

Facing p. 92

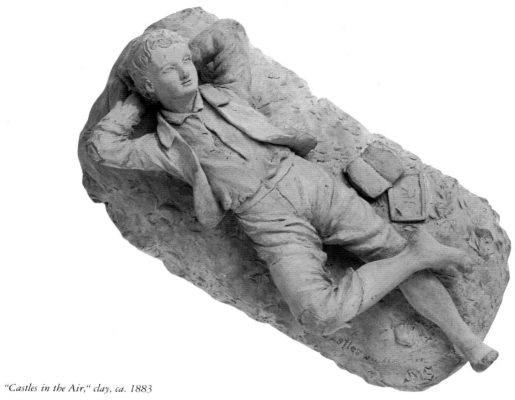

"Castles in the Air," clay, ca. 1883

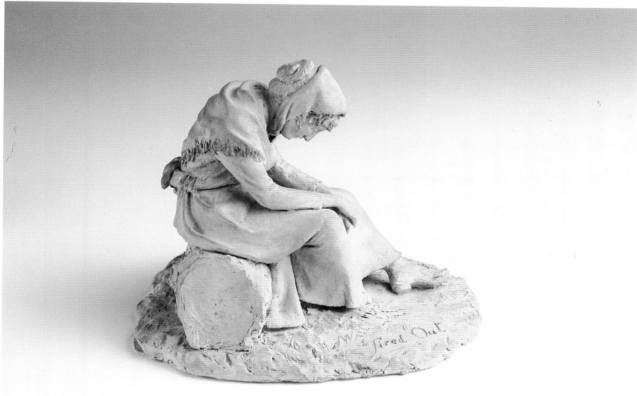

"Tired Out," clay, ca. 1883

These two were executed when Smith was about 20; see p. 12.

A62. MEMORIES AND A GARDEN
Saville, Emily Eldredge.
n. p., 1924.
Privately Printed.

Title: MEMORIES AND A GARDEN / By / Emily Eldredge Saville / Privately Printed / 1924.

Size of Book: 24.1 x 18.0 cm.

Size of Leaf: 23.5 x 17.4 cm.

Pagination: [xiv], 212, [2] pp.

Collation: Half-title [i]; frontispiece in color facing title with caption; title [iii]; copyright (1924, Henry M. Saville) (All Rights Reserved), imprint (The Riverside Press, Cambridge, Massachusetts, Printed in the U. S. A.) [iv]; in memoriam [v]; dedication [vii]; foreword [ix]-x; contents [xi]; illustrations [xiii]; verse - June [1]; text [3]-212; verse [1].

Description: Issued in full linen cloth (gray) with photographic insert on cover. Front cover stamped in gold below insert: MEMORIES / AND A / GARDEN / By / Emily Eldredge Saville. Spine stamped in gold: MEMORIES / AND A / GARDEN / (flower) / Saville / 1924. Issued in color pictorial cover jacket with same illustration as frontispiece.

Paper: Wove.

Illustrations: Color frontispiece of girl at base of stairs in pink dress, also reproduced on cover jacket. Also three black-and-white photographs.

Frontispiece "My Mother's Second Little Girl".

Publication Notes: Copyright Registered, Jun. 14, 1924, H. M. Saville. Copies received, Jun. 23, 1924. Not listed in *Publisher's Weekly*.

Note on Illustration: First and only appearance of this illustration.

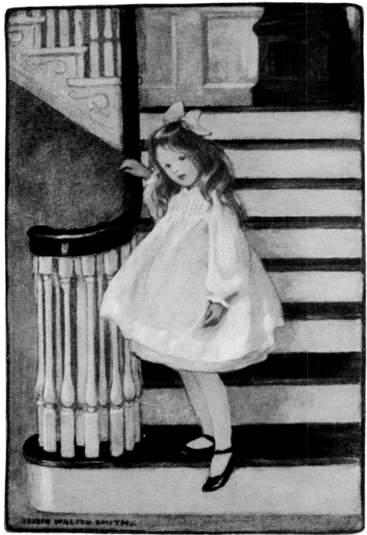

Frontispiece

Book cover

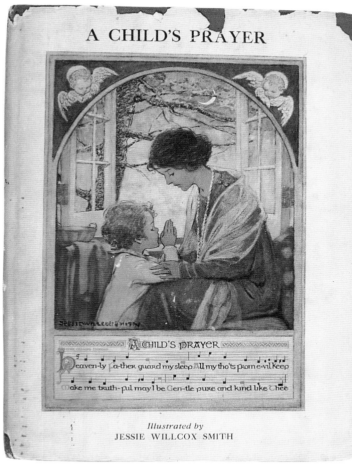

Cover jacket A63

Book cover A63

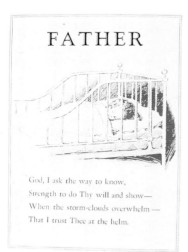

A63. *A CHILD'S PRAYER*
Cloth Edition
Toogood, Cora Cassard.
Philadelphia, 1925.
David McKay Company.
Title: A / CHILD'S / PRAYER / By Cora Cassard Toogood /
Illustrated by / Jessie Willcox Smith / David McKay
Company / Washington Square / Philadelphia.
Size of Book: 24 x 18.2 cm.
Size of Leaf: 23.5 x 17.7 cm.
Pagination: [16] pp.
Collation: Half-title [1]; frontispiece in color [2]; title with
ruled border in blue [3]; copyright with blue drawing (1925,
Cora Cassard Toogood), imprint (Engraved and Printed by
The Beck Engraving Company, Philadelphia) [4]; verse -
Jeanne [5]; drawing [6]; text [7]-[16].
Description: Issued in full linen cloth (blue) with gilt-
stamped portrait of child and title: **A CHILD'S PRAYER**. Issued
in color pictorial cover wrapper reproducing frontispiece.
Front cover of wrapper: **A CHILD'S PRAYER** / (color
illustration same as frontispiece) / Illustrated by / Jessie
Willcox Smith. Back cover: Published by / David McKay
Company / Washington Square / Philadelphia.
Cover Wrapper Dimensions: 24 x 49 cm.
Paper: Thick coated wove.
Illustrations: Color frontispiece of child with hands folded
in prayer kneeling at his mother's feet; with two lines of
verse and music at bottom of illustration. Same illustration
reproduced on wrapper. Six blue line drawings by Smith.
Publication Notes: Copyright registered Jun. 1, 1925,
Cora Cassard Toogood. Copies received, Jun. 1, 1925. Not
listed in *Publisher's Weekly.*
Note on Illustrations: First and only appearance of these
illustrations.

A63.1 *A CHILD'S PRAYER*
Wrapper Edition
Title: Same as *A63.*
Size of Book and Leaf: 23.3 x 17.5 cm.
Pagination: [12] pp.
Collation: Half-title (verso front cover); title (with blue
ruled border) [1]; copyright and imprint as *A63* [2]; verse -
Jeanne [3]; drawing [4]; text [5]-[12]; Mother - a song
(inside back cover).
Description: Issued in glossy card wrappers with blue cloth
strip on spine. Front cover with same color illustration as
frontispiece in *A63.* Rear cover with blue drawing found on
last page of *A63.* All else identical to *A63.*

A64. A BOOK OF LULLABIES
Smith, Elva S. (compiler)
Boston, 1925.
Lothrop, Lee and Shepard Co.
Title: A BOOK / OF LULLABIES / Compiled by / Elva S. Smith
/ Illustrated from Famous Paintings / (publisher's device) /
Boston / Lothrop, Lee & Shepard Co.
Size of Book: 20.3 x 13.7 cm.
Size of Leaf: 19.8 x 13.3 cm.
Pagination: [xxiv], [2], 563, [1] p.
Collation: Half-title [i]; Books Edited by Elva S. Smith [ii];
frontispiece (black-and-white plate) facing title; title [iii];
copyright (1925, Lothrop, Lee & Shepard) (All rights
reserved) (Printed in U. S. A.), imprint (Norwood Press,
Berwick & Smith Co., Norwood, Mass.) [iv]; preface, v-viii;
acknowledgments, ix-xvii; contents, xix-xx; illustrations, xxi-
xxii, verse [xxiii]; text 1-563.
Description: Issued in full cloth (purple) with cover
stamped in orange: A / BOOK OF / LULLABIES / Elva S. Smith.
Spine stamped in orange: A BOOK / OF / LULLABIES / Smith /
Lothrop, / Lee & Shepard / Co.
Paper: Wove.
Illustrations: One full-page black-and-white illustration by
Jessie Willcox Smith, 15 full-page black-and-white
illustrations by other artists.
Facing p. 474 Now I Lay Me Down to Sleep.
Publication Notes: Copyright Registered, Sep. 1, 1925.
Listed in *Publisher's Weekly,* Sep. 12, 1925 (p. 819).
Price at Issuance: $2.50.
Note on Illustrations: Illustration by Smith first appeared
as a Copley Print, copyright Curtis and Cameron, Boston,
Mass.

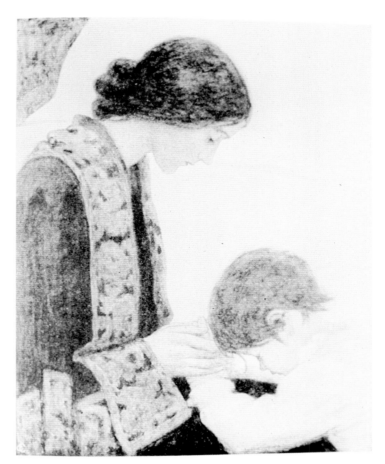

Facing p. 474

Book cover

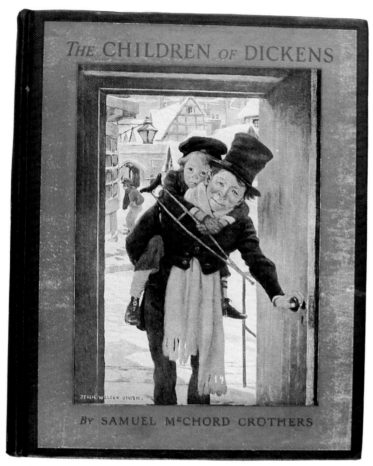

Book cover

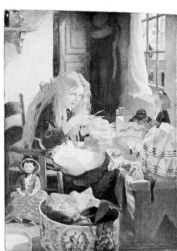

Facing p. 126

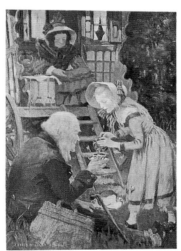

Facing p. 134

A65. *THE CHILDREN OF DICKENS*
Crothers, Samuel McChord.
New York, 1925.
Charles Scribner's Sons.

Title: THE CHILDREN / OF DICKENS / Samuel McChord Crothers / Illustrated By / Jessie Willcox Smith / (circular illustration in blue and black of houseboat) / New York / Charles Scribner's Sons / MCMXXV.
Size of Book: 24.1 x 18.2 cm.
Size of Leaf: 23.6 x 17.7 cm.
Pagination: [viii], 259, [1] p.
Collation: Half-title [i]; frontispiece in color with caption facing title, with tissue guard; title with drawing [iii]; copyright [1925, Charles Scribner's Sons] [Printed in the United States of America] [publisher's device] [iv]; contents, v-vi; list of illustrations [vii]; divisional title [1]; text, 3-259.
Description: Issued in full cloth (black) with color pictorial insert on cover. Cover insert with large gold borders; printed in darker gold: THE CHILDREN OF DICKENS / (illustration) / By Samuel McChord Crothers. Spine stamped in gold: THE / CHILDREN / OF / DICKENS / (ornament -leaf) / Samuel / McChord / Crothers / Illustrated / by / Jessie / Willcox / Smith / Scribners. Endpapers illustrated in brown and orange by Euphame Mallison. Issued in pictorial cover jacket.
Cover Jacket Description: Printed on brown paper with color insert on front cover same as cover of book. Ornamental border with additional solid rule border in black. Printed in black on cover of jacket: THE / CHILDREN OF DICKENS / (insert) / by Samuel McChord Crothers / Illustrated by Jessie Willcox Smith / Charles Scribner's Sons, New York. Spine printed in black identical to spine of book. Front flap with Tiny Tim, Oliver Twist, etc.; rear flap with an advertisement for the Scribner $2.50 series, etc. Rear cover with Scribner's list of 32 titles.
Cover Jacket Dimensions: 24.1 x 58.5 cm.
Paper: Thick wove. Top edges stained red.
Illustrations: Ten full-page color illustrations, color insert on cover of book and jacket. Title design and endpapers by Euphame Mallison.

Cover insert:	Tiny Tim and Bob Cratchit on Christmas Day.
Frontispiece:	David Copperfield and Peggotty by the Parlour Fire.
Facing p. 20	Pip and Joe Gargery.
Facing p. 30	Little Em'ly.
Facing p. 80	Oliver's First Meeting with the Artful Dodger.
Facing p. 118	Tiny Tim and Bob Cratchit on Christmas Day.
Facing p. 126	Jenny Wren, the Little Doll's Dressmaker.
Facing p. 134	Little Nell and Her Grandfather at Mrs. Jarley's.
Facing p. 152	Mrs. Kenwigs and the Four Little Kenwigses.
Facing p. 174	Paul Dombey and Florence on the Beach at Brighton.
Facing p. 206	The Runaway Couple.

Issue Points: First issue contains all the following points: a) MCMXXV on title-page; b) top edges stained red; c) cover jacket with flaps with advertisement. All later printings with date on the title-page changed accordingly. A variant issue, with MCMXXV on title-page, has top edges plain, and both flaps of cover jacket blank. Later cover jackets without ornamental border on cover, but retaining solid ruled border. These later cover jackets have $2.50 on top of front flap.
Publication Notes: Copyright Registered, Sep. 25, 1925, Charles Scribner's Sons. Copies received, Oct. 14, 1925. Listed in *Publisher's Weekly*, Oct. 3, 1925 (p. 1259).

Price at Issuance: $2.50.
Note on Illustrations: Six of the following first appeared in *Scribner's Magazine*, 1911-12. December 1911 (4): Pip and Joe Gargery; Jenny Wren; Oliver's First Meeting; Mrs. Kenwigs. August 1912 (2): Little Em'ly; Runaway Couple. All of the illustrations appeared in DICKENS'S CHILDREN (1912.

A66. A CHILD'S BOOK OF COUNTRY STORIES
Skinner, Ada M. and Eleanor L.
New York, 1925.
Duffield and Company.

Title: A CHILD'S BOOK / OF COUNTRY STORIES / Written and Compiled by / Ada M. Skinner / and / Eleanor L. Skinner / With Pictures by / Jessie Willcox Smith / (publisher's device) / New York / Duffield and Company / 1925.
Size of Book: 24.1 x 18.5 cm.
Size of Leaf: 23.3 x 18.1 cm.
Pagination: [x], 265, [1] p.
Collation: Half-title (A CHILD'S BOOK / OF COUNTRY STORIES) [i]; Other Books in the Series [ii]; frontispiece in color facing title; title [iii]; copyright (1925, Duffield and Company) (Printed in the United States of America) [iv]; contents [v]-[vi]; illustrations [vii]; introduction [viii]-[x]; divisional title [1]; text 3-265.
Description: Issued in full fine rib cloth (red) with color pictorial insert on cover. Front cover stamped in gold: (ornament - duck) A CHILD'S BOOK / (ornament - duck) / OF COUNTRY STORIES / (color insert) / Ada M. Skinner and / Eleanor L. Skinner / (rule) / With Pictures by / Jessie Willcox Smith. Spine stamped in gold: A CHILD'S BOOK / OF / COUNTRY STORIES / (rule) / Skinner / Duffield.
Paper: Wove.
Illustrations: Four full-page color illustrations, color insert on cover.

Cover insert	The Garden Gate.
Frontispiece	Day Dreams.
Facing p. 108	In Grandma's Day.
Facing p. 136	Ready for the Out-of-Doors.
Facing p. 216	The Animal Book.

Issue Points: Reprinted by Dial Press in 1935.
Publication Notes: Copyright Registered, Oct. 15, 1925, Duffield and Company. Copies received, Nov. 27, 1925. Listed in *Publisher's Weekly*, Nov. 7, 1925 (p. 1615).
Price at Issuance: $2.50.
Note on Illustrations: All of the illustrations first appeared in the following issues of *Good Housekeeping Magazine*:

Cover insert	[The Garden Gate] September 1920.
Frontispiece	[Day Dreams] September 1922.
Facing p.108	[In Grandma's Day] June 1921.
Facing p.136	[Ready for the Out-of-Doors] March 1922.
Facing p.216	[The Animal Book] February 1920.

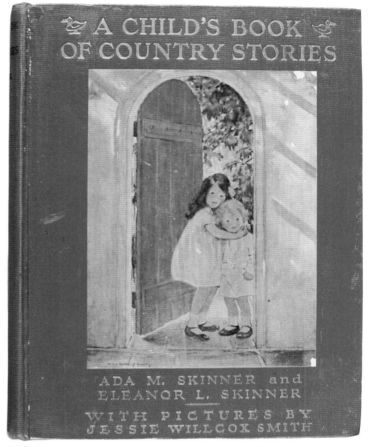

Book cover

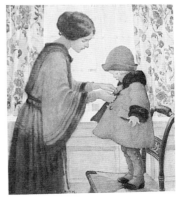

Facing p. 136

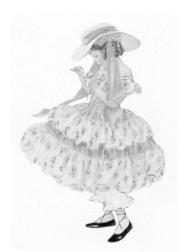

Facing p. 108

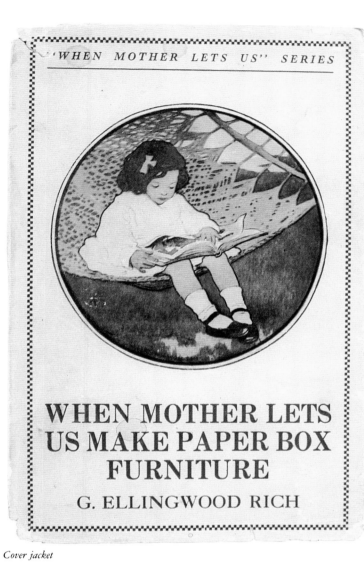

Cover jacket

Book cover

A67. *WHEN MOTHER LETS US MAKE PAPER BOX FURNITURE*

Rich, G. Ellingwood.
New York, 1925.
Dodd, Mead and Company.

Title: WHEN MOTHER LETS US / MAKE PAPER BOX / FURNITURE / A book which shows . . . (five lines) / By G. Ellingwood Rich / Teacher of Art and Manual Training, Brooklyn Training / School for Teachers / Illustrated by the Author / (ornament) / New York / Dodd, Mead and Company / 1925.

Size of Book: 20.8 x 14.0 cm.

Size of Leaf: 20.4 x 13.6 cm.

Pagination: 111, [1] p.

Collation: Half-title (WHEN MOTHER LETS US MAKE / PAPER BOX FURNITURE) [3]; black-and-white drawing [4]; title [5]; copyright (1914, Dodd, Mead and Company) (All rights reserved), (Printed in the U. S. A.), imprint (Vail-Ballou Press, Binghamton and New York) [6]; dedication [7]; table of contents [9]-[10]; list of illustrations [11]-[12]; To Grown-ups [13]; text, 14-111.

Description: Issued in full cloth (beige) with pictorial stamped cover in blue and dark brown. Printed in dark brown: WHEN MOTHER / LETS US MAKE / PAPER BOX FURNITURE / G. Ellingwood Rich. Spine printed in dark brown: WHEN / MOTHER / LETS US / MAKE / PAPER BOX / FURNITURE / (ornament) / Rich / Dodd, Mead / & Company. Issued in color pictorial cover jacket with illustration by Jessie Willcox Smith.

Cover Jacket Description: Printed on beige paper with circular color illustration on cover of girl reading book in hammock (plate p. 68, EVERYDAY FAIRY BOOK, New York, 1915, Dodd, Mead and Co.). Cover of jacket with green decorative border; printed in green: "WHEN MOTHER LETS US" SERIES / (green rule) / (color illustration) / WHEN MOTHER LETS / US MAKE PAPER BOX / FURNITURE / G. Ellingwood Rich. Spine identical to book, printed in green. Back cover with "When Mother Lets Us" Series advertisement (17 titles). Flaps blank.

Cover Jacket Dimensions: 20.8 x 45 cm.

Paper: Wove.

Illustrations: Black-and-white drawings throughout by G. Ellingwood Rich. Cover drawing by Rich. Color pictorial cover jacket by Jessie Willcox Smith.

Publication Notes: Not entered in *Publisher's Weekly*. Not entered in Copyright Office.

*A68. FOLK-LORE, FABLES, AND FAIRY
TALES*
New York, 1927.
The University Society.

Title: THE / HOME UNIVERSITY / BOOKSHELF / Prepared under the supervision of / The Editorial Board of the University Society / (publisher's device) / Volume III / Folk-lore, Fables, and Fairy Tales / The University Society / Incorporated / New York.
Size of Book: 24 x 18.7 cm.
Size of Leaf: 23.5 x 18.2 cm.
Pagination: vii, [1], 400 pp.
Collation: Frontispiece in color with tissue guard facing title; title [i]; copyright (1927, The University Society) [ii]; introduction, iii-iv; contents, v-vii; text, 1-400.
Description: Issued in cloth (maroon) with blind stamped design on front cover. In blind-stamp: THE / HOME UNIVERSITY / BOOKSHELF. Spine stamped in gold: (double rule) THE / HOME / UNIVERSITY / BOOKSHELF / (ornament) / Vol. III / (rule) / FOLK-LORE / FABLES / AND / FAIRY / TALES / (design) / The / University / Society. Endpapers illustrated in color.
Paper: Wove.
Illustrations: Illustrations throughout in color and black-and-white. One full-page black-and-white plate by Jessie Willcox Smith.
Page 156 The Fairy of The Pond.
Illustration taken from THE WAY TO WONDERLAND, New York, 1917, Dodd, Mead and Company. Frontispiece, entitled "The Fairies' Picnic".

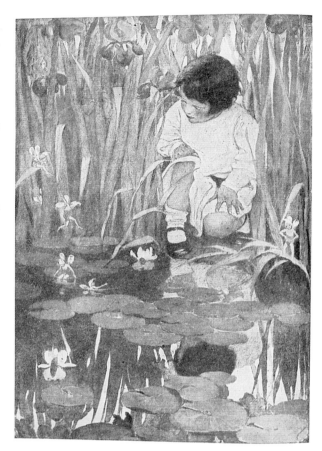

Page 156

Book cover

Cover jacket

Book cover

A69. *BOBS, KING OF THE FORTUNATE ISLE*
Franchot, Annie W.
New York, 1928.
E. P. Dutton & Co.

Title: BOBS, KING OF THE / FORTUNATE ISLE / By / A. W. Franchot / Author of "Bugs and Wings and Other Things," / "The White Giant and the Black Giant", etc. / Frontispiece in color by / Jessie Wilcox (sic) Smith / Illustrations in black and white by / Carolyn Haywood / E. P.Dutton & Co., Inc. / Publishers, New York.

Size of Book: 20.8 x 14 cm.

Size of Leaf: 20.1 x 13.6 cm.

Pagination: [xii], 210 pp.

Collation: Half-title (BOBS, KING OF THE / FORTUNATE ISLE) [i]; By the same author (3 titles) [ii]; frontispiece in color facing title; title (ruled border) [iii]; copyright (1928, E.P.Dutton & Co., Inc.) (All rights reserved) (Printed in the U.S.A.) (First Edition) [iv]; contents, v; list of illustrations, vii; verse [ix]; dedication [xi]; divisional title [1]; text, 3-210.

Description: Issued in full cloth (blue). Front cover stamped in silver: (two triangles) BOBS (two triangles) / KING OF THE FORTUNATE ISLE / By A.W. Franchot. Spine stamped in silver: BOBS / KING OF / THE / FORTUNATE / ISLE / (rule) / Franchot / Dutton.

Cover Jacket Description: Front cover with color illustration same as frontispiece. Printed in blue, front cover identical to that of book. Spine printed in blue same as book, with addition of E. P.Dutton / & Co., Inc. at bottom. Rear cover with 5 titles, printed in blue. Front flap with advertisement for BOBS, KING OF THE FORTUNATE ISLE. Rear flap with advertisement for three books and order form.

Cover Jacket Dimensions: 20.8 x 48 cm.

Paper: Wove.

Illustrations: Color frontispiece of "Bobs" with a monkey and a turtle, also reproduced on cover of cover jacket. 16 black-and-white drawings by Haywood.

Publication Notes: Copyright Registered, Oct. 31, 1928, E.P.Dutton and Company. Copies received, Oct.31, 1928. Listed in *Publisher's Weekly*, Nov. 17, 1928 (p. 2119).

Price at Issuance: $2.00.

Note on Illustration: First and only appearance of this illustration by Smith.

A70. RHYMES AND REMINISCENCES
Saville, Henry Martyn.
Boston, 1929.
The Stratford Company, Publishers.

Title: RHYMES AND / REMINISCENCES / (Humorous and Serious) / By a Parson (four ornaments) / The Reverend / Henry Martyn Saville / (drawing - lamp and book) / The Stratford Company, Publishers / Boston, Massachusetts (entire title enclosed in ornamental box).

Size of Book: 19.2 x 13 cm.

Size of Leaf: 18.2 x 12.2 cm.

Pagination: [8], iv, 139, [1] p.

Collation: Half-title (RHYMES AND / REMINISCENCES) [1]; frontispiece title and credit [3]; frontispiece in color facing title; title with decorative border [5]; copyright (1929, Stratford Company, Publishers) (Printed in the United States of America), imprint (Alpine Press, Inc., Boston, Mass.) [6]; dedication [7]; foreword, i-ii; contents, iii-iv; divisional title [1]; text, 3-139.

Description: Issued in full fine rib cloth (red) with gold stamped cover and spine. Front cover stamped in gold: RHYMES AND / REMINISCENCES / Henry Martyn Saville / (design). Spine stamped in gold: RHYMES / AND REMINIS- / CENCES / (rule) / Saville / Stratford.

Paper: Wove.

Illustrations: One full-page color illustration by Smith. *Frontispiece* Three Urchins (see p.31).

Publication Notes: Copyright Registered, Oct. 18, 1929, Stratford Company. Copies received, Oct. 21, 1929. Listed in *Publisher's Weekly:* Nov. 2, 1929 (p. 2186).

Price at Issuance: $2.00.

Note on Illustration: First and only appearance of this illustration.

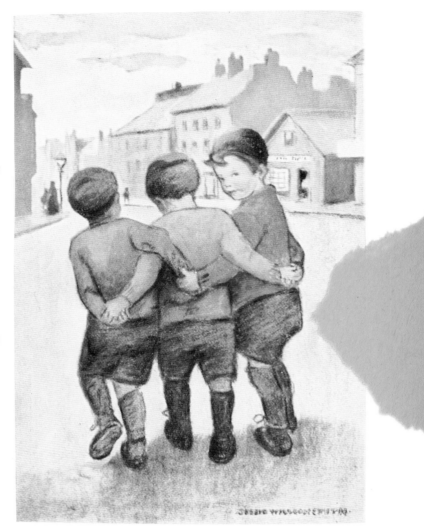

Frontispiece

Book cover

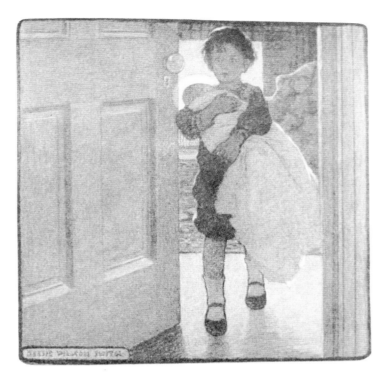

Facing p. 16

A71. *LITTLE PAUL'S CHRIST-CHILD*
Bull, Kathryn Jarboe.
n. p., 1929.
no publisher.

Title: LITTLE PAUL'S / CHRIST-CHILD (red) / by / Kathryn Jarboe Bull / (drawing - bee) / "Beeattic" / ubi apes ibi mel / Christmas, 1929 (red).
Size of Book: 22.8 x 14.3 cm.
Size of Leaf: 21.5 x 13.7 cm.
Pagination: [v], 18, [2] pp. Printed on one side only, edges unopened.
Collation: Ten Mitchell Place / New York (printed in red) [i]; title (rubricated and in ruled and ornamental rectangular box) [iv]; text, 1-18; illustrations credit (drawing - bee) [1].
Description: Issued in stiff card wrappers (red) with front cover stamped in gold: K (drawing of bee) / J. Red stock endpapers. Pages printed on one side only, with side edges unopened.
Paper: Wove.
Illustrations: Two black-and-white illustrations by Smith.
Facing p. 8 "The new Mrs. Olcutt was on her knees on the rug".
Facing p. 16 "He clasped the baby close".
Publication Notes: Not entered in Copyright Office or cited in *Publisher's Weekly.*
Note on Illustrations: These illustrations originally published in *Harper's Weekly,* Dec. 6, 1902.

Book cover

Facing p. 8

A72. *KITCHEN FUN*
Bell, Louise Price.
Cleveland, Ohio, 1932.
The Harter Publishing Company.

Title: KITCHEN FUN / Teaches children to cook successfully / By Louise Price Bell / (color drawing - not by Jessie Willcox Smith) / Printed in the United States of America) / Copyright, 1932, by / The Harter Publishing Company / Cleveland, Ohio.

Size of Book: 23.9 x 17 cm.

Size of Leaf: 22.7 x 16.2 cm.

Pagination: [ii], 28, [2] pp.

Collation: Title and copyright with colored drawing (not by Smith) (Printed in the United States of America) (1932, The Harter Publishing Company, Cleveland, Ohio) [i]; Rules for Little Cooks [1]; contents [2]-[3]; text, 4-28, [1] p.

Description: Issued in color pictorial paper-covered boards. Front cover with color illustration of girl rolling dough. 2.4 cm red border top and bottom of front cover; printed in black at top: KITCHEN FUN. Printed in black at bottom: A COOK BOOK FOR CHILDREN. Printed in black at lower left: H114. Back cover red. Endpapers red card stock.

Paper: Wove.

Illustrations: Color pictorial cover by Smith. Colored illustrations throughout of measuring spoons, apples, etc., not by Smith.

Issue Points: First issue with above dimensions, red borders top and bottom of cover, red endpapers.

Binding State B: Two variant sizes: Book: 23.8 x 17.2 cm and 24.0 x 18.7 cm. The priority is not known. State B has front pastedown endpaper, "Rules for Little Cooks" and rear paste-down endpaper, "Table Measurements". All else is identical with Binding A.

Later Printings: Reissued by The Perks Publishing Company in 1946 on cheaper paper and larger format (32.8 x 21.5 cm), in card wrappers.

Not entered in Copyright Office. Not cited in *Publisher's Weekly*.

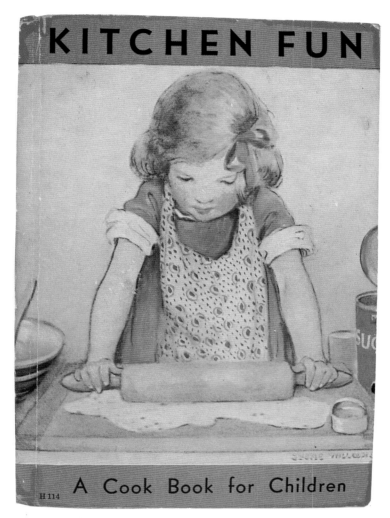

Book cover, Binding A

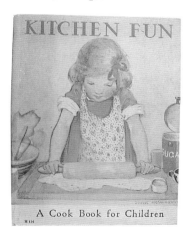

Binding B

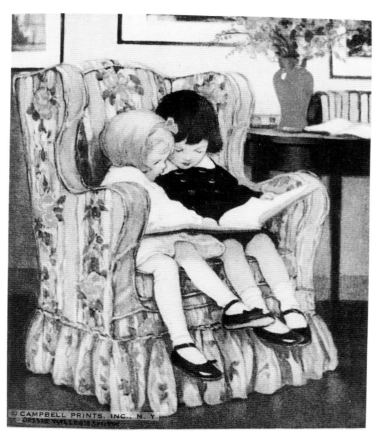

Page 141

Book cover

A73. ART STORIES - BOOK ONE
Whitford, William G.
Chicago, 1933.
Scott, Foresman and Company.

Title: Curriculum Foundation Series / ART STORIES / BOOK ONE / By / William G. Whitford / Edna B. Liek and / William S. Gray / (color picture) / Life-Reading Service / Scott, Foresman and Company / Chicago, Atlanta, Dallas, New York.

Size of Book: 20.6 x 17.3 cm.

Size of Leaf: 20 x 16.9 cm.

Pagination: 144 pp.

Collation: Title [1]; Pictures and Copyright (1933, Scott, Foresman and Company) [2]; preface, 3; Stories, 4-5; text, 6-144.

Description: Issued in full cloth (blue) with cover illustrations stamped in dark blue and yellow. Printed in dark blue: ART STORIES / BOOK ONE. / Curriculum Foundation Series. Spine printed in dark blue lengthwise: BOOK ONE, ART STORIES, S.F. & Co.

Paper: Wove.

Illustrations: 16 full-page color plates by various artists. One full-page color plate by Jessie Willcox Smith.
Page 141 Ambition.*
*Title given by editor under "Pictures," p. [2].
Illustration taken from A LITTLE CHILD'S BOOK OF STORIES, New York, 1922, Duffield and Company, p. 222 (The Reading Hour).

A74. A CHILD'S BOOK OF OLD VERSES
Dial Press Edition
Smith, Jessie Willcox.
New York, 1935.
The Dial Press.

Title: A CHILD'S BOOK OF / OLD VERSES / Selected and Illustrated / by / Jessie Willcox Smith / (publisher's device) / New York / The Dial Press, Inc. / 1935.
Size of Book: 24 x 18.8 cm.
Size of Leaf: 23.4 x 18 cm.
Pagination: ix, [3], 124 pp.
Collation: Half-title (A CHILD'S BOOK OF / OLD VERSES) [i]; Other Books in the Series (5 titles) [ii]; frontispiece in color facing title; title [iii]; copyright (The Dial Press, Inc., Reprinted, 1935) (Printed in the United States of America) [iv]; contents, v-viii; list of illustrations, ix; divisional title [2]; text 1-124.
Description: Issued in full cloth (light blue) with color pictorial insert on front cover. Front cover stamped in gold: A CHILD'S BOOK / OF OLD VERSES / (color insert) / With Pictures by / Jessie Willcox Smith. Spine stamped in gold same as Duffield edition, except The / Dial / Press appears at bottom instead of Duffield. Issued in color pictorial cover jacket and color pictorial box..
Cover Jacket Description: Printed on glossy white paper. Printed in black throughout. Cover: A CHILD'S BOOK / OF OLD VERSES / (color illustration: I Love Little Pussy) / With Pictures by / Jessie Willcox Smith. Spine: A CHILD'S BOOK / OF / OLD / VERSES / (two parallel vertical designs) / With Pictures By / Jessie / Willcox Smith / (two parallel vertical designs) / Dial Press. Rear cover with 7 titles. Front flap with advertisement for A CHILD'S BOOK OF OLD VERSES. Rear flap blank.
Cover Jacket dimensions: 24 x 61.5 cm.
Box Description: Color pictorial insert on cover with frontispiece reproduced in color. Lettering in black on cover same as cover of jacket. Sides of top of box simulated brown wood grain.
Box Dimensions: Top: 25.2 x 20.4 x 4.3 cm. Bottom: 24.5 x 19.7 x 4.3 cm.
Paper: Wove. Top edges stained orange.
Illustrations: Identical to Duffield edition.
Issue Points: First Dial Press issue with 1935 on title-page and brown simulated wood grain on box. Later Dial Press issue omits date on title-page.

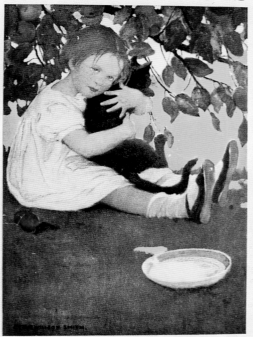

Cover jacket

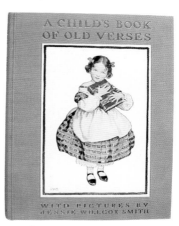

Book cover

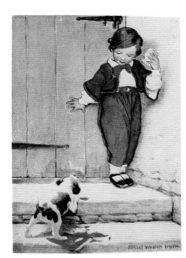

Facing p. 70

Not seen. Description extrapolated from others in the Dial
Press Series.
This book is advertised on verso of half-title in each of the
other Dial Press editions.

A75. A CHILD'S BOOK OF STORIES
Dial Press Edition
Coussens, Penrhyn W.
New York, 1935.
The Dial Press.

Title: A CHILD'S BOOK OF / STORIES / Selected and Arranged
by / Penrhyn W. Coussens / Editor of "Poems Children
Love" / With Pictures by / Jessie Willcox Smith / (publisher's
device) / New York / The Dial Press, Inc. / 1935.
Size of Book: 24.7 x 18.8 cm.
Size of Leaf: 24 x 18.5 cm.
Pagination: xi, [3], 463, [1] p.
Collation: Half-title, [i]; Other Books in the Series, [ii];
frontispiece in color facing title with captioned tissue guard;
title [iii]; copyright (The Dial Press, Inc., Reprinted 1935)
(Printed in the United States of America) [iv]; dedication
[v]; preface, vii-viii; contents, ix-xi; illustrations (2); text 1-
463.
Description: Issued in full cloth (blue) with color pictorial
insert on front cover. Front cover stamped in gold: A
CHILD'S BOOK / OF STORIES / (color insert) / With Pictures by
/ Jessie Willcox Smith / The / Dial / Press.
Issued in color pictorial cover jacket and color pictorial box.
Paper: Wove.
Illustrations: Ten full-page color plates, cover insert.
Illustrations in same positions as Duffield edition.

A76. *A CHILD'S BOOK OF MODERN STORIES*
Dial Press Edition
Skinner, Ada M. and Skinner, Eleanor L.
New York, 1935.
The Dial Press.

Title: A CHILD'S BOOK OF / MODERN STORIES / Compiled by / Ada M. Skinner / and / Eleanor L. Skinner / Compilers of the Garnet, Emerald, Topaz, Pearl, / and Turquoise Story Books / With Pictures by / Jessie Willcox Smith / (publisher's device) / New York / The Dial Press, Inc. / 1935.

Size of Book: 24 x 18.5 cm.
Size of Leaf: 23.3 x 18.1 cm.
Pagination: [xiv], 341, [1] p.
Collation: Half-title [i]; Other Books in the Series [ii]; frontispiece in color facing title; title [iii]; copyright (The Dial Press, Inc., Reprinted 1935) (Printed in the United States of America) [iv]; contents [v]-[vi]; illustrations [vii]; introduction [ix]-[xi]; divisional title [xiii]; text, 3-341.
Description: Issued in full cloth (bright green) with pictorial color insert on front cover. Front cover stamped in gold: A CHILD'S BOOK / OF MODERN STORIES / (color insert) / With Pictures by / Jessie Willcox Smith. Spine stamped in gold: A CHILD'S BOOK / OF / MODERN STORIES / Skinner / (rule) / The / Dial / Press. Issued in color pictorial cover jacket and color pictorial box.
Cover Jacket Description: Printed on glossy white paper. Color pictorial cover with "The Fairy Gardens" (p. 110) pictured. Printed in black on front cover: A CHILD'S BOOK / OF MODERN STORIES / (color illustration) / With Pictures By / Jessie Willcox Smith. Spine printed in black: A CHILD'S BOOK / OF / MODERN / STORIES / (two parallel vertical designs) / With Pictures by / Jessie / Willcox Smith / (two parallel vertical designs) / Dial Press. Rear cover with 7 titles. Front flap with advertisement for A CHILD'S BOOK OF MODERN STORIES. Rear flap blank.
Cover Jacket Dimensions: 24 x 61.5 cm.
Box Description: Color pictorial insert on cover with frontispiece reproduced in color. Lettering in black on cover same as cover of jacket. Sides of top of box with simulated brown wood grain.
Box Dimensions: Top: 25.2 x 20.4 x 4.3 cm. Bottom: 24.5 x 19.7 x 4.3 cm.
Paper: Wove. Top edges orange.
Illustrations: Eight full-page color plates, color insert on front cover. Illustrations and cover insert identical to Duffield edition.
Issue Points: First Dial Press issue with 1935 on title-page and brown simulated wood grain on box. Later Dial Press issue omits date on title-page.

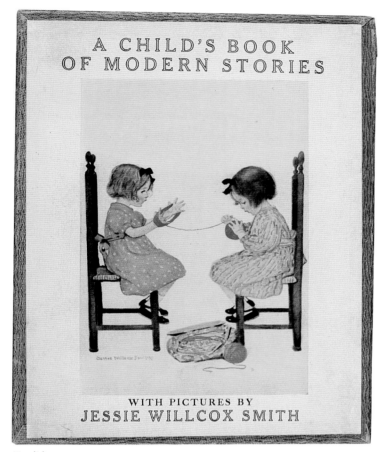

Box lid

Cover jacket

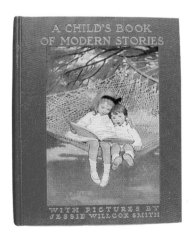

Book cover

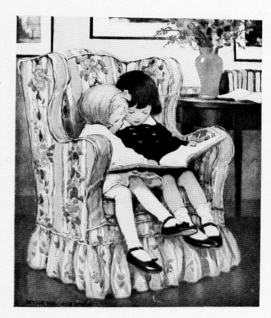

A LITTLE CHILD'S BOOK OF STORIES

WITH PICTURES BY
JESSIE WILLCOX SMITH

Cover jacket

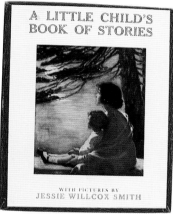

Box lid

Book cover

A77. *A LITTLE CHILD'S BOOK OF STORIES*
Dial Press Edition
Skinner, Ada M. and Skinner, Eleanor L.
New York, 1935.
The Dial Press.

Title: A LITTLE CHILD'S / BOOK OF STORIES / Compiled By / Ada M. Skinner / and / Eleanor L. Skinner / With Pictures By / Jessie Willcox Smith / (publisher's device) / New York / The Dial Press, Inc. / 1935.
Size of Book: 24 x 18.5 cm.
Size of Leaf: 23.4 x 18 cm.
Pagination: [xii], 258 pp.
Collation: Half-title (A LITTLE CHILD'S / BOOK OF STORIES) [i]; Other Books in the Series (5 titles) [ii]; frontispiece in color facing title; title [iii]; copyright (The Dial Press, Inc., Reprinted, 1935) (Printed in the United States of America) [iv]; contents [v]-[vii]; illustrations [ix]; acknowledgments [xi]-[xii]; divisional title [1]; text, 3-258.
Description: Issued in full fine rib cloth (orange) with cover insert and gold stamped printing same as Duffield edition. Spine stamped in gold same as Duffield edition, except The / Dial / Press appears at bottom instead of Duffield. Issued in color pictorial cover jacket.
Cover Jacket Description: Printed on glossy white paper. Front cover with color illustration (The Reading Hour, p. 222). Printed in black: A LITTLE CHILD'S / BOOK OF STORIES (illustration) / With Pictures By / Jessie Willcox Smith. Spine printed in black: A / LITTLE CHILD'S / BOOK OF / STORIES / (two parallel designs) / with Pictures By / Jessie / Willcox Smith / (two parallel designs) / Dial Press. Rear cover with seven titles. Front flap with advertisement for A LITTLE CHILD'S BOOK OF STORIES. Rear flap blank.
Cover Jacket Dimensions: 24 x 61.5 cm.
Box Description: Top of Box: Color pictorial insert with frontispiece reproduced on cover. Lettering in black same as cover jacket. Sides of top of box with simulated brown wood grain.
Box Dimensions: Top: 25.2 x 20.4 x 4.3 cm. Bottom: 24.5 x 19.7 x 4.3 cm.
Paper: Wove. Top edges blue-green.
Illustrations: Eight full-page color plates, color insert on front cover of book, cover jacket, and box. Illustrations same as Duffield edition.
Issue Points: First Dial Press issue with 1935 on title-page and with brown simulated wood grain on box. Later Dial Press issue omits date on title-page.

A78. A VERY LITTLE CHILD'S BOOK OF STORIES
Dial Press Edition
Skinner, Ada M. and Skinner, Eleanor L.
New York, 1935.
The Dial Press.

Title: A VERY LITTLE CHILD'S / BOOK OF STORIES / Written and Compiled by / Ada M. Skinner / and / Eleanor L. Skinner / With Pictures By / Jessie Willcox Smith / (publisher's device) / The Dial Press, Inc. / New York / 1935.

Size of Book: 24 x 18.5 cm.
Size of Leaf: 23.4 x 18 cm.
Pagination: xiv, 232 pp.
Collation: Half-title (A VERY LITTLE CHILD'S / BOOK OF STORIES); [i]; Other Books in the Series (4 titles) [ii]; frontispiece in color facing title; title [iii]; copyright (1935, The Dial Press) (Printed in the United States of America) [iv]; contents v-vii; illustrations [ix]; acknowledgments, xi; introduction, xiii-xiv; text, 1-232.
Description: Issued in full cloth (red) with color pictorial insert on front cover. Front cover stamped in gold: A VERY LITTLE CHILD'S / BOOK OF STORIES / (color insert) / Ada M. Skinner and / Eleanor L. Skinner / with Pictures By / Jessie Willcox Smith. Spine stamped in gold: A / VERY LITTLE / CHILD'S BOOK / OF STORIES / The / Dial / Press. Issued in color pictorial cover jacket and color pictorial box, with same format as A LITTLE CHILD'S BOOK OF STORIES.
Paper: Wove.
Illustrations: Illustrations same as Duffield edition.
Issue Points: First Dial Press issue with 1935 on title-page and with brown simulated wood grain on box. Later Dial Press issue omits date on title-page.

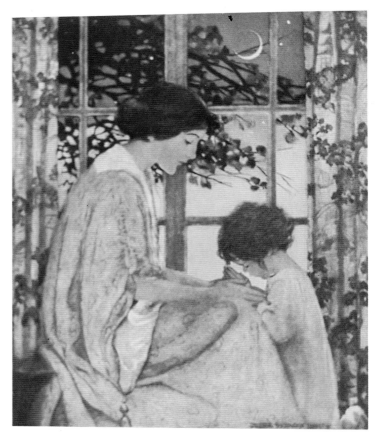

Frontispiece

Facing p 78

Facing p 92

A CHILD'S BOOK OF COUNTRY STORIES

WITH PICTURES BY
JESSIE WILLCOX SMITH

Cover jacket

Book cover

Facing p 216

A79. *A CHILD'S BOOK OF COUNTRY STORIES*
Dial Press Edition
Skinner, Ada M. and Skinner, Eleanor L.
New York, 1935.
The Dial Press.

Title: A CHILD'S BOOK / OF COUNTRY STORIES / Written and Compiled by / Ada M. Skinner / and / Eleanor L. Skinner / With Pictures by / Jessie Willcox Smith / (publisher's device) / New York / The Dial Press, Inc. / 1935.
Size of Book: 24 x 18.8 cm.
Size of Leaf: 23.4 x 18 cm.
Pagination: [x], 265, [1] p.
Collation: Half-title (A CHILD'S BOOK / OF COUNTRY STORIES) [i]; Other Books in the Series (5 titles) [ii]; frontispiece in color facing title; title [iii]; copyright (The Dial Press, Inc., Reprinted, 1935) (Printed in the United States of America) [iv]; contents [v]-[vi]; illustrations [vii]; introduction [viii]-[x]; divisional title [1]; text, 3-265.
Description: Issued in full cloth (red) with color pictorial insert on front cover. Front cover stamped in gold identical to Duffield edition. Spine stamped in gold: A CHILD'S BOOK / OF / COUNTRY STORIES / (rule) / Skinner / The / Dial / Press. Issued in color pictorial cover jacket.
Cover Jacket Description: Printed on white glossy paper with cover illustration "The Animal Book" (p. 216). Printed in black: A CHILD'S BOOK / OF COUNTRY STORIES / (color illustration) / with Pictures by / Jessie Willcox Smith. Spine printed in black: A CHILD'S BOOK / OF / COUNTRY / STORIES / (two parallel vertical designs) / With Pictures by / Jessie / Willcox Smith / Dial Press. Back cover with 7 titles. Front flap with advertisement for A CHILD'S BOOK OF COUNTRY STORIES. Rear flap blank.
Cover Jacket Dimensions: 24 x 61.5 cm.
Paper: Wove. Top edges red.
Illustrations: Identical to Duffield edition.
Issue Points: First Dial Press issue with 1935 on title-page and brown simulated wood grain on box. Later Dial Press issue omits date on title-page.

111

A80. THE WATER-BABIES
Dodd, Mead reissue
Kingsley, Charles.
New York, n. d. (c. 1936*).
Dodd, Mead and Company.

Title: THE / WATER-BABIES / by / Charles Kingsley / (drawing) / New York / Dodd, Mead & Company / Publishers.
Size of Book: 19.2 x 13.2 cm.
Size of Leaf: 18.7 x 12.5 cm.
Pagination: ix, [5], 270 pp.
Collation: Half-title [i]; title [iii]; copyright (1916, Dodd, Mead and Company, Inc.) (Printed in U.S.A.) [iv]; dedication [v]; introduction, vii-ix; contents [2]; divisional title [4]; text 1-270.
Description: Issued in full cloth (green). Front cover stamped in black: THE WATER-BABIES / Charles Kingsley / Illustrated by / Jessie Willcox Smith. Spine stamped in black: THE / WATER- / BABIES / Charles / Kingsley / Dodd, Mead / & Company. Issued in cover jacket.
Cover Jacket Description: Printed on white stock paper in brown on front cover THE WATER-BABIES / Charles Kingsley / Illustrated By / Jessie Willcox Smith. Spine printed in brown: THE / WATER- / BABIES / (double rule) / Kingsley / (double rule) / Dodd, Mead / & Company. Back cover and flaps blank.
Cover Jacket Dimensions: 19.2 x 46 cm.
Paper: Wove.
Illustrations: Illustrated with black-and-white drawings throughout. No color plates in this edition.
* Date ascertained by owners' inscriptions.

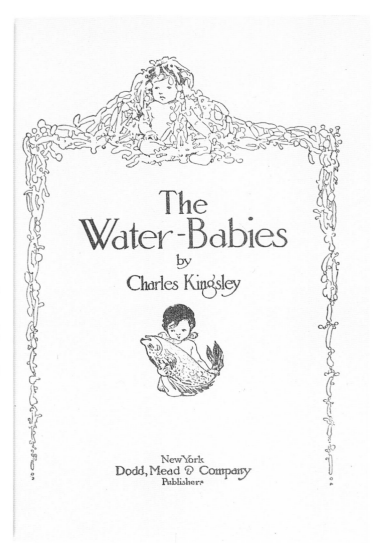

Title page

Cover jacket

Book cover

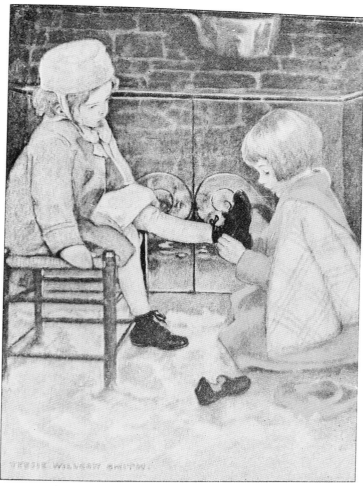

Page 55

A81. *LISTEN AND SING*
Glenn, Mabelle, etc.
Boston, 1936.
Ginn and Company.

Title: The World of Music / LISTEN AND SING / (ornament and rule) / By / Mabelle Glenn / (four additional authors) / (ornament and rule) / Ginn and Company / Boston, New York, etc.
Size of Book: 20.3 x 16.1 cm.
Size of Leaf: 19.8 x 15.9 cm.
Pagination: 140 pp.
Collation: Frontispiece in color, [2]; title [3]; copyright (1936, Ginn and Company) [4]; contents, 5-7; text, 8-140.
Description: Issued in full cloth (light green) with brown illustration of world on front cover. Printed in brown: LISTEN AND SING / (picture of the world) / The / World of Music. Spine printed lengthwise: LISTEN AND SING / Ginn and / Company.
Paper: Wove.
Illustrations: Six full-page color plates by various artists. Two full-page color plates by Jessie Willcox Smith.
Page 55 A Modern Cinderella.
Page 106 Seeing.

Issue Points: Reissued in 1943 with same illustrations ("Enlarged Edition") with same cover as TUNING UP. "A Modern Cinderella" first appeared in THE NOW-A-DAYS FAIRY BOOK, New York, 1911, Dodd, Mead and Company, facing p. 158. "Seeing" first appeared in THE FIVE SENSES, New York, 1911, Moffat, Yard and Co., facing p. 184.

Book cover

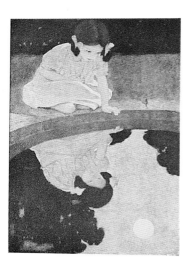

Page 106

A82. *TUNING UP*
Glenn, Mabelle, etc.
Boston, 1936.
Ginn and Company.

Title: The World of Music / TUNING UP / (ornament and rule) / By / Mabelle Glenn / (four additional authors) / (ornament and rule) / Ginn and Company / Boston, New York, etc.
Size of Book: 20 x 18.5 cm.
Size of Leaf: 19.6 x 16.2 cm.
Pagination: 176 pp.
Collation: Frontispiece in color, [2]; title [3]; copyright (1936, Ginn and Company) [4]; contents, 5-7; text, 8-176.
Description: Issued in full cloth (orange) with color pictorial cover in blue and violet. Printed in blue: TUNING UP / (in orange set off by blue world) / The World of Music. Spine printed lengthwise in blue: TUNING UP / GINN AND / COMPANY.
Paper: Wove.
Illustrations: Seven full-color plates by various artists. One full-page color plate by Smith.
Page 142 Hearing.
Issue Points: Reissued in 1943 with same illustrations. Color plate, "Hearing", taken from THE FIVE SENSES, New York, 1915, Moffat, Yard and Co., facing p. 142.

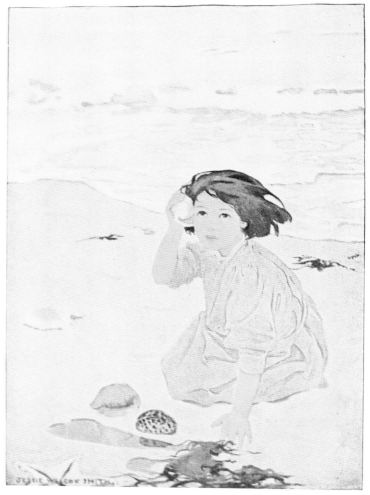

Page 142

Book cover

114

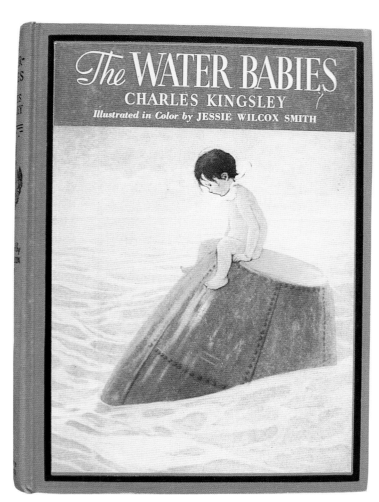

Book cover

A83. THE WATER-BABIES
Garden City Edition
Kingsley, Charles.
New York, 1937.
Garden City Publishing Company.
Title: THE / WATER-BABIES / By Charles Kingsley / (drawing) / Illustrated by / Jessie Willcox Smith / (rule) / Garden City Publishing Co., Inc. / New York.
Size of Book: 22.5 x 16 cm.
Size of Leaf: 21.8 x 15.5 cm.
Pagination: 362 pp.
Collation: Half-title (drawing) [1]; frontispiece in color facing title; title [3]; copyright (1937, Garden City Publishing Co., Inc.) (1916, Dodd, Mead & Company) [4]; dedication [5]; introduction, 7-9; illustrations [11]; Chapter 1 [13], text, 15-362.
Description: Issued in full cloth (light blue) with color pictorial insert on front cover. Printed on insert in white with red background: THE WATER BABIES / Charles Kingsley / Illustrated in Color by Jessie Wilcox (sic) Smith. Spine printed in black: THE / WATER- / BABIES / CHARLES / KINGSLEY / (drawing) / Illustrated by / JESSIE WILLCOX / SMITH / GARDEN CITY / Publishing Co. Endpapers with green pictorial illustration by G. A. F.
Paper: Wove. Top edges light blue.
Illustrations: Four full-page color plates, black-and-white drawings throughout by Smith.

Frontispiece	They hugged and kissed each other for ever so long, they did not know why.
Cover Insert	[Child sitting on buoy]
Facing p. 86	He felt how comfortable it was to have nothing on but himself.
Facing p. 272	And there he saw the last of the Gairfowl standing up on the Allalonestone, all alone.
Facing p. 344	Mrs. Doasyouwouldbedoneby.

A84. GRIMMS' FAIRY TALES
Grimm, The Brothers.
New York, n. d. (c. 1940).
Grosset & Dunlap.

Title: (Ornamental rule) GRIMMS' / FAIRY TALES / By the / Brothers Grimm / Translated by / Mrs. Lucas, Lucy Crane, / and M. Edwards / (drawing) / Grosset & Dunlap / Publishers, New York / (ornamental rule).
Size of Book: 21.3 x 14 cm.
Size of Leaf: 20.3 x 13.7 cm.
Pagination: 377, [2] pp.
Collation: Half-title [1]; frontispiece in color facing title; title [3]; copyright (Printed in U. S. A.) [4]; foreword [5]-[8]; contents [9]-[10]; divisional title [11]; text, 13-377, [1].
Description: Issued in cloth (green) with blind stamped cover design of castle. Front cover stamped in dark green: THE / GRIMMS' / FAIRY TALES. Spine stamped in dark green: THE / GRIMMS' / FAIRY / TALES / Grosset / & Dunlap. Endpapers with red illustration of castle. Issued with color pictorial cover jacket with illustration by Jessie Willcox Smith.
Cover Jacket Description: Cover with full-size color illustration of Jack and the Bean-stalk from A CHILD'S BOOK OF STORIES, New York, 1911, Duffield and Company, facing p. 70. Printed in red: GRIMMS' / FAIRYTALES against white background. Spine printed in yellow: GRIMMS' / FAIRY / TALES / Grosset / & Dunlap against white. Rest of spine light green. Back cover with advertisement for Famous Stories, 18 titles. Front flap with advertisement for The Grimms' Fairy Tales. Rear flap with advertisement for Famous Stories for Young Readers, 4 titles.
Cover Jacket Dimensions: 21.3 x 50 cm.
Paper: Wove. Top edges red.
Illustrations: Color frontispiece (not by Smith). Color pictorial cover jacket by Jessie Willcox Smith.

Cover jacket

Book cover

116

Book cover

A85. *A CHILD'S BOOK OF FAMOUS STORIES*

Coussens, Penrhyn W.
New York, 1940.
Garden City Publishing Company.

Title: A CHILD'S BOOK OF / FAMOUS STORIES / Selected and arranged by / Penrhyn W. Coussens / With Pictures By / Jessie Wilcox (sic) Smith / Garden City Publishing Co., Inc. / New York.

Size of Book: 22.6 x 15.8 cm.

Size of Leaf: 22 x. 15.5 cm.

Pagination: xi, [3], 462, [2] pp.

Collation: Half-title (A CHILD'S BOOK OF / FAMOUS STORIES) [i]; Frontispiece in color facing title; title [iii]; copyright (1940, Garden City Publishing Company) (1911, Dodd, Mead & Co.) (Printed in the United States of America) [iv]; dedication [v]; preface, vii-viii; contents, ix-xi; illustrations [2]; text, 1-462, [1].

Description: Issued in full cloth (black) with full-size color pictorial insert on cover. Printed in black on insert: A CHILD'S BOOK OF / FAMOUS STORIES / Illustrated by (in red) Jessie Willcox Smith. Spine printed in red: A CHILD'S / BOOK OF / FAMOUS / STORIES / P. W. Coussens / (drawing) / Illustrated by / Jessie Willcox / Smith / Garden City / Publishing Co.

Paper: Wove.

Illustrations: Four full-color plates, color insert on front cover.

Frontispiece Hansel and Gretel.
Facing p. 58 Red Riding-Hood.
Facing p. 88 The Sleeping Beauty.
Facing p. 456 Snow-Drop and the Seven Little Dwarfs.

Issue Points: Illustrations originally appeared in A CHILD'S BOOK OF STORIES, New York, 1911, Duffield and Company.

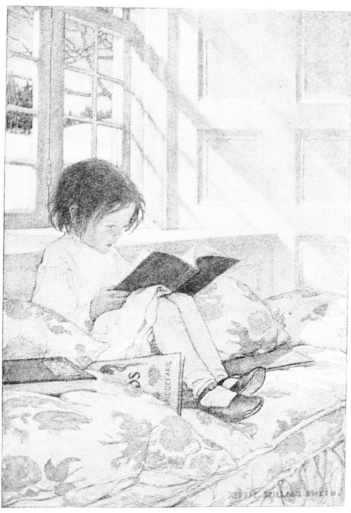

*B*3. A Child's Garden of Verses, *facing p. 78*

Facing p. 76

B1. EVANGELINE
English Edition
Longfellow, Henry Wadsworth.
London, 1897.
Gay and Bird.

Title: EVANGELINE (orange) / A TALE OF ACADIE / By / Henry Wadsworth Longfellow / With Illustrations by / Violet Oakley / and / Jessie Willcox Smith / (publisher's device) / London / Gay and Bird / 22 Bedford Street, Strand / MDCCCXCVII (orange).
Size of Book: 22.2 x 15.5 cm.
Size of Leaf: 21.7 x. 14.7 cm.
Pagination: xv, [5], 143, [1] p.
Collation: Half-title [i]; frontispiece in color with captioned tissue guard facing title; title (rubricated) [iii]; copyright (The Riverside Press, Cambridge, Mass., U. S. A.) (Printed by H. O. Houghton and Company) [iv]; introduction [v]-xi; Note on the Illustrations [xiii]-xv; List of Illustrations [2]; divisional title [4]; text, [3]-143; imprint (The Riverside Press, Cambridge, Massachusetts, U. S. A.) (Electrotyped and Printed by H. O. Houghton and Co.) [1].
Description: Issued (only copy seen) in custom full vellum binding. Front cover with inlaid morocco (green) and red and gold stamped flowers and lettering in Nouveau style. Stamped in gold on green morocco: EVANGELINE / A TALE / OF / ACADIE / (3 ornaments) / Longfellow. Spine with brown morocco label with gold stamped lettering: EVANGELINE / A TALE / OF / ACADIE / (rule) / Longfellow / (Nouveau flowers). Covers and spine with double gold stamped ruled borders, also present on inner dentelles. Endpapers marbled in green and light brown.
Paper: Coated wove. Top edges gilt.
Illustrations: Identical to American edition.
Issue Points: Facsimile of American edition, with Gay and Bird cancel on title-page.

Book cover

Facing p. 140

B2. IN THE CLOSED ROOM
English Edition
Burnett, Frances Hodgson.
London, 1904.
Hodder and Stoughton.

Title: IN / THE CLOSED ROOM (green) / by / Frances
Hodgson Burnett / Illustrations by / Jessie Willcox Smith /
London (green) / Hodder and Stoughton (green) / 27
Paternoster Row (green) / MCMIV (green).
Size of Book: 21.2 x 14.8 cm.
Size of Leaf: 20.5 x 14.2 cm.
Pagination: [2], iv, 129, [1] p.
Collation: Half-title [1]; frontispiece with caption facing
title; title (printed in black and green) [i]; list of illustrations,
iii; divisional title [1]; text 3-129, [1]; imprint (Printed in the
U.S.A. by the McClure Press) [1].
Description: Issued in full cloth (gray-beige) with color
pictorial cover of girl walking upstairs holding doll, stamped
in light blue, green, and dark brown. Printed in dark brown:
IN THE / CLOSED / ROOM / Frances Hodgson / Burnett. Spine
stamped in gold: IN THE / CLOSED / ROOM / Frances /
Hodgson / Burnett / Hodder & / Stoughton. Endpapers with
anchor design in green.
Paper: Wove.
Illustrations: Eight full-page color plates by Smith. Color
pictorial stamped cover after Smith. Green decorations
throughout, including endpapers, unsigned.

Frontispiece	The playing today was even a lovelier, happier thing than it had been ever before.
Facing p. 14	She often sat curving her small long fingers backward.
Facing p. 28	They gazed as if they had known each other for ages of years.
Facing p. 34	"Come and play with me".
Facing p. 62	She must go and stand at the door and press her cheek against the wood and wait—and listen.
Facing p. 68	She began to mount the stairs which led to the upper floors.
Facing p. 74	The ledge of the window was so low that a mere step took her outside.
Facing p. 100	"I'm going to play with the little girl, mother . . . you don't mind, do you?"

Issue Points: Facsimile of American McClure, Phillips
edition with different pictorial cloth, with Hodder and
Stoughton cancel title-page, and without McClure, Phillips
copyright page. Also top edges plain in English edition.

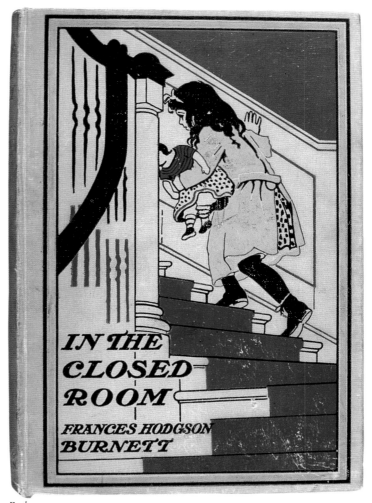

Book cover

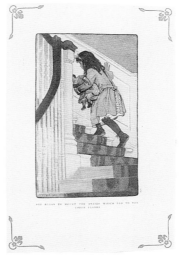

Facing p. 68

Facing p. 62

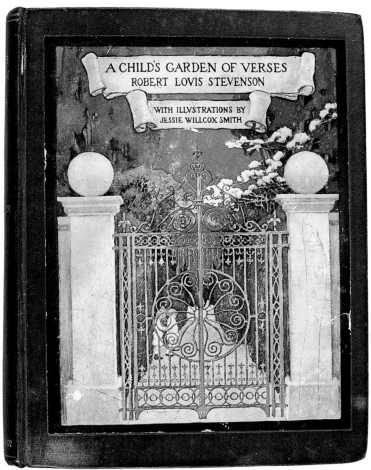

Book cover

B3. A CHILD'S GARDEN OF VERSES
English Edition
Stevenson, Robert Louis.
London, 1905.
Longmans, Green and Company.

Title: A CHILD'S GARDEN OF VERSES / Robert Louis Stevenson / With Illustrations by / Jessie Willcox Smith / Longmans, Green and Co / London / Charles Scribner's Sons / New York, MCMV.
Size of Book: 24.4 x 18.5 cm.
Size of Leaf: 23.5 x 17.8 cm.
Pagination: xii, 124, 2 pp.
Collation: Half-title (A CHILD'S GARDEN / OF VERSES) [i]; color illustrated title [iii]; imprint (Printed in the United States by The De Vinne Press, N. Y.) [iv] dedication v-vi; contents vii-ix; illustrations xi-xii; divisional title [1]; text 3-123, [1].
Description: Issued in full cloth (dark blue) with color pictorial insert front cover. Cover insert with heavy gilt blocked background. Printed in black on insert: A CHILD'S GARDEN OF VERSES / Robert Louis Stevenson / With Illustrations By / Jessie Willcox Smith. Spine stamped in gold: (double rule) / A / CHILD'S / GARDEN / OF / VERSES / R. L. / Stevenson / Longmans & Co. / (double rule). Endpapers illustrated in light blue and brown by Smith.
Paper: Wove. Top edges gilt.
Illustrations: Twelve full-page color plates with captioned tissue guards, color title, color insert and black-and-white line drawings throughout by Smith. Color illustrated endpapers in blue and brown by Smith. Illustrations in same position as American Scribner edition.
Issue Points: Facsimile of American edition, with following changes: Issued in dark blue cloth, with Longmans cancel title, without Scribner copyright (p. iv), different notations on spine.

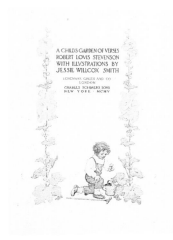

Title page

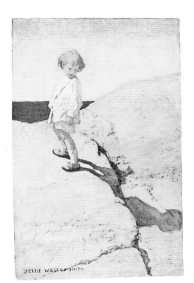

Facing p. 24

B4. RHYMES OF REAL CHILDREN
English Edition
Sage, Betty.
London, 1905.
David Nutt.

Title: RHYMES OF / REAL CHILDREN (orange) / by / Betty Sage / With Pictures by / Jessie Willcox Smith / London / David Nutt / At the Sign of the Phoenix Long Acre / 1905.
Size of Book: 30 x 27 cm.
Size of Leaf: 29.3 x 26.7 cm.
Pagination: 32 pp.
Collation: Half-title [1]; title (rubricated with border design in orange and black) [3]; copyright (All rights reserved) [4]; dedication (with color illustration) [5]; contents [6]; text 7-32.
Description: Issued in quarter cloth (brown) with color pictorial paper covered boards front and back. Printed in black on insert: RHYMES / OF / REAL CHILDREN / By Betty Sage / copyright 1903, by Fox, Duffield & Co. (in small letters) / Pictures by Jessie Willcox Smith / David Nutt London.
Paper: Coated wove.
Illustrations: Six full-page color plates, color illustration of child on toy horse on dedication page.
Facing p. 8 When Daddy Was a Little Boy.
Facing p. 10 Mother.
Facing p. 12 Natural History.
Facing p. 16 The New Baby.
Facing p. 20 "Miss Mariar".
Facing p. 24 Kittens.
Issue Points: Contains David Nutt cancel title with only "All Rights Reserved" on copyright page, with frontispiece moved to facing p. 10 in text, and with David Nutt, London on cover insert in place of Fox, Duffield & Co.

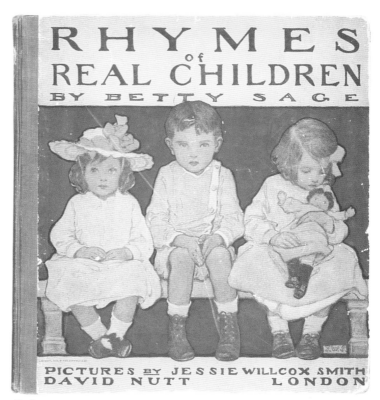
Book cover

Facing p. 20

124

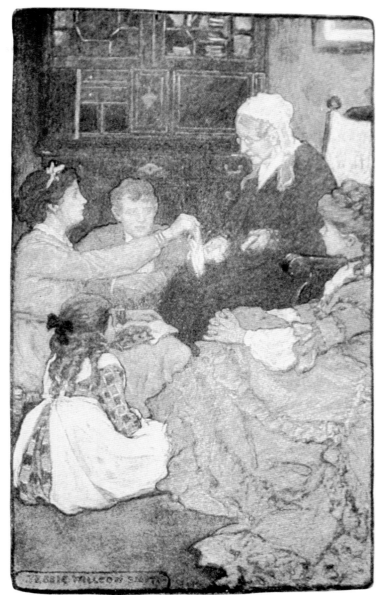

Facing page 109

English Edition
Alcott, Louisa May.
London, 1907.
Sampson, Low., Marston and Company.

Title: AN OLD-FASHIONED / GIRL / by / Louisa M. Alcott / Author of "Little Women", "Little Men", "Eight Cousins", / "Aunt Jo's Scrap-Bag", etc. / Illustrated by / Jessie Willcox Smith / (drawing) / London / Sampson, Low, Marston & Company, Limited / 1907.

Size of Book: 21.5 x 15 cm.

Size of Leaf: 21.1 x 14.6 cm.

Pagination: vi, [4], 371, [1] p.

Collation: Half-title [i]; frontispiece facing title; title [iii]; copyright (same as American Edition) imprint (Printed and bound by Hazell, Watson & Viney, Ltd., London and Aylesbury) [iv]; preface [v]-vi; contents [1]; illustrations [3]; text, 1-371.

Description: Issued in full cloth (olive green) with pictorial cover and gilt decorated spine.

Paper: Wove. Top edges gilt.

Illustrations: Twelve full-page black-and-white plates, vignette on title-page.

Frontispiece	Polly.
Title	Polly and Tom (vignette).
Facing p. 18	"Why must you be so fine to go to school?" asked Polly.
Facing p. 41	So Polly tucked herself up in front.
Facing p. 76	He surveyed himself with satisfaction.
Facing p. 109	"I choose this," said Polly, holding up a long white kid glove.
Facing p. 150	You should have seen my triumphal entry into the city, sitting among my goods and chattels.
Facing p. 178	Pushing open the door, she went quietly into the dimly lighted room.
Facing p. 219	For a moment her hands wandered over the keys.
Facing p. 260	Now then fall to, ladies, and help yourselves.
Facing p. 293	"Oh, Tom, what is it?" cried Polly, hurrying to him.
Facing p. 340	They both sat quiet for a minute.
Facing p. 363	Polly, I want to tell you something!

Issue Points: Facsimile of American edition with Sampson, Low, Marston & Co. cancel title-page, change of imprint on copyright page, and Sampson, Low printed on spine. Also gilt designs on spine as in later Little, Brown editions.

Book cover

Facing p. 260

B6. THE BED-TIME BOOK
English Edition
Whitney, Helen Hay.
London, 1907.
Chatto & Windus.

Title: THE BED-TIME BOOK / By / Helen Hay Whitney / Author of "The Punch and Judy Book","Verses for Jock and Joan", etc. / Pictures by / Jessie Willcox Smith / (Publisher's device) / London: Chatto / And Windus: MCMVII.

Size of Book: 31 x 27 cm.

Size of Leaf: 29.7 x 26.7 cm.

Pagination: 31, [1] p.

Collation: Half-title (drawing) [1]; drawing [2]; frontispiece in color facing title; title [3]; copyright (Copyright in the United States of America) (by Duffield and Company), imprint (Press of S. H. Burbank & Company, Philadelphia) [4]; text 5-31, [1].

Description: Issued in quarter cloth (brown) with color pictorial paper covered boards front and back. Illustrated endpapers.

Paper: Coated wove.

Illustrations: Six full-page color plates, drawings throughout in orange and black.

Frontispiece Picture Papers.
Facing p. 6 Auntie.
Facing p. 12 Scales.
Facing p. 18 Noah's Ark.
Facing p. 24 At Gran'papa's.
Facing p. 30 Hats.

Issue Points: A facsimile of American edition with Chatto cancel title-page, Chatto and Windus on covers, and lacking "published, August 1907" on copyright page.

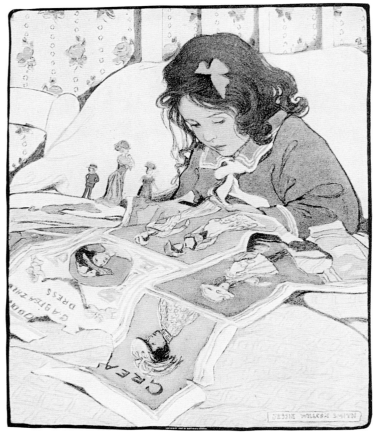

Frontispiece

Facing p. 18

Facing p. 12

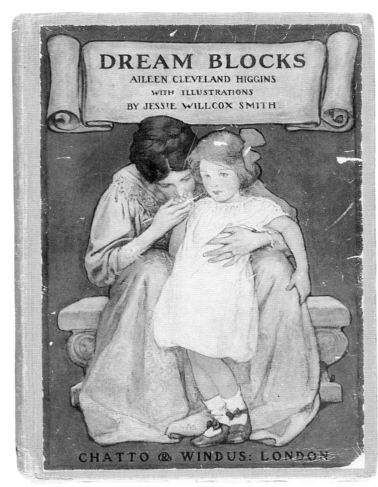

Book cover

B7. *DREAM BLOCKS*
English Edition
Higgins, Aileen C.
London, 1911.
Chatto and Windus.

Title: DREAM BLOCKS / By / Aileen Cleveland Higgins / Pictures by / Jessie Willcox Smith / London / Chatto and Windus / 1911.

Size of Book: 25 x 18.4 cm.

Size of Leaf: 24.6 x 18.4 cm.

Pagination: [10], 47, [1] p.

Collation: Half-title [1]; color illustrated title [3]; contents [5]-[6]; illustrations [7]; copyright (drawing) (1908, Duffield & Company) (Engravings by The Beck Engraving Company), imprint (Presswork by S. H. Burbank and Co., Philadelphia) [8]; divisional title [9]; drawing [10]; text 1-47; drawing [1].

Description: Issued in cloth (gray-brown) with color pictorial insert on front cover. Color illustrated endpapers.

Paper: Thick. Coated wove.

Illustrations: 14 full-page color plates, color illustrated title, color pictorial insert front cover, drawings throughout in red and black. Endpapers illustrated in color.

Title-page	[Boy at window]
Facing p. 1	Dream Blocks.
Facing p. 2	Stupid You.
Facing p. 4	Doorsteps.
Facing p. 6	The Big Clock.
Facing p. 10	A Quandary.
Facing p. 14	A Rainy Day.
Facing p. 18	The Runaway.
Facing p. 22	The Sick Rose.
Facing p. 26	Frills.
Facing p. 30	Homes.
Facing p. 34	A Prayer.
Facing p. 38	Summer's Passing.
Facing p. 40	Punishment.
Facing p. 44	Treasure Craft.

Issue Points: Facsimile of American edition, with Chatto cancel titlepage and Chatto & Windus on front cover.

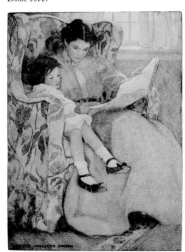

Facing p. 14

Facing p. 2

B8. A CHILD'S BOOK OF VERSES
English Edition
Smith, Jessie Willcox.
London, 1912.
Chatto & Windus.

Title: A CHILD'S BOOK OF / VERSES / Illustrated by / Jessie Willcox Smith / (drawing of girl reading a book sitting in a pile of books) / London / Chatto & Windus / 1912.
Size of Book: 23.4 x 18 cm.
Size of Leaf: 23.0 x 17.4 cm.
Pagination: vii, [8]-95, [1] p.
Collation: Half-title [i]; frontispiece in color facing title; title [iii]; copyright (All rights reserved) [iv]; contents v-vii; list of illustrations [9]; text 11-95.
Description: Issued in full cloth (blue) with color pictorial insert on front cover. Front cover stamped in gold: A CHILD'S BOOK OF VERSES / (color insert) / Illustrated by Jessie Willcox Smith. Spine stamped in gold: A / CHILD'S / BOOK / OF / VERSES / Jessie / Willcox / Smith / (publisher's device).
Paper: Wove. Top edges tinted blue. Pictorial endpapers same as Duffield edition.
Illustrations: Ten full-page color plates, drawings throughout with headpieces. Color insert on cover.

Frontispiece A Child's Grace.
Facing p. 16 I Like Little Pussy.
Facing p. 24 A Child's Question.
Facing p. 32 How Doth the Little Busy Bee.
Facing p. 44 Little Things.
Facing p. 58 Going into Breeches.
Facing p. 64 Let Dogs Delight to Bark and Bite.
Facing p. 70 Sweet and Low.
Facing p. 80 Seven Times One.
Facing p. 88 Twinkle, Twinkle, Little Star.

Issue Points: Near facsimile of Duffield American Edition, with omission of "Old" in title and variations in cover markings. Condensed in smaller version with plates in different positions.

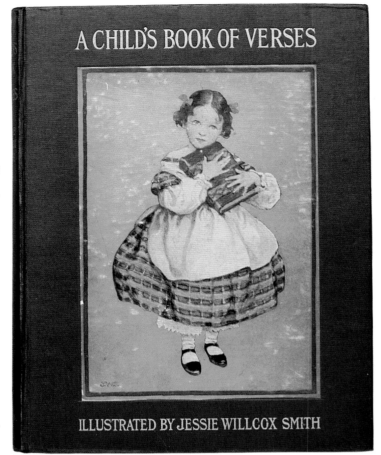

Book cover

Facing p. 24

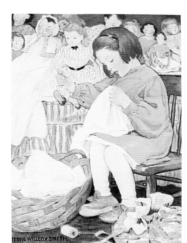

Facing p. 32

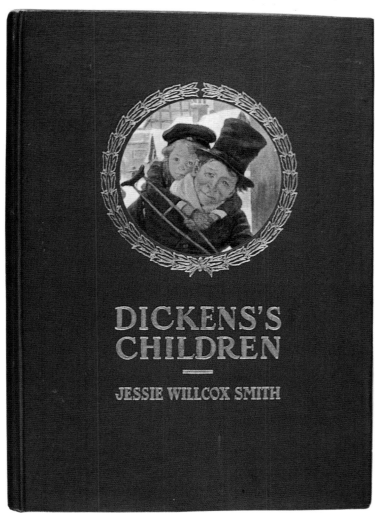

Book cover

B9. DICKENS'S CHILDREN
English Edition
Smith, Jessie Willcox.
London, 1912.
Chatto and Windus.

Title: DICKENS'S / CHILDREN / Ten Drawings / By / Jessie / Willcox / Smith / London / Chatto & Windus / MCMXII.
Size of Book: 24.5 x 17 cm.
Size of Leaf: 24 x 16.8 cm.
Pagination: [48] pp.
Collation: Half-title [1]; title (with orange decorative border) [3]; copyright (1912, Charles Scribner's Sons for the United States of America) (Printed by the Scribner Press, New York, U. S. A.) [4]; list of subjects [5]; divisional title [7]; text [8]-[46]; publisher's colophon - Scribner Seal [47].
Description: Issued in fine rib cloth (olive green) with circular color insert front cover surrounded by gilt-stamped design. Stamped in gold: DICKENS'S / CHILDREN / (rule) Jessie Willcox Smith.
Paper: Coated wove. Endpapers plain wove. Top edges gilt.
Illustrations: Ten full-page color illustrations, color insert front cover.

Page 9	Tiny Tim and Bob Cratchit on Christmas Day.
Page 13	David Copperfield and Peggotty by the Parlour Fire.
Page 17	Paul Dombey and Florence on the Beach at Brighton.
Page 21	Little Nell and Her Grandfather at Mrs. Jarley's.
Page 25	Pip and Joe Gargery.
Page 29	Jenny Wren, the Little Dolls' Dressmaker.
Page 33	Oliver's First Meeting with the Artful Dodger.
Page 37	Mrs. Kenwigs and the Four Little Kenwigses.
Page 41	The Runaway Couple.
Page 45	Little Em'ly.

Issue Points: A facsimile of American edition, with Chatto cancel title-page and "Printed by the Scribner Press, New York, U. S. A." printed on copyright page. Reissued by Chatto in 1913 with respective change of date on title-page.

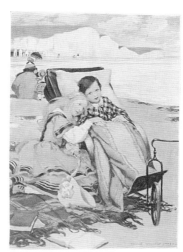

Page 17

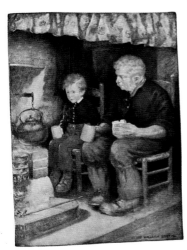

Page 25

B10. A CHILD'S BOOK OF STORIES
Coussens, Penrhyn W.
London, 1913.
Chatto and Windus.

Title: A CHILD'S BOOK OF / STORIES / Illustrated By / Jessie Willcox Smith / (publisher's device) / London / Chatto & Windus / 1913.

Size of Book: 23.9 x 18.2 cm.

Size of Leaf: 23.2 x 17.7 cm.

Pagination: viii, 142, [2] pp.

Collation: Half-title (A CHILD'S / BOOK OF STORIES) [i]; frontispiece in color with captioned tissue guard facing title; title [iii]; All rights reserved [iv]; contents v; illustrations vii; text 9-142; imprint (Printed by Ballantyne, Hanson & Co., Edinburgh & London), 142; publisher's device [1].

Description: Issued in full cloth (olive green) with color pictorial insert front cover. Front cover stamped in gold: A CHILD'S BOOK OF STORIES / (color insert) / Illustrated By Jessie Willcox Smith. Spine stamped in gold: A / CHILD'S / BOOK / OF / STORIES / Jessie / Willcox / Smith / (publisher's device). Endpapers illustrated with blue drawings not by Smith.

Paper: Wove.

Illustrations: Ten full-page color plates, each with captioned tissue guard. Color insert on front cover.

Cover Insert	[Girl and Fairy]
Frontispiece	Hansel and Grettel (sic).
Facing p. 18	Goldilocks; or the Three Bears.
Facing p. 22	Snow-White and Rose-Red.
Facing p. 34	The Goose-Girl.
Facing p. 38	Cinderella.
Facing p. 46	Red Riding Hood.
Facing p. 54	The Babes in the Woods.
Facing p. 56	Jack and the Bean-Stalk.
Facing p. 76	The Sleeping Beauty.
Facing p. 132	Snow Drop and the Seven Little Dwarfs.

Issue Points: Contains all illustrations of the Duffield American Edition but omits a large portion of the text. Contains Chatto cancel title and copyright page, omits dedication and preface found in American edition, and adds new contents page.

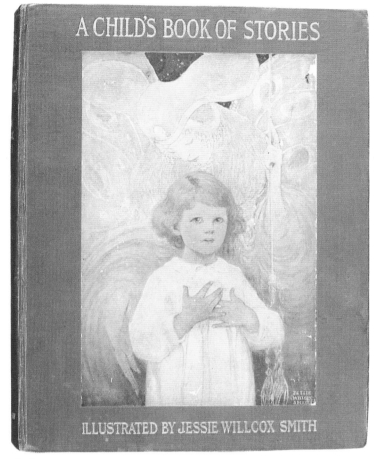

Book cover

Frontispiece

Facing p. 46

130

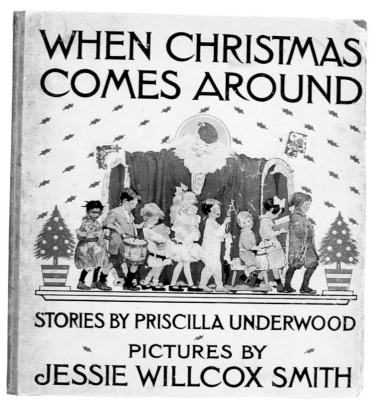

Book cover

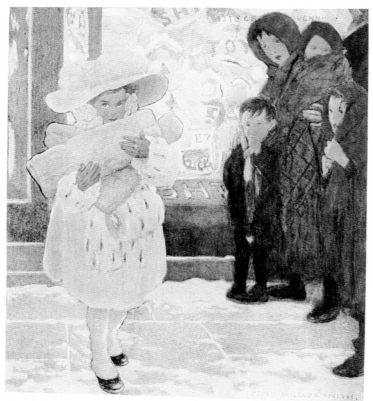

Frontispiece

B11. WHEN CHRISTMAS COMES AROUND
English Edition
Underwood, Priscilla.
London, 1915.
Chatto and Windus.

Title WHEN CHRISTMAS / COMES AROUND / Sketches of Children / By Priscilla Underwood / Pictures in colour by Jessie Willcox Smith / (publisher's colophon) / London / Chatto & Windus / 1915.

Size of Book: 28.5 x 26 cm.

Size of Leaf: 28.2 x 25.8 cm.

Pagination: [vi], 26 pp.

Collation: Half-title [i]; verse by Caxton [ii]; frontispiece in color facing title; title [iii]; copyright (1915, Duffield & Company) (New York, U. S. A.) [iv]; contents [v]; illustrations [vi]; text 1-26.

Description: Issued in quarter cream cloth with color pictorial paper covered boards front and back cover. Endpapers with orange designs of toys.

Paper: Coated wove.

Illustrations: Six full-page color plates, designs of toys as borders throughout.

Frontispiece	"Marie Louise stepped proudly across the pavement."
Facing p. 10	"John would perch on the arm of the chair and Mary would press her face close to her mother's head."
Facing p. 12	"On Easter morning, dressed in a fresh white suit, he came to claim his flower."
Facing p. 18	"Frederick squatted on the ground like a little Indian, heaping up the apples that Caroline shook down."
Facing p. 20	"Elizabeth sat on a little wicker footstool at her feet."
Facing p. 24	"They had made up their minds that they would keep awake till Santa Claus came down that chimney."

Issue Points: Facsimile of American Duffield issue, with Chatto cancel title-page and "New York, U. S. A." printed on copyright page.

B12. THE EVERYDAY FAIRY BOOK
English Harrap Edition
Chapin, Anna Alice.
London, 1917.
George G. Harrap & Company.

Title: THE EVERYDAY / FAIRY BOOK / By / Anna Alice Chapin / Author of "Humpty Dumpty," "The Now-A-Days Fairy Book," etc. / With illustrations in Color / By Jessie Willcox Smith / (drawing - three children) / London / George G. Harrap & Company / 2 & 3 Portsmouth Street, W. C. / 1917.

Size of Book: 30 x 22.3 cm.
Size of Leaf: 29.3 x 21.5 cm.
Pagination: [xii], 159, [1] p.
Collation: Half-title [i]; frontispiece in color with caption facing title; title (with drawing) [iii]; contents [v]; illustrations [vii]; verse [ix]; divisional title [xi]; verse - Pretending [xii]; text 1-159, [1].
Description: Issued in quarter cloth (light green) with light green paper covered boards and color pictorial insert (full size) front cover. Printed on cover insert in white: THE / EVERYDAY / FAIRY BOOK / by / Anna Alice Chapin / Pictured by / Jessie Willcox Smith. Spine printed in white: THE / EVERY- / DAY / FAIRY / BOOK / Chapin / Pictured / by / Jessie / Wilcox (sic) / Smith / Harrap.
Paper: Wove.
Illustrations: Seven full-page color plates with captions, color insert front cover.

Cover insert	(Facing p. 56)
Frontispiece	Ever since he had been a little, little boy, he had thought what fun it would be if Jack should pop up and cry: "Hello, Frank!"
Facing p. 42	She came down from the platform, still bravely choking back her tears.
Facing p. 56	She knew she could eat one whenever she wanted to, so she was in no hurry.
Facing p. 68	She was sitting in a hammock, trying to amuse herself with an old Atlas and not succeeding at all well.
Facing p. 92	Billy-Boy's discovery was a sea-gull, with an injured wing.
Facing p. 124	A Broken Head—and Heart.
Facing p. 144	He had crept downstairs to take a peep into the parlour.

Issue Points: Reissued by Harrap in 1919, 1924, etc. Later printings with later dates on copyright page and with Riverside Press, Edinburgh imprint on copyright page. Later Harrap editions on olive, darker green cloth. First Harrap issue differs from Dodd, Mead American issue by having Harrap cancel title-page and paper covered boards (American issue full cloth). Also, printing on spine differs in two issues.

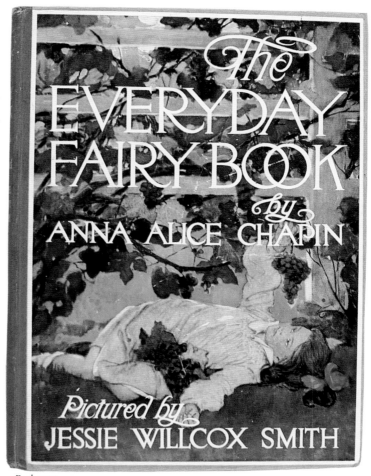

Book cover

Facing p. 144

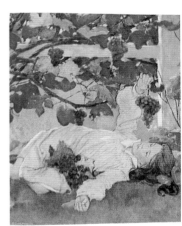

Facing p. 56

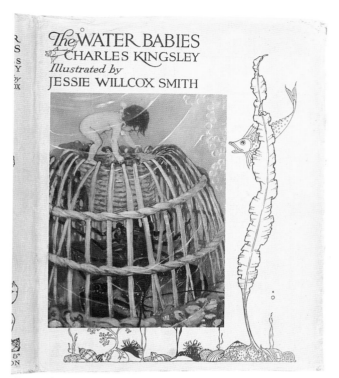

Cover jacket

Book cover

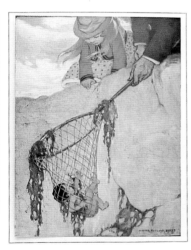

Facing p. 110

B13. THE WATER-BABIES
English Edition
Kingsley, Charles.
London, 1919.
Hodder & Stoughton.

Title: THE / WATER BABIES / by / Charles Kingsley / (drawing - child and fish) / Illustrated by / Jessie Willcox Smith / London / Hodder & Stoughton. With decorative borders in light green.
Size of Book: 28.5 x 22 cm.
Size of Leaf: 27.6 x 21.5 cm.
Pagination: [x], 240 pp.
Collation: Half-title [i]; frontispiece in color facing title; title [iii]; imprint (Hazell, Watson & Viney, Ltd.) [iv]; dedication [v]; introduction vii-viii; illustrations, ix; divisional chapter heading with drawing [1]; poem (Wordsworth) [2]; text, 3-240.
Description: Issued in full cloth (blue) with pictorial gilt design of babies and fish on front cover and spine. Front cover stamped in gold: THE WATER BABIES / Charles Kingsley / Illustrated by / Jessie Willcox Smith. Spine stamped in gold: THE / WATER / BABIES / Charles / Kingsley / Illustrated by / Jessie Willcox / Smith / (picture of child and seaweed) / Hodder & / Stoughton.
Issued in color pictorial cover jacket.
Cover Jacket Description: Printed on light brown stock. Printed in brown with color pictorial insert on front cover (Tom reached and clawed down the hole after him). THE WATER BABIES / Charles Kingsley / Illustrated by / Jessie Willcox Smith / (color insert) (brown pictures same as book cover). Spine printed in brown as book cover.
Cover Jacket Dimensions: 28.5 x 65 cm.
Paper: Wove.
Illustrations: 12 tipped-in color plates mounted onto smooth beige stock, gold ruled border around each plate, with captioned tissues guards. Line drawings throughout in light green.

Frontispiece	He looked up at the broad yellow moon . . .
Facing p. 16	"No. She cannot be dirty . . . "
Facing p. 60	He felt how comfortable it was . . .
Facing p. 84	"Oh, don't hurt me!"
Facing p. 98	And Tom sat upon the buoy long days.
Facing p. 110	He felt the net very heavy . . .
Facing p. 124	Tom reached and clawed down the hole after him.
Facing p. 128	They hugged and kissed each other . . .
Facing p. 156	Mrs. Bedonebyasyoudid.
Facing p. 180	And there he saw the last of the Gairfowl . . .
Facing p. 200	It took the form of the grandest old lady . . .
Facing p. 222	Mrs. Doasyouwouldbedoneby.

Issue Points: First English issue. Published in 1938 in smaller format (Hodder Color Books). Also, issued by Boots Pure Drug Co. published by Hodder and Stoughton.

B14. THE WAY TO WONDERLAND
English Edition
Stewart, Mary.
London, 1920.
Hodder and Stoughton.

Title: THE WAY TO / WONDERLAND / Mary Stewart / Author of / Tell Me a True Story, etc. / With Illustrations by / Jessie Willcox Smith / Decorations by / Helen M Barton / (drawing) / Hodder and Stoughton / Limited, London.

Size of Book: 25.2 x 19.2 cm.

Size of Leaf: 24.5 x 18.5 cm.

Pagination: [viii], 144 pp.

Collation: Half-title [i]; frontispiece in color tipped-in onto grey stock with tissue guard facing title; title (with decorations) [iii]; contents, v; illustrations, vi; dedication [vii]; To Wonderland [viii]; divisional title [1]; text 3-144.

Description: Issued in full cloth (light blue) with elaborate decorative cover and spine stamped in gold, blue, and brown. Front cover stamped in gold: THE WAY TO / WONDERLAND. Spine stamped in gold: THE / WAY TO / WONDER- / LAND / Mary / Stewart / Illustrated by / Jessie Willcox / Smith / (picture of girl standing on world) / Hodder & / Stoughton (blue). Endpapers illustrated in color by Barton.

Paper: Wove.

Illustrations: Six tipped-in color plates mounted onto grey stock paper with captioned tissue guards. Size of plates: 17 x 12.5 cm. Frontispiece also has caption on mounting paper.

Frontispiece	The Fairies' Picnic.
Facing p. 24	The Wind's Song.
Facing p. 56	The Door to Wonderland.
Facing p. 96	Moonlight in the Garret.
Facing p. 120	Among the Stars.
Facing p. 144	Merry Christmas.

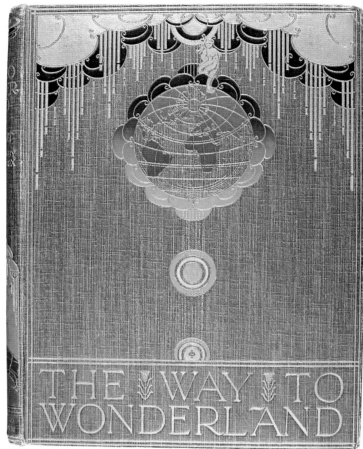

Book cover

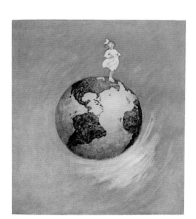

Facing p. 120

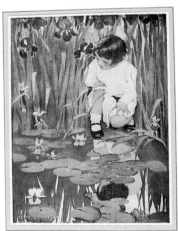

Frontispiece

134

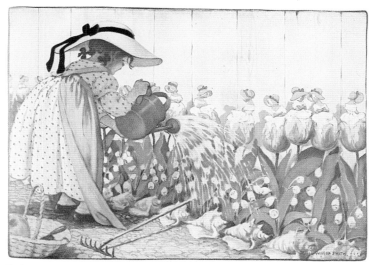

Facing p. 112

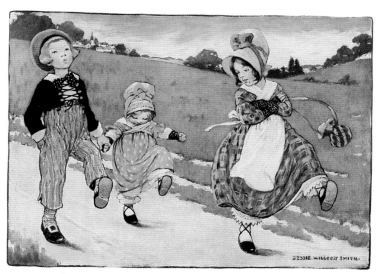

Facing p. 24

B15. MOTHER GOOSE*
English Edition
Smith, Jessie Willcox.
London, 1920.
Hodder & Stoughton.

Title: MOTHER / GOOSE / With Numerous Illustrations / In full-colour and black-and-white / By / Jessie Willcox Smith / (drawing) / Hodder & Stoughton Limited, London.
Size of Book: 23 x 18.5 cm.
Size of Leaf: 22.5 x 18 cm.
Pagination: [viii], 159, [1] p.
Collation: Frontispiece in color facing title; title (with drawing) [i]; A List of Rhymes [iii]-[vii]; illustrations [viii]; text, 1-159.
Description: Issued in full cloth (red) with color pictorial insert and illustrated cover and spine. Front cover stamped in black: MOTHER GOOSE / (color insert) / Jessie Willcox Smith / (illustration - scene of goose in country). Spine stamped in black: MOTHER / GOOSE / Jessie / Willcox / Smith / (picture of girl at door) / (spider) / (rule) / Hodder & / Stoughton.
Paper: Wove.
Illustrations: Twelve full-page color plates, drawings throughout by Smith.

Frontispiece	Hush-a-by, baby, on the treetop.
Facing p. 8	See-saw, Margery Daw.
Facing p. 16	Little Bo-Peep has lost her sheep.
Facing p. 24	One foot up, the other down.
Facing p. 40	Little Miss Muffet sat on a tuffet.
Facing p. 56	Ring-a-round a rosie.
Facing p. 72	Curly locks! curly locks! wilt thou be mine?
Facing p. 88	Eeper Weeper, Chimney-sweeper.
Facing p. 104	Rain, rain, go away.
Facing p. 112	Mary, Mary, quite contrary.
Facing p. 128	Jack fell down and broke his crown.
Facing p. 144	There was an old woman who lived in a shoe.

Issue Points: Issued in different format by Hodder & Stoughton in 1938 as Hodder and Stoughton Colour Book. This edition with same format as *B22* and reproducing all 12 of the color plates.
*Note: Book not examined, but details given to author by the archivist at the British Museum.

B16. *THE NOW-A-DAYS FAIRY BOOK*
English Harrap Edition
Chapin, Anna Alice.
London, n. d. (c. 1922).
George G. Harrap & Co., Ltd.

Title: THE NOW-A-DAYS / FAIRY BOOK / By / Anna Alice Chapin / "There are just as many Fairies now-a-days" . . . / What Grandmother always said / With Illustrations in Colour / By Jessie Willcox Smith / (drawing of fairy sitting on mushroom) / George G. Harrap & Co., Ltd. / London Calcutta Sydney.
Size of Book: 29.4 x 22 cm.
Size of Leaf: 28.5 x 21.2 cm.
Pagination: 159, [1] p.
Collation: Half-title [1]; Uniform with this Volume (Everyday Fairy Book) [2]; frontispiece with caption facing title; title (with drawing) [3]; copyright (5 line credit to Longmans, Green and Co.,) (April, 1922, George G. Harrap & Co., Ltd.)imprint (Printed in Great Britain by the Riverside Press Limited, Edinburgh) [4]; contents [5]; verse [6]; text 7-159; verse - Envoy [1].
Description: Issued in quarter cloth (brown) with brown paper covered boards and color pictorial insert (full size) on front cover. Printed in white on insert: THE / NOW-A-DAYS / FAIRY / BOOK / by / Anna / Alice / Chapin / Pictured by / Jessie Willcox Smith. Spine stamped in black: THE / NOW / - A- / DAYS / FAIRY / BOOK (ornament) / Chapin / Harrap.
Paper: Wove.
Illustrations: Six full-page color plates, color insert on front cover by Smith.

Frontispiece	Robin Put His Head Down on His Arm, and Shut His Eyes.
Facing p. 16	She Lufs Me—She Lufs Me Not.
Facing p. 38	The Three Bears.
Facing p. 68	Beauty and the Beast.
Facing p. 122	Little Red Riding Hood.
Facing p. 158	A Modern Cinderella.

Issue Points: Smaller than American edition with Harrap cancel title and copyright page. Without list of illustrations. Paper covered boards rather than full cloth.

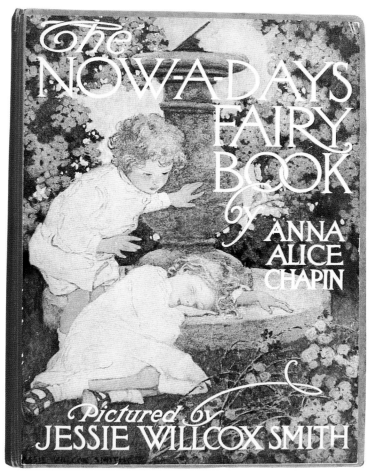

Book cover

Frontispiece

Facing p. 68

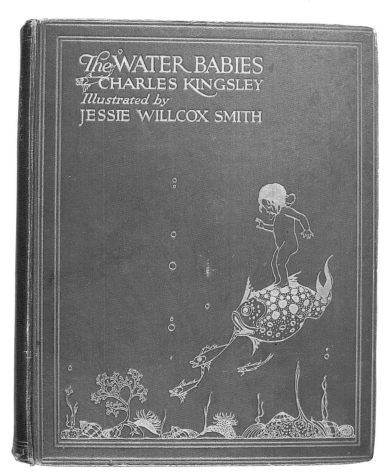

Book cover

Frontispiece

Facing p. 160

B17. *THE WATER BABIES*
English Boots Edition
Kingsley, Charles.
London, n. d. (c. 1925?).
Boots the Chemists.
Hodder and Stoughton.

Title: THE / WATER BABIES / by / Charles Kingsley / (drawing) / Illustrated by / Jessie Willcox Smith / Boots the Chemists / Branches Everywhere. With green decorative border.

Size of Book: 25.7 x 20 cm.

Size of Leaf: 25 x 19.2 cm.

Pagination: [x], 240 pp.

Collation: Half-title (with green decorations) [i]; frontispiece tipped-in in color with captioned tissue guard facing title; title (with green decorations) [iii]; copyright (Hodder and Stoughton, Limited for Boots Pure Drug Co., Ltd., Nottingham), imprint (Made and Printed by Hazell, Watson & Viney, Ltd., London and Aylesbury) [iv]; dedication [v]; introduction, vii-viii; illustrations, ix; chapter 1 (green decorations) [1]; verse - Wordsworth [2]; text 3-240.

Description: Issued in full cloth (green) with cover design stamped in gold: THE WATER BABIES / Charles Kingsley / Illustrated by / Jessie Willcox Smith / (gold design and picture). Spine stamped in gold: (rules) THE / WATER / BABIES / Charles / Kingsley / Illustrated by / Jessie Willcox / Smith / B (publisher's device) / (rules). Issued in color pictorial cover jacket with insert on front cover.

Paper: Wove.

Illustrations: Twelve tipped-in color plates mounted on inside margin onto heavy white stock, each with captioned tissue guard. Green drawings throughout.

Frontispiece	He looked up at the broad yellow moon . . . and thought that she looked at him.
Facing p. 16	"No. She cannot be dirty. She never could have been dirty."
Facing p. 64	He felt how comfortable it was to have nothing on but himself.
Facing p. 80	"Oh, don't hurt me!: cried Tom. "I only want to look at you; you are so handsome."
Facing p. 96	And Tom sat upon the buoy long days.
Facing p. 112	He felt the net very heavy; and lifted it out quickly, with Tom all entangled in the meshes.
Facing p. 128	Tom reached and clawed down the hole after him.
Facing p. 144	They hugged and kissed each other for ever so long, they did not know why.
Facing p. 160	Mrs. Bedonebyasyoudid.
Facing p. 176	And there he saw the last of the Gairfowl standing up on the Allalonestone all alone.
Facing p. 208	It took the form of the grandest old lady he had ever seen.
Facing p. 224	Mrs. Doasyouwouldbedoneby.

Issue Points: Another Boots issue is slightly smaller (24.8 x 18.5 cm), with olive green cloth but with both covers blank. This later issue with gold stamped spine: THE / WATER / BABIES / (double rule) / Charles / Kingsley and with pale blue endpapers.

B18. THE EVERYDAY AND NOW-A-DAY
FAIRY BOOK
13 Color Plates
Chapin, Anna Alice.
London, n. d. (c. 1935).
J. Coker & Co., Ltd.

Title: THE EVERYDAY / AND NOW-A-DAY / FAIRY BOOK / By / Anna Alice Chapin / Author of "Humpty Dumpty" "The Now-a-Days Fairy Book," etc. / With 13 Illustrations in Colour / By Jessie Willcox Smith / (drawing - three children sitting) / London: J. Coker & Co., Ltd. / 6 Farringdon Avenue, E. C. 4.
Size of Book: 29 x 21.9 cm.
Size of Leaf: 28.1 x 21 cm.
Pagination: [300] pp.
Collation: Half-title (THE EVERYDAY AND NOW-A-DAY / FAIRY BOOK) [1]; frontispiece in color with caption facing title; title [3]; imprint (Made and Printed in Great Britain by Jarrold and Sons Ltd. Norwich on paper supplied by W. D. Horrocks and Sons Ltd., London E. C. 4) [4]; contents [5]-[6]; text [7]-[298]; imprint (Printed by Jarrold and Sons, Ltd., Norwich) [300]p.
Description: Issued in quarter cloth (red) with color pictorial paper covered boards. Front cover with illustration of two children blowing bubbles in color. Printed in reddish-brown: THE EVERYDAY & / NOW-A-DAY FAIRY / BOOK / Spine printed in black: THE / EVERYDAY / AND / NOW-A-DAY / FAIRY / BOOK / (ornament) / Chapin / London.
Paper: Wove.
Illustrations: 13 full-color plates with captions by Smith, cover in color by E. W. B.

Frontispiece	Every since he had been a little, little boy, he had thought what fun it would be if Jack should pop up and cry: "Hello, Frank!"
Facing p. {42}	She came down from the platform, still bravely choking back her tears.
Facing p. {54}	She knew she could eat one whenever she wanted to, so she was in no hurry.
Facing p. {64}	She was sitting in the hammock, trying to amuse herself with an old Atlas, and not succeeding at all well.
Facing p. {84}	Billy-Boy's discovery was a sea-gull with an injured wing.
Facing p. {112}	A broken head—and heart.
Facing p. {130}	He had crept downstairs to take a peep into the parlour.
Facing p. {152}	She Lufs Me—She Lufs Me Not.
Facing p. {174}	The Three Bears.
Facing p. {206}	Beauty and the Beast.
Facing p. {240}	She knew she could eat one whenever she wanted to, so she was in no hurry.
Facing p. {260}	Little Red Riding Hood.
Facing p. {268}	Robin put his head down on his arm and shut his eyes.
Facing p. {296}	A Modern Cinderella.

Issue Points: First issue with 13 color plates. Some copies examined had plates inserted in varying positions. One copy had 14 color plates. Second issue with 8 color plates, has different binding.
Note on Illustrations: All of these illustrations originally appeared in THE NOW-A-DAYS FAIRY BOOK (*A34*) and THE EVERY DAY FAIRY BOOK (*A44*).

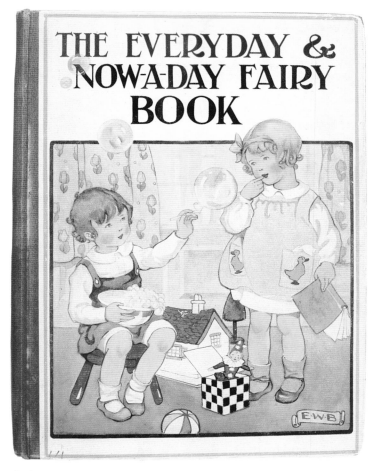

Book cover

Frontispiece

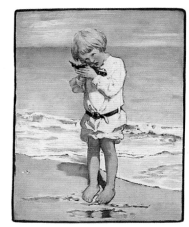

Facing p. 84

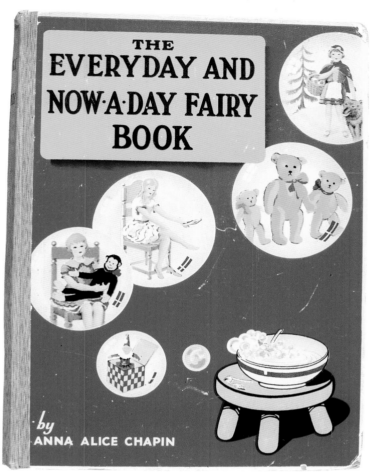

Book cover

B19. THE EVERYDAY AND NOW-A-DAY FAIRY BOOK
8 Color Plates

Title: Identical to *B18*, but with 8 in place of 13 illustrations in colour.
Size of Book: 29 x 21.5 cm.
Size of Leaf: 28.1 x 21 cm.
Pagination: [300] pp.
Collation: Frontispiece in color facing title; title [3]; imprint (Same as *B18*) [4]; contents [5]-[6]; text [7]-[298]; imprint (Same as *B18*) [300].
Description: Issued in quarter cloth (green and white) with color pictorial paper covered boards. Front cover with pictures of children, teddy bears, etc., inside bubbles, with red background. Printed in black: THE / EVERYDAY AND / NOW-A-DAY FAIRY / BOOK. Printed in white: by / Anna Alice Chapin. Spine printed in black: THE / EVERYDAY / AND / NOW-A-DAY / FAIRY / BOOK / (ornament) / Chapin / London.
Paper: Wove.
Illustrations: Eight full-color captioned plates. Color pictorial cover not by Smith.

{Frontispiece} Ever since he had been a little, little boy, he had thought what fun it would be if Jack should pop up and cry: "Hello, Frank!"
Facing p. {54} She knew she could eat one whenever she wanted to, so she was in no hurry.
Facing p. {84} Billy-Boy's discovery was a sea-gull with an injured wing.
Facing p. {130} He had crept downstairs to take a peep into the parlour.
Facing p. {174} The Three Bears.
Facing p. {206} Beauty and the Beast.
Facing p. {260} Little Red Riding Hood.
Facing p. {296} A Modern Cinderella.

Issue Points: Facsimile of *B18*, with only 8 color plates and with different color pictorial cover. The 8 color plate edition also found with color insert as *B18* (E. W. B.).
Note on Illustrations: Numerous copies examined have displaced plates in varying locations.

B20. THE EVERYDAY FAIRY BOOK
English Coker Edition
Chapin, Anna Alice.
London n. d. (c. 1935).
J.Coker & Co.

Title: THE EVERYDAY / FAIRY BOOK / By / Anna Alice Chapin / Author of "Humpty Dumpty" "The Now-A-Days Fairy Book" etc. / With Illustrations in Colour / By Jessie Willcox Smith / (drawing - three children) / London: J. Coker & Co. / 6 Farringdon Avenue, E. C. 4.

Size of Book: 29.3 x 22 cm.

Size of Leaf: 28.7 x 21.5 cm.

Pagination: [xii], 159, [3] pp.

Collation: Half-title [i]; Uniform with this Volume [ii]; frontispiece in color with caption facing title; title (with drawing) [iii]; imprint (Printed in Great Britain by Jarrold & Sons Ltd., Norwich) [iv]; contents [v]; illustrations [vii]; verse [ix]; divisional title [xi]; verse - Pretending [xii]; text 1-159, [1], drawing of girl at door [2].

Description: Issued in quarter cloth (red) with full size color pictorial insert on cover. Offset in white: THE / EVERYDAY / FAIRY BOOK / by / Anna Alice Chapin / Pictured by / Jessie Willcox Smith. Spine printed in black: THE / EVERY / DAY / FAIRY / BOOK / (ornament) / Chapin / London.

Paper: Wove.

Illustrations: Seven full-page color plates, color insert front cover and drawing on title-page.

Cover insert	She knew she could eat one whenever she wanted to, so she was in no hurry.
Frontispiece	Ever since he had been a little, little boy, he had thought what fun it would be if Jack should pop up and cry: "Hello, Frank!"
Facing p. 42	She came down from the platform, still bravely choking back her tears.
Facing p. 56	She knew she could eat one whenever she wanted to, so she was in no hurry.
Facing p. 68	She was sitting in a hammock, trying to amuse herself with an old Atlas and not succeeding at all well.
Facing p. 92	Billy-Boy's discovery was a sea-gull, with an injured wing.
Facing p. 124	A Broken Head—and Heart.
Facing p. 144	He had crept downstairs to take a peep into the parlour.

Issue Points: Facsimile of Harrap Edition with different insert on cover, different cloth spine, addition of drawing on last page, and advertisement on verso of half-title. Also, with Coker cancel title and imprint page.

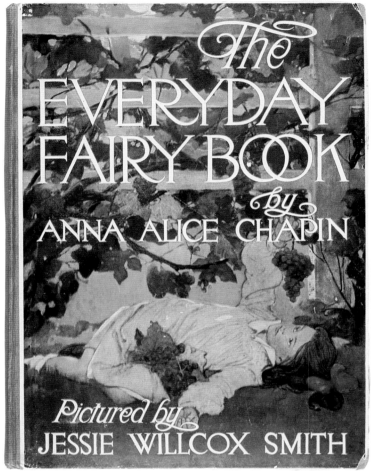

Book cover

Facing p. 124

Facing p. 92

Facing p. 16

Facing p. 122

B21. THE NOW-A-DAYS FAIRY BOOK
English Coker Edition
Chapin, Anna Alice.
London, n. d. (c. 1935).
J. Coker & Co.

Title: THE NOW-A-DAYS / FAIRY BOOK / By / Anna Alice Chapin / "There are just as many Fairies now-a-days" . . . / What Grandmother always said / With Illustrations in Colour / By Jessie Willcox Smith / (drawing) / London: J. Coker & Co. / 6 Farringdon Avenue, E. C. 4
Size of Book: 29.3 x 22 cm.
Size of Leaf: 28.7 x 21.5 cm.
Pagination: 159, [1] p.
Collation: Half-title [1]; Uniform with this Volume (EVERYDAY FAIRY BOOK) [2]; frontispiece with caption facing title; title (with drawing) [3]; imprint (Printed in Great Britain by the Riverside Press Limited, Edinburgh) [4]; contents [5]; verse [6]; text 7-159; verse [1].
Description: Issued in quarter cloth with color pictorial insert on front cover, paper covered boards.
Paper: Wove.
Illustrations: Six full-page color plates, color insert on front cover.

Frontispiece	Robin Put His Head Down on His Arm, and Shut His Eyes.
Facing p. 16	She Lufs me—She Lufs Me Not.
Facing p. 38	The Three Bears.
Facing p. 68	Beauty and the Beast.
Facing p. 122	Little Red Riding Hood.
Facing p. 158	A Modern Cinderella.

Issue Points: Facsimile of Harrap Edition with different cover insert, different color cloth on spine, paper covered boards, and Coker cancel title and imprint page.

141

B22. THE WATER BABIES
English Hodder Color Book Edition
Kingsley, Charles.
London, 1938.
Hodder and Stoughton.

Title: THE WATER BABIES / Charles Kingsley / Pictures by / Jessie Willcox Smith / (drawing) / Hodder and Stoughton. With decorative borders.

Size of Book: 25.4 x 18.3 cm.

Size of Leaf: 24.8 x 17.1 cm.

Pagination: x, 212 pp.

Collation: Half-title (decorative borders) [i]; Hodder & Stoughton's Colour Books (10 titles) [ii]; frontispiece with caption facing title; title [iii]; copyright (First Printing, 1938) (Published by Hodder and Stoughton, Limited), imprint (Made and Printed by Hazell, Watson & Viney, Ltd. London and Aylesbury) [iv]; About This Book, v; contents, vii; The Pictures, ix-x; divisional title (1); text 2-212.

Description: Issued in full cloth (gray) with pictorial cover and lettering in red: THE / WATER BABIES / Charles Kingsley / Pictured by / Jessie Willcox Smith / (pictorial illustration - child riding fish). Spine printed in red: (rule) / THE / WATER / BABIES / Charles / Kingsley / Pictured By / Jessie / Willcox / Smith / (rule) / Hodder & / Stoughton. Endpapers gray stock with decorative borders and drawing in red.

Paper: Wove.

Illustrations: Twelve full-page captioned color plates black-and-white drawings throughout, decorative borders, endpapers, all by Smith.

Frontispiece	"No. She cannot be dirty. She never could have been dirty."
Facing p. 39	He felt how comfortable it was to have nothing on but himself.
Facing p. 54	"Oh, don't hurt me!" cried Tom. "I only want to look at you; you are so handsome."
Facing p. 71	He looked up at the broad yellow moon . . . and thought that she looked at him.
Facing p. 86	Tom sat upon the buoy long days, long weeks, looking out to sea.
Facing p. 103	He felt the net very heavy; and lifted it out quickly, with Tom all entangled in the meshes.
Facing p. 118	Tom reached and clawed down the hole after him.
Facing p. 135	They hugged and kissed each other for ever so long, they did not know why.
Facing p. 150	Mrs. Be-done-by-as-you-did. "Little boys who are only fit to play with sea-beasts cannot go there," she said.
Facing p. 167	And there he saw the last of the Gairfowl standing up on the All-alone-stone, all alone.
Facing p. 182	It took the form of the grandest old lady he had ever seen.
Facing p. 206	You are our dear Mrs. Do-as-you-would-be-done-by.

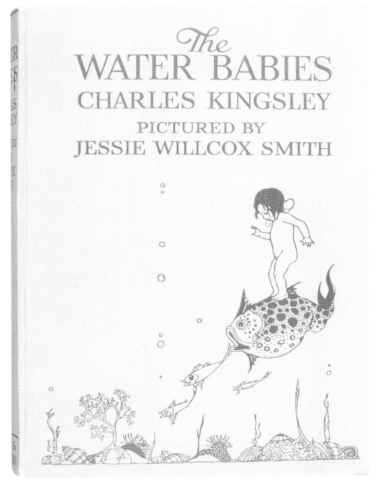

Book cover

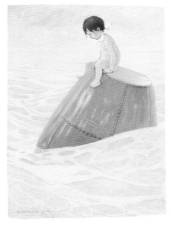

Facing p. 86

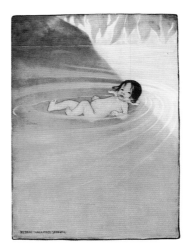

Facing p. 39

142

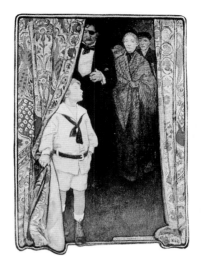

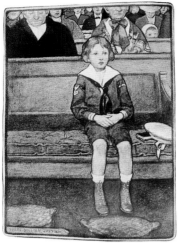

Illustrations in Periodicals

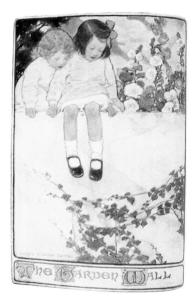

The Garden Wall

The Green Door

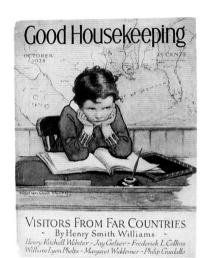

Good Housekeeping

OCTOBER
1928

25 CENTS

VISITORS FROM FAR COUNTRIES
— By Henry Smith Williams —
Henry Kitchell Webster — Jay Gelzer — Frederick L. Collins
William Lyon Phelps — Margaret Widdemer — Philip Guedalla

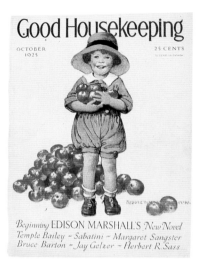

Good Housekeeping

OCTOBER
1925

25 CENTS

Beginning EDISON MARSHALL'S New Novel
Temple Bailey — Sabatini — Margaret Sangster
Bruce Barton — Jay Gelzer — Herbert R. Sass

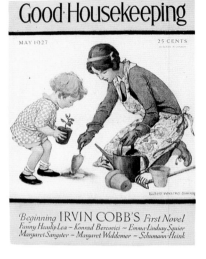

Good Housekeeping

MAY 1927

25 CENTS

Beginning IRVIN COBB'S First Novel
Fanny Heaslip Lea — Konrad Bercovici — Emma-Lindsay Squier
Margaret Sangster — Margaret Widdemer — Schumann-Heink

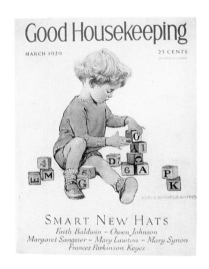

Good Housekeeping

MARCH 1929

25 CENTS

SMART NEW HATS
Faith Baldwin — Owen Johnson
Margaret Sangster — Mary Lawton — Mary Synon
Frances Parkinson Keyes

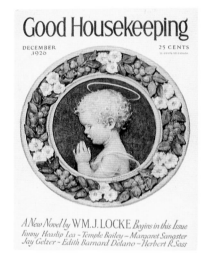

Good Housekeeping

DECEMBER
1926

25 CENTS

A New Novel by WM. J. LOCKE Begins in this Issue
Fanny Heaslip Lea — Temple Bailey — Margaret Sangster
Jay Gelzer — Edith Barnard Delano — Herbert R. Sass

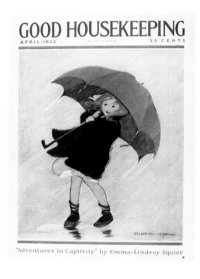

GOOD HOUSEKEEPING

APRIL 1922

25 CENTS

"Adventures in Captivity" by Emma-Lindsay Squier

Good Housekeeping

FEBRUARY
1927

25 CENTS

Mary Lawton's Autobiography of
Schumann-Heink — Fanny Heaslip Lea — Jay Gelzer
Mariel Brady — Wm. J. Locke — Margaret Sangster

Good Housekeeping

JULY 1930

25 CENTS

Beginning EDISON MARSHALL'S New Novel
Irvin S. Cobb — E. Barrington — Robert Hichens
Adventures of Two New York Society Girls in Red Russia
ANOTHER LITTLE POEM BY GRACE COOLIDGE

Good Housekeeping

MAY 1932

25 CENTS

Beginning "Half Angel"
BY FANNY HEASLIP LEA
Why I Am My Husband's Secretary
By Mrs. John N. Garner

Appleton's Magazine

1908

May.	P. 543-549. *"If the children knew that their errors will be pardoned they have less motive to cover them up."* For "Must Your Children Lie?" by G. Stanley Hall. Full-page black-and-white illustration.

Brush and Pencil

1906

October.	Not seen.

Century

1902

December.	P. 174-186. "While the Mother Works: A Look at the Day Nurseries of New York" by Lillie Hamilton French. Three full-page, four half-page, three quarter-page black-and-white illustrations.

1904

May.	P. 54. "Spring" by Alice Williams Brotherton. One full-page black-and-white illustration.

Collier's

1899

October 18.	Cover. Not seen.

1903

January 3.	Cover. Not seen.

1904

April 2.	Cover. *"Easter"*. Full-color circular illustration of woman and child smelling flower.
April 30.	Cover. *"The Maypole"*. Full-color circular illustration.
May 28.	Cover. Tinted illustration of two women sitting on wall in front of blossom tree.
June 25.	Cover. Circular tinted illustration of girl watering roses, with long stem rose on each side.
June 30.	Cover. Tinted illustration of girl on rock with feet in water.
August 27.	Cover. Full-color illustration of woman with large leaf sitting with sleeping child.
September 24.	Frontispiece (page 7). *"Autumn Days"*. Full-page black-and-white illustration.
December 3.	Frontispiece (page 7). *"Christmas Eve"*. Full-page tinted illustration.
December 31.	Frontispiece (page 5). *"Kept In"*. Full-page tinted illustration.

1905

February 25.	Cover. Circular tinted illustration of child on sled racing downhill.
March 25.	Cover. Tinted illustration of girl with umbrella.
April 15.	P. 15. *"Foreign Children"*. Full-page tinted illustration.
April 29.	Cover. *"The Secret"*. Tinted illustration.
May 13.	Frontispiece (page 7). *"The Recitation"*. Full-page black-and-white illustration.
May 27.	Cover. Tinted illustration of young boy with upraised glass at soda fountain.
June 24.	Cover. Circular tinted illustration of girl reading book in hammock.

July 29.	Cover. Circular tinted illustration of girl sewing on front step.
August 26.	Cover. Tinted illustration of woman kneeling, picking flowers.
September 16.	Cover. *"The Hayloft"*. Tinted illustration.
September 30.	Cover. Not seen.
November 25.	Cover. *"The Northwest Passage"*. Tinted illustration.
December 16.	Cover. Not seen.
December 16.	Not seen.
December 23.	Cover. *"Picture Books in Winter"*. Tinted illustration.
December 23.	P. 19-20. "Signs of the Stars" by Owen Oliver. *"She fetched her books and laid them out on the window sill"*. Quarter-page black-and-white illustration.
December 30.	Cover. *"Billy-Boy"*. Oval color illustration.
December 30.	P. 16-19. *"Billy-Boy"*. One head piece and two half-page black-and-white illustrations.

1906

January 27.	Cover. Tinted illustration of two children playing checkers.
February 24.	Cover. *"Tragedies of Childhood: The Popular Cut"*. Tinted illustration.
March 31.	Cover. *"Tragedies of Childhood: A Broken Head and Heart"*. Tinted illustration.
April 7.	Frontispiece (page 7) *"His Easter Lily"*. Full-page color illustration.
April 7.	P. 19-20, 27. "A Pillar of Society" by Josephine Bacon. One half-page headpiece, two quarter-page black-and-white illustrations.
April 28.	Cover. *"Tragedies of Childhood: The Hurt Finger"*. Tinted illustration.
May 26.	Cover. Tinted illustration of child with one shoe, holding newspaper.
May 26.	P. 16-18. "A Tempered Wind" by Georgia Wood Pangburn. Two half-page, two quarter-page black-and-white illustrations.
June 30.	Cover. Full-color illustration of mother reading large book with two children on chair.
July 28.	Frontispiece (page 5). *"The Land of Counterpane". Full-page tinted illustration.*
September 1.	P. 22-23. *"A Few Words About Art"*. Small color illustration of boy (Billy-Boy) on beach holding dove.
September 29.	Cover. *"The Comedies of Childhood: Peep-Bo!"*. Tinted illustration.
October 6.	P. 20-21. "Out of the House of Bondage" by Grace MacGowan Cooke. Two quarter-page black-and-white illustrations.
November 24.	Cover. *"The Comedies of Childhood: Jack in the Box"*. Tinted illustration.
December 15.	Cover. Full-color illustration of two children nodding in front of fireplace on stools.
December 15.	P. 23-24, 26. "Ladybird" by Edith Barnard. One half-page and two quarter-page black-and-white illustrations.
December 22.	Frontispiece (page 8). *"Bed in Summer"*. Tinted illustration.

1907

January 26.	Cover. *"Tragedies of Childhood: Lost"*. Tinted illustration.
March 16.	Cover. *"The March Wind"*. Tinted illustration.
June 29.	Cover. *"She Lufs Me-She Lufs Me Not"*. Full-color illustration.
September 28.	Frontispiece. *"Goldilocks and the Three Bears"*. In color.

October 5. **Cover.** *"The Helper"*. Full-color illustration.

December 14. **P. 8.** "The Procession of the Blest" by W. J. Foley. Full-color headpiece.

December 21. **Cover.** *"Twas the Night Before Christmas"*.

December 28. **Cover. Not seen.**

1908

January 25. **Cover. Not seen.**

May 30. **Frontispiece (page 6).** *"Beauty and the Beast"*. Full-page color illustration.

December 12. **Frontispiece (page 10).** *"A Modern Cinderella"*. Full-page color illustration.

1909

November 20. **Frontispiece (page 8).** *"Little Red-Riding-Hood"*. Full-page color illustration.

December 11. **Frontispiece (page 8).** *"Caught in the Act"*. Full-page color illustration.

1910

June 11. **Frontispiece (page 8).** *"Sleeping Beauty"* Full-page color illustration.

1914.

April 11. **Cover.** Tinted illustration of young child examining Easter lily.

1915

December 25. **P. 16-17** "Procession of the Blest" by W. J. Foley. Two-page tinted illustration reproduced from *Collier's* Dec. 14, 1907.

1916

December 9. **Cover.** Full-color illustration of girl in shawl kneeling in front of child with books.

Delineator

1915

June. **Cover.** *"Little Women"*. Full-color illustration.

Frank Leslie's Popular Monthly

1903

February. **P. 386-396.** "The Pettison Firsts" by Marion Hill. Two full-page, one three-quarter page, two half-page black-and-white illustrations.

March. **P. 482-488.** "A Princess Listens" by Roy Rolfe Gilson. Two full-page and two half-page black-and-white illustrations.

August. **P. 320-327.** "Within the Ring of Singing A Story of the Pettison Twins" by Marion Hill. One small black-and-white and two full-page illustrations.

Good Housekeeping Magazine

I. Internal Illustrations.

1912

December. **P. 730-731.** *"Pease-Porridge Hot, Pease-Porridge Cold"*. Double-page tinted illustration.

1913

January. **P. 12-13.** *"Little Miss Muffet sat on a Tuffet"*. Double-page tinted illustration.

February. **P. 156-157.** *"See-saw, Margery Daw"*. Double-page tinted illustration.

March. **P. 302-303.** *"The Way to London Town"*. Double-paged tinted illustration.

April. **P. 446-447.** *"Rain, Rain Go Away"*. Double-page tinted illustration.

May. **P. 590-591.** *"The Old Woman Who Lived in a Shoe"*. Double-page tinted illustration.

June. **P. 730-731.** *"Mary, Mary Quite Contrary"*. Double-page tinted illustration.

July. **P. 2-3.** *"Little Bo-Peep Has Lost Her Sheep"*. Double-page tinted illustration.

August. **P. 160-161.** *"Jack and Jill"*. Double-page tinted illustration.

September. **P. 306-307.** *"Rock-A-Bye Baby, On the Tree Top"*.Double-page tinted illustration.

October. **P. 462-462.** *"A Diller, A Dollar"*. Double-page tinted illustration.

November. **P. 608-609.** *"Peter, Peter, Pumpkin Eater"*. Double-page tinted illustration.

December. **P. 846-847.** *"Little Jack Horner"*. Double-page tinted illustration.

1914

January. **P. 120-121.** *"Curly Locks, Curly Locks"*. Double-page tinted illustration.

February. **P. 206-207.** *"Polly, Put the Kettle On"*. Double-page tinted illustration.

March. **P. 410-411.** *"Round the Ring of Roses"*. Double-page tinted illustration.

April. **P. 552-553.** *"Hot Cross Buns"*. Double-page tinted illustration.

1916

March. **P. 321.** "Mothers and Children" by Mrs. Louise Hogan, *"Outdoors"*. Quarter-page black-and-white illustration.

September. **P. 32-34, 108-112.** "What Really Happened" by Dorothy Canfield. *"With the scissors in his hand.."* Full-page tinted illustration.

1917

February. **P. 33-35, 113-115.** "Betty Manifests the Spirit" by Claudia Cranston. Full-page tinted illustration.

II. Covers. *All in full color. Caption or partial title noted when appearing on cover or in contents. First few words of copy on cover is given in boldface, as well as description of illustration.*

1917

December. **A Big New Serial.** Madonna and child pictured in circular illustration with border motif of winged child.

1918

January. Young child with flag wrapped around body.

February. Two young girls winding yarn.

March. Soldier kissing young girl in front yard of house.

April. Young child looking into goldfish bowl on window seat.

May. Circular illustration of baby surrounded by floral motif.

June. **Beginning "Sisters".** Young girl picking pink flowers.

July. **In This Issue: "Sisters".** Young girl and boy on hammock reading book.

August. Child about to wade in surf.

September. **Beginning: "The Web of the Spider".** Sailor pointing with boy on hill near beach.

October. **We Fight For Them.** Mother and daughter reading book under tree.

November. Child raking leaves.

December. Christ-child praying on knees.

1919

January.	New Year's child with gun and hat standing on top of world.
February.	Child knitting on chair.
March.	Two children sledding.
April.	Child smelling tulips.
May.	**Beginning: A Brand New Serial by Wm. J. Locke.** Child plowing field.
June.	**Beginning Coningsby Dawson's New Novel.** Child watering flowers.
July.	**"Young Mrs. Jimmy".** Child in wading pool.
August.	Little child in canoe with paddle.
September.	**A New Curwood Serial.** Mother and two children reading book near beach.
October.	**God's In His Heaven** by Kathleen Norris. Mother and child praying in front of window.
November.	Child rolling pumpkin.
December.	Child with halo; circular floral motif.

1920

January.	No issue; printer's strike.
February.	**All Wylie, Wiley.** Young child on chair reading *Animal Book*.
March.	**Coningsby Dawson's New Story "The Little House".** Child pouring milk for kitten.
April.	**Spring Fashions.** Young girl pictured within pendant wearing bonnet.
May.	Child picking blossoms off tree.
June.	**"The Immigrant Speaks"** by Anzia Yezierska. Child holding bowl of cut roses.
July-August.	**Midsummer Fiction Number.** Girl wading in ocean.
September.	**"More Stately Mansions"** by Ben Ames Williams. Girl and boy standing in doorway.
October.	**Kathleen Norris, Ben Ames Williams, Wm.J.Locke.** Boy and girl carrying basket of apples.
November.	**"The Flaming Forest".** Two girls saying grace.
December.	**"The Flaming Forest"** by James Oliver Curwood. Angel praying (stained glass).

1921

January.	**Beginning Coningsby Dawson's New Serial.** New Year baby sitting on the moon.
February.	**"Something Afar"** by Fanny Heaslip Lea. Girl painting at a table.
March.	**Stories by Coningsby Dawson, Kathleen Norris, James O. Curwood.** Young boy shoveling snow.
April.	**Spring Fashions.** Girl in hat and cape holding purse.
May.	**Frances Hodgson Burnett. Coningsby Dawson.** Young girl with hat box.
June.	**Stories by Kathleen Norris. Frances Hodgson Burnett.** Girl in summer dress with pantaloons and hat holding daisy.
July.	**The Story of the Women Voters' Big Convention.** Two children wading.
August.	**Midsummer Fiction Number.** Mother and child looking at moon through trees.
September.	**Beginning "The Dust Flower".** Young girl and butterflies.
October.	**"His Soul Goes Marching On"** by Mary R.S. Andrews. Mother and child reading book outside.
November.	**Dawson's New Serial "The Vanishing Point".** Two children on a chair looking at book.

December.	**"Christmas".** Madonna and child surrounded by fruit and flower motif.

1922

January.	**Basil King, James Hopper.** Baby looking over mother's shoulder, surrounded by circular design.
February.	**Beginning Locke's Serial "The Tale of Triona".** Child walking in snowshoes.
March.	**"It Gives A Lovely Light"** by Fanny Heaslip Lea. Mother buttoning child's coat.
April.	**"Adventures in Captivity"** by Emma Lindsay Squier. Young girl with green umbrella.
May.	**A Novel That Challenges Every Ambitious American.** Girl with basket of flowers.
June.	**Summer Fashions-Twelve Stories and Articles.** Young girl feeding child on stool.
July.	**"The Inheritors"-A New Serial** by I.A.R.Wylie. Child opening gate into courtyard.
August.	**Midsummer Fiction Number.** Child with dog on beach.
September.	**The Adventurers** by Ben Ames Williams. The Discovery of God. Girl lying among flowers.
October.	**Beginning a Great Big Serial of Back Home.** Child writing on chalk board.
November.	**"David Copperfield and His Mother".** Mother with parasol and white dress, and boy in black suit.
December.	**"Bob Cratchit and Tiny Tim".** Man and boy singing hymn in church.

1923

January.	**Two Big Serials.** (Hans Brinker and his sister. Gretel). Dutch boy and girl ice skating.
February.	**"Little Women".** Meg, Jo, Amy and Beth sitting together, reading book.
March.	**"Alice in Wonderland".** Alice and several characters from the story.
April.	**"The Little Lame Prince".** Prince riding inside cape in sky.
May.	**Famous Children in Fiction-Sara Crewe.** Girl and doll in window seat with opened window.
June.	**Famous Children in Fiction-Jackanapes.** Young boy on horse, goose on ground.
July.	**Famous Children in Fiction-Rebecca of Sunny-brook Farm.** Girl riding in stagecoach with umbrella, lilacs and bag.
August.	**Famous Children in Fiction-Heidi.** Girl on mountain meadow with two goats.
September.	**Famous Children in Fiction-Little Nell and her Grandfather.** Old man and young girl walking on a dirt road.
October.	**Famous Children in Fiction-Mowgli.** Young Indian boy with bear and wolf cubs.
November.	**Famous Fairy Stories-Hansel and Gretel.** Young boy and girl in dark woods.
December.	**Famous Fairy Tales-The Snow Queen.** Snow Queen in sky holding a young child.

1924

January.	**Beginning Wonder Stories of Nature.** Head of baby wearing white bonnet with blue bow.
February.	**Beginning a New Novel** by Temple Bailey **"Peacock Feathers".** Boy and girl on bench looking at a valentine.

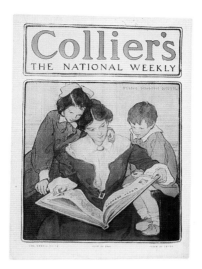

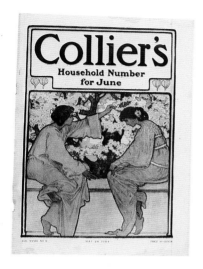

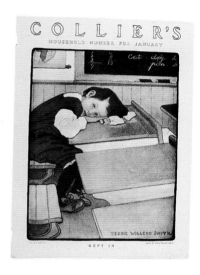

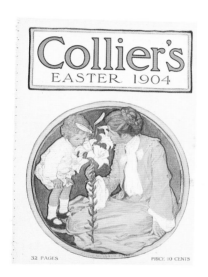

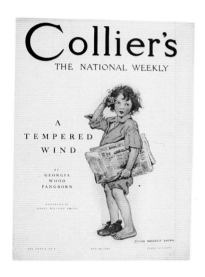

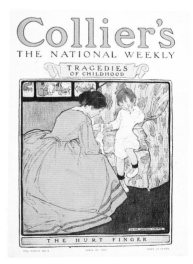

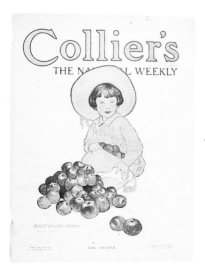

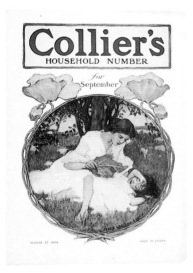

March.	A Complete Short Novel by Edith Barnard Delano. Girl in orange and blue hat with scarf.
April.	Gene Stratton-Porter, Temple Bailey, Louis Dutton. Child with orange umbrella.
May.	Beginning a Novel of the American Revolution. Girl in lilac colored dress, looking at a book.
June.	Sabatini's New Novel. Girl smelling rose on a bush.
July.	Beginning George Weston's New Novel. Two children playing in sand.
August.	The Secret of Lasting Youth by Mary Garden. Two girls picnicking on the beach.
September.	Beginning "Love". Two children holding hands going to school.
October.	Love. A Novel by "Elizabeth". Child beside large basket of grapes, eating grapes.
November.	Beginning "Children of the Twilight". Young boy sitting on a pumpkin.
December.	Beginning Old Youth by Coningsby Dawson. Mary kneeling beside Christ-child.

1925

January.	Dawson's New Novel "Old Youth". Child inside travelling bag labeled "New Year".
February.	Beginning A New Novel by Basil King. Child in winter ermine suit.
March.	"Bluebeard's Chamber" by J.A.R.Wylie. Grandmother in rocking chair reading with child.
April.	40th Anniversary Number. Child in purple cape holding bouquet.
May.	Funny Heaslip Lea's New Novel. Child feeding chickens.
June.	A New Short Story by Kathleen Norris. Mother reading with child on beach.
July.	Irvin Cobb's Newest Short Story. Young girl in yellow dress standing on rock.
August.	"The Long-Pants Age" by Irvin S. Cobb. Child with parasol and bucket on beach.
September.	Beginning Temple Bailey's New Novel. Mother carrying child through garden.
October.	Beginning Edison Marshall's New Novel. Child with apples.
November.	"Don't be a Copy-Cat" by Mary B. Mullett. Child eating turkey dinner.
December.	A New Novel by Wm. J. Locke. Statue of Angelic Child.

1926

January.	Dean Cornwell's First Hold Land Picture. New Year baby in fur suit holding 1926 lantern.
February.	Beginning a New Novel. Two children on sled.
March.	*George Weston's New Serial.* Girl with red hair sewing.
April.	Beginning "The Gallant Lady" by Margaret Widdemer. Two children huddled under red umbrella.
May.	Beginning "Tales of the Great Road". Young boy on rocking horse.
June.	"Born to the Purple" by Mabel Potter Daggett. Two young children kissing.
July.	Not seen.
August.	Midsummer Fiction Number. Child with doll sitting among suitcases and trunks.
September.	Temple Bailey's New Novel. Mother with daughter among flowers reading book.

October.	Beginning Sir Philip Gibbs' New Story. Young girl holding bunch of maple leaves.
November.	A New Genevieve Gertrude Story. Two children dancing.
December.	A New Novel by Wm.J.Locke Begins in this Issue. Angelic child surrounded by circular floral design.

1927

January.	Beginning the Life Story of a Great Singer. Child with muffler walking in wind.
February.	Mary Lawton's Autobiography of Schumann-Heink. Child mailing letter.
March.	The Law Protects the Criminal. Child playing with telephone.
April.	Beginning a New Novel by the Author of *"The Gallant Lady"*. Girl carrying potted plant.
May.	Beginning Irvin Cobb's First Novel. Mother and child planting flower.
June.	When a Girl Would Marry. Young girl looking at flowers on table.
July.	Beginning "Tales of an Antique Shop". Two children drinking water from well.
August.	Beginning a New Novel of Far Adventure. Girl in rowboat.
September.	Beginning "Silver Slippers". Girl eating slice of watermelon.
October.	Religion in Education. Young girl picking grapes.
November.	Beginning Garden Oats by Faith Baldwin. Child and large turkey.
December.	A New Series of Bible Pictures by Dean Cornwell. Madonna and child.

1928

January.	Beginning "Problems of Youth" by Jessica Cosgrave. Mother with child on lap.
February.	A Disease that Leads to Divorce. Young girl reading valentine.
March.	Beginning "Rich People" by Jay Gelzer. Two children playing pat-a-cake.
April.	Smart Spring Fashions. Child with tulips on window ledge.
May.	Beginning Edison Marshall's New Serial. Young girl picking daisies.
June.	Beginning "Tiger, Tiger" by Honore Willsie Morrow. Woman pinning rose on child's lapel.
July.	Smart Fashions for Traveling. Young boy playing golf.
August.	Beginning "Rhinestones". Mother and child waving from ship.
September.	Henry Kitchell Webster's New Mystery Novel. Girl on swing.
October.	Visitors from Far Countries. Boy at desk with chin in hands.
November.	Winter Fashions. Country child with corn and pumpkin.
December.	A New Novel by Owen Johnson. Christmas. Three carolers dressed in red.

1929

January.	"The Golden Trail" by Emma Lindsay Squier. Child with hourglass; old man with sickle.
February.	Beginning Faith Baldwin's New Novel. Two children ice skating.
March.	Smart New Hats. Boy with building blocks.
April.	Beginning a New Serial by George Weston. Two children, one crying.

May.	Neighbors Across the Line. Child selling flowers.
June	Beginning a New Novel of the North. Child smelling blossoms.
July.	A Job For Every Woman. Young girl on hammock with doll.
August.	Beginning the White House Gang. Two children holding hands on beach.
September.	Beginning Frederic Van de Water's New Mystery Novel. Child playing tennis.
October.	Castles in Spain. Mother and child collecting apples in apron.
November.	A Letter from South America. Boy with pumpkin in wheelbarrow.
December.	Beginning The Kramer Girls by Ruth Suckow. Mary kneeling before Christ-child in front of Christmas tree.

1930

January.	Beginning a New Novel by the Author of "The Constant Nymph". Boy dressed as aviator in front of airplane.
February.	Beginning "Stars and Scissors". Child on sled.
March.	Beginning Margaret Widdemer's New Serial. Mother and child rolling ball of yarn.
April.	Fashions From Paris Openings. Japanese child in Japanese dress.
May.	Beginning George Weston's New Novel. Boys playing marbles.
June.	Ring Lardner, Julia Peterkin. Young girl smelling irises.
July.	Beginning Edison Marshall's New Novel. Five children in hammock with kitten.
August.	Rex Beach, Ring Lardner. Child sitting on piling in surf.
September.	Beginning "Skywriters" by Lois Montross. Back of child on plank with picnic lunch.
October.	Beginning "My Story"-The Romance of Her Own Life. Two children and dog looking at picture book.
November.	The Castaway - A Short Story by Joseph C. Lincoln. Two children praying over harvest.
December.	Beginning Girl Alive by Kathleen Norris. Two children dressed as cooks carrying hot roast.

1931

January.	Uncle Sam and the Children. Child on skis over a globe.
February.	A Novelette by the Author of "Molly Make-Believe". Three children in winter clothes.
March.	Beginning the Murder at Hazelmoor. Young girl bouncing child on leg.
April.	Marriages Made in College by Rita S. Halle. Child getting haircut.
May.	Beginning Good-bye, Summer. Child digging up flowers.
June.	Beginning Edison Marshall's. Child picking strawberries.
July.	Eleanor Hallowell Abbot. Fanny Heaslip Lea. Boy holding American flag.
August.	Frau Albert Einstein. Mother dipping child in surf.
September.	Beginning Lord of Lonely Valley. Child with hat.
October.	Old Favorites Number. Child eating apple.

November.	Beginning "Young Mother Hubbard". Child rolling dough with rolling pin.
December.	Kathleen Norris' Story of Love on a Budget. Madonna and child.

1932

January.	"1931" boy handing four-leaf clover to "1932" New Year's Baby.
February.	"First in Peace". Child in patriot's costume.
March.	Beginning a New Cape Cod Novel. Child with toy and dog.
April.	The Lesson I Learned at Reno. Child rocking doll to sleep.
May.	Beginning"Half Angel". Child with aviator hat holding airplane.
June.	The Nurse on Horseback. Boy in tub with dog.
July.	Beginning Young and Fair. Child pinning clothes on line.
August.	Mary Roberts Rinehart's Big Fish Story. Two children in tub floating on water.
September.	Strange Morning-A Vivid Short Story. Child writing on blackboard with cat.
October.	Beginning The Light in the Jungle. Boy in football uniform.
November.	Beginning "Jigsaw" by Faith Baldwin. Child standing on footstool washing dishes.
December.	Pearl S. Buck. Mary Roberts Rinehart. Vicki Baum. More Christmas Gifts. Child lighting candle on window seat.

1933

January.	Grand Canary. New Year's Baby dropping from sky in parachute.
February.	Mr. Cohen. Child ringing doorbell with valentine.
March.	Mrs. James Roosevelt's Reminiscences of Her Son. Two girl scouts examining pussy willows.
April.	Beginning "The Man Who Went Back." Child with cat on window seat with fish bowl.

1934

May.	The Apple Tree. Child blowing out birthday cake candles.

Harper's Bazaar

1902

November.	P. 952-955. *"The Twilight of Life."* Four full-page black-and-white illustrations.
April.	P. 352-353. *"Two Careers."* Two black-and-white full-page illustration.
May.	Frontispiece. *"Stories Without Words".* Black-and-white.

1910

June.	Two girls in field of daisies.

1912

December.	P. 609. *"The Embarrassment of the Riches."* Full-page black-and-white illustration.

Harper's Monthly Magazine

1903

January.	P. 208-214. "As You Sailed" by Roy Rolfe Gilson. Full-page and two half-page black-and-white illustrations surrounded by tinted border design, and one tinted headpiece.

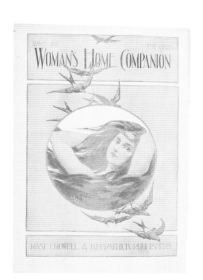

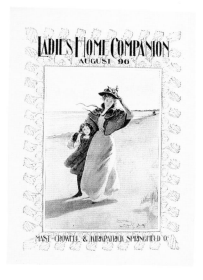

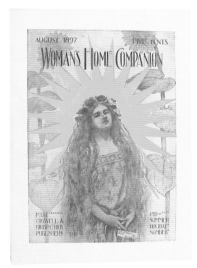

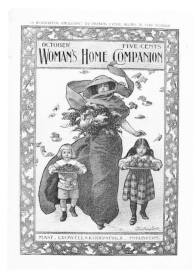

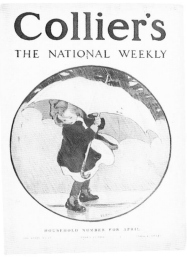

May. P. 923-928. "An Idealist" by Netta Syrett. *"Her Bedroom Window Stood Wide Open"*. Full-page black-and-white illustration.

Harper's Round Table

1891
April 14. *"Nursery Weather Signals"*. Black-and-white.

Harper's Weekly

1902
December 6. P. 16-17. *"Little Paul's Christ-child"* by Kathryn Jarboe Bull. Two half-page black-and-white illustrations.

1903
October 3. P. 1580. "Diversions of the Higher Journalist, A New Evil". *"Our elderly author finds himself in print . . . "*. One quarter-page black-and-white illustration.

Harper's Young People

1892
April 12. Cover. *"His First Easter"*.

The Independent

1915
December 6. Cover. *"Little Women"*. Full-color illustration.

Ladies' Home Companion
SEE *Women's Home Companion*.

Ladies' Home Journal

1896
September. P. 5. *"Poems of Childhood"*. Four black-and-white drawings.

1904
May. Cover. Tinted illustration of girl reading book entitled: *"This Little Pig"*.

October. Cover. Tinted illustration of Madonna kissing child with apples surrounding picture.

December. P. 7. *"The First Lesson"*. Full-page black-and-white illustration.

1905
January. P. 3 *"The First Punishment"*. Full-page black-and-white illustration.

March. P. 3. *"The First Love"*. Full-page black-and-white illustration.

April. Cover. *"The First Sermon"*. *Full-page tinted illustration*.

July. P. 5. *"The First Dissipation"*. Full-page black-and-white illustration.

November. P. 17. *"A Child's Good-Night Bedquilt"*. Half-page black-and-white illustration.

1907
April. P. 11, 76. *"Oh, I'll Be All Right, Here is Bruin"*. For "The Little White Bear" by Emerson Taylor. Half-page black-and-white illustration.

1908
November. P. 23. *"First the Infant in Its Mother's Arms"*. *Full-page black-and-white illustration*.

December. P. 13. *"Then the Toddling Baby Boy"*. Full-page black-and-white illustration.

1909
January. P. 12. *"Then the Epicure"*. Full-page black-and-white illustration.

March. P. 21. *"Then the Lover Sighing Like a Furnace"*. Full-page black-and-white illustration.

April. P. 21. *"Then the Scholar"*. Full-page black-and-white illustration.

August. P. 11. *"Then the Lean and Thoughtful"*. Full-page black-and-white illustration.

September. P. 21. *"Last Scene of All"*. Full-page black-and-white illustration.

1912
November. Cover. *"A Child's Grace"*. Full-color illustration.

1914
December. Cover. *"Tiny Tim"*. Full-color illustration.

1915
August. Cover. *"The Sandman"*. Full-color illustration.

Literary Digest International Book Review

1932
November. "More Books in the Home".

McClure's Magazine

1903
August. P. 338-347. "The Method of Charles Stuart York" by May Kelsey Champion. Two full-page illustrations, two half-page and one circular tailpiece, all in color.

1904
January. Cover. Color illustration of girl in blanket at campfire.

August. Cover. Color illustration of young girl sitting with hands across knees in long flowing dress.

August. P. 338-348. "In the Closed Room". Part One, by Frances Hodgson Burnett. Two full-page and two half-page color illustrations, one half-page black-and-white illustration.

September. P. 450, 470-481. "In the Closed Room". Part Two, by Frances Hodgson Burnett. Four full-page and one three-quarter page color illustrations.

1905
February. Frontispiece (facing p.337). *"An hour slipped by, but still the major did not come"*. For "The Old Major" by Florence Tinsley Cox (p.354-359). Full-page color illustration.

April. Facing p. 588. *"We were both silent. There did not seem to be anything more to talk about."* For "A Social Event" by Florence Tinsley Cox (p.587-592). Full-page color illustration.

1906

November.	P. 55. *"Madelon sank down upon the broad seat which stretches below the windows"*. For "Night, and the Curtain Drawn" by Justus Miles Forman (P. 56-61). Full-page color illustration.

1907

October.	P. 631-636. *"The Five Senses"*. Five full-page color illustrations and one full-page color title-plate.

1909

December.	**Cover.** Full-color illustration of two children on chair reading book.
December.	P. 177-182. *"A Child's World"*. Six full-page color plates.

National Weekly

1907

December 28.	**Cover.** *"The Sewing Lesson"*. Full-color illustration.

Red Cross Magazine

1918

December.	**Cover.** Full-color illustration of child taping Red Cross symbol to window.

Saint Nicholas Magazine

1888

May.	P. 551. *"Five Little Maidens"*. Half-page black-and-white drawing.

1891

May.	**"Dorothy, Dorcas and Dill"**. Black-and-white drawing.

1901

December.	P. 110. *"Repine-Not"*. For "Little Puritans" by Ethel Parton. Full-page black-and-white illustration.

1905

December.	P. 109. "Learning" by E. S. Martin. Full-page black-and-white illustration.

Scribner's Magazine

1900

August.	**Cover.** Full-color illustration of woman with wreath in hair wearing long white shawl and carrying book.
December.	P. 754-762. "The Emigrant East" by Arthur Colton. Two full-page, one half-page and two headpiece black-and-white illustrations.
December.	**Facing p.641.** "The Child" by Bertha Gerneaux Woods. One full-page tinted illustration.

1901

December.	P. 697-707. "The Last of the Fairy Wands" by William Henry Bishop. Two full-page, six half-page and one tailpiece, all tinted illustrations.

1902

December.	P. 685-692. For "A Mother's Days". Color title, six full-page color illustrations, color tailpiece: *"Morning"*, *"In the Garden"*, *"Fairy Tales"*, *"Supper"*, *"Checkers"*, *"Bedtime"*.

1903

April.	P. 457-466. "The Blue Dress" by Josephine Daskam. Nine one-third page black-and-white illustrations.
May.	P. 577-587. "Kitchen Sketches" by Elizabeth Hale Gilman. Four full-page tinted illustrations.
December.	P. 685-692. "The Child in a Garden". Eight full-page color plates: *"The Green Door"*, *"Five O'Clock Tea"*, *"The Garden Wall"*, *"Among the Poppies"*, *"The Lily Pool"*, *"The Spruce Tree"*.

1904

March.	P. 323-332. "Home Sketches" by Elizabeth Hale Gilman. Four full-page tinted illustrations.

1911

December.	P. 676-683. "Dickens's Children". Four Full-page color illustrations: *"Pip and Joe Gargery"*, *"Jenny Wren, the Little Doll's Dressmaker"*, *"Oliver's First Meeting with the Artful Dodger"*, *"Mrs. Kenwigs and the Four Little Kenwigses"*.

1912

August.	P. 160-163. "Dickens's Children". Two full-page color illustrations: *"Little Em'ly"*, *"The Runaway Couple"*.

1915

January.	**Frontispiece, P. 48-51.** "Kipling's Children". Four full-page color illustrations: *"Wee Willie Winkie"*, *"Baa Baa, Black Sheep"*, *"The Brushwood Boy"*, *"They"*.

1937

January.	P. 61. *"Boarding School"*. Two black-and-white drawings.

Southern Woman's Magazine

1918

February.	**Cover.** Tinted illustration of mother seated on bench with daughter's arms around her waist.

Woman's Home Companion
(Ladies Home Companion until 1897)

1896

August.	**Cover.** Black-and-white illustration of woman and girl on beach.
August.	P. 1-2, 13. *"'I never knew they committed any crimes', said Barbara, coldly"*. For "An Inheritance" by Harriet Prescott Spofford. One half-page black-and-white illustration. P. 3-4, 23. "A Colonial Dame" by Octave Thanet. One half-page black-and-white illustration and one black-and-white headpiece.

September. P. 1-2, 19. *"It was in the gray of the morning when he woke . . . and saw her kneeling at the window"* For "An Inheritance" by Harriet Prescott Spofford. One half-page black-and-white illustration.

October. P. 1-2, 13. *"He saw Nancy sitting on the hammock . . . "*. For "An Inheritance" by H. P. Spofford. One half-page black-and-white illustration.

November. P. 5-6, 13. *"He took her hand and kept it: it fluttered a moment, and then lay still in his"*. For "An Inheritance" by H. P. Spofford. One half-page black-and-white illustration.

November. **Cover.** Woman with shawl and overcoat in snow, in brown tone.

December. **Cover.** Tinted illustration of woman with angel carrying holly branch.

December. *"'Have you no mercy?', he stammered with his stiff, white lips"*. For "An Inheritance" by H. P. Spofford. One half-page black-and-white illustration.

1897
Name Changed To:
Woman's Home Companion

January. P. 1-2, 23. *"He came bounding up the steps with his cheery Halloo, Aunt Phebe! How are you?"* For "Paul Ralston" by M. J. Holmes. One half-page black-and-white illustration.

February. P. 1-2, 19. "Paul Ralston" by M. J. Holmes. Two quarter-page black-and-white illustrations.

March. **Cover.** Tinted illustration of woman with long flowing hair surrounded by birds.

March. P. 1-2. "Paul Ralston" by Mary J. Holmes. Two quarter-page black-and-white illustrations.

April. P. 3-4, 26. *"How sweet and modest and young she looked . . . "* For "Paul Ralston" by M. J. Holmes. One half-page black-and-white illustration.

June. "Paul Ralston" by Mary J. Holmes. Not seen.

August. **Cover.** Tinted illustration of woman with flowing hair under sunflowers.

1898

January. P. 9. "The New Galatea, A Farce" by Elizabeth Overstreet Cuppy. Four black-and-white drawings.

January. P. 5-6, 32. "The Wedding of Mr. Barrett's Niece" by Robert C. V. Meyers. Two quarter-page black-and-white illustrations.

March. P. 3-4. *"She nearly dropped. On the stairs, tied to the balusters, meekly sat the Reverend Mr. Markham"*. For "When the Everleigh House was Entered" by Robert C. V. Meyers. One half-page black-and-white illustration.

August. **Cover.** Not seen.

1907

December. **Cover.** Circular picture in color of mother holding child, surrounded by flower motif.

1908

November. *"The Better Treasure"* by Mary Raymond Shipman Andrews.

1909

December. *"Twinkle, Twinkle, Little Star"*. *Familiar Verses of Childhood*. Color illustration.

1910

March. P. 13-14. *"How Doth the Little Busy Bee"*. Familiar Verses of Childhood. Full-page color illustration.

May. P. 21-22. *"Let Dogs Delight to Bark and Bite"*. Familiar Verses of Childhood. Full-page color illustration.

September. P. 13-14. *"Little Drops of Water"*. Familiar Verses of Childhood. Full-page color illustration.

December. **Cover.** Madonna and child in full color.

1912

July. **Cover.** Full-color illustration of young child holding Japanese doll.

1913

March. P. 21. *"Snow White and Rose Red"*. Fairy Tales Series. Full-page color illustration.

April. *"Babes in the Wood"*. Fairy Tales Series. Full-page color illustration.

September. P. 19. *"Cinderella"*. Fairy Tales Series. Full-page color illustration.

October. P. 21. *"Goldilocks"*. Fairy Tales Series. Full-page color illustration.

December. **Cover.** Full-color illustration of woman with child in arms, surrounded by holly wreath.

1914

April. P. 21. *"Jack and the Beanstalk"*. Fairy Tales Series. Full-page color illustration.

1915

November. P. 14. *"Snow White and the Seven Dwarfs"*. Fairy Tales Series. Full-page color illustration.

December. P. 16. *"The Christmas Fairy"*. Full-page color illustration.

1919

December. P. 17. *"My Ball of Twine"*. by Josephine Fishburn. Full-page color illustration.

1920

September. P. 17. *"Diamond and His Mother by the Ocean"*. Full-page color illustration.

October. *"The collar was almost the worst part of the business"*. Full-page color illustration.

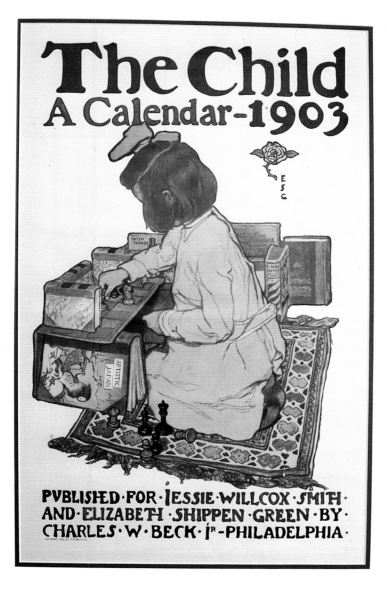

Calendars

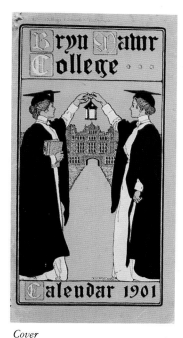

Cover

Page [4]

C1. BRYN MAWR COLLEGE CALENDAR FOR 1901

Title: BRYN MAWR / COLLEGE / CALENDAR / 1901 / Designed by / Jessie Willcox Smith / Elizabeth Shippen Green / (drawing).

Size of Book and Leaf: 34.2 x 17.5 cm.

Pagination: [19] pp.

Collation: Blank [1]-[2]; title (initials in calligraphy, B of Bryn Mawr, and design at bottom colored yellow) [3]; text [4]-[18]; [1]. Copyright (1900, Bryn Mawr College Students' Association), imprint (Beck Eng. Co., Phila.) (back cover).

Description: Gray stock wrappers with twine ties at spine. Cover with illustration in yellow, black, and silver. Printed in black with yellow and silver initials: BRYN MAWR / COLLEGE / (illustration) / Calendar-1901. Back cover with picture of lantern in silver, yellow, and black.

Paper: Wove.

Illustrations: Five full-page colored illustrations by Smith, 24 colored illustrations in the form of head and tail pieces by Elizabeth Shippen Green. Decorative floral panels throughout by Ellen W. Ahrens.

Cover.	(Two graduates holding lantern) In black, yellow, and silver.
Page {4}:	(Students ice skating) In red, black, and white.
Page {7}:	(Students playing May-Pole) In red, green, yellow, and black.
Page {11}:	(Graduates walking in long line) Signed by both Jessie Willcox Smith and Ellen W. Ahrens. In black, white, yellow, and blue.
Page {15}:	(Students playing soccer) In green, brown, black, and orange.

Note on Illustrations: First appearance of these illustrations which were made by Smith especially for this calendar while she was a student at the college.

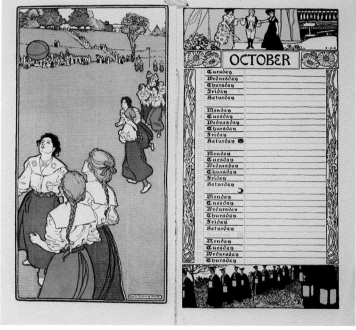

Page [15]

C2. BRYN MAWR COLLEGE CALENDAR FOR 1902

Title: BRYN MAWR / COLLEGE / CALENDAR / 1902 / Designed by Jessie Will / cox Smith and Elizabeth / Shippen Green.

Size of Leaf: 35.8 x 18.6 cm.

Pagination: [24] pp.

Collation: Copyright (1901, Bryn Mawr College Students' Association) (front cover); title (B in Bryn Mawr and 1902 in pink) [1]; text [2]-[24]; illustration (inside back cover); imprint (Beck Eng. Co., Phila.) and decorative date (back cover).

Description: Issued in stock wrappers with colored illustration front cover and decorative date back cover. Front cover with green decorative initials and printing in black: BRYN MAWR / COLLEGE / CALENDAR 1902 / (illustration by Elizabeth Shippen Green) / Copyrighted by the Bryn Mawr College Students' Association, 1901.

Paper: Wove.

Illustrations: Six full-page colored illustrations by Jessie Willcox Smith, six full-page colored illustrations by Elizabeth Shippen Green, one full-page colored illustration by Ellen Wetherald Ahrens. Decorative initials throughout.

Cover: (Student at desk with book) By Elizabeth Shippen Green. In black, brown, and green.

Page {3}: (Students spreading seeds along row of trees) By Jessie Willcox Smith. In black, red, and green.

Page {5}: (Students in library) By Jessie Willcox Smith. In black, green, and brown.

Page {7}: (Student and teacher riding horses in woods) By Elizabeth Shippen Green. In black, yellow, and green.

Page {9}: (Students in grandstand watching students play basketball). By Elizabeth Shippen Green. In black, orange, and blue.

Page {11}: (Students toasting at dinner table) By Elizabeth Shippen Green. In black, green, and light red.

Page {13}: (Graduate, woman with umbrella) By Ellen Wetherald Ahrens. In black, peach, and blue.

Page {15}: (Girl on sailboat) By Elizabeth Shippen Green. In black, white, and light blue.

Page {17}: (Students and passengers on coach in town) By Jessie Willcox Smith. In black, yellow, and green.

Page {19}: (Ye Gay Young Sub-Freshman). By Jessie Willcox Smith. In black, red, and green.

Page {21}: (Graduates with lanterns) By Jessie Willcox Smith. In black and light green.

Page {23}: (Students in costume dress) By Elizabeth Shippen Green. In black, peach, and blue.

Inside rear cover: (Students collecting boughs on snowshoes). By Jessie Willcox Smith. In black, red, and green.

Note on Illustrations: All these illustrations were commissioned by The Bryn Mawr College Students' Association and appear for the first time in this calendar.

Cover

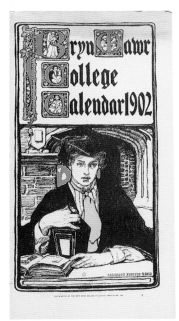

Page [5]

Page [19]

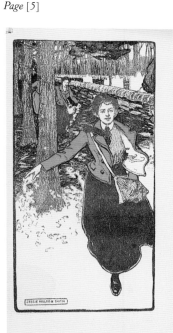

Page [3]

158

C3. "THE CHILD," CALENDAR FOR 1903

Title: THE CHILD / A CALENDAR-1903 / (color illustration) / Published for Jessie Willcox Smith / and Elizabeth Shippen Green by / Charles W. Beck, Jr.,—Philadelphia / (smaller print) Copyright 1902, C. W. Beck, Jr.

Size of Leaf: 50.5 x 35 cm.

Pagination: [7] pp.

Collation: Title and copyright [1]; text [2]-[7].

Description: Issued in folio size card sheets, bound at top with ties. Cover with color illustration and printing in black and green. Pages [2]-[7] consist of large color illustration (31 x 27.5 cm) with two months on each page printed in orange and black. On each side of the months are two panels with color illustrations.

Paper: Thick coated wove.

Illustrations: Three large color illustrations by Jessie Willcox Smith, three by Elizabeth Shippen Green. Twelve smaller color drawings as panels by Smith, twelve by Green. Cover in color by Elizabeth Shippen Green.

Note on Illustrations: (Illustrations as they appear in THE BOOK OF THE CHILD). A series of prints was simultaneously issued in portfolio in 1903 with all of these illustrations reproduced in color.

Cover:	Playing Chess. By Elizabeth Shippen Green.
Page {2}	Jan.-Feb.
	Warming Feet. By Jessie Willcox Smith.
Page {3}	Mar.-Apr.
	Playing Parchese. By Elizabeth Shippen Green.
Page {4}	May-Jun.
	Mushrooms. By Elizabeth Shippen Green.
Page {5}	Jul.-Aug.
	On the Hammock. By Jessie Willcox Smith.
Page {6}	Sep.-Oct.
	Apples. By Elizabeth Shippen Green.
Page {7}	Nov.-Dec.
	Toys. By Jessie Willcox Smith.

C4. "GIRLS," CALENDAR FOR 1905

Title: GIRLS / A CALENDAR / (color illustration) / (small letters) Copyrighted 1900, by Bryn Mawr College Students' Association / Designed by / Jessie Willcox / Smith / Fox, Duffield & Co. / Publishers / New York.

Pagination: [7] pp.

Collation: Title and copyright [1]; text [2]-[7].

Description: Issued in color pictorial wrappers. Each subsequent page with color illustration and two months at bottom.

Paper: Wove.

Illustrations: Seven full-page color illustrations by Smith.

Cover:	(Graduates walking in long line)
Page {1}	(Students ice skating)
Page {2}	(Students in library)
Page {3}	(Graduates with lanterns)
Page {4}	(Students and passengers on coach in town)
Page {5}	(Students spreading seeds along row of trees)
Page {6}	(Students collecting boughs on snowshoes)

Publication Notes: Listed in Union Catalog, 1904, "Girls". Fox, Duffield.

Price at Issuance: $1.50.

Note on Illustrations: All of these illustrations originally appeared in the Bryn Mawr College Calendars for 1901 and 1902.

C5. BRYN MAWR COLLEGE CALENDAR FOR 1909

Title: BRYN MAWR / COLLEGE / CALENDAR / 1909 / Designed by / Jessie Willcox Smith / Elizabeth Shippen Green / (drawing - lantern).

Size of Leaf: 35.3 x 18.5 cm.

Pagination: [19], [1] p.

Collation: Title (B of Bryn Mawr in brown) (drawing of lantern) [1]; text [2]-[19]; imprint (Beck, Phila) (rear cover).

Description: Stock wrappers. Cover illustration in black, white, and gold-brown, initials in gold-brown. Printed in black: BRYN MAWR / COLLEGE / (colored illustration of two graduates holding lanterns) / CALENDAR 1909. Lantern in gold, black, and white rear cover.

Paper: Wove.

Illustrations: Five full-page colored illustrations by Jessie Willcox Smith, two full-page colored illustrations by Elizabeth Shippen Green. 24 head and tail pieces by E. S. Green, ornamental floral panels by Ellen Wetherald Ahrens throughout in color.

Cover:	(Two graduates holding lantern) J. W. Smith.
Page {2}:	(Students in library) J. W. Smith.
Page {5}:	(Students playing soccer) J. W. Smith.
Page {8}:	(Students playing May-Pole) J. W. Smith.
Page {11}:	(Students toasting at dinner table) Elizabeth Shippen Green.
Page {14}:	(Girl on sailboat) Elizabeth Shippen Green.
Page {17}:	(Students with lanterns) J. W. Smith.

Note on Illustrations: All of these illustrations appeared in the Bryn Mawr College Calendars for 1901 and 1902.

C6. THE JESSIE WILLCOX SMITH CALENDAR FOR 1912

Size of Leaf: 30 x 23 cm.

Description: Full-color illustration entitled, "The Christmas Dinner"; mounted thick stock backing (46 x 33 cm). Caption below illustration. A calendar for 1912 in the form of a booklet (5 x 9 cm) is attached at bottom of sheet. Heavy stock backing is itself mounted onto artboard and the two are joined at top with maroon ties. Imprint on back of artboard: Art Calendar, Copyright, 1911, Dodge Publishing Company, New York. This illustration first appeared in THE NOW-A-DAYS FAIRY BOOK, (1911).

C7. THE JESSIE WILLCOX SMITH CALENDAR FOR 1913

Size of Leaf: 31 x 22 cm.

Description: Full-color illustration entitled, "The Night Before Christmas," mounted onto thick stock backing (46 x 33 cm). Caption below illustration. Calendar for 1913 (5 x 9 cm) in form of booklet attached at bottom. Mounted onto artboard. Imprint on back: Art calendar, Copyright, 1912, Dodge Publishing Company, New York. The illustration first appeared in *Collier's Weekly*, Dec. 11, 1909, and later in THE EVERYDAY FAIRY BOOK (1915).

C8. THE CHILDREN OF DICKENS CALENDAR

Not seen.

C9. SWIFT'S PREMIUM CALENDAR FOR 1916

Size of Leaf: 21 x 38 cm.

Pagination: [8] pp.

Collation: Title and Copyright (1915, Swift and Company), "Little Red Riding-Hood" [1]; explanation for "Swift's Premium Calendar", imprint (M. Rusling Wood, N. Y.) [2]; "Cinderella and the Glass Slipper" [3]; five advertisements for Swift's products, imprint [4]; "Jack and the Beanstalk" [5]; "Swift's Soap Products", imprint [6]; "Goldilocks and the Three Bears" [7]; Additional Copies of "Swift's Premium", imprint [8].

Description: Issued in four sheets joined at top with white silk ribbon ties. Full color illustrations and three months in boxes at bottom on front of page, with short tale and advertisements on verso of each page.

Paper: Wove.

Illustrations: Four full-page color illustrations.

Page {1}: Little Red Riding Hood
Page {3}: Cinderella and the Glass Slipper
Page {5}: Jack and the Beanstalk
Page {7}: Goldilocks and the Three Bears

Price at Issuance: Ten cents or various combinations of stamps or labels.

Note on Illustrations: First and only appearance of these illustrations by Smith, commissioned specially by Swift and Co.

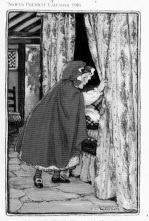

Little Red Riding Hood

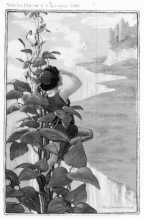

Jack and the Beanstalk

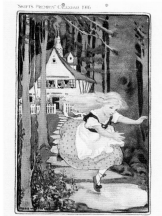

Goldilocks and the Three Bears

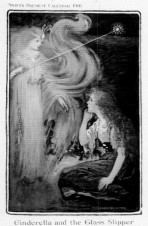

Cinderella and the Glass Slipper

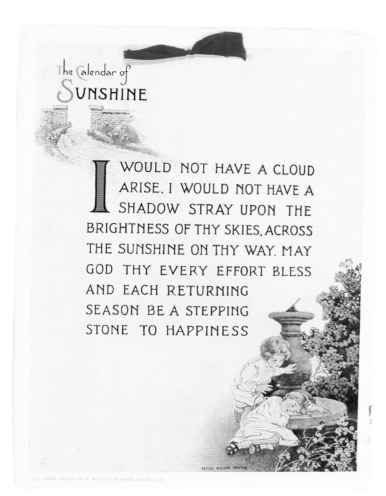

C10. CALENDAR OF SUNSHINE FOR 1918

Size of Leaf: 20.5 x 15.3 cm.
Description: Booklet with leaves joined at top with red ribbon. Printed on one side only. 54 pp. Color illustration by Smith on cover of two children on fountain, one asleep. Calendar printed in red and black with decorations, not by Smith. Copyright, 1917, Dodge Publishing Company, New York. The illustration first appeared in *Collier's Weekly*, June 11, 1910, and later in THE NOW-A-DAYS FAIRY BOOK.

C11. PROCTER AND GAMBLE CALENDAR FOR 1921

Size of Leaf: 43 x 31 cm.
Description: One full-color sheet with illustration of mother washing crying child. Copyright, 1921, Procter and Gamble Company, Cincinnati, Ohio. Illustration is a reproduction of early Ivory Soap advertisement.

C12. BUFFALO EVENING NEWS CALENDAR FOR 1930

Size of Leaf: 50 x 38 cm.
Description: One full-color sheet printed on thick card paper with aluminum (green) bands top and bottom. Illustration by Smith of girl wading in pond. Published by Wolf Company, Philadelphia. Booklet of 12 months (4 x 8 cm) attached to lower right corner. The illustration first appeared in *Good Housekeeping*, July 1919, as color cover and later appeared in A CHILD'S BOOK OF MODERN STORIES, (1920).

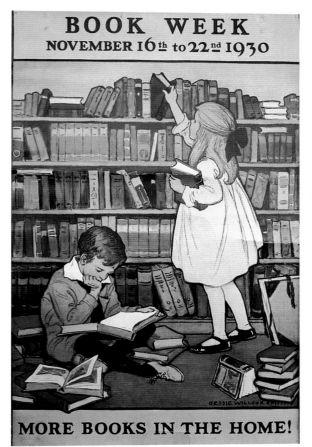

BOOK WEEK
NOVEMBER 16th to 22nd 1930

MORE BOOKS IN THE HOME!

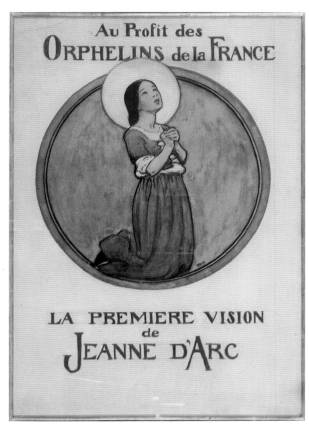

Au Profit des
ORPHELINS de la FRANCE

LA PREMIERE VISION
de
JEANNE D'ARC

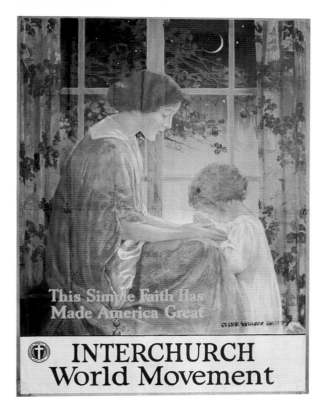

This Simple Faith Has
Made America Great

INTERCHURCH
World Movement

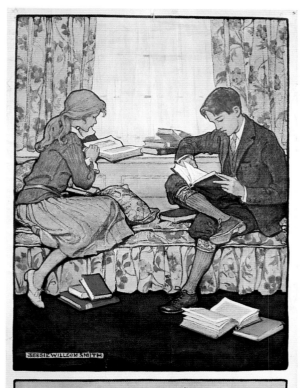

More Books In The Home!

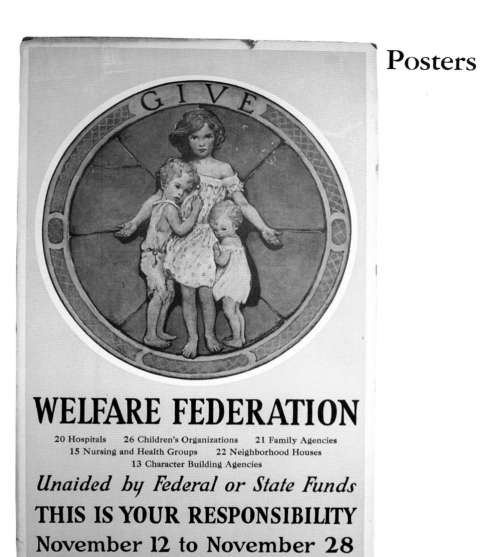

1918

"Jeanne d'Arc"
Color illustration of woman with circular halo, on her knees with hands clasped in prayer. 70 x 50 cm. Au Profit des / Orphelins de la France / (illustration) / La Premiere Vision / de / Jeanne d'Arc.

"Have You a Red Cross Service Flag?"
Full-color illustration of boy attaching Red Cross Service flag to window. Printed on plain, thin paper. Copyright, The American Red Cross, Washington, D.C. Printed by Forbes Company, Boston. (70.7 x 53 cm).

1919

"This Simple Faith Has Made America Great"
Full-color illustration of mother sitting in front of window and with child kneeling with hands together. Printed at bottom in light blue and black: **This Simple Faith Has / Made America Great** / (Interchurch World Movement Insignia) Interchurch / World Movement. Washington, D. C., 1919, Interchurch World Movement. Printed on coated paper. 70 x 53 cm.

"Children's Book Week, November 10th to 15th, 1919"
Full-color illustration of boy and girl and shelf full of books with girl taking books from shelf and boy reading book on floor. Children's Book Week / November 10th to 15th 1919 / More Books in the Home!

1922

"Children's Book Week, 1922"
Not seen.

1923

"More Books in the Home!"
Full-color illustration of boy and girl reading books on a sofa near window seat. Printed in dark blue at bottom: **More Books in the Home!**. New York, American Association of Book Publishers. Printed on white coated paper. 35.4 x 53 cm.

1924

"Twin Comforts of the Home" - American Radiator Company
Full-color illustration of two girls playing pat-a-cake seated in front of radiator. Captioned "Beans Porridge Hot" Bottom one-quarter printed in green and red: **Twin Comforts of the Home / Ideal Boilers / American Radiators / American Radiator Company.** Maroon borders. Printed on coated paper. American Radiator Company, 1924. 79 x 53 cm.

1925

"Give"
Circular color illustration of three hungry children huddled together with ornamental border and **GIVE** at top. Printed on yellow background with white borders around circular illustration and edges of poster. Printed in black below illustration: WELFARE FEDERATION. / 20 Hospitals, 26 Children's Organizations, 21 Family Agencies / 15 Nursing and Health Groups, 22 Neighborhood Houses / 13 Character Building Agencies / Unaided by Federal or State Funds / This is Your Responsibility / November 12 to November 28. 35.5 x 56 cm. Philadelphia, The Philadelphia Welfare Federation.

1926

"Somebody Cares, Do You?"
Color illustration of nurse holding infant with child holding her arm. Printed in black: **Somebody Cares - / Do You?** In small letters at bottom: Copyright, 1926, Welfare Federation of Philadelphia.

1927

"Give"
Not seen.

1930

"More Books in the Home"
Color illustration of girl and boy reading books in front of large bookcase filled with books. Printed at bottom in black: **More Books in the Home. Printed in the USA.** Printed in black at top: **Book Week / November 16th to 22nd, 1930.** 53 x 34 cm.

June 1924: *Standard Manufacturing*

Advertisements

Complete descriptions of each advertisement are given for the first appearance. In subsequent appearances, only the title is given if there are no differences pictorially. Changes in size and page numbers are noted, however. It is assumed that if a known ad ran in a given month and year, then the same ad ran in other magazines of the same month and year. What may not be known is the coloration and size of the ad, if not seen by the compiler. For example, in *Collier's* issue of July 12, 1902, the Ivory Soap ad was headlined *"Children Grow to Enjoy Bathing"*. We also know that an Ivory Soap ad was scheduled for inclusion in *Harper's Monthly Advertiser* for July, 1902. So even though the specific ad was not observed by the compiler, it is assumed that the same ad ran there. What we do not know for certain is the size and coloration.

T he salesman may offer you a strongly-perfumed soap in fancy wrapper and box, or a white soap made to look like the Ivory. If you want perfume and a fancy wrapper, well and good, but if you want pure soap, buy Ivory Soap and not one of the imitations. There is safety in Ivory Soap, it is so mild that even a baby's delicate skin is not harmed by it.

T rust a child to know the good and the true. Was there ever a boy or girl who did not love to play with Ivory Soap?

The fact that the tender little hands are always eager for the floating cake and the bubbling lather is eloquent proof of Ivory's quality and purity.

IVORY SOAP . . . 99 44/100% PURE

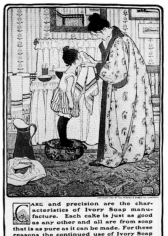

C are and precision are the char-acteristics of Ivory Soap manu-facture. Each cake is just as good as any other and all are from soap that is as pure as it can be made. For these reasons the continued use of Ivory Soap gives confidence and pleasure; confidence by its harmlessness, and pleasure in the delightful sense of cleanness it brings.

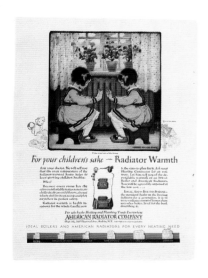

For your children's sake — Radiator Warmth

AMERICAN RADIATOR COMPANY

IDEAL BOILERS AND AMERICAN RADIATORS FOR EVERY HEATING NEED

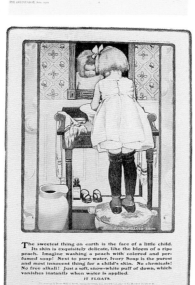

The sweetest thing on earth is the face of a little child. Its skin is exquisitely delicate, like the bloom of a ripe peach. Imagine washing a peach with colored and per-fumed soap! Next to pure water, Ivory Soap is the purest and most innocent thing for a child's skin. No chemicals! No free alkali! Just a soft, snow-white puff of down, which vanishes instantly when water is applied.

IT FLOATS.

BREAD

New Year, every year, all the year—one happy fact remains true—BREAD is your BEST food.

Supreme in nutrition, Bread is lower in cost than the same amount of nour-ishment in any other form. It is the most economical food today!

Resolve to eat more BREAD; resolve to give more of this health-build-ing, muscle-making food to your children.

Nearly all bakers use FLEISCHMANNS YEAST because it makes the best bread

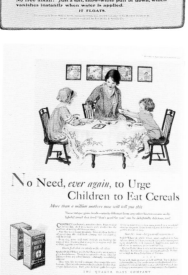

It's not "vegetables" to them . . . it's just good soup!

And without realizing it, they are eating 15 nourishing, health-giving vegetables

MEAL-PLANNING IS EASIER WITH DAILY CHOICES FROM CAMPBELL'S 21 SOUPS

No Need, *ever again*, to Urge Children to Eat Cereals

More than a million mothers now will tell you this

THE QUAKER OATS COMPANY

American Radiator Company

Collier's Magazine

1909

February 6.	*"Cosy Homes"*. Full-page color illustration of two young girls playing with dolls in front of radiator.

1916

February 12.	*"The Cleanly Warmth of Radiator Heating"*. Full-page tinted illustration of girl washing hands in basin.

Woman's Home Companion

1916

February 24.	*"The Cleanly Warmth of Radiator Heating"*. P. 112.

Youth's Companion

1917

October 18.	*The Cleanly Warmth of Radiator Heating"*.

Campbell's Soup Company

American Magazine

1931

June.	*"It's not 'vegetables' to them . . . it's just good soup!"* Full-page advertisement with color illustration of two children eating soup at table. P. 83.

Delineator

June.	*"It's not 'vegetables' to them . . . it's just good soup!"*

Good Housekeeping

June.	*"It's not 'vegetables' to them . . . it's just good soup!"*

House and Garden

June.	*"It's not 'vegetables' to them . . . it's just good soup!"* Black and white.

Ladies Home Journal

June.	*"It's not 'vegetables' to them . . . it's just good soup!"*

Vanity Fair

June.	*"It's not 'vegetables' to them . . . it's just good soup!"*

Cream of Wheat

Delineator

1909

April.	*"I know that man"*. Full-page tinted illustration. Inside front cover.

Ladies Home Journal

1909

April.	*"I know that man"*.

Eastman Kodak Company

All ads dated 1904

Collier's

November 26.	*"A Christmas Morning"*. Full-page advertisement with half-page tinted illustration of mother taking picture of child with doll sitting in bed.

Harper's Weekly

December 10.	*"A Christmas Morning"*. Illustration in black and white. P. 37.

Ladies Home Journal

December.	*"A Christmas Morning"*. Black and white. Inside front cover.

Metropolitan Magazine

December.	*"A Christmas Morning"*. Illustration in full color.

Youth's Companion

November 24.	*"A Christmas Morning"*. Black and white.

Fisk Tire Company

Country Life

Date unknown.	*"Time to Re-Tire"* Full-page color advertisement of children with candles walking through tire.

Fleischmann Company

Delineator

1920

January.	*"Bread"*. Half-page advertisement for Fleischmann's Yeast with quarter-page black-and-white illustration of girl slicing bread.

Procter & Gamble Company: Ivory Soap

Century Magazine

1901

February.	Not seen.

Collier's

1902

July 12.	*"Children Grow to Enjoy Bathing"*. Full-page black-and-white illustration of mother washing child in bathtub with another child drying off on floor. Inside front cover.
October 4.	*"The Sweetest Thing on Earth"*. Quarter-page black-and-white illustration of girl on stool washing hands in tub. Inside front cover.

Delineator

1914

December.	*"Before the Days of Ivory Soap"*. Version I. Full-page black-and-white illustration of mother holding hem of child's dress. P. 4.

1921

June.	*"Trust a Child to Know the Good and True"*. Half-page tinted illustration of girl at table with bowl of soap and water.

Everybody's Magazine

1920

March.	*"Before the Days of Ivory Soap"*. Version II. Full-page advertisement with black-and-white illustration of mother washing child who is turning away with tears in his eyes. P. 8.

Harper's Magazine

1901

October.	*"The Salesman May Offer You"*. Size not known.

1902

July.	*"Children grow to Enjoy Bathing"*. Size not known.

Harper's Weekly

1902

July 5.	*"Children Grow to Enjoy Bathing"*. Inside front cover.
October 4.	*"The Sweetest Thing on Earth"*. Full-page black-and-white illustration. Inside front cover.



Ladies Home Journal

1901

August.	*"The Salesman May Offer You"*. Quarter-page black-and-white illustration of mother and child on lap with blanket. Inside front cover.
October.	*"Care and Precision"*. Full-page black-and-white illustration of mother wiping child's face. P. 2.

1902

July.	*"Children Grow to Enjoy Bathing"*. Size and location unknown.
October.	*"The Sweetest Thing on Earth"*. P. 2.

1912

July.	Not seen.

1914

December.	*"Before the Days of Ivory Soap"*. Version I. P. 4.

1920

March.	*"Before the Days of Ivory Soap"*. Version II. P. 6.

Ladies' World

1921

February.	Two children playing with building blocks. Full-page color illustration.

Literary Digest

1921

June 25.	*"Trust a Child to Know the Good and True"*. Black and white.

Pictorial Review

1907

May.	Not seen.

1920

March.	*"Before the Days of Ivory Soap"*. Version II.

1921

March.	Not seen.

Saturday Evening Post

1914

December 12.	*"Before the Days of Ivory Soap"*. Version II.

Scribner's Magazine

1901

August.	*"The Salesman May Offer You"*. Full-page black-and-white illustration.
October.	*"Care and Precision"*. P. 112.
December.	*"The Salesman May Offer You"*. Full-page black-and-white illustration.

1902

July.	*"Children Grow to Enjoy Bathing"*.
October.	*"The Sweetest Thing on Earth"*. Quarter-page black-and-white illustration. Inside front cover.

Woman's Home Companion

1901

February.	*"Those Who Have Tried Ivory Soap"*. Quarter-page tinted illustration of woman putting coat on chair. P. 19.
October.	*"Care and Precision"*. Quarter-page black-and-white illustration. Inside front cover.

1902

July.	*"Children Grow to Enjoy Bathing"*.
October.	*"The Sweetest Thing on Earth"*. Quarter-page black-and-white illustration. Inside front Cover.

1921

June.	*"Trust a Child to Know the Good and True"*. Quarter-page tinted illustration.



Woman's World

1917

May.	Not seen.

Youth's Companion

1901

August 1.	*"The Salesman May Offer You"*. P. 383.
October 31.	*"Care and Precision"*. Size and location unknown.

1902

July 3.	*"Children Grow to Enjoy Bathing"*. Size and location unknown.
October 23.	*"The Sweetest Thing on Earth"*. Size and coloration unknown.

Quaker Oats Company

Delineator

1927

November.	*"No need, ever again, to urge children to eat cereals"*. Full-page color illustration for Puffed Rice.

Good Housekeeping

1928

September.	*"Suppers for the Youngest Generation"*. Full-page advertisement with top one-third a full-color illustration of two children seated at table. P. 115.

Ladies Home Journal

1926

October.	*"You Must Eat Certain Foods"*. Half-page color illustration of mother serving (Puffed Wheat) cereal to child.

1927

November.	*"No need, ever again, to urge children to eat cereals"*. Half-page color illustration of mother and two children eating breakfast with five framed JWS prints on wall.

McCall's Magazine

1927

October.	*"No need, ever again, to urge children to eat cereals"*.

Saturday Evening Post

1926

October 16.	*"You Must Eat Certain Foods"*. Full-page color illustration.

Woman's Home Companion

1923

November.	Two children seated at table with Mad Hatter and March Hare in panels on each side. Full-page color advertisement for Puffed Rice.

Standard Sanitary Manufacturing Company

Century Magazine

1924

June.	Full-page color advertisement of little girl entering bath.

Prints

Dimensions are listed width x height.

1903

P1. *"The Book of the Child".* Frederick A. Stokes Company. 7 large color prints issued as a set in "art folio".

P2. *"A Mother's Days".* Charles Scribner's Sons. 6 color prints; *Morning; Supper; In The Garden; Fairy Tales; Checkers; Bed Time.* (20 x 32 cm). $4.00.

1904

P3. *"Portfolio of Real Children".* Fox, Duffield and Company. 7 large color prints. $3.00.

P4. *"The Child in a Garden".* Fox, Duffield and Company. 6 color prints. Boxed. *Green Door; Among the Puppies; Five O'Clock Tea; Lily Pool; Garden Wall; Spruce Tree.*

1905

P5. *"The First Steps in a Child's Life".* Ladies Home Journal, Curtis Publishing Company. 5 color prints: *The First Lesson; The First Sermon; The First Punishment; The First Love; The First Dissipation.* $1.00 each, or one free with new subscription. (23 x 34 cm).

1906

P6. *"Child's Garden of Verses".* Charles Scribner's Sons. 4 color prints: *Picture Books in Winter; Land of Counterpane; Hayloft; Looking-Glass River.* (21 x 31 cm).

1906-1910

P7. Various *Collier's* Covers in tint printed on coated paper. Collier's (35 x 55 cm) also (29 x 39 cm).

1907

P8. *"The Five Senses".* Charles W. Beck Engraving Company. Set of 5 color prints mounted on heavy stock with captions in green: *Touching; Tasting; Smelling; Hearing; Seeing.* (19 x 26.5 cm mounted onto 35.5 x 46 cm). $.75 each, $3.50 set.

1918-1925

P9. *Good Housekeeping Magazine*
Cosmopolitan Print Department, House of Art.
For bibliographic clarity, this series is designated P9 and includes all prints issued from 1918 to 1925. Individual prints may be identified as P9-901, P9-902, etc.

1918

900 "The Little Admiral". Full Color. (28 x 35 cm) $.25.
901 "The Madonna". Full color. (58.5 x 71.2 cm) $2.00
902 "Mother and Child". (28 x 35 cm). $.25. Full Color.
903 "A Welcome Star". (28 x 35 cm). $.25. Full color.
904 "All for the Cause". (28 x 35 cm). $.25. Full color.
905 "Good-Bye Daddy". (28 x 35 cm). $.25. Full color.
906 "Curiosity". (28 x 35 cm). $.25. Full Color.
907 "Ray of Sunshine". (28 x 35 cm). $.25. Full Color.
908 "Rosebuds". (28 x 35 cm). $.25. Full Color.
909 "Playmates". (28 x 35 cm). $.25. Full Color.
910 "O-O-Oh, Its Cold". (28 x 35 cm). $.25. Full Color.
911 "Over There". (28 x 35 cm). $.25. Full Color.

1919

912 "Among Autumn Leaves". (28 x 35 cm). $.25. Full Color.
913 "Down". (28 x 5 cm). $.25. Full Color.
914 "A Babe in Arms". (28 x 35 cm). $.25. Full Color.
401-418 "Mother Goose Pictures". 18 Full-color prints enclosed in pictorial paper portfolio. Prints with caption printed at base of picture. (35.7 x 30.5 cm). Set of 18: $4.50; also sold in sets of 6 for $1.50.
401 "Ring Around a Rosie".
402 "One Foot Up, The Other Foot Down".
403 "See-Saw, Margery Daw".
404 "Jack Fell Down and Broke His Crown".
405 "Curly Locks! Curly Locks".
406 "There Was An Old Woman Who Lived in a Shoe".
407 "Peter, Peter Pumpkin-eater".
408 "Little Miss Muffet Sat on a Tuffet".
409 "Rain, Rain, Go Away".
410 "Mary, Mary Quite Contrary".
411 "Hush-aby, Baby, on a Treetop".
412 "Little Bo-Peep Has Lost Her Sheep".
413 "A Dillar, A Dollar".
414 "Polly, Put the Kettle On".
415 "Little Jack Horner Sat in a Corner".
416 "Hot Cross Buns".
417 "Pease Porridge Hot, Pease Porridge Cold".
418 "Mother Goose".
419-424 Set of 6 color prints on heavy white pebbled paper. 2.50 set of 6: $.50 each. (30.5 x 40.7 cm).
419 "The Sandman".
420 "Little Drops of Water".
421 "Twinkle, Twinkle, Little Star".
422 "I Like Pussy".
423 "A Child's Grace".
424 "Babes in the Wood".

1920

916-990 Color prints. $.25 each, 12 for $2.50. (28 x 36 cm).
916 "Tulip Time".
917 "The Farmerette".
918 "The Water Sprite".
919 "Once Upon a Time".
920 "Baby's Prayer".
921 "Roly Poly".
922 "And A Little Child Shall Lead Them".
923 "Concentration".
924 "Pals".
925 "A Miniature".
926 "Blossoms".
927 "Mother's Roses".
928 "Come on In".
929 "Waiting for Daddy".
930 "Helping Hands".
931 "We Give Thee Thanks".
932 "Game of Hearts".
933 "Mother's Own".
934 "Daisies Won't Tell".
935 "The First Dip".
936 "Moonbeams".

1921

938 "The First Lesson".
939 "Ambition".
940 "Bobby".
941 "Off to Play".
942 "April Showers".

1922

943 "Springtime".
944 "Playing Mother".
945 "The Runaway".
946 "Don't Be Scared".
948 "School Days".
949 "David Copperfield and His Mother".
958 "Heidi".
960 "Mowgli".
962 "The New Book".

1923

963 "North Wind Doth Blow".
964 "Roses".
968 "Chick, Chick".
969 "Good Morning".
970 "Autumn".
971 "Off to School".
973 "Daisies".
974 "Spring Beauties".
975 "Sunshine and Shower".
976 "A Windy Day".

1924

977 "Modern Lullaby".
978 "Dollie's Day".
979 "Inquisitive".
980 "Learning".
981 "Kitchen Duty".
990 "Moonlight Harmony".

1925

8854 "Wistaria" Collotype in color. (33.5 x 43 cm). $2.50.
8856 "A Child's Prayer". Collotype in color. (30.5 x 43 cm). $2.50.

Miscellaneous

Handkerchief Illustrations.

"RHYMES OF REAL CHILDREN." Set of 6 handkerchiefs each with color illustration taken from the book issued in the same year. Each handkerchief with color decorative border and with several lines of verse. Copyright, 1903, Fox, Duffield and Company.

Sale of the Estate of Jessie Willcox Smith Comprising the Largest Group of Her Paintings Ever Sold.
Samuel T. Freeman and Co.,
Philadelphia, 1940.

Public Auction, November 25th and 26th, 1940.
NOTE: A total of 72 paintings were auctioned to the highest bidders at Freeman's auction house on Chestnut Street. These paintings were all bequeathed by Smith to her gardner and closest friend, Henrietta Cozens. Miss Cozens died on April 13, 1940, and the entire estate of paintings by Jessie Willcox Smith was soon after put to auction by the family of Cozens. Since this auction represents the most comprehensive record of the original paintings of Jessie Willcox Smith, the exact entries are given below with dimensions. The location of signature is in brackets.

{The Item Number in Freeman's Catalog is given first}

12. *Child Reading.* Academy Board: 22 x 15" [lower right]
13. *"New Year's".* Academy Board: 22 ½ x 14 ¾" [lower right]
14. *"A Modern Bambino".* Academy Board: circular diameter 14" [lower center]
15. *"Vanilla Cream".* Academy Board: 16 ¼ x 13"
16. *Night Before Christmas.* Water color: 7 x 28 ¼" [lower left]
17. *Angels and Child.* Academy Board: 15 ¼ x 16" [lower right]
18. *Curdy went on after her flashing torch.* Academy Board: 21 ½ x 15 ½" [lower left]
33. *"August".* Academy Board: 17 x 12 ½" [lower right]
34. *Portrait Study.* Canvas: 20 x 16"
35. *April.* Academy Board: 19 x 15 ½" [lower right]
36. *Daisy Petals.* Academy Board: 20 x 14 ¾" [lower left]
37. *The Ruling Passion.* Academy Board: 22 ½ x 15" [lower right]
38. *May I Have the Pleasure.* Academy Board: 17 x 12" [lower right]
39. *The Blue Pump.* Academy Board: 21 ½ x 15 ½" [lower right]
54. *Autumn.* Academy Board: 21 ½ x 15 ½" [lower right]
55. *Christmas Carols.* 19 x 17 ½" [lower right]
56. *A Little Child Shall Lead Them.* Academy Board: Circular diameter 14" [lower right]
57. *Heidi Visits the Blind.* Academy Board: 20 ⅝ x 15 ⅝" [lower right]
58. *New Year's-1933.* Academy Board: 22 ½ x 16 ½" [lower right]
59. *Easter Lily.* Academy Board: 19 ¼ x 14 ¼" [lower left]
60. *The Sand Man.* Canvas: 39 ½ x 29 ½" [lower left]
76. *Playing Golf.* Academy Board: 21 ½ x 15 ½" [lower right]
77. *Plum Pudding (Christmas).* Academy Board: 17 ¾ x 16" [lower right]
78. *Five of a Kind.* Academy Board: 15 ¾ x 16" [lower right]
79. *The Hurt Finger.* Drawing: 17 ½ x 15 ⅜" [lower right]
80. *Lost.* Drawing: 17 ½ x 15 ⅜" [lower right]
81. *What Really Happened.* Academy Board: 18 x 16 ¾" [lower right]
82. *Come, and She Still Held Out Her Arms.* Academy Board: 21 ⅝ x 15 ⅝" [lower left]
83. *Portrait of Girl Reading a Book.* Canvas: 21 x 28" [lower right]

123. *"Baby's Head".* Academy Board: 13 ½ x 11 ½" [lower center]
124. *"Losing Curls".* Academy Board: 14 ½ x 16" [lower right]
125. *Portrait (unfinished).* Canvas: 60 ½ x 40 ½"
126. *Two Goats.* Sketch: 19 ½ x 14 ½"
127. *Goat and Kid.* Sketch: 19 ½ x 14 ¼"
128. *Garden Doorway.* Canvas: 28 x 18"
129. *School Days.* Academy Board: 22 x 16" [lower right]
136. *Extremes Meet.* Academy Board: 21 ¾ x 15 ¾" [lower right]
144. *"Daisy Field".* Canvas: 35 x 28"
145. *Her Sick Boy.* Canvas: 22 ¼ x 16" [lower right]
146. *"Where I First Met Her".* Canvas: 17 ¾ x 24 ¼" [back]
147. *"Story Hour".* Academy Board: 19 ¾ x 29 ½" [lower left]
148. *"Daddy's Over There".* Academy Board: 29 ¼ x 19 ½" [lower left]
149. *"They".* Canvas: 28 x 20" [lower right]
150. *New Year-1932.* Academy Board: 25 ¾ x 19" [lower right]
157. *"The Pink Feather".* Watercolor: 23 ½ x 9 ½" [lower right]
158. *Going to School.* Academy Board: 23 x 15 ¾" [lower right]
159. *Are You Ill, Dear?* Academy Board: 21 ½ x 15 ½" [lower left]
160. *A Call to Arms.* Academy Board: 21 ½ x 15 ½" [lower left]
161. *"The Little Cook".* 21 x 15" [lower right]
162. *"Christmas".* Academy Board: 21 x 14 ⅞" [lower right]
176. *They Flew Like a Bird.* Academy Board: 21 ½ x 15 ½" [lower right]
177. *New Year's-1931.* Academy Board: 22 ½ x 16 ½" [lower right]
178. *Decorations for Water Babies.* Drawing: 12 ¾ x 20 ¾" Companion 28 x 16 ½"
179. *Decorations for Water Babies.* Watercolor: 22 x 28"
180. *Heidi.* Academy Board: 21 ½ x 15 ¾" [lower right]
181. *Heidi and Peter Reading.* Sketch: 19 ½ x 14 ½" [lower left]
189. *Heidi and Grandmother.* Sketch: 19 ½ x 14 ½" [lower right]
190. *Heidi and Peter Milking Goat.* Sketch: 19 ½ x 14 ½"
191. *Heidi Undressing.* Sketch: 19 ½ x 14 ¼"
192. *Thanksgiving.* Academy Board: 14 ¾ x 14 ¼" [lower left]
193. *Peter with Kid.* Sketch: 19 ½ x 14 ¼"
194. *Child with Grapes* Collier's. Drawing: 22 ¾ x 15 ¾" [lower left]
195. *Little Jack Horner.* Academy Board: 17 ¼ x 24 ½"
196. *Girl at Door.* Academy Board: 24 x 13" [lower left]
197. *Meditation.* Academy Board: 22 x 14 ½"
198. *Easter Cover - Collier's.* Academy Board: 21 ½ x 15 ¼" [lower left]
199. *Daffodils For Sale.* Academy Board: 21 ½ x 15 ½" [lower right]
200. *First in Peace.* Academy Board: 18 x 15" [lower right]
201. *Anniversary.* Academy Board: 22 x 16" [lower center]
202. *Chums.* Drawing: 24 ½ x 16 ½" [lower left]
203. *The Cut Rose.* Academy Board: 21 ½ x 15 ½" [lower right]
204. *Drousie.* Canvas: 50 x 25"

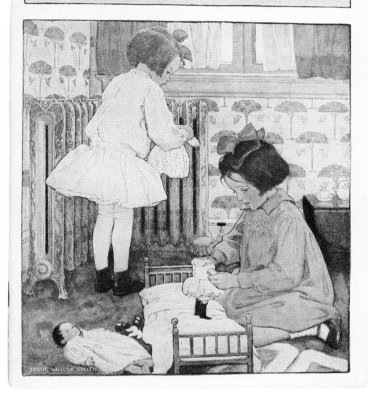

THE HOMES SUCCESSFUL

Postcards.

Curtis and Cameron—1905-1910
Reproducing various covers from *Ladies Home Journal* in brown tone. Printed on cards: Curtis and Cameron, Copley Print. (10.3 x 15.8 cm).
1905-1910—Reinthal and Newman, New York.
Reproducing various covers from *Collier's Magazine* in full color. (14 x 9 cm).
1910-1920—Reinthal and Newman, New York.
A. Reproducing a set of 6 illustrations from *Scribner's* December 1902 entitled, "A Mother's Days". Each card with full-color illustration. (14 x 8.8 cm).
B. Reproducing a set of 6 illustrations from *Scribner's* December 1903 entitled, "The Child in a Garden". Each card with full-color illustration. (14 x 8.8 cm).
19?? Reproducing illustration in "Peregrination of Philadelphia": "Rittenhouse Square".

Booklets.

The Homes Successful. Booklet measuring 20 x 14.5 cm with full-color illustration reproduced on front and back cover of two girls playing with dolls in front of radiator. New York, 1900, American Radiator Company. 40 pp. This illustration was later reproduced by American Radiator Company and entitled "Cosy Homes" and appeared in February 6, 1909, edition of *Collier's Magazine*.

Printing Art Sample Book. November 1911. One full-page color plate of girl with sand running through fingers at

beach (Duffield and Company). (**CHILD'S BOOK OF OLD VERSES** 1910; p. 58).

Printing Art Sample Book. "Morrill Inks". Norwood, Massachusetts (c. 1912). Little Bob and Tiny Tim, reproduced in blue and again in green (p. 40, 55). (**DICKENS'S CHILDREN**, 1912, p. 9).

Instruction Paper. "Illustrating, Lesson 3". Correspondence Institute of America, Scranton, PA, 1900. One black-and-white drawing, "Chickering Hall", winning $500 prize (p. 18). First and only appearance of this illustration.

The Bookman Portfolio. Thick card wrappers with 3 tipped-in color plates illustrating **THE WATER BABIES.** Published by Hodder and Stoughton, London, 1920. 6 pp. 32 x 20 cm. Plates measure 19 x 14 cm. "And There He Saw the Last . . . "; "He Felt How Comfortable . . . "; and "Upon the Snow White Pillow . . . ". A promotional booklet for the book of the same title.

Bryn Mawr College Class Book for 1924. Gray paper covered boards with picture of dodo bird on front cover in blue and yellow. Oblong, 19.5 x 24 cm. 149 pp. Five full-page black-and-white illustrations by Smith taken from her Bryn Mawr Calendar series 1901-1902.

Portfolios.

Title: THE CHILD / Seven facsimiles of drawings in color / by / Jessie Willcox Smith / and / Elizabeth Shippen Green / Frederick A. Stokes Company, Publishers.
Size of Portfolio Covers: 40.5 x 37 cm.
Size of Mat: 40 x 36 cm.
Size of Print: 32.5 x 29 cm.
Description: Plain gray-brown boards with cloth spine (4cm.). Maroon ties at middle of outside pages. Paper label on cover. Seven facsimile color illustrations from THE BOOK OF THE CHILD CALENDAR mounted onto gray-brown stock. Color reproductions inferior to calendar and book.

Title: EIGHT / AMERICAN / ARTISTS / (design - shield) / Jessie Willcox Smith / Albert Sterner / Maxfield Parrish / William T. Smedly / Harrison Fisher / F. X. Leyendecker / A. B. Frost / E. W. Kemble / Artist Proof / Impressions.
Size of Portfolio: 51 x 36 cm.
Size of Proofs: 49.7 x 35.5 cm.
Description: Eight proof illustrations by eight different artists enclosed in gray paper covered boards with dark gray cloth spine and dark gray ties. Each proof with paper label denoting artist and title of proof.
Paper: Smooth coated paper.
Illustrations: One full-color illustration by Smith.
"The Gardener" Maxfield Parrish. In full color.
"The Early Morning Train" W. T. Smedly. In full color.
"The Story Book" F. X. Leyendecker. In full color.
"All Arms Around" Jessie Willcox Smith. In full color.
"You Can't Teach an Old Dog New Tricks" E. W. Kemble. Black and white.
"Good Night" Albert Sterner. Tint.
"Getting Around the Old Man" A. B. Frost. Black and white.
"The End of the Season" Harrison Fisher. Tint.
Issue Points: Issued by P. F. Collier and Son in 1906. Jessie Willcox Smith proof, *"All Arms Around"*, first appeared in BILLY BOY.

Greeting Card.

Cogshill, 1916.
no publisher.
Description: Christmas Greeting / Cogshill / 1916 / (emblem - colored illustration of potted Christmas tree in front of draped window).

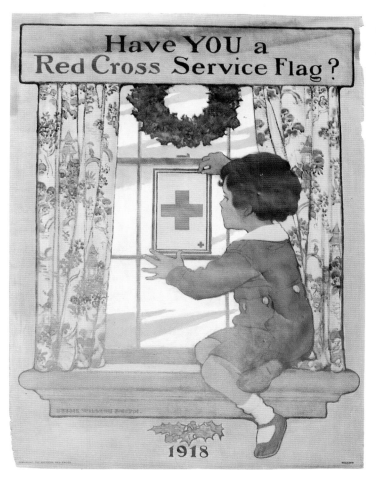

Index of First Appearances of Illustrations

This index lists first appearances of illustrations in books and periodicals. Book appearances are listed first even if the illustrations appeared first in periodicals. However, first periodical appearances are also stated following the book listing. Illustrations in [brackets] are uncaptioned and we have described them as simply as possible. Most begin with "Child . . . ," "Girl and boy . . . ," "Two children . . . ," "Mother and child . . . ," etc. Number and gender of persons is given first in all cases.

When a number occurs in (parentheses) following a caption, that means that there were the stated number of illustrations present in the periodical listed, all pertaining to that caption.

NOTE: The *Good Housekeeping* series of prints includes reprints of uncaptioned covers from *Good Housekeeping, Ladies Home Journal,* and *Woman's Home Companion.* For the print issuance, many are captioned for the first time even though they were untitled in their magazine appearance. In this index, the covers are listed by description rather than by print title. Illustrations which appeared with captions in book form are listed by those captions even if they first appeared in magazines without captions or titles.

A

Abbot's Trout, The *A15*

Against this he laid his ear, and then he heard the voice quite distinctly, *A53*

Ah-Goo *A2*

Alice in Wonderland *A61 Good Housekeeping 3/23*

All of a sudden Ben punched me. *A25 Scribner's 4/03*

All the girls saw it. *A25 Scribner's 4/03*

All was ended now, the hope, and the fear, and the sorrow. *A3*

Among Autumn Leaves *A60 Good Housekeeping 11/18*

Among the Poppies *Scribner's 12/03*

Among the Stars. *A47 McClure's 12/09*

[An hour has slipped by, but still the major did not come] *A28 McClure's 2/05*

And my dear mistress, now Mistress D-. *A8*

And now I am in the country once more. *A8*

And there he saw the last of the Gairfowl standing up on the Allalonestone, all alone. *A45*

And Tom sat upon the buoy long days. *A45*

And waking up the sleepy ones *A2*

[Angelic child surrounded by circular floral motif] *Good Housekeeping 12/26*

Answer to a child's question. SEE Child's question, A

Animal Book, The *A66 Good Housekeeping 2/20*

Are you ill, dear North Wind? *A53*

Are you the child that lives up with Alm-Uncle, are you Heidi? *A58*

As you Sailed (4) *Harper's 1/03*

At Gran'papa's *A24*

Auntie. *A24*

Autumn Days *Collier's 9/24/04*

B

Baa, Black Sheep *Scribner's 1/15*

Babes in the Wood *A33 Woman's Home Companion 4/13*

Baby is Born *A14 {Baby looking over mother's shoulder, circular motif} Good Housekeeping 1/22*

[Baby surrounded by circular floral motif] *Good Housekeeping 5/18*

Baby's First Outing *A14*

[Baby's head wearing white bonnet with blue bow] *Good Housekeeping 1/24*

Baby's Prayer *A60 Good Housekeeping 10/19*

[Back of child on plank with picnic lunch] *Good Housekeeping 9/30*

Beauty and the Beast *A34 Collier's 5/30/08*

Bed in summer *A22 Collier's 12/22/06*

Bedtime *Scribner's 12/02*

Before the days of Ivory Soap [mother holding hem of child's dress] *Procter & Gamble Ivory Soap ad: Delineator 12/14*

Before the Days of Ivory Soap [Mother washing child who is turning away with tears in his eyes] *Procter & Gamble: Ivory Soap ad 3/20*

Bell, The *A2*

Bells were ringing in every direction now, sounding louder and fuller as they neared the valley, The. *A58*

Better Treasure, The. *Woman's Home Companion 11/08*

Betty Manifests the Spirit *Good Housekeeping 6/18*

Betty Romney *A6*

Betty's Posy Shop *A54 Good Housekeeping 6/18*

Big Clock, The *A26*

Billy-Boy *A23 Collier's 12/30/05 (4)*

Billy-Boy's discovery was a sea-gull, with an injured wing. *A44 Collier's 3/31/06*

Blast, that resounded . . . through the still damp air of the evening, A *A3*

Blossom, The *A54 Good Housekeeping 8/18*

Blossoms *A59 Good Housekeeping 5/20*

Blue Dress, The (9) *Scribner's 4/03*

Boarding School (2) *Scribner's 1/37*

[Boy and Girl at front door] *A50 McClure's 4/05*

[Boy and girl carrying basket of apples] *Good Housekeeping 10/20*

[Boy and girl on bench looking at a valentine] *Good Housekeeping 2/24*

[Boy and girl reading books on sofa near window seat] *P5*

[Boy at desk with chin in hands] *Good Housekeeping 10/28*

[Boy at window] *A26*

[Boy attaching Red Cross Service flag to window] *P1*

[Boy ("Bobs") with a monkey and a turtle] *A69*

[Boy dressed as aviator in front of airplane] *Good Housekeeping 1/30*

[Boy holding American flag] *Good Housekeeping 7/31*

[Boy in football uniform] *Good Housekeeping 10/32*

[Boy in tub with dog] *Good Housekeeping 6/32*

[Boy on a rocking horse] *Good Housekeeping 5/26*

[Boy playing golf] *Good Housekeeping 7/28*

[Boy shoveling snow] *Good Housekeeping 3/21*

[Boy sitting on a pumpkin] *Good Housekeeping 11/24*

[Boy with building blocks] *Good Housekeeping 3/29*

[Boy with pumpkin in wheelbarrow] *Good Housekeeping 11/29*

[Boy with upraised glass at soda fountain] *Collier's 6/24/05*

[Boys playing marbles] *Good Housekeeping 5/30*

Bread *Fleischmann's Yeast ad: Delineator 1/20*

Broken Head-and Heart, A *A44*

Brushwood Boy, The *Scribner's 1/15*

But in spite of herself she listened *A13*

Butterflies, The *A59 Good Housekeeping 9/21*

Bye-Lo-Land *A2*

C

Care and Precision *Procter & Gamble: Ivory Soap ad, LadiesHome Journal 10/21*

Caught in the Act. *Collier's 12/11/09*

Charlotte and the Little Helper *A54 Good Housekeeping 5/19*

Checkers *Scribner's 12/02*

Chickering Hall. *Booklet: Correspondence Institute of America "Illustrating, lesson 3".*

Child, The *Scribner's 12/00*

Child, himself surrounded by a group of curious girls, clung to Nora's hand, The *A7*

[Child about to wake in surf] *Good Housekeeping 8/18*

[Child beside large basket of grapes, eating grapes] *Good Housekeeping 10/24*

[Child blowing out birthday cake candles] *Good Housekeeping 5/34*

[Child digging up flower] *Good Housekeeping 5/31*

[Child eating apple] *Good Housekeeping 10/31*

[Child eating turkey dinner] *Good Housekeeping 11/25*

[Child examining Easter Lily] *Collier's 4/11/14*

[Child feeding chickens] *Good Housekeeping 5/25*

[Child getting haircut] *Good Housekeeping 4/31*

[Child holding bowl of cut roses] *Good Housekeeping 6/20*

[Child holding Japanese doll] *Woman's Home Companion 7/12*

[Child in canoe with paddle] *Good Housekeeping 8/19*

[Child in patriot's costume] *Good Housekeeping 1/32*

[Child in purple cape holding bouquet] *Good Housekeeping 4/25*

[Child in wading pool] *Good Housekeeping 7/19*

[Child in winter ermine suit] *Good Housekeeping 2/25*

[Child inside travelling bag labelled "New Year"] *Good Housekeeping 1/25*

[Child knitting on chair] *Good Housekeeping 2/19*

[Child lighting candle on window seat] *Good Housekeeping 12/32*

[Child looking into goldfish bowl on window seat] *Good Housekeeping 4/18*

[Child mailing letter] *Good Housekeeping* 2/27
[Child on chair reading "Animal Book"] *Good Housekeeping* 2/20
[Child on skis over globe] *Good Housekeeping* 1/31
[Child on sled] *Good Housekeeping* 2/30
[Child on sled racing downhill] *Collier's* 2/25/05
[Child opening gate into courtyard] *Good Housekeeping* 7/22
[Child picking blossoms off a tree] *Good Housekeeping* 5/20
[Child picking strawberries] *Good Housekeeping* 6/31
[Child pinning clothes on line] *Good Housekeeping* 7/32
[Child playing tennis] *Good Housekeeping* 9/29
[Child playing with telephone] *Good Housekeeping* 3/27
[Child plowing field] *Good Housekeeping* 5/19
[Child pouring milk for kitten] *Good Housekeeping* 3/20
[Child raking leaves] *Good Housekeeping* 11/18
[Child ringing doorbell with valentine] *Good Housekeeping* 2/33
[Child rocking doll to sleep] *Good Housekeeping* 4/32
[Child rolling dough with rolling pin] *Good Housekeeping* 11/31
[Child rolling pumpkin] *Good Housekeeping* 11/19
[Child selling flowers] *Good Housekeeping* 5/29
[Child sitting on piling in surf] *Good Housekeeping* 8/30
[Child smelling blossoms] *Good Housekeeping* 6/29
[Child smelling tulips] *Good Housekeeping* 4/19
[Child standing on footstool washing dishes] *Good Housekeeping* 11/32
[Child taping Red Cross symbol to window] *Red Cross Magazine* 12/18
[Child walking in snowshoes] *Good Housekeeping* 2/22
[Child watering flowers] *Good Housekeeping* 6/19
[Child with apples] *Good Housekeeping* 10/25
[Child with aviator hat holding airplane] *Good Housekeeping* 5/32
[Child with cat on window seat with fish bowl] *Good Housekeeping* 4/33
[Child with corn and pumpkin] *Good Housekeeping* 11/28
[Child with dog on beach] *Good Housekeeping* 8/22
[Child with doll sitting among suitcases and trunks] *Good Housekeeping* 8/26
[Child with flag wrapped around body] *Good Housekeeping* 1/18
[Child with halo in circular floral motif] *Good Housekeeping* 12/19
[Child with hands folded in prayer kneeling at his mother's feet] A63
[Child with hands out-stretched] A29
[Child with hat] *Good Housekeeping* 9/31
[Child with hourglass; old man with sickle] *Good Housekeeping* 1/29
[Child with muffler walking in wind] *Good Housekeeping* 1/27
[Child with one shoe holding newspaper] *Collier's* 5/26/06
[Child with orange umbrella] *Good Housekeeping* 4/24
[Child with parasol and bucket on beach] *Good Housekeeping* 8/25
[Child with toy and dog] *Good Housekeeping* 3/32
[Child with tulips on window ledge] *Good Housekeeping* 4/28
[Child writing on blackboard with cat] *Good Housekeeping* 9/32
[Child writing on chalkboard] *Good Housekeeping* 10/22
Child's Night bedquilt, A *Ladies Home Journal* 11/12
Child's Question, A A30
Children grow to enjoy bathing *Procter & Gamble: Ivory Soap ad: Collier's* 7/12/02
Children ran to me, The A10
Children were nestled all snug in their beds, The A36
[Christ-child praying on knees] *Good Housekeeping* 12/18
Christmas Eve *Collier's* 12/3/04
Christmas Has Come A14
Christmas Morning, A *Eastman Kodak ad: Collier's* 11/26/04

Cinderella A33 *Woman's Home Companion* 9/13
Cinderella and the Glass Slipper *(Swift's Calendar)* C9
Cleanly warmth of Radiator Heating, The *American Radiator ad: Collier's* 2/12/16
Clearing the way A60 *Good Housekeeping* 3/21
Coasters, The A59 *Good Housekeeping* 3/19
Collar was almost the worst part of the business, The A53, *Woman's Home Companion* 10/20
Colonial Dame, A (2) *Ladies Home Journal* 8/96
Come and play with me A20 *McClure's* 8/04
"Come," and she still held out her arms A55
Comedies of Childhood: Jack in the Box *Collier's* 11/24/06
Comedies of Childhood: Peep-Boo! *Collier's* 9/29/06
Cosy Homes, American Radiator ad: Collier's 2/6/09
Cradle Hymn SEE Scales
Curdie went on after her, flashing his torch about. A55
Curly locks! Curly locks! Wilt thou be mine? A39 *Good Housekeeping* 1/14

D

David Copperfield A61 *Good Housekeeping* 11/22
David Copperfield and his mother *Good Housekeeping* 11/22
David Copperfield and Peggotty by the Parlour Fire A35
DayDreams A66 *Good Housekeeping* 9/22
"Dear boy!" said his mother; "Your father's the best man in the in the world." A53 *Woman's Home Companion* 9/20
Diamond and his mother by the ocean *Woman's Home Companion* 9/19
Diller, a dollar, a ten o'clock scholar, A A39 *Good Housekeeping* 10/13
Don't be scared A60 *Good Housekeeping* 8/22
Door to Wonderland, The A47 *McClure's* 12/09
Doorsteps. A26
Dorothy, Dorcas and Dill *St Nicholas* 5/91
Down the mountain they shot like two birds darting through the air A58
Dream Blocks. A26

E

Easter (Woman and child smelling flower) *Collier's* 4/2/04
Elizabeth sat on a little wicker footstool at her feet A41
Embarrassment of the Riches, The *Harper's Bazaar* 12/12
Emigrant East, The (5) *Scribner's* 12/00
Ever since he had been a little boy, he had thought what it would be if Jack should pop up and cry "Hello, Frank." A44 *Collier's* 11/24/06

F

Fable of the wish, The A54 *Good Housekeeping* 2/19
Fair in sooth was the maiden A3
Fairies' Picnic, The A47 *McClure's* 12/09
Fairy Gardens, The A54 *Good Housekeeping* 6/19
Fairy Tales *Scribner's* 12/02
Few Words about art, A *Collier's* 9/1/06
First Dissipation, The *Ladies Home Journal* 7/05
First Lesson, The *Ladies Home Journal* 12/04
First Love, The *Ladies Home Journal* 3/05
First Prayer, The A14
First Punishment, The *Ladies Home Journal* 1/05
First Sermon, The *Ladies Home Journal* 4/05
First Step A14
First the infant in his mother's arms A29 *Ladies Home Journal* 11/08
[Five children in hammock with kitten] *Good Housekeeping* 7/30
Five maidens all in a row A1 *St Nicholas Magazine* 5/88
Five o'clock tea *Scribner's* 12/03
Flowers, The A22
For a moment her hands wandered over the keys A16
Foreign children A22 *Collier's* 4/15/05
Foreign Lands A22

Frederick squatted on the ground like a little Indian, heaping up the apples that Caroline shook down *A41*

Friendly Game, A *A27 Collier's 1/27/06*

Frills *A26*

Frisky & Flossy *A2*

G

Game of Hearts, A *A60 Good Housekeeping 2/21*

Garden Gate, The *A66 Good Housekeeping 9/20*

Garden Wall, The *Scribner's 12/03*

[Girl and boy on hammock reading book] *Good Housekeeping 7/18*

[Girl and boy reading books in front of large book case filled with books] *P11*

[Girl and boy standing in doorway] *Good Housekeeping 9/20*

[Girl and butterflies] *Good Housekeeping 9/21*

[Girl and large turkey] *Good Housekeeping 11/27*

[Girl bouncing child on leg] *Good Housekeeping 3/31*

[Girl carrying potted plant] *Good Housekeeping 4/27*

[Girl eating slice of watermelon] *Good Housekeeping 9/27*

[Girl entering bathtub] *Standard Sanitary ad Century 6/24*

[Girl feeding child on stool] *Good Housekeeping 6/22*

[Girl holding bunch of maple leaves] *Good Housekeeping 10/26*

[Girl in blanket at campfire] *McClure's 1/04*

[Girl in hat and cape holding purse] *Good Housekeeping 4/21*

[Girl in lilac-colored dress, looking at a book] *Good Housekeeping 5/24*

[Girl in orange and blue hat with scarf] *Good Housekeeping 3/24*

[Girl in rowboat] *Good Housekeeping 8/27*

[Girl in summer dress with pantaloons and hat holding Daisy] *Good Housekeeping 6/21*

[Girl in yellow dress standing on a rock] *Good Housekeeping 7/25*

[Girl kneeling in shawl in front of child with books] *Collier's 12/9/16*

[Girl looking at flowers on table] *Good Housekeeping 6/27*

[Girl lying among flowers] *Good Housekeeping 9/22*

[Girl on hammock with doll] *Good Housekeeping 7/29*

[Girl on rock with feet in water] *Collier's 7/30/04*

[Girl on swing] *Good Housekeeping 9/28*

[Girl painting at a table] *Good Housekeeping 2/21*

[Girl picking daisies] *Good Housekeeping 5/28*

[Girl picking flowers] *Good Housekeeping 6/18*

[Girl picking grapes] *Good Housekeeping 10/27*

[Girl reading book in hammock] *Collier's 6/24/05*

[Girl reading valentine] *Good Housekeeping 2/28*

[Girl rolling dough] *A72*

[Girl selling irises] *Good Housekeeping 6/30*

[Girl sewing on front step] *Collier's 7/29/05*

[Girl sitting on fence post] *A50 McClure's 2/05*

[Girl sitting with hands across knees in long flowing dress] *McClure's 8/04*

[Girl smelling rose on a bush] *Good Housekeeping 6/24*

[Girl students and passengers on coach in town] *C2*

[Girl students ice skating] *C1*

[Girl students in library] *C2*

[Girl students playing May-Pole] *C1*

[Girl students playing soccer] *C1*

[Girl students spreading seeds along row of trees] *C2*

[Girl students walking in long line] *C1*

[Girl students with lanterns] *C2*

[Girl wading in ocean] *Good Housekeeping 7-8/20*

[Girl watering roses, with long stem rose on each side] *Collier's 6/25/04*

[Girl wearing bonnet within pendant motif] *Good Housekeeping 4/20*

[Girl with basket of flowers] *Good Housekeeping 5/22*

[Girl with book, gold background] *A30*

[Girl with Fairy] *A33*

[Girl with green umbrella] *Good Housekeeping 4/22*

[Girl with hatbox] *Good Housekeeping 5/21*

[Girl with red hair sewing] *Good Housekeeping 3/26*

[Girl with umbrella] *Collier's 3/25/05*

Girls knelt on the branches with clasped hands, The *A5*

Give (three hungry children huddled together) *P7*

Give me thy breath, my sister *A9*

Goblins fell back a little when he began, and made horrible grimaces all through the rhyme, The *A55*

Going into Breeches *A30*

Goldfish, The *A54 Good Housekeeping 4/18*

Goldilocks *A38 Collier's 9/28/07*

Goldilocks and the Three Bears *(Swift's Calendar) C9*

Goldilocks; or the Three Bears. *A33 Woman's Home Companion 10/13*

Good Greeneye and her Ass *A15*

Goose Girl, The *A33*

[Grandmother in rocking chair reading to child] *Good Housekeeping 3/25*

Great drawing-room was haunted by a toneful spirit that came and went unseen, The *A43*

Green Door, The *Scribner's 12/03*

H

Hans Brinker *A61 Good Housekeeping 1/23*

Hansel and Gretel *A33*

Hansel and Gretel *Good Housekeeping 11/23*

Hard Lesson, The *A2*

Hats. *A24*

"Have you no mercy?" he stammered with his stiff, white lips. *Ladies Home Journal 12/96*

Hayloft, The *A22 Collier's 9/16/05*

He came bounding up the steps with his cheery Halloo, Aunt Phebe! How are you? *Woman's Home Companion 1/97*

He felt how comfortable it was to have nothing on him but himself. *A45*

He felt the net very heavy; and lifted it out quickly, with Tom all entangled in the meshes. *A45*

He had crept downstairs to take a peep into the parlour. *A44 Collier's 12/11/09*

He looked up at the broad yellow moon . . . and thought that she looked at him. *A45*

He put his arms about her, as she stood on the step above him. *A43*

He put in into my hand so tenderly that for the first time I began, perhaps, to understand *A23 Collier's 12/30/05*

He saw Nancy sitting on the hammock *Ladies Home Journal 10/96*

He spoke not a word, but went straight to his work. *A36*

He sprang to his sleigh, to his team gave a whistle *A36*

He surveyed himself with satisfaction *A16*

He took her hand and kept it; it fluttered for a moment, and they lay still in his. *Ladies Home Journal 11/96*

He was chubby and plump, a right jolly old elf. *A36*

He was dressed all in fur, from his head to his foot. *A36*

"He's a papist priest," thought John. *A5*

Hearing *A32 McClure's 10/07*

Heidi *A61 Good Housekeeping 8/23*

Heidi introduced each in turn by its name to her friend Clara. *A58*

[Heidi with goat] *A58*

[Heidi with mother] *A58*

Helper, The *A38 Collier's 10/5/07*

Helping hands *A59 Good Housekeeping 10/20*

Her bedroom window stood wide open *Harper's 5/03*

His Easter Lily *Collier's 4/7/06*

His eyes-how they twinkled! His dimples how merry! *A36*

His first Easter *Harper's Young People 4/12/92*

Holding onto the banisters, she put him gently away *A43*

Holiday, The *A2*

Home *A26*
Home sketches (4) *Scribner's* 3/04
Hot cross buns. *A39 Good Housekeeping* 4/14
How can any institutional child have a fair chance o' being fully human? *A31*
How Doth the busy little bee. *A30 Woman's Home Companion* 3/10
How sweet and modest and young she looked *Woman's Home Companion* 4/97
Howl away, my painted beauties *A5*
Hush-a-by, baby, on the treetop. *A39*

I

I am never called anything but Heidi. *A58*
I beheld, twirling his mustachios, the figure of a gallant *A4*
"I choose this," said Dolly, holding up a long white kid glove *A16*
I found that Billy had put a chair under the lock. *A23 Collier's* 12/30/05
I have taught him to play cat's-cradle with a bit of string. *A5*
I know that man *Cream of Wheat ad: Delineator* 4/09
I like little Pussy. SEE I love little Pussy.
I love little Pussy. *A30*
"I never knew they had committed any crimes," said Barbara coldly. *Ladies Home Journal* 8/96
"I want to see what you have inside the house," said Heidi *A58*
I'm going to play with the little girl, mother you don't mind, do you? *A20 McClure's* 8/04
If children know that their errors will be pardoned they have less motive to cover them up. *Appleton's* 5/08
In a minute a hand came down over the page, so that she could not draw. *A43*
In an instant she was on the saddle, and clasped in his great strong arms. *A55*
In Grandma's Day *A66 Good Housekeeping* 6/21
In the Garden *Scribner's* 12/02
It took the form of the grandest old lady he had ever seen. *A45*
It was "arms all 'round." *A23 Collier's* 12/30/05
It was in the gray of the morning when he woke . . . and saw her kneeling at the window. *Ladies Home Journal* 9/96
It's not "vegetables" to them . . . it's just good soup! *Campbell's ad: American Magazine* 6/31

J

Jack and Jill *Good Housekeeping* 8/13
Jack and the Bean-Stalk *A33 Woman's Home Companion* 4/14
Jack and the Beanstalk *(Swift's Calendar) C9*
Jack fell down and broke his crown. *A39*
Jackanapes *A61 Good Housekeeping* 6/23
[Japanese child in Japanese dress] *Good Housekeeping* 4/30
Jeanne d'Arc *P1*
Jenny Wren, the Little Dolls' Dressmaker *A35 Scribner's* 12/11
Joe and Beth *A43*
John would perch on the arm of the chair and Mary would press her face close to her mother's head. *A41*

K

Kept In *Collier's* 12/21/04
Kitchen sketches (4) *Scribner's* 5/03
Kittens *A18*
Kneeling beside him as she would have knelt by her brother, she tried to comfort him. *Woman's Home Companion* 5/97
Knitter, The *A54 Good Housekeeping* 2/18

L

Ladybird (3) *Collier's* 12/15/06
Land of Counterpane, The *A22 Collier's* 7/28/06

Last of the Fairy Wands, The (9) *Scribner's* 12/01
Last scene of all that ends this strange and eventful history. *A29 Ladies Home Journal* 9/09
Learning *St Nicholas* 12/05
Ledge of the window was so low that a mere step took her outside, The *A20 McClure's* 8-9/04
Let dogs delight. *A30*
Lifted in his arms, and walked with great strides across the beach *A13*
Lily pool, The *Scribner's* 12/03
Little Bo-Peep has lost her sheep *Good Housekeeping* 7/13
Little boy who forgot to wash his hands, The *A54 Good Housekeeping* 7/19
Little drops of water *A30 Woman's Home Companion* 9/10
Little Eleanor and Little Pepper *A15*
Little Em'ly *A35 Scribner's* 8/12
Little Jack Hale *A2*
Little Jack Horner sat in a corner *A39 Good Housekeeping* 12/13
Little Lame Prince, The *A61 Good Housekeeping* 4/23
Little Land, The *A22*
Little Mabel *A2*
Little Miss Muffet sat on a tuffet. *A39 Good Housekeeping* 1/13
Little Mistress Goodhope *A15*
Little Nell and her Grandfather *A61 Good Housekeeping* 9/23
Little Nell and her Grandfather at Mrs Jarley's *A35 Scribner's* 12/11
Little Paul's Christ-Child (2) *Harper's Weekly* 12/6/02
Little Red Riding Hood *A34 Collier's* 11/20/09
Little Red Riding Hood *C9*
Little Things. SEE Little Drops of Water
Little Women *Delineator* 6/15
Little Women *A61 Good Housekeeping* 2/23
Looking-glass river *A22*

M

Madelon sank down upon the broad seat which stretches below the windows *McClure's* 11/06
Madness of the Abbot of Buckfast, The *A15*
[Madonna and child] *Woman's Home Companion* 12/10
[Madonna and child] *Good Housekeeping* 12/27
[Madonna and child] *Good Housekeeping* 12/31
[Madonna and child in circular illustration with winged child border motif] *Good Housekeeping* 12/17
[Madonna and child surrounded by fruit and flower motif] *Good Housekeeping* 12/21
[Madonna kissing child with apples surrounding picture] *Ladies Home Journal* 10/04
Man in dirty overalls, A *A25 Scribner's* 4/03
March Wind, The *Collier's* 3/16/07
[Mary kneeling before Christ-child in front of Christmas tree] *Good Housekeeping* 12/29
[Mary kneeling beside Christ-child] *Good Housekeeping* 12/24
Mary, Mary, quite contrary. *A39 Good Housekeeping* 6/13
Meg, Jo, Beth and Amy. [Little Women] *A43 The Independent* 12/6/15
Merry Christmas *A47 McClure's* 12/09
Miss Mariar. *A18*
Marie Louise stepped proudly across the pavement. *A41*
Maypole, The *Collier's* 4/30/04
Method of Charles Stuart York, The (7) *McClure's* 8/03
Modern Cinderella, A *A34 Collier's* 12/12/08
Moon, The *A2*
Moon on the breast of the new-fallen snow, The *A36*
Moonbeams *A59 Good Housekeeping* 8/21
Moonlight in the Garret *A47 McClure's* 12/09
Moonlight was shining in through the open door and fell on a white figure standing motionless in the doorway, The *A58*

More Books in the Home *Literary Digest* 11/32
Morning *Scribner's* 12/02
Mother. *A18*
[Mother and child collecting apples in apron] *Good Housekeeping* 10/29
[Mother and child looking at moon through the trees] *Good Housekeeping* 8/21
[Mother and child planting flower] *Good Housekeeping* 5/27
[Mother and child praying in front of window] *Good Housekeeping* 10/19
[Mother and child reading book outside] *Good Housekeeping* 10/21
[Mother and child rolling ball of yarn] *Good Housekeeping* 3/30
[Mother and child waving from shop] *Good Housekeeping* 8/28
[Mother and daughter among flowers reading book] *Good Housekeeping* 9/26
[Mother and daughter reading book under tree] *Good Housekeeping* 10/18
[Mother and two children reading book near beach] *Good Housekeeping* 9/19
[Mother buttoning child's coat] *Good Housekeeping* 3/22
[Mother carrying child through garden] *Good Housekeeping* 9/25
[Mother dipping child in surf] *Good Housekeeping* 8/31
[Mother Goose] *A39*
[Mother holding child surrounded by flower motif] *Woman's Home Companion* 12/07
[Mother kissing child's hand on cement bench] *A26*
[Mother on bench with Daughter's arms around her] *Southern Woman's Magazine* 2/18
[Mother pinning rose on child's lapel] *Good Housekeeping* 6/28
[Mother reading large book with two children on chair] *Collier's* 6/30/06
[Mother reading to child on beach] *Good Housekeeping* 6/25
[Mother sitting in front of window with child kneeling with hands together] *P2*
[Mother with child on lap] *Good Housekeeping* 1/28
[Mother with parasol and white dress; boy in black suit] *Good Housekeeping* 11/22
Mowgli *A61* *Good Housekeeping* 10/23
Mrs Bedonebyasyoudid. *A45*
Mrs Doasyouwouldbedoneby. *A45*
Mrs Kenwigs and the Four little Kenwigses. *A35*
My Ball of Twine *Woman's Home Companion* 12/19
My Mother's second little girl *A62*
My Shadow *A22*
Myee in the wood *A49*

N

Natural History. *A18*
"Never mind, Princess Irene," he said "You mustn't kiss me tonight. But shan't break your word I will come another time." *A55*
New Baby, The *A18*
New Galatea, The (4) *Woman's Home Companion* 1/98
New Mrs. Olcutt was on her knees on the rug, The *A71* *Harper's Weekly* 12/6/02
[New Year's baby dropping from sky in parachute] *Good Housekeeping* 1/33
[New Year's baby in fur suit holding 1926 lantern] *Good Housekeeping* 126
[New Year's baby sitting on the moon] *Good Housekeeping* 1/21
[New Year's child with gun and hat standing on top of world] *Good Housekeeping* 1/19
"1931" boy handing four-leaf clover to "1932" New Year's Baby. *Good Housekeeping* 1/32
No need ever again to urge children to eat cereals *Quaker Oats ad: Delineator* 11/27

No. She cannot be dirty She never could have been dirty. *A45*
Noah's Ark. *A24*
Northwest Passage. *A22* *Collier's* 11/25/05
Now as Julia sat there drinking tea from the quaintest of old-fashioned china cups. *A7*
Now Dasher! Now Dancer! Now Prancer and Vixen! *A36*
Now I lay me down to sleep. *A64*
Now then fall to, ladies, and help yourselves. *A16*
"Now you lead me," he said, taking her hand, "and I'll take care of you." *A53*
[Nurse holding infant with child holding her arm] *P8*
Nursery Weather Signals *Harper's Roundtable* 4/14/91

O

"Oh, don't hurt me!" cried Tom. "I only want to look at you; you are so handsome." *A45*
Oh, how I enjoyed a dull, rainy day. *A8*
Oh, I'll be all right, here is Bruin *Ladies Home Journal* 4/08
Oh, I'll tell you what, girls, let us work for Manuel! *A7*
"Oh, Tom, what is it?" cried Polly, hurrying to him. *A16*
Oliver's first meeting with the Artful Dodger. *A35* *Scribner's* 12/11
On Easter morning, dressed in a fresh white suit, he came to claim his flower. *A41*
On the goose's back sat a tiny figure. *A15*
On the Hammock. *A17*
One foot up, the other foot down. *A39* [The way to London] *Good Housekeeping* 3/13
Our elderly author finds himself in print *Harper's Weekly* 10/3/03
Out of the House of Bondage. (2) *Collier's* 10/6/86
Outdoors *Good Housekeeping* 3/16

P

Pals *A59* *Good Housekeeping* 3/20
Passers-by probably thought them a pair of harmless lunatics. *A43*
Paul Dombey and Florence on the beach at Brighton. *A35*
Paul Ralston (4) *Woman's Home Companion* 2/97, 3/97 and 6/97
Pease porridge hot, pease porridge cold. *A39* *Good Housekeeping* 12/12
Peter, Peter Pumpkin-eater *A39* *Good Housekeeping* 11/13
Pettison Firsts, The (5) *Frank Leslie's Popular Monthly* 2/03
Picture-books in winter. *A22* *Collier's* 12/23/05
Picture Papers. *A24*
Pillar of Society, A (3) *Collier's* 4/7/06
Pip and Joe Gargery. *A35* *Scribner's* 12/11
Playing mother. *A60* *Good Housekeeping* 6/22
Playing today was even a lovelier, happier thing than it had ever been before, The *A20* *McClure's* 8-9/04
Poems of Childhood (4) *Ladies Home Journal* 9/96
Polly *A16*
Polly and Tom *A16*
Polly, I want to tell you something! *A16*
Polly, put the kettle on. *A39* *Good Housekeeping* 2/14
Posy, A *A59* *Good Housekeeping* 5/22
Pray, what's in your basket? *A2*
Prayer, A *A26*
Princess listens, A (4) *Frank Leslie's Popular Monthly* 3/03
[Princess with cape] *A55*
Procession of the Blest, The *Collier's* 12/14/06
Punishment. *A26*
Pushing open the door, she went quietly into the dimly lighted room. *A16*
"Put your foot down firmly once," suggested Heidi. *A58*

Q

Quandary, A *A26*

R

Rain, rain, go away A39 *Good Housekeeping* 4/13
Rainy Day, A A26
Reading hour, The A59 *Good Housekeeping* 11/21
Ready for the out-of-doors. A66 *Good Housekeeping* 3/22
Rebecca of Sunnybrook Farm A61 *Good Housekeeping* 7/23
Recitation, The *Collier's* 5/13/05
Red Riding-Hood. A33
Repine-not *St Nicholas* 12/01
Riding on a rail-car A2
Ring-a-round a rosie. A39
[Round the ring of roses] *Good Housekeeping* 3/14
Rittenhouse Square A37
Rob, the Peddler's boy A15
Rock-a-bye, baby. SEE Hush-a-by, baby, on the treetop *Good Housekeeping* 9/13
Robin put his head down on his arm, and shut his eyes A34
Runaway, The A26
Runaway, The A60 *Good Housekeeping* 7/22
Runaway Couple, The A35 *Scribner's* 8/12
Running the gauntlet A5

S

[Sailor pointing with boy on hill near beach] *Good Housekeeping* 9/18
Salesman may offer you, The *Procter & Gamble: Ivory Soap ad; Ladies Home Journal* 8/01
Sandman, The *Ladies Home Journal* 8/15
Sara Crewe *Good Housekeeping* 5/23
Scales (also titled "Cradle Hymn" in A42) A24
See-saw, Margery Daw. A39 *Good Housekeeping* 2/13
Seeing. A32 *McClure's* 10/07
Seven times one. A30
Sewing Lesson, The. *National Weekly* 12/28/07
She began to mount the stairs which led to the upper floors. A20 *McClure's* 8-9/04
She bent her head and I stood over her. A4
She came down from the platform, still bravely choking back her tears. A44
She clapped her hands with delights and rose such a flapping of wings. A55
She fetched her books and laid them out on the window-sill. *Collier's* 12/23/05
She knew she could eat one when she wanted to, so she was in no hurry. A44
She lufs me-she lufs me not. A34 *Collier's* 6/29/07
She must go and stand at the door and press her cheek against the wood and wait-and listen. A20 *McClure's*
She nearly dropped. On the stairs, tied to the balusters, meekly sat the Reverend Mr. Markhem. *Woman's Home Companion* 3/98
She often sat curving her small long fingers backward. A20 *McClure's* 8-9/04
She ran for some distance, turned several times, and then began to be afraid. A55
She took his hand and giving him the broad part of the spiral stair to walk on, led him a good way. A53
She was able to rush on and pick them up as they were dashed against a lamp-post. A7
She was sitting in a hammock, trying to amuse herself with an old Atlas and not succeeding at all well. A44 *Collier's* 6/24/05
Sick Rose, The A26
Sixth Age shifts to lean and slender maidenhood, The [Then the lean and thoughtful] A29 {*Ladies Home Journal*} 8/09
Sleeping Beauty. *Collier's* 6/11/10
Sleeping Beauty, The A33
Smelling A32 *McClure's* 10/07
Snow-Drop and the Seven Little Dwarfs. A33 *Woman's Home Companion* 11/15
Snow Queen, The *Good Housekeeping* 12/23

Snow-White and Rose-Red A33 *Woman's Home Companion* 3/13
So Diamond sat down again and took the baby in his lap. A53
So Heidi had plenty of time from day to day to sit and picture how everything at home was now turning green, and how the yellow flowers were shining in the sun. A58
So into dear Susan's charge I was given. A8
So Polly tucked herself up in front. A16
[Soldier kissing girl in front yard of house] *Good Housekeeping* 3/18
Speaking words of endearment, where words of comfort availeth not. A3
Spring *Century* 5/04
Spruce Tree, The *Scribner's* 12/03
[Stained glass angel praying] *Good Housekeeping* 12/20
Star, The. SEE Twinkle, twinkle little star.
[Statue of Angelic child] *Good Housekeeping* 12/25
Stories without words. *Harper's Bazaar* 5/02
Stump of a pipe he held tight in his teeth, The A36
Stupid you. A26
Summer's Passing. A26
Supper. *Scribner's* 12/02
Suppers for the youngest Generation. *Quaker Oats ad: Good Housekeeping* 9/28
Sweet and Low. A30
Sweetest thing on earth, The *Procter & Gamble: Ivory Soap ad: Collier's* 10/4/02

T

Tasting. A32 *McClure's* 10/07
Tempered Wind, A A38 *Collier's* 5/26/06
That's the way with all the orphans'll be took care of when-when the millennium comes. A31
Then the Epicure. A29 *Ladies Home Journal* 1/09
Then the lover sighing like a furnace. A29 *Ladies Home Journal* 3/09
Then the Scholar. A29 *Ladies Home Journal* 4/09
Then the Toddling baby boy. A29 *Ladies Home Journal* 1297
There sat his mother by the fire, and in her arms lay the princess fast asleep. A55
There was a dreamy look in Amy's eyes. A13
There was an old woman who lived in a shoe. A39 *Good Housekeeping* 5/13
They *Scribner's* 1/15
They all drew to the Fire A43 *Delineator* 6/15
They both sat quiet for a minute. A16
They felt a little perturbed as they stood in the small vestibule of the chapel. A13
They gazed as if they had known each other for ages of years. A20 *McClure's* 8/04
They had made up their minds that they just would keep awake until Santa Claus came down that chimney. A41
They hugged and kissed each other for ever so long, they did not know why. A45
This Little Pig *Ladies Home Journal* 5/04
Those who have tried Ivory Soap. *Procter & Gamble: Ivory Soap ad: Woman's Home Companion* 2/01
Three Bears, The A34 *Collier's* 9/28/07 Also: A27
[Three carolers dressed in red] *Good Housekeeping* 12/28
[Three children in winter clothes] *Good Housekeeping* 2/31
Three Urchins. A70
Time to Re-Tire. *Fisk Tire ad: Country Life Magazine* date unknown
Tiny Tim. *Ladies Home Journal* 12/14
Tiny Tim. A61 *Good Housekeeping* 12/22
Tiny Tim and Bob Cratchit on Christmas Day. A35
Tiny Tim and Bob Cratchit singing hymn in church. *Good Housekeeping* 12/22
To Auntie. A22
Tom reached and clawed down the hole after him. A45

Tommy the Bad. *A15*

Touching. *A32 McClure's* 10/07

Toys. *A17*

Tragedies of Childhood: A Broken Head and Heart. *Collier's* 3/31/06

Tragedies of Childhood: Lost. *Collier's* 1/26/07

Tragedies of Childhood: The Hurt Finger. *Collier's* 4/28/06

Tragedies of Childhood: The Popular Cut. *Collier's* 2/24/06

Treasure Craft. *A26*

Trust a child to know the good and true. *Procter & Gamble: Ivory Soap ad: Delineator* 6/21

Tulip Time. *A60 Good Housekeeping* 4/22

Twas the night before Christmas. *Collier's* 12/21/07

Twas the night before Christmas. *A36*

Twilight of Life, The (4) *Harper's Bazaar* 11/02

Twinkle, twinkle little star. *A30 Woman's Home Companion* 12/09

Two careers. (2) *Harper's Bazaar* 4/02

[Two children and dog looking at picture book] *Good Housekeeping* 10/30

[Two children at base of fountain] *A34 Collier's* 6/11/10

[Two children at table with Mad Hatter and March Hare in framing panels] *Quaker Puffed Rice ad: Woman's Home Companion* 11/23

[Two children dancing] *Good Housekeeping* 11/26

[Two children dressed as cooks carrying hot roast] *Good Housekeeping* 12/30

[Two children drinking water from well] *Good Housekeeping* 7/27

[Two children in tub floating on water] *Good Housekeeping* 8/32

[Two children holding hands] *Good Housekeeping* 9/24

[Two children holding hands on beach] *Good Housekeeping* 8/29

[Two children huddled beneath Mother Goose's wings] *A39*

[Two children huddled under red umbrella] *Good Housekeeping* 4/26

[Two children ice skating] *Good Housekeeping* 3/29

[Two children kissing] *Good Housekeeping* 6/26

[Two children in front of fireplace on stools] *Collier's* 12/15/06

[Two children on chair looking at book] *Good Housekeeping* 11/21

[Two children on chair reading book] *McClure's* 12/09

[Two children on hammock reading book] *A54 Good Housekeeping* 7/18

[Two children on sled] *Good Housekeeping* 2/26

[Two children, one crying] *Good Housekeeping* 4/29

[Two children playing checkers] *Collier's* 1/27/06

[Two children playing in sand] *Good Housekeeping* 7/24

[Two children playing in surf] *A45*

[Two children playing pat-a-cake] *Good Housekeeping* 3/28

[Two children playing with building blocks] *Procter & Gamble: Ivory Soap ad: Ladies' World* 2/00

[Two children praying over harvest] *Good Housekeeping* 11/30

[Two children sledding] *Good Housekeeping* 3/19

[Two children wading] *Good Housekeeping* 7/21

[Two girl graduates holding lantern] *C1*

[Two girl scouts examining pussy willows] *Good Housekeeping* 3/33

[Two girls in field of daisies] *Good Housekeeping* 6/10

[Two girls picnicking on beach] *Good Housekeeping* 8/24

[Two girls saying grace] *Good Housekeeping* 11/20

[Two girls winding yarn] *Good Housekeeping* 2/18

[Two women sitting on wall in front of blossom tree] *Collier's* 5/28/04

U

Using her oar as a lever, she tried to push off. *A13*

W

Warming Feet *A17*

Way to London Town, The SEE One foot up, the other foot down.

We give thee thanks. *A59 Good Housekeeping* 11/20

We must run away. *A5*

We took a walk. *A2*

We were both silent. There did not seem to be anything more to talk about *A28 McClure's* 4/05

Wedding of Mr Barrett's Niece, The (2) *Woman's Home Companion* 1/98

Wee Willie Winkie. *Scribner's* 1/15

What do you think? *A2*

When Daddy was a little boy. *A18*

When out on the lawn there arose such a clatter. *A36*

Where nothing was seen but the Quaker gown. *A8*

While the mother works: A look at the Day Nurseries of New York. (10) *3Century* 12/02

Why, Brenda Barlow, why are you lying in this downcast position? *A7*

"Why must you be so fine to go to school?" asked Polly. *A16*

Wind's Song, The *A47 McClure's* 12/09

Winkie Wee. *A2*

With a little old driver so lively and quick. *A36*

With a shriek they turned and fled as if from a pestilence. *A4*

With the scissors in his hand . . . *Good Housekeeping* 9/16

Within the ring of singing: A story of the Pettison Twins. *Frank Leslie's Popular Monthly* 8/03

[Woman and girl on beach] *Ladies' Home Companion* 8/96

[Woman kneeling, picking posies] *Collier's* 8/26/05

[Woman with angel carrying holly branch] *Ladies Home Companion* 12/96

[Woman with child in arms, surrounded by holly wreath] *Woman's Home Companion* 12/13

[Woman with flowing hair under sunflowers] *Woman's Home Companion* 8/97

[Woman with shawl and overcoat in snow] *Ladies' Home Companion* 11/96

[Woman with wreath in hair wearing long white shawl and carrying a book] *Scribner's* 8/00

Y

Ye Gay Young Sub-Freshman. *C2*

You can have that, I have plenty. *A58*

You must eat certain foods. *Quaker Oats ad, Ladies' Home Journal* 10/26

You should have seen my triumphal entry into the city, sitting among my goods and chattels. *A16*

[Young woman] *A19*

Index of Book Titles

A

American Art by American Artists, *A38*
Art Stories-Book One, *A73*
At the Back of the North Wind, *A53, A53.1*

B

Baby's Red Letter Days, *A14*
Bed-Time Book, The, *A24, B6*
Billy-Boy, *A23*
Bobs, King of the Fortunate Isle, *A69*
Book of Lullabies, A, *A64*
Book of the Child, The, *A17*
Boys and Girls of Bookland, *A61, A61.1, A61.2*
Brenda, Her School and Club, *A7*
Brenda's Summer at Rockley, *A13*
Bugs and Wings and Other Things, *A49*

C

Children of Dickens, The, *A65*
Child's Book of Country Stories, A, *A66, A79*
Child's Book of Famous Stories, A, *A85*
Child's Book of Modern Stories, A, *A54, A76*
Child's Book of Old Verses, A, *A30, A74*
Child's Book of Stories, A, *A33, A75, B10*
Child's Book of Verses, A, *B8*
Child's Garden of Verses, A, *A22, B3*
Child's Prayer, A, *A63, A63.1*
Child's Stamp Book of Old Verses, A, *A42*
Chronicles of Rhoda, The, *A28*

D

Dickens's Children, *A35, B9*
Dream Blocks, *A26, B7*

E

Evangeline, *A3, B1*
Everyday & Now-a-Day Fairy Book, The *B18, B19*
Everyday Fairy Book, The, *A44, B12, B20*

F

Fairy and Wonder Tales, *A51*
Five Senses, The, *A32*
Folk-lore, Fables and Fairy Tales, *A68*

G

Grimm's Fairy Tales, *A84*

H

Head of a Hundred, The, *A4, A6*
Heidi, *A58*

I

Ideal Heads, *A1*
In the Closed Room, *A20, A21, B2*

J

Jessie Willcox Smith Mother Goose, The, *A39*

K

Kitchen Fun, *A72*

L

Little Child's Book of Stories, A, *A59, A77*
Listen and Sing, *A81*
Little Folks Illustrated Annual, The, *A50*

Little Mistress Goodhope, *A15*
Little Mother Goose, The, *A48*
Little Paul's Christ Child, *A71*
Little Women, *A43, A57*
Lullaby Book, The, *A56*

M

Memories and a Garden, *A62*
Mosses from an Old Manse, *A9, A11*
Mother Goose, *B15*
Mother Goose Melodies Toybooks, *A40*

N

New and True, *A2*
Now-a-Days Fairy Book, The, *A34, B16, B21*

O

Old-Fashioned Girl, An, *A16, B5*

P

Peregrination of Philadelphia, A, *A37*
Poems Old and New, *A52*
Princess and the Goblin, The, *A55, A55.1, A55.2*

R

Reminiscences of an Old Chest of Drawers, *A8*
Rhymes and Reminiscences, *A70*
Rhymes of Real Children, *A18, B4*

S

Seven Ages of Childhood, The, *A29*
Sonny's Father, *A31*

T

Tales and Sketches, *A10, A12*
Ten to Seventeen, *A25*
Thirty Favorite Paintings, *A27*
Truth Dexter, *A19*
Tuning Up, *A82*
Twas the Night Before Christmas, *A36*

V

Very Little Child's Book of Stories, A, *A60, A78*

W

Water Babies, The, *A45, A45.1, A46, A80, A83, B13, B17, B22*
Way to Wonderland, The, *A47, B14*
When Christmas Comes Around, *A41, B11*
When Mother Lets Us Make Paper Box Furniture, *A67*

Y

Young Puritans in Captivity, *A5*

Index of
Book Authors

Alcott, Louisa May, *A16, A43, A57, B5*
Bacon, Josephine Daskam, *A25*
Bell, Louisa Price, *A72*
Bull, Kathryn Jarboe, *A71*
Burnett, Frances Hodgson, *A20, A21, B2*
Chapin, Anna Alice, *A34, A44, B12, B16, B18, B19, B20, B21*
Coussens, Penrhyn W., *A33, A75, A85, B10*
Cox, Florence Tinsley, *A28*
Crothers, Samuel McChord, *A65*
Dickens, Charles, *A35, B9*
Franchot, Annie W., *A49, A69*
Glenn, Mabelle, *A81, A82*
Goodwin, Maud Wilder, *A4, A6*
Grimm, The Brothers, *A84*
Hawthorne, Nathaniel, *A9, A10, A11, A12*
Higgins, Aileen C., *A26, B7*
Humphrey, Mabel, *A17*
Keyes, Angela M., *A32*
Kingsley, Charles, *A45, A45.1, A46, A80, A83, B13, B17, B22*
Long, John Luther, *A23*
Longfellow, Henry Wadsworth, *A3, B1*
MacDonald, George, *A53, A53.1, A55, A55.1, A55.2*
McCall, Sidney, *A19*
Moore, Clement C., *A36*
Newton, A. Edward, *A37*
Pratt, Charles and Ella, *A50*
Reed, Helen Leah, *A7, A13*
Rich, G. Ellingwood, *A67*
Sage, Betty, *A18, B4*
Saville, Emily Eldredge, *A62*
Saville, Henry Martyn, *A70*
Shelby, Anne Blanche, *A56*
Sill, Sarah Cauffman, *A8*
Skinner, Ada M. and Eleanor L., *A54, A59, A60, A66, A76, A77, A78, A79*
Smith, Elva S., *A64*
Smith, Jessie Willcox, *A14, A30, A39, A40, A42, A48, A74, B8, B15*
Smith, Mary P. Wells, *A5*
Smith, Nora Archibald, *A61, A61.1, A61.2*
Spyri, Johanna, *A58*
Staver, Mary Wiley, *A2*
Stevenson, Robert Louis, *A22, B3*
Stewart, Mary, *A47, B14*
Stuart, Ruth McEnery, *A31*
Taylor, Mary Imlay, *A15*
Toogood, Cora Cassard, *A63, A63.1*
Underwood, Priscilla, *A41, B11*
Waugh, Ida, *A1*
Wells, Carolyn, *A29*
Whitford, William G., *A73*
Whitney, Helen Hay, *A24, B6*